COMPUTER
BOOK SERIES
FROM IDG

VCR's & Camcorders For Dummies®, 2nd Edition

Cheat Sheet

S0-ABA-557

Quick VCR and Camcorder Fixes

The Problem	The Solution
The VCR is flashing 12:00.	The clock isn't set, possibly because the power went out. To reset it, see Chapter 5.
The VCR won't record on a tape.	If there's a small, square hole in the tape's label side, the tape's safety record tab has been broken off. Just cover the hole with Scotch tape.
White lines appear on TV screen when playing back a tape.	Twist the VCR's *tracking* knob until the lines disappear.
The top and bottom of the picture are black.	There's no solution. The TV station is broadcasting a movie to fit the TV screen. The station isn't cropping off the picture's edges, so to keep the proportions correct, the station blackens the top and bottom of the picture.
The picture turns black when I press Pause.	Many camcorders can't display a paused picture if it was recorded at a slow speed.

Tips for Shooting Interesting Videos

Don't walk while taping. Let your subject do the moving.

Do vary your shots. Shoot from different angles, mix close-ups with far-away shots, and don't always stand while shooting.

Don't talk while videotaping. Viewers want to see and hear what you're videotaping, not what you're saying.

Do try to include interesting sounds. Time your shots to capture interesting sounds as well as video.

Don't forget to bring a spare battery that's charged up.

How to Set My VCR Clock

Steps	Comments
1.	
2.	
3.	
4.	
5.	
6.	
7.	
8.	

. . . For Dummies: #1 Computer Book Series for Beginners

COMPUTER
BOOK SERIES
FROM IDG

VCR's & Camcorders For Dummies®, 2nd Edition

Cheat Sheet

Advanced VCR Features

Feature	Check (or rank) the features you want
Audio-video jacks	
Auto head cleaning	
Auto power on-off	
Auto rewind	
Auto tracking	
Center-mounted	
Closed caption	
Commercial skipper	
Digital effects	
Flying erase heads	
Four heads	
Hi-fi	
HQ	
Index search	
Manual tracking	
Message center	
On-screen programming	
Power backup	
Quasi S-VHS Playback	
Quick start	
Real-time counter	
Secondary audio program	
Shuttle ring	
Stereo	
VCR Plus	
Video noise reduction	
Voice-activated programming	

Quick Steps for Programming a VCR

1. Make sure that your VCR's clock is set accurately.

 (Chapter 5 covers this terror.)

2. Find the VCR's program menu.

 Push the VCR button that brings a menu onto the TV screen and choose the programming or recording option. (*Hint:* The button may be hiding on the VCR's remote control and not the VCR itself.)

3. Specify the starting date and time of your show.

 Because most VCRs let you program them at least a week in advance, you have to specify the date (or day of the week) and the time your show begins.

4. Specify the ending date and time.

 Most VCRs make you punch in a date and time for when to stop recording.

5. Specify the channel to record.

 For example, tell the VCR to record Channel 3 (to pick up whatever the cable box is dialed to). If you don't have cable, just tell the VCR to record whatever channel number your show appears on.

6. Specify the recording speed.

 Most VCRs automatically choose a recording speed, but some can pack more information onto a tape by recording at slower speeds (like EP or LP). When in doubt, however, choose SP for best quality.

The Faux O'Clock

Can't figure out how to set your VCR's clock? Tired of those bright, blinking numbers? Then cut out the fake clock below. Tape the Faux O'Clock over your VCR's own clock and banish that twinkling 12:00 forever.

4:00 PM

IDG
BOOKS
WORLDWIDE

. . . For Dummies: #1 Computer Book Series for Beginners

VCRs & CAMCORDERS FOR DUMMIES®

2ND EDITION

VCRs & CAMCORDERS FOR DUMMIES®

2ND EDITION

by Gordon McComb
and Andy Rathbone

IDG Books Worldwide, Inc.
An International Data Group Company

Foster City, CA ◆ Chicago, IL ◆ Indianapolis, IN ◆ Braintree, MA ◆ Dallas, TX

VCRs & Camcorders For Dummies,® Second Edition

Published by
IDG Books Worldwide, Inc.
An International Data Group Company
919 E. Hillsdale Blvd.
Suite 400
Foster City, CA 94404

Library of Congress Catalog Card No.: 95-80824

ISBN: 1-56884-397-6

Printed in the United States of America

10 9 8 7 6 5 4 3 2 1

2A/SV/RQ/ZV

Distributed in the United States by IDG Books Worldwide, Inc.

Distributed by Macmillan Canada for Canada; by Computer and Technical Books for the Caribbean Basin; by Contemporanea de Ediciones for Venezuela; by Distribuidora Cuspide for Argentina; by CITEC for Brazil; by Ediciones ZETA S.C.R. Ltda. for Peru; by Editorial Limusa SA for Mexico; by Transworld Publishers Limited in the United Kingdom and Europe; by Al-Maiman Publishers & Distributors for Saudi Arabia; by Simron Pty. Ltd. for South Africa; by IDG Communications (HK) Ltd. for Hong Kong; by Toppan Company Ltd. for Japan; by Addison Wesley Publishing Company for Korea; by Longman Singapore Publishers Ltd. for Singapore, Malaysia, Thailand, and Indonesia; by Unalis Corporation for Taiwan; by WS Computer Publishing Company, Inc. for the Philippines; by WoodsLane Pty. Ltd. for Australia; by WoodsLane Enterprises Ltd. for New Zealand.

For general information on IDG Books Worldwide's books in the U.S., please call our Consumer Customer Service department at 800-762-2974. For reseller information, including discounts and premium sales, please call our Reseller Customer Service department at 800-434-3422.

For information on where to purchase IDG Books Worldwide's books outside the U.S., contact IDG Books Worldwide at 415-655-3021 or fax 415-655-3295.

For information on translations, contact Marc Jeffrey Mikulich, Director, Foreign & Subsidiary Rights, at IDG Books Worldwide, 415-655-3018 or fax 415-655-3295.

For sales inquiries and special prices for bulk quantities, write to the address above or call IDG Books Worldwide at 415-655-3200.

For information on using IDG Books Worldwide's books in the classroom, or ordering examination copies, contact Jim Kelly at 800-434-2086.

For authorization to photocopy items for corporate, personal, or educational use, please contact Copyright Clearance Center, 222 Rosewood Drive, Danvers, MA 01923, or fax 508-750-4470.

is a trademark under exclusive license to IDG Books Worldwide, Inc., from International Data Group, Inc.

About the Authors

Gordon McComb

As a kid, Gordon McComb watched too much TV. Morning, noon, and night he could be found sitting in front of the boob tube. But it all turned out to be research for this book. He sacrificed watching countless hours of *Andy Griffith* reruns so that you'd have the best book possible on VCRs and camcorders. That's the kind of deep dedication he has for his work.

When not watching TV, Gordon can occasionally be found in front of his computer monitor (a kind of TV screen) writing books and magazine articles. So far, he's written over 45 books and some 1,000 magazine articles. His specialties are video, computers, high technology, and home improvement. He is the author of the best-selling *Troubleshooting and Repairing VCRs* (Tab/McGraw-Hill), is the West Coast Editor of *Camcorder Buyer's Guide* magazine, and is a frequent contributor to *Video* magazine.

Gordon lives in the San Diego area with his wife, Jennifer, and two children, Merci and Max. Keeping them company is an assortment of dogs, cats, and birds, none of which know how to set the clock on the VCR.

Andy Rathbone

An electronics engineer by trade, Andy Rathbone's father, Rhett, spent many hours showing his young son how to fiddle with short-wave radios, oscilloscopes, reel-to-reel tape recorders, and other gadgets.

Years later, Andy began playing with computers and camcorders, as well as working part time at Radio Shack. When not playing computer games, Andy worked at several local newspapers, taking photographs and writing stories.

During the next few years, Andy combined his interests in writing and electronics by writing books about computers, as well as writing articles for magazines like *Supercomputing Review*, *ID Systems*, *DataPro*, and *Shareware*.

In 1992, Andy and *DOS For Dummies* author/legend Dan Gookin teamed up to write *PCs For Dummies*, which was a runner-up in the Computer Press Association's 1993 awards. Andy subsequently wrote *Windows For Dummies*, *More Windows For Dummies*, *Windows 95 For Dummies*, *OS/2 For Dummies*, *Upgrading & Fixing PCs For Dummies*, and *Multimedia & CD-ROMs For Dummies*.

Today, Andy writes for magazines like *PC World* and *CompuServe*, and lives with his most-excellent wife, Tina, and their cat in San Diego, California. When not writing or making movies, Andy fiddles with his MIDI synthesizer and tries to keep the cat off both keyboards.

ABOUT IDG BOOKS WORLDWIDE

Welcome to the world of IDG Books Worldwide.

IDG Books Worldwide, Inc., is a subsidiary of International Data Group, the world's largest publisher of computer-related information and the leading global provider of information services on information technology. IDG was founded more than 25 years ago and now employs more than 7,700 people worldwide. IDG publishes more than 250 computer publications in 67 countries (see listing below). More than 70 million people read one or more IDG publications each month.

Launched in 1990, IDG Books Worldwide is today the #1 publisher of best-selling computer books in the United States. We are proud to have received 8 awards from the Computer Press Association in recognition of editorial excellence and three from Computer Currents' First Annual Readers' Choice Awards, and our best-selling ...For Dummies® series has more than 19 million copies in print with translations in 28 languages. IDG Books Worldwide, through a joint venture with IDG's Hi-Tech Beijing, became the first U.S. publisher to publish a computer book in the People's Republic of China. In record time, IDG Books Worldwide has become the first choice for millions of readers around the world who want to learn how to better manage their businesses.

Our mission is simple: Every one of our books is designed to bring extra value and skill-building instructions to the reader. Our books are written by experts who understand and care about our readers. The knowledge base of our editorial staff comes from years of experience in publishing, education, and journalism — experience which we use to produce books for the '90s. In short, we care about books, so we attract the best people. We devote special attention to details such as audience, interior design, use of icons, and illustrations. And because we use an efficient process of authoring, editing, and desktop publishing our books electronically, we can spend more time ensuring superior content and spend less time on the technicalities of making books.

You can count on our commitment to deliver high-quality books at competitive prices on topics you want to read about. At IDG Books Worldwide, we continue in the IDG tradition of delivering quality for more than 25 years. You'll find no better book on a subject than one from IDG Books Worldwide.

John J. Kilcullen

John Kilcullen
President and CEO
IDG Books Worldwide, Inc.

WINNER
Eighth Annual
Computer Press
Awards ⟹ 1992

WINNER
Ninth Annual
Computer Press
Awards ⟹ 1993

IDG
BOOKS
WORLDWIDE

IDG Books Worldwide, Inc., is a publication of International Data Group, the world's largest publisher of computer-related information and the leading global provider of information services on information technology. International Data Group publishes over 250 computer publications in 67 countries. Seventy million people read one or more International Data Group publications each month. International Data Group's publications include: **ARGENTINA:** Computerworld Argentina, GamePro, Infoworld, PC World Argentina; **AUSTRALIA:** Australian Macworld, Client/Server Journal, Computer Living, Computerworld, Digital News, Network World, PC World, Publishing Essentials, Reseller; **AUSTRIA:** Computerwelt, PC TEST; **BELARUS:** PC World Belarus; **BELGIUM:** Data News; **BRAZIL:** Annuário de Informática, Computerworld Brazil, Connections, Super Game Power, Macworld, PC World Brazil, Publish Brazil, SUPERGAME; **BULGARIA:** Computerworld Bulgaria, Networkworld/Bulgaria, PC & MacWorld Bulgaria; **CANADA:** CIO Canada, ComputerWorld Canada, InfoCanada, Network World Canada, Reseller World; **CHILE:** Computerworld Chile, GamePro, PC World Chile; **COLUMBIA:** Computerworld Colombia, GamePro, PC World Colombia; **COSTA RICA:** PC World Costa Rica/Nicaragua; **THE CZECH AND SLOVAK REPUBLICS:** Computerworld Czechoslovakia, Elektronika Czechoslovakia, PC World Czechoslovakia; **DENMARK:** Communications World, Computerworld Danmark, Macworld Danmark, PC World Danmark, PC World Danmark Supplements, TECH World; **DOMINICAN REPUBLIC:** PC World Republica Dominicana; **ECUADOR:** PC World Ecuador, GamePro; **EGYPT:** Computerworld Middle East, PC World Middle East; **EL SALVADOR:** PC World Centro America; **FINLAND:** MikroPC, Tietoverkko, Tietoviikko; **FRANCE:** Distributique, Golden, Info PC, Le Guide du Monde Informatique, Le Monde Informatique, Reseaux & Telecoms; **GERMANY:** Computer Business, Computerwoche, Computerwoche Extra, Computerwoche Focus, Electronic Entertainment, GamePro, I/M Information Management, Macwelt, PC Welt; **GREECE:** GamePro, Macworld & Publish; **GUATEMALA:** PC World Centro America; **HONDURAS:** PC World Centro America; **HONG KONG:** Computerworld Hong Kong, PCWorld Hong Kong, Publish in Asia; **HUNGARY:** ABCD CD-ROM, Computerworld Szamitastechnika, PC & Mac World Hungary, PC-X Magazine; **INDIA:** Computerworld India, PC World India, Publish in Asia; **INDONESIA:** InfoKomputer PC World, Komputek Computerworld, Publish in Asia; **IRELAND':** ComputerScope, PC Live!; **ISRAEL:** PC World 32 BIT, People & Computers; **ITALY:** Computerworld Italia, Computerworld Italia Special Editions, Lotus Italia, Macworld Italia, Networking Italia, PC Shopping, PC World Italia, PC World/Walt Disney; **JAPAN:** Macworld Japan, Nikkei Personal Computing, SunWorld Japan, Windows World Japan; **KENYA:** East African Computer News; **KOREA:** Hi-Tech Information/Computerworld, Macworld Korea, PC World Korea; **MACEDONIA:** PC World Macedonia; **MALAYSIA:** Computerworld Malaysia, PC World Malaysia, Publish in Asia; **MEXICO:** Computerworld Mexico, GamePro, Macworld, PC World Mexico; **MYANMAR:** PC World Myanmar; **NETHERLANDS:** Computable, Computer! Totaal, LAN Magazine, Macworld, Net Magazine; **NEW ZEALAND:** Computer Buyer, Computerworld New Zealand, MTB, Network World, PC World New Zealand; **NICARAGUA:** PC World Costa Rica/Nicaragua; **NIGERIA:** PC World Africa; **NORWAY:** Computerworld Norge, Computerworld Privat, CW Rapport Klient/Tjener, CW Rapport Nettverk & Telecom, CW Rapport Offentlg Sektor, IDG's KURSGUIDE, Macworld Norge, Multimedia World, Computerworld Eksprens, PC World Nettverk, PC World Norge, PC World's Produktguide, Windows Spesial; **PAKISTAN:** Computerworld Pakistan, PC World Pakistan; **PANAMA:** GamePro, PC World Panama; **PARAGUAY:** PC World Paraguay; **P. R. OF CHINA:** China Computerworld, China Infoworld, Computer & Communication, Electronic Product World, Electronics Today, Game Camp, PC World China, Popular Computer Week, Software World, Telecom Product World; **PERU:** Computerworld Peru, GamePro, PC World Profesional Peru, PC World Peru; **POLAND:** Computerworld Poland, Computerworld Special Report, Macworld, Networld, PC World Komputer; **PHILIPPINES:** Computerworld Philippines, PC Digest, Publish in Asia; **PORTUGAL:** Cerebro/PC World, Correio Informático/Computerworld, Mac•In/PC•In Portugal; **PUERTO RICO:** PC World Puerto Rico; **ROMANIA:** Computerworld Romania, PC World Romania, Telecom Romania; **RUSSIA:** Computerworld Rossiya, Network World Russia, PC World Russia; **SINGAPORE:** Computerworld Singapore, PC World Singapore, Publish in Asia; **SLOVENIA:** MONITOR; **SOUTH AFRICA:** Computing S.A., Network World S.A., Software World; **SPAIN:** Computerworld España, COMUNICACIONES WORLD, Dealer World, Macworld España, PC World España; **SWEDEN:** CAP&Design, Computer Sweden, Corporate Computing, MacWorld, Maxi Data, MikroDatorn, Nätverk & Kommunikation, PC/Aktiv, PC World, Windows World; **SWITZERLAND:** Computerworld Schweiz, Macworld Schweiz, PCtip; **TAIWAN:** Computerworld Taiwan, Macworld Taiwan, Publish Taiwan, Windows World; **THAILAND:** Thai Computerworld, Publish in Asia; **TURKEY:** Computerworld Monitör, MACWORLD Turkiye, PC WORLD Turkiye; **UKRAINE:** Computerworld Kiev, Computers & Software Magazine, PC World Ukraine; **UNITED KINGDOM:** Acorn User, Amiga Action, Amiga Computing, Amiga, Appletalk, CD Powerplay, CD-ROM Now, Computing, Connexion, GamePro, Lotus Magazine, Macaction, Macworld, Open Computing, Parents and Computers, PC Home, PC Works, The WEB; **UNITED STATES:** Cable in the Classroom, CD Review, CIO Magazine, Computerworld, Computerworld Client/Server Journal, Digital Video Magazine, DOS World, Electronic, InfoWorld, I-Way, Macworld, Maximize, MULTIMEDIA WORLD, Network World, PC World, PUBLISH, SWATPro Magazine, Video Event, WebMaster; **URUGUAY:** PC World Uruguay; **VENEZUELA:** Computerworld Venezuela, GamePro, PC World Venezuela; and **VIETNAM:** PC World Vietnam 10/3/95

Acknowledgments

Special thanks to Kristin Cocks, Becky Whitney, Kaon Koo (the sysop of an on-line consumer electronics forum — CompuServe ID 74040,142), Dan and Sandy Gookin, Bill Gladstone, Barb Terry, and Matt Wagner.

(The publisher would like to thank Patrick J. McGovern, without whom this book would not have been possible.)

Credits

**Senior Vice President
and Publisher**
Milissa L. Koloski

Associate Publisher
Diane Graves Steele

Brand Manager
Judith A. Taylor

Editorial Managers
Kristin A. Cocks
Mary Corder

Product Development Manager
Mary Bednarek

Editorial Executive Assistant
Richard Graves

Editorial Assistants
Constance Carlisle
Chris Collins
Stacey Holden Prince
Kevin Spencer
Laurie Maudlin

Acquisitions Assistant
Suki Gear

Production Director
Beth Jenkins

**Supervisor of
Project Coordination**
Cindy L. Phipps

Supervisor of Page Layout
Kathie S. Schnorr

Production Systems Specialist
Steve Peake

Pre-Press Coordination
Tony Augsburger
Patricia R. Reynolds
Theresa Sánchez-Baker
Elizabeth Cárdenas-Nelson

Media/Archive Coordination
Leslie Poppelwell
Kerri Cornell
Michael Wilkey

Project Editor
Kristin Cocks
Barbara M. Terry

Graphic Coordination
Shelley Lea
Gina Scott
Carla C. Radzikinas

Copy Editor
Becky Whitney

Technical Reviewer
Kaon Koo

Associate Project Coordinator
Sherry Gomoll

Production Staff
Angela F. Hunckler
Jane Martin
Laura Puranen

Proofreaders
Arielle Carole Mennelle
Gwenette Gaddis
Dwight Ramsey
Robert Springer

Indexer
Steve Rath

Book Design
University Graphics

Cover Design
Kavish + Kavish

Contents at a Glance

Introduction .. *1*

Part I: Bare-Bones VCR Basics .. *5*

Chapter 1: Beginner's Guide to VCRs .. 7

Chapter 2: What *Are* All Those Features? .. 17

Chapter 3: Hooking Up Your VCR .. 39

Chapter 4: The VCR's Arsenal of Buttons, Knobs, and Lights 61

Chapter 5: Facing the Blinking Clock ... 71

Part II: Making the VCR Do Something *83*

Chapter 6: Taping and Watching Programs .. 85

Chapter 7: Programming Your VCR (Oh, No!) 97

Chapter 8: Using VCR Plus ... 107

Chapter 9: Keeping Your VCR Healthy ... 119

Chapter 10: Everything You Never Wanted to Know about Videotapes 129

Chapter 11: Slightly More Strenuous TV/VCR Hookups 149

Part III: Cradling the Camcorder *167*

Chapter 12: Camcorders, Tapes, and Formats 169

Chapter 13: The Camcorder's Arsenal of Knobs and Buttons 181

Chapter 14: Pointing and Shooting without Goofing 191

Part IV: Something's Messed Up! *199*

Chapter 15: Pointing Fingers: When the VCR Is Not at Fault 201

Chapter 16: Buzz, Pop, Fizz — Curing TV Interference 215

Chapter 17: In Case of Trouble...Break Glass 229

Chapter 18: When Trouble Persists: Fixing the Big Problems 239

Part V: The Part of Tens ... 249

Chapter 19: Ten Tips for Making Better Tapes ..251

Chapter 20: Ten Neat Things to Buy for Your VCR......................................255

Chapter 21: Ten Ways to Make Big Bucks with Your VCR or Camcorder259

Chapter 22: Ten Most Common Mistakes (and How to Fix Them)263

Chapter 23: Ten (or more) Answers to the Most Common Questions267

Chapter 24: Ten Camcorder Tricks and Tips ..273

Chapter 25: Ten Ways to Drive the Video Superhighway279

Part VI: Appendixes .. 287

Appendix A: Sources for Videos You Can Order by Mail289

Appendix B: How to Read a TV Listing ..295

Appendix C: Glossary ...301

Index ... 311

Reader Response ... Back of Book

Cartoons at a Glance

By Rich Tennant

page 70

page 166

page 199

page 96

page 83

page 248

page 167

page 287

page 5

page 249

Table of Contents

Introduction ... **1**

About This Book .. 1

How to Use This Book .. 2

How This Book Is Organized ... 2

 Part I: Bare-Bones VCR Basics ... 2

 Part II: Making the VCR Do Something 3

 Part III: Cradling the Camcorder 3

 Part IV: Something's Messed Up! .. 3

 Part V: The Part of Tens ... 3

 Part VI: Appendixes ... 3

 Icons Used in This Book ... 4

Where to Go from Here ... 4

Part I: Bare-Bones VCR Basics ... **5**

Chapter 1: Beginner's Guide to VCRs **7**

Why Are VCRs So Popular? .. 7

What Can I Do with a VCR? ... 8

 Control the TV .. 8

 Play movies ... 9

 Record movies ... 9

 Edit movies ... 10

 Fiddle with movies .. 10

Why Are VCRs So Blasted Hard to Use? .. 10

Should I Care How VCRs Work? .. 11

What's the Difference Between VHS, S-VHS, and Other Video Formats? 11

 VHS format .. 12

 Super-VHS (S-VHS) format .. 13

 A VCR built into the TV ... 14

 Beta format ... 14

Chapter 2: What *Are* All Those Features? **17**

A VCR's Basic Features .. 17

 Recording shows ... 18

 Playing back movies ... 18

 Tuning in channels .. 19

A VCR's More Complicated Features ... 20
 Audio/video jacks ... 20
 Auto head cleaning ... 21
 Auto power on-off .. 22
 Auto/rewind .. 22
 Auto-manual tracking ... 22
 Cable ready .. 23
 Center- or midmount chassis .. 23
 Closed caption ... 23
 Commercial skipper ... 24
 Digital effects .. 24
 EP, LP, or SP .. 24
 Flying erase heads ... 25
 Heads .. 25
 Hi-fi .. 25
 HQ ... 26
 Index search ... 26
 Message center ... 27
 Power backup ... 27
 Programming .. 27
 Quartz tuning .. 28
 Quasi S-VHS playback ... 28
 Quick start .. 29
 Real-time counter .. 29
 SAP (secondary audio program) .. 29
 Shuttle ring ... 30
 StarSight, ... 30
 Stereo ... 32
 VCR Plus (VCR+) .. 32
 Video-noise reduction .. 32
 Voice-activated programming .. 33
Buying a VCR ... 33
 THE three big decisions .. 33
 Should I buy from a local dealer, mail-order company,
 warehouse club, or garage sale? .. 35
 Choosing the right remote control .. 36
 Uh, what do I do with the old VCR? ... 36
 Are extended service warranties a ripoff? 37

Chapter 3: Hooking Up Your VCR ... 39
Unpacking the VCR from the Box ... 39
 Open the box ... 40
 Find a packing list .. 41
 Look for damage .. 41
 Save all materials ... 41
 Put the batteries in the remote control 42

Clearing a Space Beside the TV for the VCR 42
 Good spots, bad spots for the VCR 43
 Move the TV to get to the back 43
Connecting the VCR 44
 Cable hookup 45
 Plain old antenna 47
 Plug in the VCR to the wall socket 50
How Do I Hook Up My Nintendo or Atari Jaguar? 50
Should I Choose Channel 3 or 4? 50
Connecting the VCR to Your Stereo System 51
 Find the Aux connector 52
 Buy the right cable 53
 Connect the audio cable 54
Testing to Make Sure That It All Works 54
 Turn the VCR on 54
 Dial the channels on the VCR 55
 Play a prerecorded tape 55
 Record a test tape 55
 Test the front-panel controls 56
 Test the remote control 56
 Setting Up the VCR 56
Looking over the Manual 58
 Skip the cautionary stuff at the beginning 58
 Find the setup information 58
 Leave the special-features section for now 59
 Having problems? Check the troubleshooting chart 59
 Ignore the VCR specifications 59
 Read the glossary 59
 Keep the manual in a safe place 60

Chapter 4: The VCR's Arsenal of Buttons, Knobs, and Lights **61**

Basic Buttons You May Find 62
Extra Buttons 64
Jogging and Shuttling 64
Naughty and Nice Knobs 65
Tracking Control: Sometimes a Knob, Sometimes a Button,
 Sometimes Nothing 66
Lights, Lights, and More Lights! 67
Switches and Other Stuff on the Back of Your VCR 69
Buttons on the Remote Control 69

Chapter 5: Facing the Blinking Clock **71**

Why VCRs Have Clocks in the First Place 72
What If I Don't Set the Clock? 72
When to Set the Clock 73

Does It Matter Whether the Clock Says 4:52 When It's Really 4:53? 74

Finding Help in the Manual for Setting the Clock 75

Don't Lose That Remote! .. 75

Common Ways to Set the Clock on a VCR .. 76

 Before you begin ... 76

 If your remote has a Clock button .. 77

 If your remote has a Menu button .. 78

 But my VCR doesn't use the remote to set the clock 80

Write Down How to Set the Clock .. 81

When All Else Fails ... 81

Part II: Making the VCR Do Something 83

Chapter 6: Taping and Watching Programs 85

Yeah, But I Just Want to Play Tapes! ... 85

 Putting the tape into the VCR ... 86

 Playing the tape ... 86

 The other buttons .. 87

 My VCR doesn't have control buttons on it! 87

 Using the remote control rather than the buttons on the VCR 88

Scanning through the Tape .. 88

Pausing a Tape ... 89

When to Press Stop ... 90

Recording Something of Your Own ... 90

 Watching and taping the same TV show or movie 91

 Watching and taping two different shows simultaneously 92

 Help! I have a cable box ... 92

Making the VCR Shut Off Automatically after Recording 93

Taping Programs While You're Away ... 94

Setting the Recording Speed .. 95

Chapter 7: Programming Your VCR (Oh, No!) 97

How to Avoid Programming a VCR .. 98

Programming Isn't As Difficult As It Looks — Usually 98

Programming Your VCR .. 99

Programming a VCR: A Sample Guide ... 101

Canceling a Programmed Event ... 104

I Don't Have On-Screen Programming ... 105

Uh, Do I Have to Read the VCR's Manual? 106

Chapter 8: Using VCR Plus .. 107

Why Use VCR Plus? .. 108

Two Flavors of VCR Plus ... 108

Setting Up VCR Plus .. 109
Setting up the stand-alone type 110
Setting up the built-in type ... 111
Using VCR Plus .. 112
I Want to Review the Shows I Have Programmed 113
I've Decided Not to Record a Program ... 113
I'm Recording a Football Game and I Think That It Will Go to Overtime 113
It Says CLASH When I Enter a Program! 114
What Do the Little _ _ _ Bars Mean in the LCD? 114
The VCR Plus Is Chopping Off My Shows! 115
My TV Listing Doesn't Have PlusCode Numbers! 115
Some Do's and Donuts for Using VCR Plus 116
Other Instant Programming Aids ... 116

Chapter 9: Keeping Your VCR Healthy **119**

Ways to Make Your VCR Last Longer .. 119
Clean the outside of your VCR 120
Use a dust cover .. 120
Use a head cleaner .. 120
Use your VCR once in a while 121
Don't set your VCR on a blanket 122
Check the batteries in your remote control 122
Turn off your VCR when you're not using it 123
Don't keep a videotape in your VCR 123
Don't spill liquids in your VCR 123
Get your VCR professionally cleaned 124
Enemies to Keep Away from Your VCR .. 124
Keep smoke and cats away from your VCR 124
Don't let kids put Gummi Bears in your VCR 125
Keep your VCR away from sunlight 125
Clean the connectors ... 125
Suntan lotion can dissolve front-panel lettering 126
Keep loose cables away from traffic 126
Keep tapes off the ground ... 127
Keep tapes cool .. 127
Rent your tapes from a quality rental store 127
Never open the access door on a videotape 128

**Chapter 10: Everything You Never Wanted to Know
about Videotapes** ... **129**

All about Prerecorded Tapes .. 130
Why isn't the picture any good? 130
What speed did you use to record this tape? 131
There's no picture when I pause or fast-scan this tape! ... 131
Wear and Tear on Tapes Mean Ugly Pictures 132

Dropouts ... 132
Scratches ... 132
Wrinkles .. 133
Stretches .. 133
Rental-Tape Questions and Answers ... 133
Is it safe to play rental tapes? ... 133
Are previously rented tapes OK to buy? 134
What happens if I wreck a rental tape? ... 134
Can I copy rental tapes? ... 136
All about Blank Tapes ... 136
The record tab: your best rriend; your worst enemy 136
Can I open a video cassette to see what's inside? 137
Not all tape brands are the same .. 137
Tapes come in different grades .. 139
What about tapes for the Super-VHS thing? 141
Tapes come in different lengths ... 142
What are these miniature T-20 tapes? ... 144
What's this L-500 tape? ... 145
What about blank tapes for my 8mm camcorder? 145
All about Storing Videotapes ... 146
Can Tapes Safely Go Through the Airport X-Ray Machine? 147

Chapter 11: Slightly More Strenuous TV VCR Hookups 149

Extra Stuff to Buy for Extra VCR Needs ... 149
Coax cable ... 150
Matching transformer ... 150
Signal splitters .. 151
A/B switch ... 151
Video input selector ... 152
Limitations and Variations ... 153
Hooking Up One VCR to Two TVs .. 153
Stuff you need for the job ... 153
What you have to do ... 153
How it works ... 154
Pros and cons .. 154
Hooking Up Two VCRs to One TV .. 154
Stuff you need for the job ... 155
What you have to do ... 155
How it works ... 156
Pros and cons .. 156
Hooking Up Two VCRs to Two TVs ... 156
Stuff you need for the job ... 156
What you have to do ... 157
How it works ... 158
Pros and Cons ... 158
Hooking Up Both a Cable and an Antenna ... 158

 Stuff you need for the job .. 158
 What you have to do ... 158
 How it works .. 159
 Pros and cons ... 159
 Hooking Up a Stereo System ... 160
 Stuff you need for the job .. 160
 What you have to do ... 160
 How it works .. 161
 Pros and cons ... 161
 What's All This "Home Theater" Stuff? .. 162
 Making Your Own Cables .. 162
 What you have to do ... 164

Part III: Cradling the Camcorder 167

Chapter 12: Camcorders, Tapes, and Formats 169

 Which Camcorder Is Which? ... 169
 The big camcorders .. 170
 The small camcorders ... 171
 Camcorder Tape Formats .. 173
 VHS camcorder tapes ... 174
 S-VHS camcorder tapes .. 174
 8mm camcorder tapes .. 174
 Hi8 camcorder tapes .. 174
 VHS-C camcorder tapes ... 175
 S-VHS-C camcorder tapes .. 175
 Camcorder Features ... 175
 Auto Fade ... 175
 Auto Focus .. 176
 CCD pixels .. 176
 Character generator ... 176
 Color viewfinder .. 177
 Date/Time stamping ... 177
 Digital effects ... 177
 Digital Superimpose ... 178
 Image stabilization .. 178
 Manual override .. 179
 Remote control .. 179
 Caring for a Camcorder .. 179
 Keep your camcorder dry .. 179
 Don't bend anything ... 180
 Be careful at the beach ... 180
 Store your camcorder carefully .. 180

Chapter 13: The Camcorder's Arsenal of Knobs and Buttons **181**

The Camcorder's Strange and Foreign Buttons 181
Auto/Manual ... 182
Exposure .. 182
Focus .. 182
Input/Output ... 183
Record Review ... 183
Shutter speed .. 183
White Balance ... 184
Zoom .. 184
The Camcorder's VCR-Like Buttons 185
Connecting Your Camcorder to TVs and VCRs 185
Hooking your camcorder to your TV 185
Hooking your camcorder to your VCR 186
Editing Camcorder Tapes .. 188

Chapter 14: Pointing and Shooting without Goofing **191**

What to Bring on a Photo Shoot .. 191
Shot Composition 101 .. 192
This stuff bores viewers ... 193
This stuff turns viewers on ... 194
Fun Camcorder Accessories ... 196
Keeping Batteries from Dying ... 198

Part IV: Something's Messed Up! *199*

Chapter 15: Pointing Fingers: When the VCR Is Not at Fault **201**

My VCR Doesn't Change Channels! 202
Try pressing the TV/Video (or TV/VCR) button 202
The show's not on the right channel! 202
I can't get channel 14 and higher! 203
My Old VCR Doesn't Receive Channels Clearly 204
Cable Messes Everything Up! .. 204
With cable, the channel numbers are wrong! 205
Do I tune channels from my VCR or the cable box? 205
All the good channels are scrambled! 205
Channels 3 and 4 Don't Work Right! 206
My TV Has Two Antenna Inputs ... 206
My TV Has Audio/Video Connectors 207
The TV Controls Aren't Adjusted Right 207
I Think the Cables and Wires Are Loose 208
Something's Interfering with My Picture! 208
The Tape Looks Awful .. 210

Macrovision Mayhem .. 210
 What Macrovision looks like .. 211
 My TV goes light and dark ... 211
 What Macrovision does ... 211
 Macrovision doesn't affect all VCRs 212
 Is there a way to remove Macrovision signals? 212
 Things to remember about Macrovision 212

Chapter 16: Buzz, Pop, Fizz — Curing TV Interference 215
 Before We Begin: Caution .. 215
 I See Sparkles! .. 216
 I See Wavy Lines! .. 217
 I See Dark Horizontal Lines! ... 219
 I See a Ghost of the Picture I'm Watching! 220
 I See the Ghost of Another Picture! ... 222
 I See One or Two Thick, Dark Bars That Float up and down My Screen 223
 I See Diagonal Lines in the Picture! ... 224
 I See Diagonal Lines That "Dance" to the Music 225
 Do I Have Legal Recourse If I Get Interference? 226

Chapter 17: In Case of Trouble…Break Glass 229

Chapter 18: When Trouble Persists: Fixing the Big Problems 239
 Check Everything Else First .. 240
 Your VCR Eating Tapes? Get It Fixed Immediately! 240
 Is It Still under Warranty? .. 241
 Finding a Good Repair Shop ... 241
 Word of mouth is best .. 242
 Referrals from the people at the video-rental store 242
 Recommendations from places that sell VCRs 242
 Letting your fingers do the walking 243
 Always Call First ... 243
 Should I Pay for an Estimate? .. 243
 When to Throw In the Towel .. 244
 How to Avoid Getting Ripped Off .. 245
 Look for established outfits .. 246
 Get everything in writing .. 246
 Ask for all the parts that were replaced 246
 Expensive repairs: Get a second opinion 246
 What to Do If You Do Get Ripped Off ... 246
 All about Extended Service ... 247
 Should I Change the Belt Myself? .. 248

Part V: The Part of Tens .. 249

Chapter 19: Ten Tips for Making Better Tapes 251

Start with Good Connections 251
Buy Only Good-Quality, Brand-Name Videotapes 252
Record Only at SP Speed ... 252
Record Junk Stuff for the First 30 Seconds 252
Before Using a Tape, Fast-Forward It to the End and Then Rewind ... 253
Use Audio/Video Connections Rather Than Antenna Connections 253

Chapter 20: Ten Neat Things to Buy for Your VCR 255

Gold-Plated Cables and Connectors 255
Automatic Tape Rewinder ... 256
Surge Protector ... 256
Head-Cleaning Cassette .. 257
Fancy Electronic Labeler (such as the Brother p-Touch) 257
Cassette Drawers .. 258
Complete Home Theater System for Your VCR 258
Bulk Tape Eraser .. 258

Chapter 21: Ten Ways to Make Big Bucks with Your VCR or Camcorder .. 259

Send Your Tape to America's Funniest Home Videos 259
Videotape Weddings(and Other Events) for Profit 260
"String" for the Local News 260
Make Instructional Videos of Something You Know About 261
Write a Book About VCRs and Camcorders 261
No Money in It But It's Fun Department: Make a Video
 Album Autobiography for Your Family 261

Chapter 22: Ten Most Common Mistakes (and How to Fix Them) 263

Keeping the Dust Cover on When Your VCR Is on 263
Placing Tapes Near Speakers or Your Child's
 Collection of Fridge Magnets 264
Inserting a Dirty or Wet Tape in a VCR or Camcorder 264
Storing Tapes the Wrong Way Without Protective Cover 264
Taking Apart Your VCR or Camcorder without
 Knowing What You're Doing 265
Leaving Tapes and Your Camcorder in a Hot Car 265
Forgetting to Recharge Your Camcorder Battery 266
Forgetting to Label Your Tapes
 (Erasing over the Ones You Want to Keep) 266

Chapter 23: Ten (or more) Answers to the Most Common Questions 267

Why Is My VCR Flashing 12:00? .. 267
How Do I Record One Show while Watching Another? 268
How Can I Quickly See What's on an Unmarked Tape? 268
Why Doesn't My VCR Record When I Press the Record Button? 269
Why Do I See Ugly White Lines on My Screen When I Play a Tape? 269
Why Are Some PlusCode Numbers Longer Than Others? 270
What Is This "Dolby Surround" Thing I See on the
 Back of the Videotape Box? .. 270
Why Are the Top and Bottom of the Picture Black? 271
What Stuff Can I Copy? ... 271
How Do I Make Video Copies of My Slides and Movies? 272
Will My Tape Work in Uncle Miklos' VCR in Greece? 272

Chapter 24: Ten Camcorder Tricks and Tips 273

Clean the Lens ... 273
Fast-Forward and Rewind New Hi8 Tapes ... 274
Record Real Movies on Your Camcorder .. 274
Record Old Family Films on Your Camcorder ... 274
Record Classes in School .. 275
Make Tapes for Insurance ... 275
Use Fake Sounds in Your Videos ... 276
The Weird Rule of Thirds ... 276
Keep a Second Camcorder Battery Handy .. 277
Never Check Your Camcorder As Luggage ... 277
Wear Your Wind Sock ... 277
Use a Shotgun Microphone to Get Faraway Sounds 278
Check the Battery If You're Using an External Microphone 278

Chapter 25: Ten Ways to Drive the Video Superhighway 279

Try a Crystal-Clear Laser-Disc Player .. 280
Get on the Direct-Broadcast Satellite Bandwagon 280
See Lots of Stuff on a Big Satellite Dish .. 281
What Is This Wireless Cable Thing? .. 282
Talk Back with Interactive Cable .. 282
Get the Scoop on High-Definition TV ... 283
See TV on a CD? ... 284
Digitize Rover with Digital Videocassette ... 284
What Else Might Come down the Information Superhighway? 285

Part VI: Appendixes ... *287*

Appendix A: Sources for Videos You Can Order by Mail 289

Appendix B: How to Read a TV Listing 295

What Does All the Junk in the TV Listings Mean? .. 295
Other Symbols You May See in a TV Listing .. 297
All about Film Ratings and TV Listings .. 298

Appendix C: Glossary ... 301

Index .. *311*

Reader Response ... *Back of Book*

Introduction

For millions of people, a VCR is as easy to use as a toaster. They just push the videotape into the VCR's little slot, press a button, and begin watching the movie. The hardest part? Remembering to return the movie to the video rental store by 6 p.m. the next day.

But pushing anything other than the Play button on a VCR can make *anybody* feel like a dummy. It's commonly known that most people can't set the clock on their VCR — it's something to laugh about communally at parties. The problem extends even to Washington: Tipper Gore admitted in a *Time* magazine article that she had put a strip of black masking tape over her VCR to cover its blinking 12:00 display.

When Tipper wants to record Jay Leno, of course, she just hits the intercom and barks an order to a member of her staff. Most of us, unfortunately, aren't that lucky.

That's where this book comes in. Don't worry — it won't transform you into a technoweenie. Even when you're hovering over the hors d'oeuvre tray at parties, you don't have to tell people that your VCR is automatically recording *Seinfeld* back at your house.

Nobody has to know. *You* know, however, and that's what matters.

About This Book

This book's not a manual, heaven forbid. Those things stay hidden behind the TV. This book is a quick reference — a friendly helper in times of VCR stress. Within these pages are clear-cut steps for tasks like these:

- Fixing a broken rental tape
- Changing the clock for daylight saving time
- Recording one show while watching another
- Automatically recording favorite TV shows
- Taping family gatherings with a camcorder
- Editing out the family gatherings' boring parts

Specific chapters explain how to set up a new VCR in a home. Other chapters spell out what that VCR Plus stuff is supposed to do — and whether it really works. If the TV starts looking funny, read the chapter that shows how to make those wavy lines go away. Finally, you will find lists of all sorts of good stuff: explanations of how to make better videotapes, funny words like *F-connector,* and proper etiquette when a guest's child pours root beer inside your new VCR.

How to Use This Book

This book isn't really a *book* — you're not supposed to read it, page by page, to learn about your VCR. Instead, treat this book like a VCR dictionary. Want to know what a button does? Look in the index, find a page number, read for a minute, close the book, and use or ignore the button. It's up to you. There's no real learning involved here. Leave that stuff to the VCR salespeople — they get paid for it.

When your VCR is acting weird, look up the problem in this book's table of contents, and flip to the short section containing the information you're looking for. Read the applicable nugget of information, and then you're finished. You don't have to wade through Important Information About Adaptive Picture Control when you're just trying to fix a broken videotape.

How This Book Is Organized

This book is divided into six parts; each part contains several chapters, and those are divided into even smaller sections. By dishing out the information in digestible chunks, this book lets you in and out of its pages as quickly as possible.

Part I: Bare-Bones VCR Basics

This part of the book contains some VCR basics. It describes the VCR buttons you eventually have to touch; it explains the little buzzwords VCR manufacturers thought everybody already knew, and it shows how to buy and hook up that new VCR.

Oh, yeah — the part also explains how to set the clock, if you're feeling particularly adventuresome.

Part II: Making the VCR Do Something

This part covers some of the scarier stuff: making your VCR automatically tape your favorite shows — no more missed episodes of *Deep Space Nine*! If your new VCR comes with that VCR Plus stuff, it's explained here. You also can find everything you ever wanted to know about videotapes: "Can I copy a rental tape?" and "How do I know whether the *tape* or the *VCR* is goofing up?" and "Should videotapes be stored in the wine cellar?"

Part III: Cradling the Camcorder

Making movies with a camcorder is about as easy as watching movies: Just push a button and peer through the viewfinder. Making movies that somebody else will want to watch is much tougher.

This part of the book tackles camcorders: which of the 43 buttons is important, how to buy a camcorder, and how to connect a camcorder to a VCR. An entire chapter contains tips on the best ways to point and shoot.

Part IV: Something's Messed Up!

Weird lines going across the screen? This part of the book lets you finger the culprit: the VCR, the tape, the TV, the cable company, or Fred — the nerdy guy next door with the new remote-control wristwatch.

Part V: The Part of Tens

Everybody loves lists, from David Letterman to Moses. So this book is packed with bunches of 'em. Ten ways to make better videotapes. Ten answers to the most commonly asked questions. Ten excuses for being late when you're returning the rental tape to the video store — you get the idea.

Part VI: Appendixes

Want to order some videos by mail? Still not sure how to read a TV listing? Wondering what exactly a coaxial cable is? Then check out the appendixes.

Icons Used in This Book

When you find something good in this book, feel free to mark it up with a pencil or highlighting pen. But to make things a little easier to find, we've already marked up most of the good stuff. We wanted to circle the good stuff by hand, but our publisher stuck with the time-tested *icon* method. When you see these little pictures printed in the margins, here's what they mean:

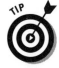

Quick bits of valuable information live near this icon.

Don't forget this stuff! (If you *do* forget, look for this icon so that you can remember it again.)

Don't do any of this stuff!

Skip this boring technical stuff; it's superfluous fluff you really don't need to know. Why is it even mentioned? When somebody at the office tells you that he never uses his VCR's Control-L jack, you can read about the Control-L jack in a Technical Stuff box and realize that you never use it either. But at least you'll be *sure* that you don't use it.

Where to Go from Here

That pretty much explains this book. If you're stuck somewhere — or if your tape's stuck somewhere — just head to that particular chapter and give it an ogle. This book has a great deal of information in it, so don't get bogged down by trying to read it all. Just keep the book close by so that it's there when you need it.

Part I
Bare-Bones VCR Basics

The 5th Wave By Rich Tennant

"He must be an impaired VCR user—there's a blinking clock etched on his retina."

In this part...

This part of the book explains how to connect your VCR to the TV set and worm those long cables past any video-game machines, home stereos, cable boxes, and any dusty old *TV Guide*s currently living behind the TV set.

You'll find plenty of VCR basics: explanations of the VCR buttons you eventually have to touch and understandable definitions of the little buzzwords VCR manufacturers think that everybody learns in grade school. Thinking of buying a new VCR or camcorder? One chapter helps you choose between all those video formats. If you're feeling particularly adventuresome, yet another chapter explains how to set the VCR's clock.

Finally, there's some good news, too: If those old *TV Guide*s have been lost behind the TV set for a few years, take 'em to a comic-book store — some of those back issues are drawing big bucks from collectors, especially the ones with Kirk and Spock on the cover.

Chapter 1

Beginner's Guide to VCRs

· ·

In This Chapter

▶ Why are VCRs so popular?

▶ What can I do with a VCR?

▶ Why are VCRs so blasted hard to use?

▶ Should I care how VCRs work?

▶ What are VCR formats such as VHS and S-VHS?

· ·

*J*ust about everybody has a VCR. Even people who proclaim that they never watch TV still have a VCR. (To them, watching rental movies doesn't count as "watching TV.")

This chapter tackles the VCR basics — introducing the language and sorting through the various tape formats. If you're holding a screwdriver and flipping desperately through the pages with a wet thumb, flip past this chapter — you want the hands-on stuff in Chapter 3 and Part II.

But if you're looking for a quick introduction to your VCR, begin reading here.

Why Are VCRs So Popular?

VCRs — or *videocassette recorders* — contain the word *record* built into their name, but most people don't bother touching the Record button. No, VCRs are popular today because they can play back rental movies. That's about it.

> ✔ Millions of people don't want their VCRs to do anything more elaborate than play back the latest movie rentals. And that's perfectly understandable. After all, there's barely anything on TV worth watching, much less recording and saving for the grandchildren.

✔ After somebody has successfully recorded a television show for the first time, however, it's difficult to go back to plain old movie watching. That relieved "Wow, that wasn't so hard" feeling is difficult to stifle.

✔ There are some even more boring reasons for a VCR's popularity too: A VCR can often handle the cable company's gizmos better than a plain old TV can. Some VCRs, in fact, can pull in a crisper picture than an older-model television set can by itself.

What Can I Do with a VCR?

Everybody knows that a VCR like the one shown in Figure 1-1 can show rental movies from the place down the street. Most VCRs, however, can do a little more. (Some of the newest ones can do *much* more.) When the VCR cables are connected to the right places, most VCRs can tackle the chores in this section.

Figure 1-1:
A typical
VCR.

Control the TV

After the VCR is hooked up, you can ignore your TV set's channel-selector switch. The VCR handles all the channel-switching chores now. (If you *do* change channels from your TV set, in fact, your VCR might not be able to talk to it anymore.) The VCR takes over most of the television mechanics, and your TV becomes simply a picture tube at the end of a wire.

Chapter 3 shows how to hook up your VCR so that it can control your TV with a skilled, robotic hand.

Most VCRs want your television to stay perpetually tuned to either Channel 3 or 4. (You get to choose which channel your VCR uses, although most VCRs are set, out of the box, for Channel 3.) If your TV set isn't talking to your VCR — or vice versa — make sure that your TV is turned to Channel 3 or 4. That might cure the problem.

Play movies

No surprise here. A VCR can play a movie from a videocassette, whether it's borrowed from a friend, rented from the video store, or purchased from a Video of the Month Club.

Record movies

The *concept* of recording is easy enough to understand: The VCR stores stuff on videotape so that you can watch it later. The hard part is that VCRs can record stuff in *three* different ways, as described in the next three sections.

Record as you watch a program

A VCR can simultaneously record something as you're watching it on television. You can keep a collection of your favorite shows — or record the latest Los Angeles disaster to add to your Live News Action Shows collection.

Record while you're watching something else

When the TV ratings week arrives, the networks stop running their normal, dumb shows and begin airing their best stuff. Unfortunately, doing so usually means that two great shows run at the same time. The solution? Outwit the networks by watching one show and making your VCR record the other show in the background. (Don't worry about what this does to a show's ratings. Recorded shows still show up in the Nielsen ratings.)

Record while you're not around

Still can't stay awake for David Letterman's show? Then let your VCR record that late-timer so that you can watch him the next morning during breakfast. You can even fast-forward through the commercials, to save time. Some VCRs, in fact, have commercial-skipping features, which let you leapfrog ahead in 30-second chunks until the commercials stop and the show resumes.

Edit movies

People are snapping up camcorders today almost as fast as they first snapped up VCRs a decade ago. But some camcorder owners make five-hour vacation videos — and expect their friends to watch them. If you expect to have friends, you will want to edit your handiwork down to 20-minute highlights. Many of today's VCRs come with special controls to work in tandem with camcorders, making it easier to edit out the rough spots. (Part III carries all the camcorder stuff.)

Fiddle with movies

VCRs have always had a Pause button, making it easy to stop the movie while somebody heads for the rest room. But although the movie stopped, funny lines ran across the picture, making it difficult to see what was going on. The Pause button on today's more expensive VCRs can "freeze" the movie clearly on the screen. Better yet, the VCRs can move forward or backward in slow motion, letting you see each part of the movie, frame by frame.

In VCR language, a Pause button that lets you stop a movie — but still see the picture clearly — is called Freeze Frame.

Sound a little dopey? Actually, it can be a lot of fun; the extra detail adds a new dimension to movies. When something in a movie races past too quickly, those frame-by-frame peeks let you see what *really* happened. Try it next time you record *The Simpsons*.

VCRs that can pause a movie and move forward or backward, frame by frame, and still show a clear picture come with four video heads. The cheaper VCRs that show a bunch of ugly lines when you hit the Pause button use only two video heads.

Why Are VCRs So Blasted Hard to Use?

VCRs have never been easy to use, and they're not getting much easier, for several reasons. First, there's no single person to yell at when things go wrong. TV stations, cable-TV stations, cable companies, and VCR manufacturers all play a role in what you're seeing on TV, and they rarely send out representatives for group lunches. As a result, nobody in the industry can agree on a way to simplify things.

Also, VCRs completely take over your television set, turning it into a picture tube at the end of a wire. Want to change channels? The VCR does that now. Want to turn down the volume? Chances are, the VCR's remote control has grabbed that task as well.

Adding to the confusion is the mass of "improvements" they've made to VCRs over the years, with each manufacturer trying to outdo the other guy. Most of the whiz-bang features on today's VCRs began as marketing gimmicks. With everybody competing for your buck, VCR makers have added lots of complex-sounding features.

Finally, VCRs are hard to use because they try to do too much. Some people want a VCR that does *everything;* others want the bare minimum. But to please the tech-hounds, manufacturers cram more buttons on the VCR and its remote control. That makes it more difficult for normal people to find their Play and Record buttons.

- ✔ VCRs hold their terror because almost all models and brands work differently. Learning how to use your own VCR doesn't mean that you'll be able to casually walk up to and set the clock on your mother-in-law's VCR.

- ✔ Some companies are trying to simplify VCR life. You know those little numbers printed next to the TV shows' names in *TV Guide?* Punch one of those numbers into a gizmo called a VCR Plus, and the little gadget will handle the chores of programming your VCR to record that particular show. (Chapter 8 covers this ghostly new technology.)

Should I Care How VCRs Work?

Nope. There's nothing interesting going on inside there, anyway.

Magnets can damage the information stored on your videotapes; keep videocassettes away from magnets and from the disguised magnets that live in older-style telephones (the ones with *real* bells in them), speakers, and magnetized paper-clip holders.

What's the Difference Between VHS, S-VHS, and Other Video Formats?

Let's keep things simple here. Unless you're shopping for a camcorder, only two types of VCR formats really matter: the traditional VHS format or a more expensive format called Super-VHS. They're both described in this section, along with a few other formats you might encounter on store shelves.

Tom Cruise and Daryl Hannah are magnetic bits

Videocassettes contain a long, thin strip of plastic tape that's familiar to anybody who's tried to untangle one.

Using electrical energy, VCRs transform sounds and pictures into magnetic impulses, sort of in the same way computers store programs on floppy disks. Little rollers inside the VCR move the tape past electromagnets, known as *heads*.

To record video, the VCR magnetizes the tape in a special way as it flows past the heads. To play back previously recorded video, the VCR reads the magnetic information already stored on the tape and converts the impulses back into sound and video.

Bulk tape erasers contain powerful electromagnets to quickly wipe out (demagnetize) an entire videocassette. By scrambling all the tape's magnetic impulses, the bulk tape eraser turns Tom Cruise, Daryl Hannah, and any other recognizable piece of show-biz information into mincemeat.

VHS format

Description: This format is the most common type of VCR by far. Because this format is so popular, most rental stores rent videotapes in only this particular format.

Pros: The VHS type of VCR has been comfortably recording and playing back movies for more than 18 years. These VCRs are cheap and widespread and work well for most needs.

Cons: These oldsters can't deliver a very high-quality picture; new technology has brought newer types of VCRs that look and sound better. VHS VCRs can't copy tapes very well either, with duplicate tapes losing their sharpness and colors.

Who buys VHS systems: Nearly everybody buys a VHS VCR. Some people don't know that higher-quality VCRs exist. But most people just don't want to pay higher prices and struggle with the problems that infest any new technology.

All official VHS VCRs and tapes will have the official VHS logo, as shown in Figure 1-2.

Figure 1-2:
The official
VHS logo.

Most video rental stores carry tapes in only VHS format.

VHS stands for Video Home System. VCR stands for videocassette recorder.

Super-VHS (S-VHS) format

Description: Antsy engineers wanted something a little better than plain ol' VHS, so they created a fancier system called *Super-VHS*, or S-VHS. From the outside, S-VHS tapes and VCRs *look* the same as the VHS tapes and VCRs, but the S-VHS versions can put a much sharper picture on the television.

Pros: Super-VHS VCRs record and play back videos with much greater clarity than do their VHS predecessors. On a VHS-format movie, an actor's skin often blends into a pool of beige. With Super-VHS, you can see freckles. Here's the best part: S-VHS VCRs can still play back those old VHS-format videos and record on VHS tape, so S-VHS owners can rent movies, just like anybody else can.

Cons: S-VHS technology adds about $200 to the cost of the VCR, so few people consider it. And because the technology is so expensive, most rental shops don't carry S-VHS videos — S-VHS owners are stuck with the VHS quality of rentals. Also, Super-VHS quality isn't extremely noticeable on an average TV; it takes an expensive, high-quality TV to really show the difference. Finally, blank S-VHS tapes cost at least twice as much as regular VHS tapes do.

Who buys it: S-VHS VCRs are grabbed mainly by well-to-do folks who record their own high-quality videos for later watching on high-quality TVs with a bowl of high-quality popcorn. S-VHS also works well for editing movies, making them popular among camcorder owners.

All official Super-VHS VCRs and tapes will have the official S-VHS logo, as shown in Figure 1-3.

An S-VHS VCR can play back most VHS tapes, but most VHS VCRs *can't* play back S-VHS tapes. And in a pinch, an S-VHS VCR can record something on a regular VHS cassette, but not at its usual high level of quality.

A VCR built into the TV

Description: These VCRs come built into a television set — a one-piece unit that's easy to slide next to the blender in the kitchen with no messy tangle of wires to get in the chef's way. It's perfect for watching videos on how to debone a chicken! Because nothing high-tech is involved, just about all these "combo" units stick with the traditional VHS format.

Pros: Because the VCR is already connected to the TV, there's nothing to set up. The tapes just slide into a slot in the front of the TV. As a self-contained package, it's easy to cram into small places, like kitchens and dorms. Many can plug into a car's cigarette lighter for on-the-road viewing.

Cons: Neither the TV nor the VCR is top-of-the-line with all the latest features. And if one breaks down, it affects both: You don't have the TV to watch while the VCR's in the shop, and you can't watch a videotape if the TV breaks down. You're paying a little, too, for the convenience: The units often cost more than do a separate TV and VCR.

Some TV-VCR combinations come with input-output jacks so that you can connect them to other TVs or VCRs. That capability lets you make copies of tapes, for example, or send the output to a larger TV on occasion.

Who buys it: People looking for a second TV-VCR combination often choose these built-in units because they're small and relatively easy to use. Owners of campers and motor homes often buy the ones that work off car batteries.

Beta format

Description: This is an early format by Sony that faded away like 8-track tapes.

Pros: Beta-format VCRs can make higher-quality recordings than VHS-format VCRs can.

Cons: Fading away fast, Beta-format VCRs are more difficult to repair, and few stores sell blank tapes. The final straw? Few rental stores carry Beta tapes anymore. And those that do don't offer much selection.

Who buys it: Retired electrical engineers. Actually, Sony still sells Beta VCRs, which are purchased mainly for work in professional video studios.

Don't bore me with history *already!*

When broadcasters began sending television signals through the airwaves in the late 1940s, everything had to be filmed *live*—no matter how awkward. Broadcasters were begging for a way to prerecord dog-food commercials in order to keep the carpets clean. The engineers scrambled, and a company called Ampex came up with the first videotape recorder (VTR) in the 1950s. The Ampex VTR was expensive and bulky, but it was quickly embraced in the studios.

In the 1960s, a company called Phillips took the videotape off the studio reels, stuffed it into cassettes, and created a new machine: a videocassette recorder (VCR). After another decade of enhancements, VCRs finally became cheap enough for schools, training, and other nonbroadcast use.

Smelling the profits, companies began elbowing for position, experimenting with tape width and recording technology to create something for the home. Sony's Betamax system ruled the home market in the mid-'70s, but a competitor, JVC, began marketing a new machine called Video Home System (VHS). The picture quality wasn't quite as good as the Beta, but the videocassettes were larger, which meant that customers could save money by recording more shows on the same cassette.

Sony's early Beta VCRs didn't come with a remote control, which added to their demise. Consumers made their decision and began snapping up VHS systems. Today Beta has been left by the wayside: Many video rental stores carry only VHS tapes.

Extra History Bonus Points: Home video recorders were first demonstrated as early as 1958. Yep, during the Eisenhower Administration. These machines used giant reels of tape that spun around at tremendous speeds. A ten-inch reel of tape was used up in just a matter of minutes. Obviously, these early home videotape machines weren't a hit with consumers because of cost and picture quality. It took another 16 years to make an affordable home video recorder that delivered decent pictures.

Chapter 2

What *Are* All Those Features?

· ·

In This Chapter

▶ Understanding your VCR's features

▶ Deciding which features are important

▶ Buying the right VCR

▶ Choosing the right remote control

▶ Deciding on an extended warranty

· ·

*B*uying a new television isn't too rough of a decision: It's basically a choice between small, medium, large, and "Wow!"

VCRs live in a much more complicated world, unfortunately, where manufacturers scramble to come up with the latest, greatest deluxe feature. As soon as an engineer has thought up something new, the manufacturers squeeze a new button on their latest model. The result? VCRs have turned into a wacky circus of words like "flying erase heads" and "shuttle rings."

This chapter translates that VCR lingo into modern English. That gives you a fighting chance regardless of whether you're buying a new VCR, trying to figure out the one you've just bought, or wondering whether any of this new stuff is exciting enough to warrant replacing that six-year-old VCR in the family room.

A VCR's Basic Features

Almost every VCR on the market can jump through the hoops described here. Although the engineers continually fine-tune their details, just about every VCR on the market can record videos, play them back, and change channels on the television. The next few sections describe how VCRs manage to complicate those simple functions as well.

Recording shows

Although the word *recorder* is part of a VCR's name, some VCRs can't record anything. They're not broken; they're just designed for people who want only to play back rental movies. A VCR that only plays back tapes is called a videocassette player, or VCP. Bargain models start at about $125. Electronics stores usually hide VCPs on the bottom shelf in the showroom.

If you want a VCR for your RV, get a VCP instead.

The zillion models lining the shelves above those cheapies can record TV shows and movies in a variety of ways. Some VCRs make recording a simple task; others offer more control. That brings us to the first rule of VCRs:

The more control a VCR offers its owners, the more complicated it will be to use.

- ✔ The simplest VCRs begin recording when you press the Record button. They stop recording when you press the Stop button. If you're looking for utmost simplicity, look for the one with the biggest Record button. Although almost all Record buttons are labeled with red ink, some can get lost in a sea of buttons.

- ✔ Slightly more complicated VCRs come with a *one-touch recording* (OTR) button. Press the button *once,* and the VCR immediately begins recording for 30 minutes and then stops. Push it *twice* for a 60-minute session or *three* times for a 90-minute session — each push makes the VCR record for 30 minutes longer. That capability allows for spontaneity but ensures that the VCR still turns itself off if you fall asleep during the program.

- ✔ As an example of how VCR makers try to confuse you, some VCRs have an ITR button rather than one labeled OTR. Same thing; different name. (ITR stands for *I*nstant *T*imer *R*ecording.)

- ✔ Horrendously complicated VCRs can be *programmed.* By fiddling with their controls, you can tell these VCRs to automatically record shows on a daily or weekly basis.

- ✔ For no-brainer recording of television shows, look for a refreshingly simple feature called VCR Plus. When you punch a special number into a keypad, the VCR Plus mechanism automatically tells your VCR which show to record. For the full scoop, see Chapter 8.

Playing back movies

The majority of VCR users simply want to play a movie rented from the video store down the street. Luckily, just about every VCR on the market can play back a movie. However, they each add their own personality to this function.

To watch a movie on some VCRs, insert the tape and push the Play button. The movie begins to play.

Other VCRs _automatically_ begin playing the tape as soon as you insert it. Still others go one step further: They automatically play the tape when it's inserted, rewind the tape when it's over, and spit it out when it's finished rewinding.

It's a prime example of how VCRs can take the simplest chore and force prospective owners to make an on-the-spot decision at the video store.

✔ VCRs offer even _more_ playback options to choose from. Some VCRs let you play back a movie in slow motion so that you can watch the action go by, frame by frame.

✔ Playing back a TV show recorded from the night before? Some VCRs can jump over the commercials and skip ahead to the good stuff at the touch of a button.

✔ You can find more examples of features that fine-tune your VCR's playback chores later in this chapter.

Tuning in channels

Contrary to popular belief, VCRs don't record movies from your television. In fact, a VCR can record movies and television shows even if no TV is attached.

The reason is that all VCRs come with a _built-in_ television tuner. After you've installed your VCR, it takes over the chores of grabbing television signals from a cable or the airwaves. The VCR takes the picture, fine-tunes it, and sends the image into your TV set, which then puts the picture on the screen.

In fact, if your TV's tuner knob doesn't turn very well, a VCR can give it new life.

✔ Even when your TV set is in the shop for repairs, your lonely VCR can still record your favorite shows for later viewing. Just record the program like you always have, either by using VCR Plus, programming the VCR by punching buttons on its front panel, or by simply pushing the VCR's Record button when your TV show normally comes on.

✔ The term _cable ready_ means that the VCR is ready and willing to connect to your cable-TV system and to receive channels from it. You can skip the cable box. The bad news: The VCR can't help you tune in channels that are scrambled by your cable company. You still need a cable box for that. The cable dangling from your wall can screw onto a jack on the back of your VCR.

✔ When many VCRs are first installed, they can automatically search through the cable system or your region's airwaves. If a VCR finds any TV stations, it automatically remembers their channels. More important, the VCR remembers which channels *don't* receive anything. That keeps it from displaying "snowy" channels with no shows on them.

✔ Because both your TV and your VCR can tune in TV stations, sometimes it's not clear whether you're watching your *TV* or watching your *VCR*. (*Hint:* Push the TV/VCR button on your remote control; that switches from one to the other until you're sure that you're watching the right one.)

A VCR's More Complicated Features

Today's VCRs come with many different combinations of the features listed in this section. There's no "right" blend of features; like a margarita, everything depends on personal taste.

Before shopping for a VCR, don't just look at the features you think that you want; take note of the ones you're sure that you *don't* want as well. Sometimes VCR shopping comes down to the simple process of elimination.

Audio/video jacks

Most people are content with a VCR that simply connects to their TV set. Other people want their VCR to connect to a TV set, a second VCR, *and* a camcorder. To please these multifaceted folks, some VCRs come with several *audio/video jacks* — one set of jacks for every gadget that will eventually connect to the VCR (see Figure 2-1). That capability frees folks from the bother of disconnecting one goodie in order to plug in another.

Figure 2-1:
Audio and video jacks give you added convenience and a better picture.

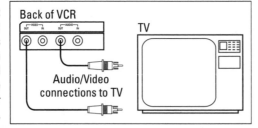

Verdict: Extra jacks add convenience. You get a slightly better picture if you connect your TV and VCR by using audio/video jacks. Obviously, your TV must have audio/video jacks too. Some TVs do; some don't. If you want to connect your VCR to several TVs, a second VCR, or a camcorder, make sure that the VCR has an extra set of jacks for each one.

Alias: Input-output jacks.

If you intend to hook up a camcorder to a VCR, look for a VCR with audio/video jacks along the front of its case; that makes them *much* easier to reach.

Auto head cleaning

When you play or record a videotape, the VCR pulls it over an internal gizmo called a *head*. With miles of videotape constantly flowing over it, the head can pick up dirt and grunge. Some people run special head-cleaning cassettes through their VCR a few times a year to wipe off any detritus.

To save the inconvenience, some VCRs come with an *automatic head cleaner*. It's a little, internal pad that automatically wipes any muck off the heads whenever a tape is loaded or unloaded.

Other people don't worry about head cleaning, however, and find that their VCRs still work fine. Still, an automatic head cleaner is a good safeguard.

Verdict: The greatest VCR minds still argue over this one. Some say that head-cleaning cassettes can do more damage than good. They agree on one thing, though: The cheaper the videotape you use for recording and playing back, the more damage it can do to your VCR. Besides, most mid- and high-end VCRs come with an automatic head-cleaner feature, so even if you don't want it, you're stuck with it.

Stay away from those cheap, "no-name" videotapes. They can coat your VCR's heads with gunk and leave bits of gross stuff inside your VCR, eventually jamming the mechanism. Look for the official *VHS* logo on the tape.

If head-cleaning cassettes are overused, they can damage your VCR. Be especially careful with the ones that require you to soak the cleaning tape with a cleaning solution. Too much cleaning solution can mess up the innards of your VCR. A little dab will do ya.

Auto power on-off

Designed for people who want to watch rental movies with a minimum amount of hassle, these VCRs automatically turn themselves on as you insert the tape. When the movie's over, they automatically rewind, eject the tape, and turn themselves off.

Verdict: This feature can be convenient for people who fall asleep before the movie's over. Most of these VCRs can turn only *themselves* off, however — your TV will continue casting its eerie, blue light over your sleeping body.

Auto/rewind

Nothing complicated here: These VCRs automatically rewind the tape when the movie's over.

Verdict: Because most rental shops flagellate customers who return movies without rewinding them, auto-rewind is a good idea. (Now if they would only come up with "Auto return to the video rental store.")

You can save wear and tear on your VCR by investing ten bucks in a videotape rewinder. After watching the movie, pop it into the rewinder, and let it spin the tape back to the beginning.

Auto-manual tracking

VCRs sometimes have trouble playing back tapes that were recorded on other VCRs. To make these foreign tapes play back a little more clearly, you have to adjust the VCR's *tracking*. A VCR with *manual* tracking has a little knob you turn, or two buttons you push, until the picture clears up. VCRs with *auto-tracking* automatically give you the best picture: no knobs or buttons to bother with.

Verdict: If you don't like getting up to adjust the picture when you're watching rental movies, spring for auto-tracking. Otherwise, save some money by sticking with manual. You usually have to adjust the tracking only when the tape first begins to play, anyway.

Alias: Digital tracking.

Except for the bargain-basement models, most VCRs sold these days have auto-tracking.

Cable ready

The back of these VCRs have a jack that's ready for your cable-TV system. Just screw the cable to the back of the VCR, and you're done.

Verdict: All new VCRs are cable ready. Some of the *really* old ones need a special converter, described in Chapter 3.

Center- or midmount chassis

These VCRs have the tape-input slot directly in the middle of their case, as opposed to along one side or another. Designed around 1992, the engineers say that these center-loading mechanisms are supposed to reduce vibration, leading to a cleaner picture.

Verdict: Nobody *really* thinks that a center-mount chassis improves the picture quality, but lots of people think that the symmetry looks cool. So keep your VCR sitting on a steady surface, don't set the TV on top of it, and don't pay extra for this center-mount stuff.

Closed caption

Closed-caption technology puts words along the bottom of the TV screen, spelling out what people are saying on the screen. That way, people who can't hear the TV can still figure out what's going on. The feature is built into most new TVs, however, *not* to VCRs.

Verdict: If your TV doesn't have the closed-caption feature, a VCR can't add it.

Alias: Closed-caption system (CCS).

Through some funky technostuff, public broadcasting stations are now broadcasting the current time and date by using a portion of the TV signal reserved for closed-caption technology. The latest, greatest VCRs grab the current time and date from that signal whenever they're turned on or off. Voilà! The VCR is instantly turned into the most accurate clock in the house. Sony has added the feature to a few of its most elaborate VCRs. (The people who bought those feature-laden monsters probably didn't have any trouble setting the clock in the first place, however.)

Commercial skipper

What a fantastic way to weed out any commercials recorded along with a TV show! When the car salesman starts his pitch, push the Skip button: The VCR quickly fast-forwards through 30 seconds worth of tape. Because most commercials are 30 or 60 seconds long, a few presses of the button will blast past the entire commercial interlude, letting the *real* show start again.

Verdict: This feature is a convenience rather than a necessity, but oh, is it convenient. After you get used to skipping the commercials, you'll find yourself reaching for the VCR's remote control in frustration even when you're watching live TV. Some skip ahead 30 seconds; others skip ahead 60 seconds. If you're conservative, go with the 30-second model. That way, you'll never skip too far ahead and miss part of your program.

Alias: Picture search, skip, skip search.

Digital effects

A VCR with digital effects gives you some artistic control over what you see. The most common digital effect is called PIP, for *picture-in-picture.* The VCR presents one program normally and then displays another program in the corner. You can watch two shows on one TV, all from the same couch. Another popular digital effect is *crystal-clear freeze frame.* A computer inside the VCR takes a "snapshot" of one frame of the picture, without the ugly lines and jitter that can occur when you're still-framing with other VCRs.

Verdict: Digital effects are nice but not of much help. The PIP feature is found on many higher-end TVs, so if you already have it in your TV, you probably don't need it on your VCR, too.

EP, LP, or SP

These letters refer to how fast the VCR pulls the tape through its machinery. The faster it pulls the tape, the better the picture quality. By slowing down the tape speed, you can pack more video on a single cassette, but the quality isn't as good.

Verdict: Use *Standard Play — SP —* for recording important stuff: favorite movies or shows. Switch to *Extended Play — EP —* for stuff that's not quite as important. Use EP mode to stuff a collection of *Sewing with Nancy* shows on a single tape, for example, so that you can find button-sewing techniques when you need them later. A few VCRs also offer *Long Play — LP —* a speed midrange between SP and EP that didn't really catch on.

The most popular blank videotape will record for two hours. This length is at SP speed. EP is three times as slow, so the same two-hour tape really records for six hours at EP speed.

Alias: Some very old VCRs use the term SLP rather than EP.

Almost all VCRs can play a tape recorded at LP speed, but few models can record at LP speed. If yours records at LP, avoid it because, even though it offers a faster recording speed than EP, the picture quality isn't likely to be as good. There are many highly technical reasons for this warning, which are beyond the scope of this book. You just have to trust us on this one.

Flying erase heads

In addition to being a great name for a rock band, *flying erase heads* are a way to edit videos more smoothly. When pieces of video are edited together, the picture often jumps or breaks up where the two scenes meet. Flying erase heads make the transitions smoother so that the video looks more like a *real* movie.

Verdict: Flying erase heads work great for people who want to create their own movies by editing together pieces of camcorder footage. If you won't be splicing lots of pieces of video into a professional package, fly past this option.

Heads

Like sci-fi film robots, VCRs come with *heads*. A head converts audio and video into magnetic impulses and stores them on the videotape; a head also reads the magnetic impulses and turns them back into something we can watch and listen to on TV.

Verdict: All VCRs have heads. The basic ones have two video heads. The fancier ones have four video heads. In fact, choosing between a *two-head* or *four-head* VCR will probably be your biggest decision when you're shopping. (That's why that big decision gets its own section, later in this chapter.)

Hi-fi

When you watch a movie, you're also listening. Who wants to watch a Western without the sounds of galloping horses and gunshots? Good sound makes the movie more realistic, which adds to its enjoyment. Almost all movies are

recorded in stereo, and many television shows broadcast a stereo soundtrack as well. With a hi-fi VCR, you can record and play back sounds in good quality from stereo movies and TV shows.

Verdict: To bring hi-fi stereo to VHS, VCR makers have added two more heads to pick up the sound. These heads add anywhere from $50 to $100 to the price of the VCR, a price paid by audiophiles and shunned by people who were never excited about Walkmans either.

Depending on the age of your VCR, hi-fi and stereo are two different things. On older VCRs — made before 1984 or so — VCR makers used a different, cheaper method of providing stereo sound. Hi-fi was not yet developed. Nowadays, all stereo VCRs are hi-fi. If you want stereo, you have to fork over the bucks for hi-fi.

HQ

HQ makes the picture sharper. *HQ* — which stands for *High Quality* — uses electronics to artificially clarify the picture. With HQ you can see more distinct features, and colors don't blur into one another that much. HQ is both a recording and playback process. HQ-recorded tapes benefit partially even when you play them in a non-HQ VCR.

Verdict: HQ really works, though not all VCRs use the same HQ electronics. The HQ on one VCR, therefore, may not be as good as the HQ on another VCR. Let your eyes decide. HQ is now standard equipment on most VCRs except the cheapo ones.

HQ is found on only VHS machines. It's not used in Beta or 8mm.

Index search

When you're ready to jump to the next song on a CD, you simply push the Next Song button. But how do you jump to the next TV show on that tape containing five *Star Trek* episodes? VCRs with an *Index Search* feature stick an invisible marker on the tape whenever you begin recording. To jump from the beginning of one show to the beginning of the next one, just push the Index Search button. Some VCRs use the name VISS (which stands for VHS Index Search System) for this feature.

Verdict: If you plan to record a number of shows on a single tape, this feature is a real time-saver, letting you jump quickly from show to show.

Don't know what's on that unmarked videotape you found in the closet? Put it in the VCR and push the Index Search button — by jumping from index to index, you can quickly see the beginning of everything you've recorded on the tape.

Message center

In this age of blending technology, some VCRs double as pseudo answering machines. You can punch the message "Please pick up turkey franks" into a VCR; when the VCR is turned on the next time, it flashes the message on the TV screen.

Verdict: Most people find sticky notes a little less complicated and much cheaper. Just put the sticky note on the TV screen, and everyone is sure to see it. (And if somebody's sitting down to watch TV, will they really want to get back up to buy some turkey franks?)

Power backup

Ever spent 15 minutes setting your VCR's clock, only to see it blinking again when the vacuum cleaner accidentally pulls the VCR's cord out of the wall? VCRs with *power backup* have a little battery inside that remembers your VCR's settings if the power dies.

Verdict: It's cheap, it's effective, and it's amazing that VCRs haven't had this feature since the beginning. Now let's hope that they can extend the battery life; most power backup features last from about 30 minutes to four hours before making the clock flash again.

Programming

One of the most complicated aspects of VCR life, this feature turns your VCR into a robot that automatically waits for your favorite programs to begin and then records them for later viewing.

Verdict: Some people love the idea of never missing a favorite TV show. Others would rather miss an episode of *The Simpsons* than learn how to program their VCR. It's your call here. (See the description of VCR Plus, later in this section.)

A VCR Plus gadget, described in Chapter 8, reduces programming chores to simply punching in a number on a keypad. It's by far the easiest way to tell your VCR to record a show. The latest VCRs come with VCR Plus built in; you don't have to buy anything.

A VCR that allows *on-screen programming* is usually easier to use than one that makes you fiddle with buttons on its front panel. (On-screen programming still isn't as easy to use as VCR Plus, however.) A few VCR models use a bar-code wand, like you see in some grocery stores, to program shows. You use a sheet of bar codes to tell the VCR what to do, in response to on-screen prompts. The bar-code thing is a good idea, but it never took off; too many people accidentally programmed their VCR to record a bag of potato chips.

When a VCR boasts of an 8-event/1-month timer, it means that it can be programmed to capture your *eight* favorite programs within *one month's* time. If you want the VCR to capture your *nine* favorite TV shows automatically, you're out of luck. Capacities vary, but most record as many as eight programs within anywhere from a week to a year's time. Realistically, being able to record more than just a few shows during a week or so is pretty useless because a single videotape can only hold so much, so don't be swayed by a timer that can record 1,771,561 shows from now through the twenty-third century.

Quartz tuning

The VCR takes over the chore of tuning in TV stations; your TV just sits there and displays whatever picture the VCR sends to it. *Quartz-tuning* means that the VCR can automatically "lock in" the stations; without it, you have to turn knobs and fine-tune each station yourself.

Verdict: Just about all VCRs on the market today have quartz-tuning, thank goodness, so this really isn't an issue unless you're eyeing an older VCR at a garage sale.

Aliases: PLL tuner, frequency synthesized tuner.

Quasi S-VHS playback

This feature gets a little weird. Expensive VCRs can record in a high-quality video mode called Super-VHS, or S-VHS.

All the regular VCRs simply record in VHS mode — nothing super. And regular VCRs can't play back a tape recorded in S-VHS mode either — that's out of its league.

A VCR with Quasi S-VHS playback, however, *can* play as S-VHS tape. It still can't record in that mode, though; you have to buy a real S-VHS VCR for that.

Verdict: When a VCR plays back an S-VHS tape using Quasi S-VHS, it can play the tape only in regular VHS mode — the picture quality doesn't look any

better. Why bother? Quasi S-VHS playback is a niche feature for people who own both an S-VHS and a regular VHS VCR. Unless you'll be dealing with S-VHS tapes, don't bother.

Quick start

When you push the Play button on some VCRs, it takes a few seconds for the tape to begin playing — especially if the VCR has just been rewinding or fast-forwarding. The *quick-start* feature keeps the videotape wrapped around the special videotape grabbers inside the VCR. That way, the video jumps to the screen almost instantly when you push the Play button.

Verdict: If you edit tapes, you want this feature; it makes it easier to find exact spots on a tape. Other folks don't mind waiting a second for the picture to begin.

Alias: Quick access, quick play, full loading.

Real-time counter

All VCRs have a counter, which is sort of an odometer for videotape. When the numbers count down rapidly, you know that the VCR is *really* rewinding. The best models display hours and minutes rather than numbers; that way, you know how long you've been watching the movie. This kind of counter is called a real-time counter — it shows the count in "real time" rather than some arbitrary number.

Verdict: Real-time counters come in handy when you're recording, using standard tapes with two hours of recording time. Start the counter at 0:00:00 (many VCRs automatically reset the counter for you) and begin recording. You know that you're about to run out of tape and miss the climax to the movie when the counter reads 1:59:59. Real-time counters are also great when you're rewinding: You know how much longer the blessed event will take. Also, by writing down counter numbers of various scenes on a tape, you can fast-forward to them later, eliminating frustrating searches.

SAP (secondary audio program)

The TV stations in some big cities can broadcast in two languages simulta-neously without confusing anybody: They sneak the second language onto a special part of their broadcast signal. Stereo VCRs can pick up and record this signal if you push the right button, usually labeled *SAP*. By switching the SAP on and off, you can switch between the two languages.

While watching a rerun of *Columbo* on television last night, for example, Andy Rathbone turned the SAP feature *on* — Lt. Columbo began speaking in Spanish. When Andy Rathbone turned SAP *off,* Lt. Columbo began speaking in English again. By turning SAP on *and* off rapidly, he began to annoy his wife, so he stopped.

Verdict: Because the SAP feature comes built into most stereo VCRs, you're not really paying anything extra.

Shuttle ring

For years, VCR users pushed the Fast Forward button to move forward and the Rewind button to move backward. By fast-forwarding and rewinding, they could eventually find the scene they were looking for. But a *shuttle ring* is a round knob — not a button. Turn the knob in one direction to move the tape forward: the other direction rewinds. So? Well, the ring adds more control: The more you turn the ring, the faster the VCR moves the tape.

Verdict: These rings come in handy mostly when you edit tapes. Their finer control lets you find *exact* spots on the tape. If you don't need such precise control, shuttle past the shuttle ring.

Some VCRs with a shuttle ring also come with a *jog control.* In fact, the jog control — which is a pancake-shaped knob — fits inside the shuttle ring. The jog control lets you inch through a tape one frame at a time. You spin the jog control with your finger to advance the tape. It's a neat feature, but it's not an absolute requirement.

StarSight

Manufacturers want to make their VCRs as easy as possible to use. But a nagging problem still remains: how to make recording simple. For over 20 years, manufacturers have tried all sorts of ways to make it easier to program a VCR so that it records shows while you're away. VCR Plus (mentioned later in this chapter) is one way. Yet another is StarSight. StarSight is the name of a company that developed a nifty on-screen menu of all the programs on during the week. To record a show, you find it in the menu, and then select it with a button on the remote control. That's it! A picture of the StarSight screen is shown in Figure 2-2.

```
                  STARSIGHT
┌──────┬─────────────────────────────────────────┐
│ SEP  │  MON  TUE  WED  THU  FRI  SAT  SUN        │
│  7   │   9:00P          9:30P        10:00P      │
├──────┼─────────────────────────────────────────┤
│ CNN  │ Larry King Live!           World News    │
│ SHOW │ City Slickers              The Search    │
│ HBO  │ Bingo          Home Alone                │
│ DISC │ All In a Day's Work        All In a Da   │
│  26  │ Math ... Who Needs It?!    Rassias In    │
│ ESPN │ Major League Baseball                    │
│ FAM  │ Batman                     700 Club W    │
│  4   │ In the Best Interest of    News          │
│ DISN │ Casablanca                 Gaslight      │
│ REQ  │ Juice                                    │
├──────┴─────────────────────────────────────────┤
│ HBO  HOME BOX  CBL  8      7:25P  MON SEP 7     │
└─────────────────────────────────────────────────┘
```

Figure 2-2:
StarSight ®
makes it
easy to use
your VCR to
record
shows while
you're away.

To use StarSight, your VCR (or cable box) must be equipped with the StarSight electronics. Then you have to pay a monthly fee to get the StarSight programming menu. The cost is about $5 per month. The StarSight menu is broadcast along with the PBS channel in your area. If you don't get PBS, you can't get StarSight.

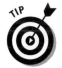

StarSight has competition, and some VCRs are coming with these other systems rather than with StarSight. Some VCRs are using a competing on-screen menu system; one of the most popular systems was developed by the folks who publish *TV Guide*, and is called TV Guide On-Screen; another system is from the same company that sells the VCR Plus.

Verdict: StarSight not only makes it amazingly simple to set up your VCR to record while you're away, but it lets you look up programs by type. If you're hankering for a Western, for example, you can look up all the Westerns scheduled for the week. Using StarSight to plan your TV choices is a lot easier than flipping through pages of *TV Guide*. The one bad thing about StarSight is that it adds to the expense of watching TV. The price for StarSight is over and above what you pay for cable.

Stereo

Most TV stations and cable companies broadcast at least part of their shows' soundtracks in stereo. A stereo VCR can pick up and record the high-quality sound. But here's the trick: Unless you have a stereo TV — or you connect the VCR to your home stereo — you can't hear the stereo sound.

Verdict: Stereo sound can add incredible new dimensions to movies — but only when they're hooked up to a home stereo system and played through the right speakers. Otherwise, a stereo VCR doesn't sound any different from a mono VCR. (A stereo TV doesn't really sound all that good, in fact, unless it's hooked up to a home stereo, too.)

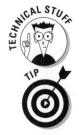

Today, stereo VCRs require a feature called "hi-fi," which is discussed earlier in this chapter. Those VCRs still have to be hooked up to a home stereo before you hear stereo. One speaker just can't crank out stereo sound.

For a cheap taste of a "home theater" system, connect your stereo VCR to your home stereo, as described in Chapter 3.

VCR Plus (VCR+)

Programming a VCR is about as exciting as reading the ingredients label on a potato chip bag. But the *VCR Plus* gadgetry makes programming easy: Simply find the number listed next to your favorite show in the *TV Guide* (or the TV section in your local newspaper) and punch it into the VCR Plus system's remote control. VCR Plus automatically tells the VCR when to turn on, which channel to record, and when to turn off.

Verdict: VCR Plus makes programming a VCR as easy as dialing a phone number: Just punch in a number. If VCR programming makes you queasy, check out VCR Plus. (It's covered in Chapter 8.) Some VCRs come with the VCR Plus system built in, which makes things even easier.

Video-noise reduction

VCRs with this feature constantly watch the movie along with you, automatically tweaking the picture when necessary to make sure that it looks "purty" on the screen.

Verdict: These automatic picture tweakers are like fancy shock absorbers on a Lexus: They make things more comfortable, but they cost a little more. It's your decision.

Alias: Adaptive picture control (APC), automatic picture control (APC), artificial intelligence, fuzzy logic, intelligent picture.

Voice-activated programming

After watching *Star Trek* in the '60s, people *wanted* their gizmos to talk. Bark an order from the command chair, and watch in satisfaction as the computer handles the chore.

After wading through today's "press 6 for sales" telephone systems, however, most people have lost their infatuation with computerized conversations. Still, some VCRs work with voice commands, letting you bark out "Pause" when you want more popcorn.

Verdict: When you have guests over, do you *really* want them to see you talking to your VCR?

Buying a VCR

Four out of five people on the street own at least one VCR. The other ones are currently shopping. But which one are they looking for? This section covers not only the three big decisions you have to make when you're shopping, but also where you should shop and what to do with the old VCR you're replacing.

THE three big decisions

When you choose a VCR, you have to wade through dozens of options and features, all explained earlier in this chapter. But three of the decisions are biggies — they can each add or subtract about $100 to the VCR's total price. The Big Three are described here.

VHS or S-VHS

The regular VCRs that just about everybody owns record in something called *VHS mode.* The fancier VCRs that cost much more can also record in a higher-quality version called *S-VHS mode.* Chapter 1 covers the two formats in more detail, but it boils down to this: If you have a great deal of money, a big TV, or a hankering for the best quality, go for S-VHS.

But if you're like most people, stick with VHS, the format everybody's been using for more than a decade.

Two heads or four heads

A VCR with *four* video heads can play back a video in slow motion, letting you watch explosions and car crashes in minute detail. It also lets you freeze the picture on the screen clearly. Four-head VCRs can record a little more clearly as well.

A *two*-head VCR merely plays and records videos. And when it pauses the movie, a blurry line covers part of the screen, making it difficult to see what's going on.

More blurry lines appear when you *fast-scan* a movie — play it while pushing the Rewind or Fast Forward buttons. VCRs with four heads deliver a much sharper picture when you fast-scan.

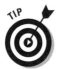

If you just play back rental movies, stick with a two-head VCR. If you record movies, however, check out a four-head VCR at the showroom before making a final decision.

Stereo or mono

Most people know that stereo music sounds better than regular — *mono* — music. Because of the extra doodads required in a VCR to play stereo, adding stereo capability to a VCR adds about $100 to the cost. Most rental movies have a stereo soundtrack you miss without a stereo VCR. And a stereo TV can't play a rental movie's stereo soundtrack unless it's connected to a stereo VCR.

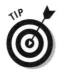

Before making a decision, listen to a movie played on a mono VCR and on a stereo VCR. Compare the sound, compare the price tags, and let your ears decide.

Why four heads are better than two

Only two video heads in a VCR, even in a four-head model, are used at any given time. In a four-head model, two of the heads are used to record and play back pictures at SP (Standard Play) speed. The other two are used to record and play back pictures at EP (Extended Play) speed.

Having four heads lets the VCR pick the heads best suited for playing pictures recorded at the two speeds. Each pair of heads is specifically designed for use at that specific speed. On a two-head model, heads are designed as a compromise between playing at SP and EP speeds because they must handle both. The picture quality, especially when you're fast-scanning or pausing the tape, isn't as good.

Should I buy from a local dealer, mail-order company, warehouse club, or garage sale?

Where should you buy that new VCR? You have several options, but your best bet is usually a local electronics dealer.

First, local dealers let you touch the VCR before you buy it. You can view the picture on the TV. You can compare remote controls from different brands and see which is easier to use. Plus, a salesperson usually hovers nearby to answer questions and point out differences between machines.

Mail order can save money, but you pay for it in convenience. You can't see and play with what you're ordering, and some mail-order houses can take weeks to ship their orders. Plus, you don't have anybody to yell at if it doesn't work.

Warehouse or club stores also sell VCRs for less money, but they usually don't let you sample several different machines. Also, salespersons are few and far between.

If you like to tinker, go ahead and buy a VCR from a garage sale. Note, however, that current VCR repair-shop rates run about $50 to $75 per hour.

✔ When you buy a used VCR, make sure that it comes with its remote control. Many features can be accessed *only* through the remote control.

✔ When you're comparing VCRs and deciphering the salesperson's "feature talk," make sure that you buy a VCR you *want* to use now — not one you promise to "figure out sometime." Sure, buy some nifty, new features that look like fun. But make sure that the VCR's basic operation is comfortable and easy to figure out — even if you never figure out what all those other buttons do.

✔ Surprisingly, not all VCRs can record. Some of the cheapest ones can just play back tapes. Don't try to save money only to find that you can't record a special show.

✔ When you shop, take your own movie into a VCR showroom and play it back on several different VCR brands and models. By comparing the look and sound of a movie you're familiar with, you get a more accurate estimate of its quality.

✔ Don't be afraid to negotiate over price. Most shops will haggle a little over price or toss in some free videotapes if you whine a little.

✔ VCR technology changes monthly. Check out the newsstands for the latest video magazine to see what this month's fuss is all about.

> ✔ Be prepared to spend more than $250.
>
> ✔ Make sure that your salesperson is friendly enough to offer help over the phone if you have trouble setting the thing up.

Choosing the right remote control

Chances are that you'll spend more time working with the VCR's remote control than with the VCR itself. When you shop for VCRs, compare the remote controls that come with different models so that you aren't unpleasantly surprised when you start fiddling with it at home.

> ✔ Look for a remote control that's not overly packed with buttons. The more buttons on the remote control, the harder it is to find the right one.
>
> ✔ Make sure that the most important buttons — the channel changers, the volume control, and the on-off switch — are easy to find. If the switches aren't located in the remote control's corners or along an edge, you won't be able to find them while watching a movie in the dark.
>
> ✔ Hold the remote in your hand and fiddle with it until it's comfortable. Then look at the position of your fingers: Does it feel natural to push the buttons with your thumb or index finger? Try each method and then choose a remote control that seems the most comfortable for your particular style.

Uh, what do I do with the old VCR?

Congratulations on the new VCR! But what do you do with the old one?

If it still works, keep it around. By connecting two VCRs, you can make copies of your favorite tapes. (That's described in Chapter 11.) But if the old VCR doesn't work, donate it to a charity; at least it's worth a tax deduction. (Remember to include the remote control, though.) Figure 2-3 shows Gordon's old VCR. This beat-up old thing is still going strong. It may not look like much, but it still delivers great pictures, and the kids love having their own VCR.

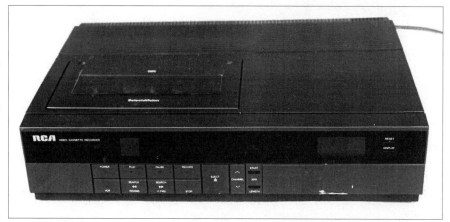

Figure 2-3:
Don't be
afraid of
keeping your
old VCR. Use
it in the
family room
or a
bedroom.

Are extended service warranties a ripoff?

Most VCRs come with a warranty of at least 90 days. If something goes wrong, the manufacturer fixes it for free. But what if the VCR dies after 91 days?

That's the question an extended service warranty tries to answer. By purchasing an extended service warranty, you can extend your warranty by months or even years.

Are they worth it? Well, it's a gamble, like earthquake insurance. Some folks like the easy feeling they get, knowing that their VCR is protected for an extra six months or a year. Other people say that if a VCR is going to break, it probably will break in the first three months anyway.

- ✔ Check the fine print on your credit card. Some credit-card companies automatically double the warranty of anything you purchase. If so, you don't want to pay for something you're already getting for free.

- ✔ Also check the fine print on the extended warranty. Chances are that it doesn't cover most of the things you may want fixed anyway: removing a broken tape from its innards, cleaning its heads, or sucking out a spilled beverage. Warranties cover manufacturer *defects,* not user mishaps.

- ✔ Finally, keep in mind that salespeople are eager to sell extended warranty plans because they usually get a commission. Don't get talked into something you're not sure about.

Chapter 3

Hooking Up Your VCR

In This Chapter

▶ Unpacking the VCR

▶ Clearing a space for the VCR

▶ Connecting the VCR to your TV

▶ Connecting the VCR to a stereo

▶ Testing to make sure that everything works

▶ Setting up the VCR

▶ Looking over the manual

Most people can easily create a long list of chores that they would rather do than hook up a new VCR. You know, things like "Change the cat litter" or "Retrieve the chicken bone that rolled underneath the refrigerator."

Let's face it: Having a VCR also means having to hook it up to the TV set. Fortunately, the job is much easier than it looks. That's where this chapter comes in. It explains how to unpack your VCR without losing any of the pieces. It also explains how to fasten the right part of your VCR to the right part of your TV.

If you're really adventurous, read the part about connecting your VCR to your home's hi-fi system so that you can enjoy *Matlock* reruns in stereo.

Finally, to make sure that your VCR lives a long and healthy life, a section spells out the good and bad places to put your VCR.

Unpacking the VCR from the Box

Bringing home a new VCR is much like bringing home a new baby. There's lots of cooing from other family members as they proudly look upon the new arrival. Of course, there's also plenty of sibling rivalry among your other appliances. The microwave oven may refuse to work that night, or the vacuum may blow out dust rather than suck it in. But in time, all this will pass and your new VCR will be welcomed into your home by all.

The first step after bringing home baby is to unpack it from its shipping container. Do this at your kitchen table so that you have room to spread out all the assorted junk stuffed in the box along with the VCR.

A towel or blanket placed over the kitchen table can protect it from scratches.

Open the box

Use a knife to slit the packing tape and open the box. If any big metal staples are holding the box shut, remove them with a pair of pliers. Your teeth are a poor substitute for this procedure. Make sure that you get the staples all the way out or the sharp ends will eventually scratch you.

The VCR is secured in the box with chunky Styrofoam inserts. If you try to pry out these inserts with your hands, you'll just end up breaking the inserts into tiny styrobite-size pieces. So a better way is to flip the box over carefully and let the VCR slide out of the box onto the table. Let the other stuff fall out of the box along with it. Remove the Styrofoam inserts and place them back into the box. Turn the VCR over (so that the top is face up) and remove any remaining packing material.

While unpacking the VCR, take care not to destroy the box or any packing material inside. You may need the box and packing material if you have to return the VCR to the store.

There's one exception to keeping all the packing materials: Most vendors include little packets of crystals that remove any moisture from the box. The moisture-removing crystals in the packets, known as *desiccants,* can be poisonous, so put them in your trash can where children can't get to them.

The box contains other stuff you should set aside for now:

- ✔ **Manual:** Tells you important things about using your VCR. It begins by warning you not to operate your VCR in the rain and then goes downhill from there.

- ✔ **Hookup wire (or cable):** Connects the VCR to your TV.

- ✔ **Remote control:** Lets you command your VCR without leaving your easy chair.

- ✔ **Set of batteries:** For the remote control.

- ✔ **Matching transformer:** For older-style TVs that don't have a modern, cable-ready connector. The transformer lets you attach the VCR's cable to the two screws on the back of the TV — the spot where the antenna currently lives.

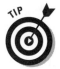

Your VCR may come with other stuff, depending on its accessories. It may come with a weird keypad thingie, for example, for connecting to your cable box. These kinds of accessories differ from VCR model to VCR model, so you might have to brave the instruction manual for help or ask a friendly neighbor whether you need any of those things. (Chances are that they're stuck with the same cable system as you are.)

Find a packing list

Most VCRs come with a packing list — usually it's a piece of paper with the words *packing list* printed across the top. It lists everything you should find in the box.

Compare the junk on your kitchen table with the packing list. Is anything missing? If so, contact the salesperson at the store where you bought the VCR. Unless the salesperson comes up with a good explanation, you should get everything that's on the packing list.

Look for damage

Most VCRs travel a long way before reaching your home. They're shipped on big boats from Japan and then on semitrailers to your neighborhood electronics store. Big, burly people load and unload the boxes as they move from Japan to your hometown, and these people are not known for their gentleness.

Lots of bad stuff can happen to your VCR while in transit, and you may not be able to see any of the damage from the outside of the box. So before you hook up your VCR, check it carefully for damage. Look for bent pieces, squashed corners, or cracks.

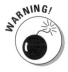

If you find any signs of external damage, pack up your VCR and return it to the store. Damage on the outside can be a good sign of even worse damage on the inside.

Save all materials

Assuming that your VCR passes the visual damage inspection, tuck all the packing material neatly back inside the box. Save the box for at least 90 days — or the duration of the warranty, whichever is longer — in case anything evil happens to your VCR. You need that box to return the VCR safely to the store or to ship it back to the factory for any repairs.

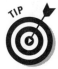

Many folks save their VCR boxes for *years* (even after they've gotten rid of the VCR). The box and its packing materials come in handy whenever the VCR has to be transported, including when you move to a new house. Keep the box in the garage, in a closet, under the bed — wherever it won't get crushed.

Put the batteries in the remote control

Wasn't it thoughtful for the VCR manufacturer to give you batteries for the remote control? Sure, it was. Unfortunately, most manufacturers give you the cheapest batteries they can find. Throw them away and put in a new set of special *alkaline* batteries. If you don't have a set of alkaline batteries handy, go ahead and use the batteries that came with the VCR, but promise to buy alkalines the next time you're at the store.

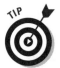

Buy alkaline batteries for two reasons: They last longer, and they don't leak as often as regular batteries do. Always replace the batteries in the remote control with the alkaline type.

Look for little arrows or pictures of batteries printed inside the remote control's battery compartment. Those arrows or pictures show the right way to insert the batteries. The end of the battery with the little bump on it should face in the direction of the *arrow* or *plus sign.* The flat end of the battery usually rests against the spring, if there is one.

Clearing a Space Beside the TV for the VCR

The logical spot for the VCR is within six feet of the TV. It's logical because you almost always use the TV with the VCR. Besides, the wire they give you to connect the VCR and TV is only about six feet long.

Begin by clearing a space beside the TV.

- If your TV is a large console model, you can place the VCR right on top of the TV. (You have to find another spot for the bowling trophies.)

- If your TV is the portable kind, it probably doesn't have enough space on top for the VCR. Don't try to balance the VCR if the top of the TV is too small. Instead, find a spot beside the TV for the VCR, like a bookshelf.

- If you can't put the VCR on top of the TV and the nearest bookshelf is in your neighbor's apartment, consider buying a cart or stand for your VCR. No need to get fancy here — just something sturdy enough to hold it.

Never, never, never place the TV on top of the VCR, even if the TV is a small, 13-inch model. The TV is much too heavy. Even if the VCR seems to work with the TV on top, the pressure eventually stretches it out of the shape, which keeps it from playing tapes right.

Good spots, bad spots for the VCR

You probably put your TV in its current position because it's close to the cable or antenna wire. Fair enough. TVs are pretty resilient, and they can withstand a lot of abuse.

Your VCR, on the other hand, is a fragile piece of high-tech machinery. Think carefully about where your VCR will live, and avoid any situation that can shorten its life.

- ✔ Keep the VCR away from radiators, heat vents, air conditioners, and windows. The heat from radiators and heat vents can damage the VCR. The cold blast of air from an air conditioner can cause condensation inside the VCR, which spells trouble. And dust can flow through an open window and spread a layer of icky grime all over the VCR.

- ✔ Place your VCR in an area with plenty of free air circulation. Don't jam it into a tight corner where the ventilation slots can't get any air.

- ✔ Keep the VCR out of reach of children. Small kids and VCRs don't mix. Put the VCR high enough so that your children can't operate its controls or put peanut butter sandwiches inside without using a stepladder. Then hide the stepladder.

- ✔ Place the VCR on *top* of other hi-fi gear if you must stack it with the goodies in your stereo system — like when space is at a premium, for example. The transport mechanism of the VCR (the part that moves the tape) is sensitive. Putting a heavy amplifier on top of the VCR can eventually warp its innards, and it will never be able to play back tapes correctly.

- ✔ Place your VCR on a flat, smooth surface. Never put it on a blanket or carpet. Those items can block any air vents along the VCR's bottom.

- ✔ Keep your VCR at least a foot away from the following items: hi-fi speakers, telephones, microwave ovens, and giant electromagnets.

- ✔ Keep your VCR away from anyplace where it might get wet: the kitchen counter, the wet bar in the living room, or the shower.

Move the TV to get to the back

You need access to the back of your TV to hook up the VCR. If there's junk around your TV, you probably have to push it aside. You don't have to move the TV completely away from the wall to install your VCR — you just need easy access to the antenna connection on the back of your TV.

Unfortunately, TV makers can be thoughtless cretins, and they tend to hide the antenna connection way back at the bottom rear of the TV. You probably will have to move the TV out from the wall a few feet or turn it a full 90 degrees to reach that awkward antenna connection.

Connecting the VCR

Your TV must be connected to your VCR with a wire or it can't pick up any pictures. Luckily, the VCR probably came with a suitable wire — more correctly called a *cable* — that hooks up to your TV.

If the cable's too short, you can buy a longer one. Video cables come in standard lengths of 3, 6, 9, and 12 feet; some fearless folks make their own to any length. The cables are available at Radio Shack and most home improvement or electronics stores. Make sure that the cable has something called an *F-connector* on the end: It's a round thing with a little wire poking out from its center, as shown in Figure 3-1. Look for the words *F-connector* on the package or ask your salesperson for help.

Figure 3-1:
Video cables come with an F-connector on each end.

The exact way you hook up your VCR depends on how your TV is connected to the antenna or cable system. The next two sections show how to connect a VCR to your TV if you're using a cable-TV service or a plain old antenna. (Chapter 11 explains more advanced methods for more troublesome connections.)

Cable hookup

Most homes these days are connected to a cable-TV service. The cable comes out of the wall and either plugs in directly to the back of the TV or makes a stop at a cable box (also known as a *cable converter* or *cable decoder*).

The little plug on the end of the video cable is one of two types: slip-on or screw-on (the most common).

The *slip-on* type, shown in Figure 3-2, is the easiest to use: The cable just slides on or off the connector that's on the back of your TV or VCR.

Figure 3-2:
A slip-on connector simply slides on or off a video connector.

The *screw-on* type, shown in Figure 3-3, is a little rougher to use: You have to turn a little ring on the end of the cable to attach or detach it from the connector on the back of your TV or VCR. If the little ring is turned on too tightly, a pair of pliers can help remove it.

Figure 3-3:
A screw-on connector screws on and off its connectors.

To connect your VCR to your TV, follow these steps. Beneath each step, additional details offer more instructions.

1. Disconnect the current cable from your TV.

If a video cable connects directly between your TV and the wall, unhook it from the TV. It either unscrews or pulls off from the back of your TV. Keep the loose end of the cable handy for now because you'll need it in just a bit.

If a video cable connects from the wall to a cable box, look carefully for a cable running between the cable box and the back of your TV. Disconnect this cable at the TV end. Keep the loose end of the cable handy for now.

2. **Attach one end of the VCR's new cable to your TV.**

Take the new cable — the one that came with the VCR — and connect it to the place where the video cable connected to your TV. (Either end of the cable will do.) Figure 3-4 shows how to connect the VCR to a TV, if your TV is equipped with screw terminals for the antenna connection. The figure also shows how to connect to a TV equipped with a round cable connector.

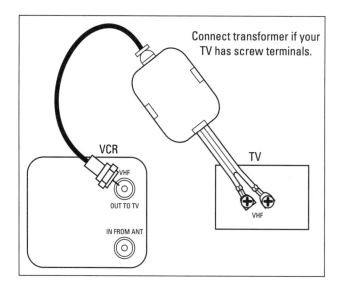

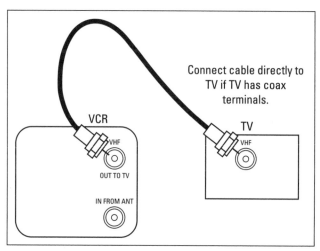

Figure 3-4:
Connect
your VCR to
your TV .

3. Attach the other end of the VCR's new cable to your VCR.

Push or screw the *other* end of the new cable into a connector on the back of your VCR. The connector should be labeled Antenna Out, VHF Out, VHF/ UHF Out, or something similar. (The word *Out* is the key word here.) Figure 3-5 shows the back of a typical VCR, with VHF input and output connectors. Some VCRs have extra connectors on the back labeled Audio and Video, as shown in Figure 3-5. Unless you're connecting to a TV with the same kind of inputs, you can ignore these. (Chapter 11 talks more about how and when to use these Audio/Video connectors.)

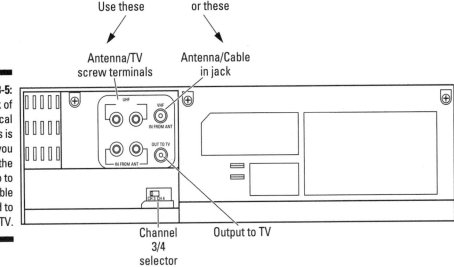

Figure 3-5: The back of a typical VCR. This is where you hook the thing up to your cable box and to your TV.

4. Plug the TV's original cable into the back of the VCR.

Now take the cable you removed from the antenna connector at the back of the TV and push it into the connector on the back of your VCR — the one labeled Antenna In, VHF In, VHF/UHF In, or something similar. (The word *In* is vital here.)

If your TV doesn't have a cable connection on the back, head for the next section. Chances are that your TV is connected to a plain old antenna.

Plain old antenna

No cable dangling from a wall? Then you probably have an outdoor or indoor antenna connected to your TV. Don't worry — hookup is pretty simple, although it varies a little, depending on whether that cable is flat or round.

1. Disconnect the antenna from the TV.

If the antenna's cable is the round kind — with connectors like the ones shown in Figure 3-2 or 3-3 — it either pulls off or unscrews.

If the cable is the flat kind, as shown in Figure 3-6, you need a screwdriver: Loosen the two screws on the back of the TV where the antenna wires connect.

Figure 3-6:
Televisions without cable often use these flat wires.

2. Connect the antenna to the VCR.

If the antenna cable is the round kind — with a connector like the one shown in Figure 3-2 or 3-3 — plug its connector directly into the VCR's Antenna In, VHF In, or UHF/VHS In connector.

Is the antenna the flat kind, as shown in Figure 3-6, you need a gizmo called a *matching transformer* shown in Figure 3-7 which lets you convert your flat cable to the more modern round variety. Check your VCR's box carefully — many new VCRs include one, and they're small enough to get lost in the packaging. Then fasten the flat cable's two wires to the gadget's two screws and push the gadget onto the Antenna In, VHF In, or UHF/VHF In connector on the back of your VCR.

If the VCR didn't come with a matching transformer, head to Radio Shack and ask for a 300- to 75-ohm matching transformer. Feel free to bring this book along and point to the picture; that might help the salesperson find the right one.

Figure 3-7:
These devices let older, flat-style antenna cables connect to modern VCRs.

3. Connect the VCR to the TV.

Now connect the cable from the VCR's Antenna Out, VHF Out, or VHF/UHF connector to the TV's antenna connector.

Does the TV have a round antenna connector on it for the VCR cable? Good; just slide or screw the VCR's cable into the antenna connector.

If the TV has only two screw terminals for the antenna, you need yet another *matching transformer,* shown in Figure 3-8, to attach the round VCR cable to the TV's screw terminals. For this procedure, you need a 75- to 300-ohm matching transformer. One usually comes with the VCR, so search the packaging carefully.

Figure 3-8:
These devices let modern VCRs connect to older-style TVs that use screws as connectors.

 If your TV is equipped with "rabbit ears" for an antenna, you probably have to buy a new indoor antenna for your VCR. The rabbit ears on some TVs are built in — they can't be detached and hooked up to the VCR. Radio Shack and most home improvement stores carry indoor antennas. A good tabletop model (you can put it on the VCR or TV) costs about $25. Connect it to your *VCR,* not to your *TV.*

 Matching transformers are sometimes called plain old *converters* at the electronics store.

 Moved your new VCR and TV to a new room? Unfortunately, the cable company doesn't automatically activate the cable hookups in every room. The cable hookup in the living room might work, but the one in the bedroom might not work until you start paying an additional room fee. Check with your cable company if you're confused about how many connections you're paying for.

Plug in the VCR to the wall socket

With the VCR now hooked up to your TV, you can plug in the VCR to a nearby wall socket. The plug on the VCR is *polarized,* which means that one of the prongs is bigger than the other. It's designed this way so that the plug fits just one way in the newer electrical outlets. Be sure to plug in the VCR in the proper way.

Older homes and extension cords don't have polarized outlets. No real problem . . . usually. If you should ever see a dark, rolling bar move up and down the screen while watching TV, you may want to reverse the VCR plug in the wall socket. This step usually removes the dark rolling bar from the picture.

How Do I Hook Up My Nintendo or Atari Jaguar?

Video games hook up through a TV's antenna or cable connector, too. The video game machine puts a special adapter on the back of the TV. The adapter has a special outlet that lets you hook up the incoming antenna or cable.

1. **To hook up your VCR to this mess, disconnect the cable or antenna cable *before* it reaches the video game adapter.**

2. **Then plug that end of the cable into the VCR's Antenna In (or VHF In) connector.**

3. **Plug the short VCR cable between the Antenna Out (or VHF Out) connector of the VCR and the video game adapter. Whew.**

Should I Choose Channel 3 or 4?

Almost all VCRs have a switch in the back labeled *Channel 3/4* or something similar (see Figure 3-9). This switch determines which channel the VCR uses to send its signals to the TV. (The switch has nothing to do with how the VCR receives channels.)

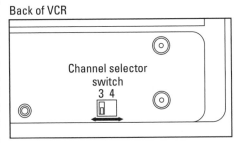

Figure 3-9:
Switch to
Channel 3 or
4 on the
back of the
VCR and
tune to that
channel on
the TV.

Back of VCR

Channel selector
switch
3 4

Most VCRs come with the switch set in the Channel 3 position. You then dial your TV to Channel 3 to see the pictures from the VCR.

If Channel 3 is used by a local TV station, however, switch the VCR to Channel 4 instead. This step prevents the Channel 3 signal coming from the VCR from interfering with the Channel 3 signal coming in over the air.

Make a mental note of the channel the VCR is switched to. You have to dial your TV to this channel before you can watch stuff from your VCR.

Connecting the VCR to Your Stereo System

Most rental movies are recorded in stereo — the same stereo that is used when the movie was shown at the local bijou. If you have a stereo TV, you automatically hear stereo sound from your stereo VCR.

But even if your TV is not the stereo kind, you can still enjoy movies in stereo — if you have a home stereo system with a set of Aux (auxiliary) audio connectors on it. (Most do.)

Didn't buy a stereo VCR? Then you're stuck with mono — not even a stereo TV can pull stereo sound from a mono VCR.

But if you're ready to hear stereo sound from your stereo VCR, you have to follow three steps: Find the right jacks on your home stereo, find the right cable, and connect the cable between those jacks and your VCR. Each chore gets its own section here. Figure 3-10 shows the basic VCR-to-stereo setup.

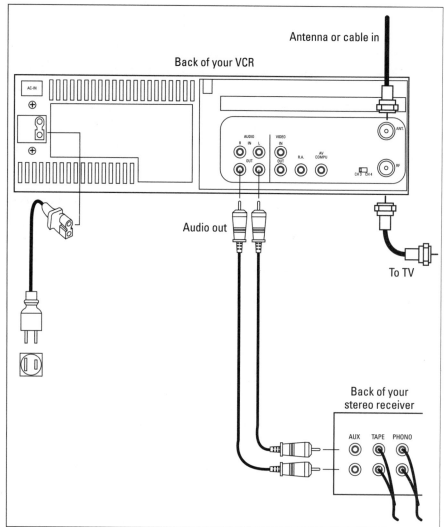

Figure 3-10:
For
connection
to your
stereo,
attach
cables as
shown.

Find the Aux connector

If you're not sure which connectors your stereo system has, look at the back of it. You want a pair of round connectors marked Aux, or something similar, as shown in Figure 3-11.

Figure 3-11:
A pair of Aux jacks on a home stereo.

Don't use the Phono connectors to hook your VCR to your stereo system. Not only does it sound terrible, but you also can damage your stereo.

You can use the Tape In, CD, DAT, or LD connectors on your stereo if it doesn't have Aux connectors.

If your stereo system doesn't have Aux connectors or if the Aux connectors are already taken up by cables that got there first, you can't hook up your VCR to your hi-fi. (Check out Chapter 11 if you're interested in upgrading your stereo system.)

Buy the right cable

You need a pair of cables to connect from your VCR to your hi-fi system. The cables come in different sizes, so figure the cable length you need before buying anything. The cables come in standard lengths of 3, 6, 9, and 12 feet.

The cables come in pairs, so one set handles both the right and left channels of the stereo sound. The cables are usually colored: white for the left channel and red for the right channel. (Don't worry if the cable you buy doesn't use these colors; the colors are only for your convenience.)

The cables need *RCA phono* (or just plain *phono*) jacks on each end, as shown in Figure 3-12. Audio cables are different from video cables, so don't try to mix and match. Be sure that the cable you buy has jacks hanging from each end — one jack apiece for the right and left channels of your stereo system.

Figure 3-12:
Audio cables have RCA phono jacks on each end.

Each end of a stereo cable ends in two jacks: The *red* jack always connects to the plug marked *right*.

Connect the audio cable

Attach one end of the cable (both the right and left sides) to the two connectors on your VCR marked Audio Out. Attach the other end to the Aux In connectors on your home stereo.

Be sure to keep the right and left sides straight. That is, attach the *left* Audio Out connector on the VCR to the *left* Aux connector on the stereo. If you swap them, sounds that should come out the right speaker come out the left speaker instead and vice versa. You don't want to hear the movie's explosions coming from the wrong side of the room.

✔ Many TV shows and movies are broadcast in stereo too. When you tune in to a stereo broadcast, you can hear the stereo sound on your home stereo system.

✔ If you don't have a stereo VCR, you can still listen to TV sound through your home stereo by using a special "Y" adapter cable. One end of the cable contains a single jack that plugs in to the single Audio Out connector on the VCR; the other end of the cable has two jacks, one apiece for the right and left plugs on your home stereo. You still hear mono sound, but it sounds better coming out of both speakers of your stereo system.

Testing to Make Sure That It All Works

Before settling down in your easy chair, check out the following sections to make sure that your VCR was installed correctly and that everything works as it should.

Turn the VCR on

The moment you plug in your VCR, its built-in clock should appear, flashing the numbers 12:00. Those numbers should appear even if the VCR hasn't been turned on yet. A completely blank VCR can be a sign of some serious trouble. Its built-in clock should flash the numbers 12:00 or look like this (—:—:—).

If the VCR is plugged in but the clock doesn't appear, check to see whether you've plugged in the VCR to a "switched" outlet. These outlets are controlled by a wall switch somewhere in the room. If so, plug in the VCR somewhere else. Otherwise, your VCR forgets the current time each time you flip that wall switch.

Turn on the VCR by pressing its switch marked Power. Some lights should appear along its front, letting you know that the VCR has been powered up.

Turn the TV on and tune it to Channel 3 or 4, depending on the switch setting on the back of the VCR (see the section "Should I Choose Channel 3 or 4?," earlier in this chapter).

Dial the channels on the VCR

Find the channel-control buttons on the VCR. Press the buttons to tune to different channels. You should be able to tune in to all your favorite stations.

If you watch cable TV through a cable box, dial your VCR to Channel 3 or 4 (the same channel you tuned to when you watched cable on your TV). Use the cable box to dial in the channel you want to watch, and leave the channel control on your VCR alone.

If your VCR displays a Setup or Initial Set screen when you first turn it on, you have to follow the directions in the manual that came with the VCR to set it up before you can continue with any more testing.

Play a prerecorded tape

Find a prerecorded tape, like a rental movie, and insert it in the VCR. The VCR may begin to play automatically. If it doesn't, find the Play button and press it. After a few moments, the movie should appear on the TV.

When you're finished with this test, press the Stop button and then eject the tape. You do this by pressing the Eject button, if the VCR has one. On some VCRs, the Stop button doubles as the Eject button: Press *once* to stop the tape; press *twice* to eject the tape.

Record a test tape

Insert a new, blank tape in the VCR. Tune the VCR to a local TV station. The picture and sound should be relatively clear.

Find the Record button and press it. (On some VCR models, you have to press Record and Play at the same time.) The VCR should begin recording. After about a minute, press Stop. Find the Rewind button and press it. The tape should rewind to the beginning and then stop. Press the Play button. The program you recorded should appear.

Test the front-panel controls

Press the Stop button and rewind the tape again. When the tape stops rewinding, press Fast Forward. The VCR should fast-forward through the tape. After a second or two, press the Stop button and then press Play. The program you previously recorded should start in midstream because you fast-forwarded past the beginning.

When you're finished with this test, press the Stop button and eject the tape.

Test the remote control

For most folks, the remote control is the most important part of the VCR, so be sure that it works correctly. Repeat the steps in the preceding section, but this time use the remote control to operate the VCR.

When you're recording by using the remote control, you probably have to press the Record and Play buttons simultaneously. Most remote controls work this way. This setup is a precaution to prevent accidentally hitting the Record button while you're reaching for pizza and inadvertently erasing a tape already in the machine.

When using your VCR's remote control, try to keep the control within about 30 degrees to either side of the front of the VCR (the front is where the sensor is for the invisible infrared light from remote control, as shown in Figure 3-13). Most remote controls aren't effective at distances greater than about 20 feet.

Setting Up the VCR

OK, so you hooked up your VCR and it plays back the Madonna tape your friends in the office gave you for your birthday. The hard part is over. But you still have to set up your VCR — things like setting the clock, selecting channels to watch, and other such stuff.

All VCRs are different when it comes to setting them up. To do the job, you have to open the manual that came with your VCR and read about how to set it up — probably under the "Setting up your VCR" section.

On the latest VCRs, you set the following:

 ✓ **The date and time:** This part is optional; many carefree people simply let their VCRs blink 12:00.

 Your VCR works whether or not you set the clock. (Chapter 5 has more information about setting the clock, if you're ready for this step.)

✔ **The channels you want to watch:** If you're on cable and you use a cable box to tune in channels, skip this part: You leave your VCR set perpetually on Channel 3 or 4, whichever channel the cable box uses. On the latest VCRs, setting the channels to watch is largely automatic: The VCR scans through the channels and eliminates those that don't have a picture.

✔ **Reception band:** Look for a switch marked TV/CATV. Then, if you use an antenna, set this switch to TV. If you use cable, set it to CATV. Often, you don't have to choose this setting yourself; it's automatic.

✔ **VCR Plus Guide Channel:** If your VCR is equipped with VCR Plus (it helps you program your VCR to record shows) and you use cable, you have to tell the VCR which guide channels are used for your area. The *guide channels* help your VCR to tune in to the proper cable channels to receive the shows you want. (Chapter 8 is devoted to VCR Plus.)

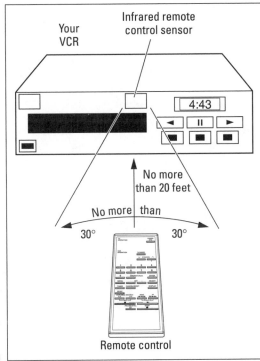

Figure 3-13: Keep the remote control within 30 degrees to either side of the VCR.

Looking over the Manual

In this book, we joke about the manuals that come with VCRs, but sometimes there's no escaping them. Because all the doodads, lights, and features of VCRs differ, there's no way to cover all the variations you're likely to encounter. You still need the manual for your VCR to really learn all there is to know about it. (If you would *want* to, for crying out loud.)

That doesn't mean that you have to read the manual from cover to cover and get more confused the longer you look at it. This section tells you how to read a manual with an absolute minimum of effort.

Most manuals ask you to write down the serial number of your VCR; you might need the number later if your VCR is stolen or needs servicing. Don't bother searching for the special place to write it down, though; just write it on the front of the manual. The serial number is usually stamped on the back of the VCR, printed on the name plate that lists the make and model of the machine.

Skip the cautionary stuff at the beginning

All VCR manuals begin with dire warnings, all designed to protect the manufacturer from lawsuits. You never know when somebody will try to use their VCR as a pool float. The VCR manufacturer's legal department therefore adds a "don't do this stuff" section to the front of every manual. If you can follow general common sense — and don't have a swimming pool, anyway — feel free to skim this part.

Find the setup information

You've already installed your VCR, so you can skip the part of the manual that shows how to hook it up to your TV. Go directly to the part that explains how to set it up. If it's a newer-model VCR, you are told which buttons to press and in which order.

Read through the instructions first and then try pushing the buttons. Don't worry; you can't break anything if you make a mistake. If something goes wrong, just start over. Or if you're really frustrated, unplug the VCR. That step starts you over from scratch.

Most new VCRs are set up in about the same way. After you've set up one task, the rest is relatively easy. On most VCRs, pressing a Menu button displays on your TV screen a *setup menu* that lists several options. Press the Channel Up and Channel Down buttons to move to the option you want and then press a button labeled Select or Execute. Repeat the process to change other settings in the same way.

Leave the special-features section for now

Don't bother learning everything about your VCR the moment you hook it up and turn it on. All you really have to know is how to play a tape and eject a tape. Everything else can come in time.

For now, ignore any advanced special features, like VCR Plus, instant (one-touch) recording, programming, and similar stuff. These features aren't going anywhere, and you have plenty of time to get to know them in the coming weeks and months.

Don't feel that you have to understand and learn how to use every feature on your VCR. Most people don't bother to learn half of what their VCRs can do, yet they still live full, productive lives.

Having problems? Check the troubleshooting chart

Most of the better VCR manuals have a problem/solution chart. The chart identifies common symptoms and tells you how to go about fixing the problems. Read through this chart if you can't get something on your VCR to work properly.

And check out Chapter 17 for *the* mondo troubleshooting chart of all time. You can use this chart if your VCR manual doesn't have one.

Ignore the VCR specifications

All VCR manuals devote a page or more to *specifications:* technical mumbo jumbo about what the VCR is equipped with. These specifications mean little unless you're hopelessly curious about such things. Plus, they don't help you to learn how to use your VCR.

Leave that stuff for the engineers to browse.

Read the glossary

The better manuals have a glossary of terms, to explain words like *coaxial* and *tracking.* If you're curious, skim the glossary; knowing the lingo can help you understand the manual.

The glossary in the back of this book is probably much more friendly, however; give it a quick flip-through to look up any unfamiliar terms. It might help you understand some of the features and capabilities of your VCR that are mentioned in your VCR's manual.

Keep the manual in a safe place

Keep the manual near the VCR as you are getting used to your new toy. If your VCR doesn't have ventilation slots on the top, set the manual there for the time being.

When you're accustomed to your VCR and no longer have to refer to it quite so often, file away the manual in a safe place.

- ✔ **Good places to put the manual:** The family filing cabinet; underneath the TV; the bottom of your sock drawer.

- ✔ **Bad places to put the manual:** Your two-year-old's bedroom, on top of or underneath the VCR (it can block the ventilation slots), in any box or drawer labeled Miscellaneous.

All VCR manuals come with one or more addresses for sending in the VCR for repair. If nothing else, be sure to keep the manual so that you know where to send your VCR in case it has to be repaired.

Chapter 4

The VCR's Arsenal of Buttons, Knobs, and Lights

In This Chapter

▶ Basic buttons on every VCR

▶ Extra buttons on some VCRs

▶ The jog/shuttle control

▶ A VCR's knob controls

▶ The tracking control

▶ Switches with lights

▶ Switches and connectors on the back of your VCR

▶ A remote control's buttons

*L*ike a spaceship in an old sci-fi movie, the buttons and lights on a VCR can make it look more complex than it really is. On the other extreme, some VCR makers try to streamline their VCRs by hiding the buttons behind panels and doors. But you know that they're there, lurking in the darkness, ready to confuse you. Figures 4-1 and 4-2 show controls of two different VCRs.

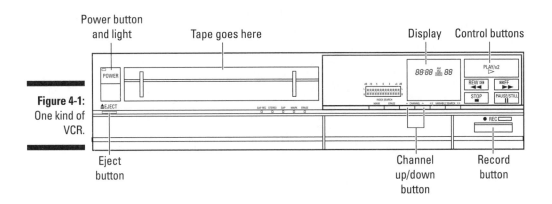

Figure 4-1: One kind of VCR.

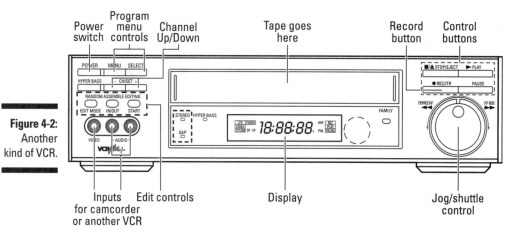

Figure 4-2:
Another
kind of VCR.

Power switch · Program menu controls · Channel Up/Down · Tape goes here · Record button · Control buttons

Inputs for camcorder or another VCR · Edit controls · Display · Jog/shuttle control

Your VCR may have not have *all* the controls and lights mentioned in this chapter — rich people would feel bad if their mega-expensive VCRs didn't have more buttons than do the VCRs most people buy.

Regardless of price, this chapter explains what a VCR's buttons, lights, and knobs are supposed to do and when you're supposed to poke them.

Basic Buttons You May Find

VCRs are controlled by pressing buttons. Just about all VCRs have the main buttons listed in Table 4-1. (Some of the buttons may be located behind a door or panel, so look around if you don't find them at first.)

Table 4-1	Most VCRs Have These Buttons
Button	*VCR Does This When You Poke the Button*
Power	Turns the VCR on and off.
Play	Plays the tape in the VCR.
Fast Forward	If the tape is *stopped*, quickly winds the tape forward; if the tape is *playing*, scans the tape forward while still playing so that you can make commercials run past more quickly. Release this button or press Play to make the tape play at normal speed again.

Button	VCR Does This When You Poke the Button
Rewind	If the tape is *stopped*, winds the tape backward; if the tape is *playing*, scans the tape backward and you see the picture in fast motion. Release this button or press Play to play the tape normally.
Stop	Stops the tape from moving, whether it's playing, moving fast-forward, or rewinding. (Some VCRs make you press the Stop button twice to eject the tape.)
Pause/Still	If your VCR is *recording*, temporarily stops the tape (press Pause/Still or Play to resume recording); if your VCR is *playing*, temporarily stops the tape and displays a still picture (press Play or Pause/Still to resume playback).
Record	Records onto a tape.
Eject	Removes the tape from the VCR. (Pressing the Stop button twice on some VCRs ejects the tape.)
Channel Up	Tunes to the next-higher channel number.
Channel Down	Tunes to the next-lower channel number.
TV/Video	Watches the channel that your television is tuned to receive (TV) or watches the channel that your VCR is tuned to receive (Video).

What? No Fast Forward and Rewind buttons? Then your VCR probably has a jog/shuttle control, a big, round knob that lets you fast-forward and rewind your tapes. See the section "Jogging and Shuttling," a little later in this chapter, for more details.

On some VCRs, you must press the Record and Play buttons *simultaneously* to begin recording. In addition, on some models, just pressing Record activates the VCR's one-touch recording (OTR) timer feature, where you can record for a specified period. The OTR feature goes by different names, such as ITR (instant timer recording) and a bunch of others.

There's no way to know all the possible names given to buttons, knobs, and lights. When in doubt about a button, knob, or light, your VCR's manual might be your only source for an answer.

Extra Buttons

Many VCRs have even *more* buttons that do even *more* special things. Table 4-2 describes some of the buttons sported by some of the fancier VCRs.

Table 4-2	Buttons Found on Some Fancy VCRs
Button	*Does This When You Push It*
Timer	Turns timer mode on. The timer mode can record programs while you're away. If your VCR doesn't have a specific Timer button, it probably has a bunch of buttons for setting on-off times by using a special on-screen display. (Turn your TV on first or else you can't see the display.)
Counter Reset	Resets the tape counter to 0:00:00.
Counter Memory	Sets a special marker at the current spot the tape is playing. The VCR automatically stops at this spot when you rewind the tape. On some VCRs, counter memory simply stops the tape at counter zero during rewind rather than memorizing a specific location on the tape.
Menu	Makes the VCR display a menu of options on your TV screen.
Select	Chooses an option from a menu displayed on your TV screen.
+	Highlights or points to the next selection in an on-screen display menu. (On many VCRs, the + button is shared with the Channel Up button.)
–	Highlights or points to the preceding selection in an on-screen display menu. (On many VCRs, the – button is shared with the Channel Down button.)
Family Message	Records a short message for someone in the family. The family member sees the message when they turn the TV on. (It's kinda dopey.)
Cancel	Cancels a menu option or setting.

Jogging and Shuttling

Many of the fancier VCRs come with a *jog/shuttle control.* It's a round knob about two inches in diameter with a ring around it. The point? By slowly twisting the knob around, you can make subtle adjustments in how fast your tape moves forward or backward.

In fact, you can slow your movies down until you're watching individual pictures pop onto the screen every second or so. Of course, this capability can turn a two-hour feature into a two-day marathon, so somebody has to make lots of extra popcorn.

✔ The jog control has an indent in it so that you can twirl the knob with the tip of your finger. When the tape is playing back in jog mode, spin the knob to advance the tape one picture — one *frame* — at a time. The more you spin the jog control, the more the tape moves. On really nice VCRs, you can spin the knob back and forth and locate a specific frame you want in the tape.

✔ The *shuttle control* is a ring that fits around the jog control. You use the shuttle control to fast-forward and rewind the tape.

✔ Crank the shuttle control all the way clockwise to fast-forward the tape. If you are playing the tape, crank it only partially to watch the tape in fast-forward mode at different speeds. Release the shuttle control, and the tape resumes playing back normally.

✔ Crank the shuttle control all the way counterclockwise to rewind the tape. If you are playing the tape, crank it only partially to watch the tape in rewind mode at different speeds. Release the shuttle control to play the tape normally.

Naughty and Nice Knobs

The latest VCRs don't have many *knobs* — revolving controls that you turn to make them work. In the olden days, VCRs used to have lots of knobs, until engineers began murmuring to production managers and they came to a realization: Knobs are more expensive than buttons.

Most of today's VCRs have only these few knobs:

✔ **Tracking:** Spin this knob to track the tape. Tracking helps the VCR replay the signal on the tape exactly as it was recorded. Tweak the tracking knob when you see heavy white lines at the top or bottom of your screen.

✔ **Phone Level:** Rotate this knob to make the sound through the headphone jack louder or softer. If your VCR doesn't have a headphone jack, it doesn't have a Phone Level knob either.

✔ **Picture sharpness:** Depending on your room lighting — and what you're watching — tweak this knob to make the picture look a little sharper or fuzzier.

✔ **Jog/shuttle control:** Some of the more expensive late-model VCRs come with a jog/shuttle control knob. Described in the preceding section, it allows fine-tuned videotape movements.

Tracking Control: Sometimes a Knob, Sometimes a Button, Sometimes Nothing

When you're playing a tape, a VCR has to follow the same "track" that was made when the tape was originally recorded. If the VCR wanders off this track, heavy white lines pop up along the top and bottom of the picture, and the sound may have an irritating popping noise in it, as shown in Figure 4-3.

Figure 4-3:
Turn the tracking control to fix the ugly lines at the top and/or bottom of the screen.

VCRs made in the 1970s and 1980s came with a manual tracking control, with which you adjusted the tracking if it was off. This control came in two forms: a knob you turned or two buttons you pressed.

If you have a tracking knob, turn it back and forth until the picture looks the best.

If you have tracking buttons, press one or the other until the picture looks the best.

✔ Many VCRs made these days come with *automatic* tracking: You don't have to adjust the tracking yourself because the VCR does it. Finally.

✔ Automatic tracking goofing up? Many VCRs still let you adjust the tracking manually. The ones without a separate Manual Tracking button have other buttons that do double-duty. The usual surrogate tracking buttons are the Channel Up and Channel Down buttons: When the VCR is goofing up its automatic tracking, press the Channel Up or Channel Down button to adjust the tracking manually.

Lights, Lights, and More Lights!

Your VCR uses lights — sometimes called *indicators* — to tell you what it's doing. Sometimes the indicators are small lights that glow (the lights may be red or green, depending on their function); more literate indicators spell out the current function, such as TIMER or VIDEO. Table 4-3 describes some VCR indicators.

Table 4-3	VCR Indicators and What They Mean
Indicator	*What It Means*
Power	The VCR is turned on.
Play	The VCR is playing.
Record	The VCR is recording.
SP	The VCR is playing or recording at SP speed.
LP	The VCR is playing or recording at LP speed.
EP (or SLP)	The VCR is playing or recording at EP/SLP speed.
VIDEO	The VCR is in video mode (press the TV/Video button to change the mode).
TIMER	The VCR is in timer mode (programmed shows will record).
M	The counter memory has been set. The VCR automatically returns to the marked spot when it rewinds the tape.
Stereo	Your VCR is picking up a stereo broadcast.
SAP	Your VCR is picking up a stereo broadcast that contains a second audio channel (usually a foreign language).

✔ Many VCRs also include displays for the current time and channel number and the tape counter.

✔ Sometimes these three functions are combined in one display — you push a button on your VCR or remote control to change the display between the current time, current channel number, and tape counter. This process can be extremely annoying.

✔ The better VCRs display the current time and channel number and the tape counter on separate displays so that you can see them all at the same time.

✔ On many VCRs, the clock/counter/channel number display is dimmed a little when the VCR is turned off. If you want to use your VCR as a clock for your living room or den, you probably should keep the machine turned on so that the clock numbers are bright enough to see, even in daylight.

Extra stuff on really, really old VCRs you probably shouldn't worry about

If your VCR was made in the 1970s or early 1980s, it probably has some extra switches and knobs that confuse even VCR technicians. The most common extra switches and knobs are used to set up the channels you want to watch.

You see, in the olden days, VCRs had channel "presets." You could tune to any TV channel, but you were limited to selecting from only a couple dozen channels at a time. The preset channels were often set by opening a little access door on the top or side of the VCR. Inside the access door was a bank of switches and a bunch of knobs like those shown in the figure. The switches set the

"channel band" (such as 2-13, 14-30, and so on), and the knobs let you fine-tune into each channel.

If you still have one of these older VCRs, you may have to adjust these channel presets every so often to retune the channel. You also have to adjust the presets if you want to watch different channels.

Some older VCRs also used switches to control the tape's recording speed. Set the switch to SP to record at SP speed, for example. Or set the switch to SLP (the original name for EP) to record at the slower SLP/EP speed.

Switches and Other Stuff on the Back of Your VCR

Most VCRs hide a switch or two on their backside.

- ✔ **Channel 3/4 switch:** Lets you set the channel your VCR uses to transmit its signal to your TV. Most people keep the switch set to Channel 3.

- ✔ **TV/Cable switch:** Lets you tell your VCR whether it's receiving channels from an antenna (switch to TV) or from cable (switch to Cable).

- ✔ **TV/IRC/HRC switch:** Sometimes found on older-model VCRs to complicate matters. Set the switch to TV if you get channels from an antenna, or to IRC or HRC, depending on which makes your screen look better.

Buttons on the Remote Control

On the modern VCR, the remote control is your lifeline to the VCR's features. Whereas the VCR has fewer and fewer buttons, remote controls have more. (It costs less to put buttons on a remote control than on a VCR.)

The remote control has all the basic operating buttons that your VCR has, including Play, Stop, Rewind, Fast Forward, and so on. In addition, your remote control is likely to have other buttons that control special features of your VCR.

 Because the remote control contains special buttons not found on your VCR, it is important that you never lose your remote. If your remote becomes lost or damaged, you have to buy a replacement — at considerable cost — in order to access all the features of your VCR. For most VCRs, replacement remotes cost $75 to $100. Keep them away from dogs.

Most remote controls come with these buttons:

Button	What It Does
Program	Lets you program the VCR.
Clock	Lets you set the clock.
A/B	Lets you use one remote to control two VCRs of the same make.
TV/VCR	Lets you control your TV or VCR with your remote.
Skip	Lets you skip commercials when you play tapes; each press lets you skip ahead about 30 seconds.

Useless drivel about why your VCR doesn't have more buttons

VCR makers say that they're putting fewer buttons, knobs, and lights on their VCRs to make them easier to use. Don't believe them. They're just trying to save some cash.

Every added button, knob, or light costs the manufacturer more money. In such a highly competitive business, VCR makers have to be conscious of their costs.

So they remove the manual knobs and replace them with a computerized menu, sort of like the way voice-mail has replaced receptionists at far too many businesses.

To adjust the VCR, you have to turn on the TV, push the VCR's Menu button, and begin weeding your way through the various menu options. In fact, these new menus often make VCRs even *more difficult* to use: They force people to bumble through a lengthy process just to accomplish what used to be done with a flick of a switch.

Multifunction remotes have buttons for controlling TVs, too. You need a TV that's compatible with your remote control (usually the same make as your VCR). You'll find buttons for controlling the power and volume of your TV, for example, and buttons for changing the channels. Sometimes the buttons are separate from the ones used to control your VCR; other times the buttons are shared, and you flick a TV/VCR switch to control either your TV or your VCR.

The 5th Wave — By Rich Tennant

"I asked for a simpler way to set VCRs, but I didn't expect this - a remote control with only one button- ON or OFF!?!"

Chapter 5

Facing the Blinking Clock

● ●

In This Chapter

▶ Why does a VCR have a clock?

▶ Will anything blow up if the clock isn't set?

▶ When do I need to set the clock?

▶ Is accuracy really important in setting the clock?

▶ Can the VCR's manual help set the clock?

▶ How do I set the clock on a VCR?

● ●

Despite what your know-it-all Uncle George says, you *don't* have to set the worst clock to play tapes on your VCR. About the worst thing that happens is that the VCR flashes "12:00" all the time. That's it. Nothing will leak; nothing will smolder.

If you just want to watch videotapes, skip this chapter: The VCR's clock has no bearing on playing tapes. You can still record shows too: Put in a tape and push the Record button.

But if you want your VCR to record shows *automatically,* you have to knuckle down and figure out how to set the blasted clock.

This chapter eases the pain of setting the VCR's clock. Because all VCRs are different, this chapter doesn't give *exact* details for your particular machine; you need your VCR's manual for that. Many VCRs are similar, however, when it comes to setting the clock; this chapter makes setting the clock on your VCR much less stressful.

Why VCRs Have Clocks in the First Place

You've probably wondered: Why the heck does my VCR even have a clock? Does the VCR really care when you watch that tape of *The Sound of Music* your aunt gave you the Christmas before last? Nope. That little ticker's there for two reasons:

First, the clock tells you the current time so that you know when *The Simpsons* is about to begin. It's a bonus for people without a clock in their living room.

Second, the clock tells your *VCR* the current time. Unless your VCR knows the current time, it can't turn on automatically to record *The Simpsons* while you're away on important business trips.

✔ If your VCR doesn't display the time, don't fret. Look for an appropriate button on the remote control (it may be labeled Display or something similar) and press it; the time should appear in the corner of the screen.

✔ The clock on your VCR may serve double — and even triple — service. Press a button on some VCR remote controls and the VCR displays the time. Press the button again and the VCR displays the current TV channel. Press the button one more time and the VCR may display a counter, telling you how many hours, minutes, and seconds have elapsed on the tape you're watching.

What If I Don't Set the Clock?

Programming a VCR — telling it when to turn itself on and tape TV shows automatically — is the only reason VCRs have a clock. That's it. The clock doesn't do anything else.

Even if you don't bother setting your VCR's clock, you can still do the following things:

Play already-recorded tapes. This includes tapes you rent or buy or have previously recorded yourself. You still can pause tapes, scan through them in fast-forward, view them in slow motion, and perform any other tape-viewing tricks your VCR can handle.

Watch TV. Go ahead and channel-surf all you want. Your VCR won't turn on or off at weird hours.

Record tapes manually. See something you want to record? Then press the Record button, and the VCR begins recording it to tape. Press the Stop button, and the VCR stops recording. You have to be present to push the buttons yourself because, without a properly set clock, the VCR doesn't know when to record by itself.

TECHNICAL STUFF

Good excuses to use when you don't set the clock

OK, so you've decided that because you don't use the programming features on your VCR to record shows while you're away, setting the clock simply isn't worth the effort. Fair enough.

But you probably will want some good excuses for why your VCR flashes 12:00 all the time. Here are a few; use them in rotation for maximum effect:

✔ "The power went out during last night's storm, and I haven't had a chance to reset it."

✔ "Oh, that! It's reminding me that I have a luncheon at 12:00 today."

✔ "Jerry moved the VCR from the den to the living room this morning to watch his golf swing."

✔ "The clock on the VCR isn't set? I don't know what you're talking about, Millie; we don't have a VCR."

✔ "The rhythmic flashing of the clock induces delta brain-wave activity, which helps me stay awake through boring shows."

Now, the bad side. If you don't set the clock on the VCR, you can't program the VCR to tape programs while you're away. Programming is covered in more detail in Chapter 7.

When to Set the Clock

Just plugged in your VCR? Then the clock will start blinking. It begins blinking whenever the power goes out in your house, too. That annoying flash is deliberate; it lets you know that technology has let you down once again and that the VCR is displaying the wrong time.

REMEMBER

Setting the clock on your VCR is really no more difficult than setting the clock on your microwave oven or the clock beside your bed.

TIP

✔ Some VCRs begin keeping track of time as soon as they're plugged in — but they still have the wrong time. For example, the VCR displays 12:00 when it's plugged in, but it begins to keep time afterward. The clock still flashes, however, to tell you that the time isn't correct.

TIP

✔ Because your VCR has a clock, it's important that you keep the VCR plugged in all the time. Don't plug your VCR into a wall outlet that is "switched." You flip a switch on the wall to turn the juice on. Switched outlets are great for turning on lamps from across the room, but they're horrible for VCRs.

✔ Many of the latest VCRs come with a battery backup circuit so that the clock remembers the correct time if the power dies for just a few minutes. The backup circuit saves you from having to reset the clock even if a momentary power glitch occurs. These VCRs can remember the time of any program's TV shows, even if the power is off for as long as 10 or 15 minutes. How 'bout that!

✔ Although some VCRs are smart enough to adjust themselves for daylight saving time, most models aren't. If your neck of the woods observes daylight saving time, twice a year you have to reset the clock on your VCR for that, too.

In the spring, spring *ahead* an hour. In the fall, fall *back* an hour. In the summer, there's nothing but reruns.

Does It Matter Whether the Clock Says 4:52 When It's Really 4:53?

VCR clocks are fairly accurate, but after a month or two, the clock may no longer show the exact time. This is normal and is perfectly acceptable. But if the time is more than a couple of minutes off, reset the clock to the exact time.

The more accurate the clock, the more faithful your VCR is when it records TV shows. It's always better for the clock to be a little *fast* than a little slow. That way, the VCR turns itself on and begins recording your shows a little early. If your clock's running *slow,* on the other hand, you miss the first few minutes of your show, which makes *Murder, She Wrote* much less entertaining. Don't let your clock run too fast, though, or your VCR will cut off the end of the program and you'll never know who dunnit.

If you absolutely, positively *must* tape a particular program in its entirety and you don't want to take any chances of missing the first or last minute, you can cover all your bases by programming the VCR to begin recording two or three minutes before the show starts and finish recording two or three minutes after the show ends. You may have to fast-forward through a commercial or two, but you won't miss any of your program.

When you set the VCR clock, make sure that you have the correct time. Call the local time number in case the other clocks in your house are a few minutes off. (Gordon and Andy call 853-1212.)

Finding Help in the Manual for Setting the Clock

Though cryptic, the manual that came with your VCR is often the last line of defense when you're trying to set the blasted clock on your VCR. Most VCRs are pretty straightforward until it comes to setting the clock (that and programming for recording while you're away). You can pretty much ignore everything else in the manual.

Odds are that you will have to consult the manual at least once to set the clock. Find the section in the manual that talks about setting the clock and slip a sticky note on that page for easy reference. Although it may look daunting at first, setting the clock on most VCRs is quite easy.

- ✔ We lied. Setting the clock is agonizingly difficult. But hey, the power of positive thinking and all that stuff.

- ✔ The trick is not to try to see any rhyme or reason in why the VCR manufacturer made it so difficult to set the clock. Some mysteries are better left unsolved.

Don't Lose That Remote!

For years, VCR makers have been putting the clock-setting buttons on the VCR's remote control rather than on the VCR. What does this mean? It means that *you need the remote control in order to set the clock!* If you lose the remote control or the remote control breaks, you're outta luck.

- ✔ If your VCR's remote control becomes damaged or lost, contact the manufacturer for a replacement. Be forewarned: Replacement remotes can be pretty expensive — upward of $75 to $100.

- ✔ Some VCR models also have a Clock button on the VCR. You can use this Clock button in lieu of the Clock button on the remote control.

- ✔ *Universal* remotes — generic replacement remote controls that are preprogrammed to operate a VCR — seldom offer clock-setting functions. No, universal remotes work well for the VCR's basic functions (Play, Stop, Record, and stuff like that), but they come up short for such advanced functions as clock setting.

Common Ways to Set the Clock on a VCR

Utopia is a place where all the VCRs work the same. They all have the same buttons and blinky lights and features and labels and remotes with big buttons.

Alas, they can send men to the moon and invent leaf blowers, but they can't come up with a VCR utopia. Each model of VCR has its own unique buttons, lights, and features and uses its own method for setting the clock. Some of these methods are downright comical and require three hands just to push all the buttons at the same time.

Fortunately, for models made after about 1988 or 1989, VCR makers have followed pretty much the same basic formula for clock setting. The exact details may vary between VCR models, but the general approach is the same.

In the following sections are the two most popular ways VCRs offer to set their clocks (all require the remote control). Find the method that most closely resembles your VCR and give it a whirl.

Even if your VCR doesn't work exactly like the procedure detailed here, it's probably close. If, after reading the following text, you are still having trouble setting the clock, dig out the manual that came with your VCR and look in the beginning sections where it talks about setting up the VCR. That's where the stuff about setting the clock is.

Before you begin

Follow these general steps before setting the clock on your VCR, no matter which method your VCR uses:

1. **Turn your TV on.**

 Many later-model VCRs have *on-screen programming,* which means that when you set up the VCR, words appear on the TV screen to show what you're doing — kind of like a bank's Instant Cash machine. If your VCR lacks on-screen programming, you have to watch the tiny lights on the front of your VCR as you set its clock. Bummer.

2. **Turn your VCR on.**

3. **Press the TV/Video button.**

 Find the TV/Video button or switch on the remote, press it so that the VIDEO light on the VCR comes on, and make sure that your TV is dialed to Channel 3 or 4 so that it's receiving the picture from the VCR. (This step isn't necessary if your VCR lacks on-screen programming.)

Now check your remote control. If it has a button with the word *Clock* on it, head for the very next section. If it has a button marked Menu, head for the section immediately following that one. I think I can, I think I can, I think I can. . .

If your remote has a Clock button

Look at the remote control for your VCR. Look at it closely. Does it have a Clock button? If so, follow these steps:

1. Press the Clock button on the remote control.

If your VCR has *on-screen programming* — the VCR puts words on the screen — the clock-setting screen should pop up. This may appear as lettering on a blue or black background, or the clock's time may simply pop up on top of your current TV show.

The clock time is often displayed by showing both the time *and* the date (or at least the day of the week). You have to set the time *and* the date to take advantage of all your VCR's fancy programming features.

2. Press the Up/Down buttons and adjust the first setting.

Here's the first tricky part: VCRs vary widely in how they label the buttons used to change the numbers while setting the digital clock. On some VCRs, the buttons are labeled with a plus (+) or minus (-) sign. (Many VCRs use these same buttons for changing channels.) Other remote controls use buttons with up and down arrows on them.

Found the right buttons? Then look for a flashing spot on the TV screen. Only a portion of the time or the date will be flashing. The hour portion of the time will flash, for example, and the rest of the time and date will appear normal. The flashing portion is the *cursor,* and it marks the area you'll change.

When you've found the buttons and the cursor, press the buttons to *increase* or *decrease* the flashing number. Pressing the + (or up-arrow) button, for example, changes the current time from 12 p.m. to 1 p.m. Press it again and the time shows 2 p.m., and so on.

When you've pressed the button enough times for the number to look right on the screen, move to step 3.

3. Locate on the remote control a button labeled Enter, and press it.

Pressing Enter tells the VCR that you've finished entering that number and are ready to tackle the next. If the hour portion is flashing, for example — and you've just set the hour to the right time — press Enter to make the minute portion begin flashing instead.

Some VCR remotes don't have an Enter button. Instead, look for a single button marked Select or Execute, or perhaps a pair of buttons, one with a right arrow and the other with a left arrow. Press the appropriate button to move the flashing number to the next area you want to change.

If you press a button too much and pass up what you were aiming at, don't give up. Just keep pressing the button. Most of the buttons keep the action moving in a big loop. If you missed a spot, it eventually cycles through and gives you another chance.

4. **Press the Up/Down buttons to change the next setting.**

Keep pressing the Up/Down buttons until the next setting is correct, whether you're changing the minutes, hours, or date.

Some VCRs work like a calculator: You can enter the time by pressing the number buttons on the remote control. To set the time to 36 minutes, for example, you press 3 and then 6.

5. **Repeat Steps 3 and 4 to set the remainder of the time as well as the date.**

When you're setting the time, remember to set the hour and the minute as well as a.m. or p.m. On some VCRs, the a.m./p.m. setting is separate. On others, you set the hour to indicate whether it's a.m. or p.m. If the time says 1 a.m. and it's 1 *p.m.*, keep pressing the + button until 1 p.m. rolls around.

When you're setting the date, you might have to set the month, day, and year. Other VCR models want to know only the day of the week — Sunday, Monday, Tuesday, and so on.

6. **Press Clock when you're finished.**

Done? Then press the Clock button to tell the VCR that you've finished entering the time. The VCR should begin displaying the time you just set — and the numbers should stop flashing. Are the time and date correct? Hurrah! If they're not, however, head back to Step 1. You have to press that Clock button again and give it another go.

When you set the clock, press the Enter (or Select) button to skip past any part of the time and date that's already correct. You have to change only the part of the time and date that isn't set right.

If your remote has a Menu button

Some VCR remote controls don't have a separate button marked Clock for setting the clock. For these, the clock is part of the overall settings on the VCR. These sophisticated VCRs usually have a button labeled *Menu* (see Figure 5-1). Press the Menu button, and the VCR puts a laundry list of options on the TV screen for you to ponder. Choose the Set Clock option, and away you go. (Oh, this Menu button stuff is known as *on-screen programming.* You paid extra for it.)

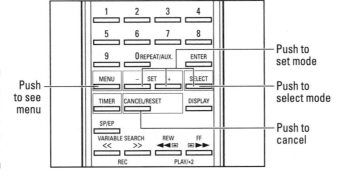

Figure 5-1:
The menu
button on a
VCR remote
control.

Push
to see
menu

Push to
set mode

Push to
select mode

Push to
cancel

1. **Press the Menu button on the remote control.**

 If your VCR has on-screen programming, the initial menu screen should appear. Don't see a Clock Set menu? Then keep pressing the Menu button until the Clock Set menu appears. (Some VCRs make you display an Initial Set menu in order to set the clock.) Is the Clock Set area on the screen? Good; head to step 2.

2. **Press the Select or Execute button.**

 The Select button lets you select the portion of the time and date you want to set. For example, you can press the Select button until the hour flashes.

 When you're setting the clock, press the Select button to skip past any part of the time and date that's correct. You have to change only the part of the time and date that is not properly set.

3. **Press the Up/Down buttons to reach the correct setting.**

 VCRs differ in how they label the buttons used for adjusting numbers in setting the clock. Some put a plus (+) and minus (-) sign on their buttons; others use up and down arrows. Still others make you press the channel-changing buttons. Although you might have to experiment a little, press the Up or Down-arrow button until the correct setting appears.

4. **Repeat steps 2 and 3 to set the remainder of the time as well as the date.**

 Be sure to set the hour and the minute in addition to whether it's currently a.m. or p.m. Some VCRs make you set the a.m./p.m. stuff separately; others automatically lump the a.m./p.m. stuff with the hour setting.

 Some VCRs make you set the month, day, and year; be sure to set them all or the VCR will still be confused. Other VCRs want to know only the day of the week — Sunday, Monday, Tuesday, and so on.

5. **Press Menu when you are finished.**

When the clock is set, press the Menu button until the boring setup stuff disappears from your TV screen and the regularly scheduled programming resumes.

The remote controls on the latest Panasonic VCRs have a nifty little thumbwheel you twirl to set the clock. The wheel takes the place of the + and - buttons as well as the Select button. Twirl the wheel to select the portion of the time and date you want to set and then click down on the wheel to select it. Turn the wheel again until the screen displays the right time; then click the wheel to move on. After turning and clicking a few times, you're through.

But my VCR doesn't use the remote to set the clock

Older VCRs don't use the remote control to set the clock. Depending on the model, separate buttons on the VCR, like those shown in Figure 5-2, are used to set the clock and the day of the week. The exact steps with your VCR may vary, but the general procedure works like this:

Push to set clock

Figure 5-2:
The VCR
buttons
used to set
a clock.

CLOCK	SET	ENTER

| BAND | ∨ TUNING ∧ | | SKIP | AFT |

1. **Press and hold down the Clock Set button.**

2. **Look at the flashing indicator lights on the VCR.**

 The light that's flashing tells you which part of the time and date you have to set next. If the Hour light flashes, for example, you have to punch in the correct hour.

3. **Keep pressing the buttons, as indicated by the flashing lights, to set the time.**

On most VCRs, you must specify the following:

 ✔ Day of the week

 ✔ a.m. or p.m.

 ✔ Hour

 ✔ Minutes

If you skip any of these, the frustrated VCR will refuse to reset the clock, and you'll have to start all over again.

Write Down How to Set the Clock

Hopefully, you won't have to set the clock on your VCR very often — at most, twice a year when you fall back or spring ahead for daylight saving time.

Few people can set the clocks on their VCRs. An even smaller number of people can *remember* how to set their VCR's clock, even after figuring it out for the first time.

So when you figure out which buttons to push in what order, write them down in the following handy chart:

How to set the clock on my VCR	
Steps	*Comments*
1. _____	_____
2. _____	_____
3. _____	_____
4. _____	_____
5. _____	_____
6. _____	_____
7. _____	_____
8. _____	_____

 If your VCR's clock-setting instructions are short, write them on a 3 x 5 index card and tape the card to the side of the VCR (but don't cover up any ventilation slots!). Chances are that the card will be easier to find than this book when your VCR's clock begins flashing at you again.

When All Else Fails

OK, so you tried your best to set the clock. You've looked over the manual and read the example how-to's in this chapter, and still your lousy VCR refuses to cooperate. Don't fret! You can conquer your VCR yet with the Handy-Dandy Faux O'Clock, included with this book.

The Faux O'Clock is on the Cheat Sheet at the front of this book. The Faux O'Clock has a permanent 4:00 printed on it.

To use the Faux O'Clock, do the following:

1. **Cut out the Faux O'Clock from the Cheat Sheet.**

 Go slowly. It's the only one you get (unless you want to buy another copy of this book, in which case, that's OK with us).

2. **Find some transparent tape and pull off an inch or two.**

 We like the tape with the green plaid wrapper.

3. **With the sticky part facing out, wrap the tape around the barrel of a pencil.**

 Wrap loosely, and let the tape stick to itself.

4. **Apply the tape to the left end of the back side of the Faux O'Clock.**

 With the tape wrapped completely around the pencil, gently slip it off the pencil and stick it to the left, back side of the Faux O'Clock.

5. **Repeat steps 2 and 3.**

 This step creates another piece of tape, ready to be applied to the other side of the Faux O'Clock.

6. **Apply the tape to the right end of the back side of the Faux O'Clock.**

 You're really getting good at this, but it's time to move on to bigger and better things.

7. **Carefully position the Faux O'Clock over the itinerant clock on your VCR.**

 Press firmly but carefully. Congratulations! You've installed the Faux O'Clock on your VCR.

Sony's answer to setting VCR clocks: You don't!

The latest VCRs from Sony — and no doubt other manufacturers in the near future — can set their own clocks *automatically*. The VCR ferrets out the current time and date from a special spot among the airwaves.

In addition to sending sitcoms and soaps, some TV stations are now sending the time and date, hiding the information in a special portion of the transmission. (Technically speaking, and that's why we're hiding in this little box, the special portion is known as the *vertical blanking interval,* or *VBI*).

The Sony VCRs check up on the current time and date every time they're turned on and use the information to set their own clocks. Not all TV channels provide the time and date, but many public-broadcasting stations do. If the VCR can't find the time and date on one channel, it can search through the other available channels until it finds one.

If no stations in your area are broadcasting the time and date, however, grab that remote control: You have to set the clock manually.

Part II
Making the VCR Do Something

By Rich Tennant

"Oh sure, it'll float alright, but plugging in the VCR's gonna be a killer."

In this part...

You don't have to make friends with your VCR. No, a simple cause-effect relationship is fine: When *you* do this, the VCR agrees to *do* this.

This part of the book spells out what you have to do before your VCR jumps to action. It covers how to record and play back tapes — even when you're not there to push the buttons. It covers that new VCR Plus gadget that makes VCR programming as easy (and fun) as a bank's 24-hour teller machine.

Finally, this is the part of the book you're looking for if that rental cassette just fell apart and your VCR is drooling shiny, black videotape. (Videotape reconstruction techniques are in Chapter 10.)

Chapter 6
Taping and Watching Programs

In This Chapter

▶ Using your VCR to play tapes

▶ Using buttons other than Play

▶ Finding hidden buttons on a VCR

▶ Skimming quickly through tapes

▶ Pausing a tape

▶ Recording programs

▶ Watching and recording the same show

▶ Watching one show while taping another

*P*laying a tape on a VCR is easy enough; you have to know only two things: which way the tape goes into the VCR and which button is Play.

But which buttons will fast-forward through a tape when you're trying to wade through boring parts or commercials? Which buttons will stop the action when you need more popcorn? What if you can't find *any* buttons on your VCR? And what if you want to perform one of the ultimate VCR tricks: recording one TV show while watching a different one?

This chapter tackles these questions and more.

Yeah, But I Just Want to Play Tapes!

The fundamental use of a VCR is playing tapes. More than 90 percent of the time, that's what you use your VCR for, so it makes sense to cover the ins and outs of tape-playing first. We get to the recording part later.

Putting the tape into the VCR

This one's easy: Just point the tape so that the spine label faces you and the little clear plastic window is on top. Aim the tape for the slot in the front of the VCR and push it in. Assuming that everything is working correctly, the VCR will suck in the tape and make all sorts of scary clicking and whirring noises. So far, so good.

- ✔ **The tape loads from the top on my VCR.** Older VCRs use a top-loading mechanism; the tape goes into this funny-looking elevator thing, and the elevator gets pressed down to load the tape into the VCR. The VCRs look cool, but they are hard to reach inside small shelves. Today, all new VCRs are front-loading; you insert the tape into a slot in the front of the machine.

- ✔ **I can't find the slot to insert the tape.** Some VCR makers put little doors over the slot to make their machines look pretty. You have to slide the door down or out of the way to reveal the slot inside.

- ✔ **Oops! There's already a tape in the VCR.** You have to eject the first tape before you can insert the other one. Press the button labeled Eject on the VCR. If it has no Eject button, try pressing the Stop button a couple of times.

- ✔ **The tape is too small for the slot**. The tape is probably for a Beta VCR, a format rarely encountered today (it was used ten years ago). You need a Beta VCR in order to watch the tape; try the electronics aisle at the Goodwill store.

- ✔ **The tape is really too small for the slot.** You're trying to put your old 8-track of the Moody Blues into your VCR, maybe?

- ✔ **The tape doesn't go in, or the VCR keeps spitting it back out.** Make sure that you are inserting the tape properly. If the problem still persists, something may be wrong with the tape or your VCR. Try a different tape. Still happens? Time to service your VCR.

Playing the tape

Got the tape inside the VCR? Then press the button marked Play, and the VCR will begin playing your tape.

Before you can see a tape, your TV must be tuned to either Channel 3 or 4, depending on how your VCR was set up. Don't know which channel to try? Then try both, flipping first to one and then the other. The picture will appear clearly on one of the channels.

In an effort to make VCRs more "international," VCR makers often use symbols rather than words for the buttons. The Play button is marked with a right arrow. Other commonly used symbols are shown in Figure 6-1.

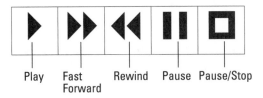

Figure 6-1:
Commonly
used symbols
on VCR
buttons.

Play Fast Rewind Pause Pause/Stop
 Forward

The other buttons

Get to know the other buttons on your VCR. These buttons are first described
in Chapter 4, but here's a rundown of the most important ones you use when
you play tapes:

- **Stop:** Press to stop playing, either because you've finished watching the
 movie or you've grown tired of it.

- **Rewind:** Finished with the tape? Press Stop and then press this button
 once to rewind the tape back to the beginning.

 Can't believe what you just saw? Then press the Rewind button to back up
 the tape a little. Press Play and you can watch the scene again.

- **Fast Forward:** Press to skip past a part of the tape you don't want to see
 (such as commercials or the chest-bursting scene in the movie *Alien*).

- **Pause or Still:** Press to momentarily pause the tape for a minute or so. To
 start things rolling again, press Play.

- **Eject:** Press to make the VCR spit out the tape. No Eject button on your
 VCR? Then try pressing the Stop button twice. (On many of the newer
 machines, the Stop button serves double duty: Press once to stop; twice
 to eject.)

Does your VCR have a big wheel on it rather than Fast Forward and Rewind
buttons? If so, your VCR is equipped with a shuttle knob for fast-forwarding and
rewinding tapes. Turn the knob clockwise to fast-forward; turn it counterclock-
wise to rewind. Some shuttle knobs are touch-sensitive: The farther you turn
the knob, the faster the VCR moves the tape.

My VCR doesn't have control buttons on it!

Yes, it does. Your narcissistic VCR considers buttons to be unsightly, so it
covers them up with a "vanity" panel. Look for a hinged panel around the
bottom edge of the front of the VCR. Pop open the panel, and you should find
the control buttons lurking inside.

There's no law that makes you keep the vanity panel closed while playing tapes. If you think that the panel's a nuisance, leave it open.

Using the remote control rather than the buttons on the VCR

Almost every VCR's remote control has the important Play, Stop, Rewind, Fast Forward, and Pause/Still buttons; most remotes don't have an Eject button, however. Still, feel free to use the buttons on the remote: They do *exactly* the same thing as the buttons on the VCR do.

Even though the VCR may have its own set of buttons, most people prefer the buttons on the remote instead. In fact, they even spend several minutes hunting down the remote just so that they can push its Play button. It's a quirk of human nature, and nobody can adequately explain it.

Scanning through the Tape

Want to get to the good parts of the tape fast? Then you'll want to fast-forward through the tape while it's playing on the TV screen. This feature goes by different names, but it is often referred to as *fast-scanning* or *picture search.*

You simply use your Fast Forward or Rewind buttons, but there's a catch: Push the Play button first so that the tape begins playing. Then press the Fast Forward and Rewind buttons to speed up the action on the screen, going either forward or in reverse.

- To scan forward, press the Fast Forward button while the tape is playing.

- To scan backward, press the Rewind button while the tape is playing.

- Found the right spot on the tape? Then quickly press the Play button, and the VCR will begin playing the tape at normal speed.

- On most VCRs, press and release the Fast Forward or Rewind button to fast-scan at the fastest possible speed. Press and *hold* down the Fast Forward or Rewind button to fast-scan at a slower speed.

- If you're in a hurry to fast-forward or rewind a tape, don't scan through it. Your VCR winds tape much more quickly when it's not simultaneously showing you the action on the screen.

- Don't use the fast-scan feature to rewind or fast-forward all the way to the beginning or end of the tape. When the tape clunks to an unexpected halt, the tension adds a great deal of wear to the tape and the VCR.

Pausing a Tape

You're watching *Star Trek II* and Ricardo Montalban is about to get fried by the Genesis device. But you gotta hit the rest room or you'll explode before Ricardo does. The solution: Press the Pause/Still button. The VCR remains in play mode, but playback is momentarily paused for you to conduct your business. When you return, just tap the Play button and the movie resumes.

On most VCRs, when you press the Pause/Still button, the picture freezes, and the word PAUSE appears on the screen.

Don't leave your VCR in pause mode for more than a few minutes — five is the tops. The reason? Inside the VCR is a set of wildly spinning magnetic heads. That's the whirring you hear when you play a tape. When a tape is paused, these heads spin over the same portion of tape again and again. Sooner or later, the heads just dig a rut into the tape and ruin it.

Most VCRs automatically prevent Pause damage by kicking themselves out of pause mode after five minutes or so. But there's no reason for you to contribute to the premature aging of your tapes. If you think that you'll be away for more than a couple of minutes, stop the tape rather than pause it.

Ugly explanations for ugly lines appearing on paused tapes

When you pause a tape, you may see annoying lines at the top or bottom of the screen. These lines are called *noise bars,* and there's no avoiding them on some VCRs. The better the VCR, the cleaner the screen appears.

Noise bars are caused when the video heads inside the VCR can't trace the same path used to record the signal on the tape. Better-quality VCRs, like those with four or six video heads rather than two, have special video heads and circuitry to minimize or eliminate noise bars.

If you press the Pause/Still button to better analyze a picture — a once-in-a-lifetime football pass, for example — and the noise bars show up, try adjusting the tracking control on the VCR. The *tracking control* helps your VCR zero in on the signal recorded on the tape, often minimizing any noise bars in the process.

Even if your VCR doesn't have a control labeled tracking, it still probably has a way to adjust the tracking. On many VCRs, during tape playback you press the Channel Up and Channel Down buttons to adjust the tracking. Check the manual that came with your VCR for exact instructions.

On some VCRs — and when playing tapes recorded at certain speeds — pressing the Pause/Still button may blank out the screen. The word PAUSE appears to let you know that the VCR is in Pause mode, not just turned off.

When some VCRs are paused, they put ugly lines across the picture, often covering up the part of the picture you're trying to examine more closely. To make the lines move to a different part of the screen, try pushing the Pause button again.

When to Press Stop

Brace yourself for a quick, time-saving VCR trick: You don't *have* to press the Stop button when you go from one mode of your VCR to the other.

For example, if you're fast-forwarding a tape and suddenly want to watch it, you don't have to press Stop before pressing Play. Simply press Play while the VCR is still fast-forwarding. Your clever VCR knows what you want to do and immediately shifts from fast-forward mode to play mode. The same concept applies to rewinding a tape.

✔ If your VCR is an ancient model, with mechanical "piano key" controls that make clunky clicking sounds when you press them, you have to press Stop before you can press Play.

✔ If you're playing a tape and want to fast-forward it, pressing Fast Forward doesn't put the VCR into fast-forward mode. Sure, it fast-forwards the tape. But it speeds up the action on the screen too, letting you eyeball the action as you fast-forward. This subject is covered earlier in this chapter, in the section "Scanning Through the Tape."

Recording Something of Your Own

It's bound to happen. You've watched the 1,500 movies at the local video store. You want to make your own tapes of shows you see on TV. It's easy. It's often easier, in fact, than deciding what to rent. Just follow these steps:

1. Get a tape you can record on.

The video store will not be pleased with you if use its only copy of *Goldfinger* to tape David Letterman. New blank videotapes cost about $2.50 each in quantities of five or ten. Don't know which type of tape you need? Tiptoe ahead to Chapter 10.

2. Make sure that the tape's record tab hasn't been removed.

If you're using one of your own tapes (and you're sure that it doesn't have anything worth keeping on it), make sure that it still has its record tab. The *record tab,* described in Chapter 10, is a little plastic thingie on the spine — the label — of the videocassette. Hold the cassette so that the spine faces you and the little window faces up: The record tab is on the left. If the tab is gone, there is just a square hole there. Unless you cover this hole with some masking tape, you can't use this cassette for recording.

3. Insert the tape and set up for recording.

Insert the tape you want to use for recording in the VCR. Then, if you're not on cable, use the Channel Up and Channel Down buttons to tune to the channel you want to watch.

If you *are* on cable, turn the VCR to Channel 3 or 4 and use the cable box to tune to the channel you want to watch.

4. On the VCR, press the Record button to begin recording.

When the show you want to record appears on the TV, press the Record button. The VCR should show you that it's recording by pasting a REC or RECORDING message on the screen. (This message doesn't get recorded; you just see it on your TV.)

Some VCRs make you press the Record and Play buttons *simultaneously* to begin recording. By making you press the two buttons at the same time, the wary VCR makes it less likely that you'll accidentally record over a tape you meant to keep.

Watching and taping the same TV show or movie

It's pretty easy to tape a TV show or movie while you're watching it. Just press the remote control's TV/VIDEO switch so that the VCR indicates VIDEO.

Now dial your TV to Channel 3 or 4. What you see is the same picture the VCR will record. When the show begins, tell the VCR to begin recording. That's it.

(If you're confused about this Channel 3 or 4 stuff, turn to Chapter 3. You have to choose one of those two channels when you first install your VCR.)

Watching and taping two different shows simultaneously

Don't have a cable box? Then you can watch one program while recording a completely different one in the background. Yep — you can watch two shows, even if they're airing at the same time. Here's how you do it:

1. **Dial the channel you want to record on the VCR.**

 Tune your VCR to the channel you want to record; the channel should appear on your TV screen.

2. **Begin recording.**

 When the coveted show starts, tell your VCR to begin recording. Never recorded anything before? A complete explanation of recording appears earlier in this chapter.

3. **Press the TV/VIDEO switch on the VCR so that the VCR indicates TV.**

 Now that your VCR is recording, pressing the TV/VIDEO switch turns the TV's attention to itself. Meanwhile, the VCR continues to record your show in the background.

4. **Dial the channel you want to watch on the TV.**

Now settle back and watch the other show live on your TV. When the show's over — and if your VCR is finished taping your other show — go ahead and watch the show you just recorded.

See, both the VCR and the TV have built-in tuners for pulling in stations from the airwaves. So you're just telling the VCR to pull in one station while the TV pulls in another. Simple — just like the best things in life.

Help! I have a cable box

Bad news, cable fans. If your cable system makes you dial the channel you want to watch on a *cable box,* you can't record and view two different shows at the same time using the setups in this chapter.

To record a show while watching it, however, dial the VCR to Channel 3 or 4, and then use the cable box to tune to the channel you want to watch.

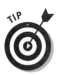
If you're the courageous type (or just plain sneaky) and don't mind fiddling with the wires behind your TV and VCR, you may be able to arrange your home video setup so that you can watch and record different shows, even if you are on cable. Read Chapter 11 for a rundown on other ways you can wire up your TV and VCR.

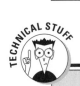

Can I legally tape programs I receive through my VCR?

Making a photocopy of a book or an entire magazine constitutes copyright infringement. The folks who publish the book or magazine want you to buy an extra copy rather than make one of your own with the office copying machine. When you buy an official copy, the publisher (and, hopefully, the starving authors) receive a royalty for the work they did.

Do the same rules apply to programs you tune in to with your antenna or cable box? The Supreme Court says no. As long as you make a copy of TV shows for your own personal use and don't try to sell or give them away to others, you are free to copy anything you want.

The Supreme Court made this landmark decision in the now infamous "Betamax case." This case was brought before the Court by Universal Stu-

dios and Disney Studios, against Sony, maker of the Beta format VCR (along with some poor sap who just happened to have bought a Beta VCR). Universal and Disney wanted to restrict copying of programs beamed over the air because they considered home taping on VCRs to be detrimental to their royalty earnings.

Though Sony lost some of its earlier court battles in its fight against the Hollywood movie studios, it won at the Supreme Court. Sony's win is also *your* win. It means that you can tape your favorite TV shows without worrying about breaking the law. Just be sure that you don't try to profit (for money or otherwise) from the tapes you record.

The Supreme Court specifically did not include making copies of tapes you rent or buy as part of its decision. That's still illegal.

Making the VCR Shut Off Automatically after Recording

When you press the Record button on your VCR, the VCR records to the end of the tape or until you press the Stop button. But suppose that you want it to record for only a half-hour, to catch just *Married with Children*. You have to pick up some more laundry detergent halfway through the show, so you can't be there to press the Stop button.

The solution? Use the *one-touch recording* (OTR) timer feature on your VCR. (Not all VCRs have a one-touch recording timer feature, but most of the newer models do.)

1. Press the Record button once (and Play, if necessary).

The VCR begins recording normally. (If you chicken out, just press Stop to stop recording.)

2. Press the Record button again.

The VCR will go into one-touch recording (OTR) timer mode. The VCR or on-screen display will say "0:30," meaning that the VCR will record for 30 minutes and then shut off. Some VCRs record in 15-minute chunks when you press the button, instead of 30.

3. Press the Record button yet again.

The VCR will tack on another 30 minutes to the record time and display "1:00," meaning that it will now record for an hour before shutting off.

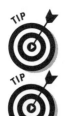

 ✔ Each press of the Record button adds another half-hour of time to the OTR timer.

 ✔ Whoops — went too far? If you accidentally set it for too much time, keep pressing the OTR button until the indicator reads 0:00 and then start over again.

The OTR feature on your VCR may be called ITR, for *instant timer recording.* OTR, ITR — it's all the same thing. And some VCRs confuse the issue even more by calling the feature *Quick Timer.*

Taping Programs While You're Away

You can't get out of it: You've been invited to your annoying brother-in-law's for dinner, and you're going to miss your favorite rerun of *The Invaders* (you know, the one where someone finally believes David Vincent's claim that there *are* aliens on Earth). Even though you can't be home to watch the program, your VCR can. It's only natural for it to record the program while you're away.

Telling your VCR to record programs in your absence is heavy stuff. We've saved the nitty-gritty details of VCR programming for Chapter 7, but here's the general gist:

1. Put a tape into the VCR.

2. Tell the VCR when to begin recording.

3. Tell the VCR when to stop recording.

4. Tell the VCR which channel to record.

If you have a cable box, tune the channel you want to record ahead of time on the box and tell the VCR to pick up the program on Channel 3 or 4.

5. Hit the Timer button and turn *off* the VCR.

6. Pray that you got everything right.

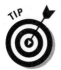

The faint of heart swear by a contraption called VCR Plus for recording programs automatically. Just look in *TV Guide* for the VCR Plus number next to the show you want, and punch that number into the VCR Plus controller. The rest is done for you. Chapter 8 has much more information about using a VCR Plus.

Setting the Recording Speed

Most VCRs let you choose between several different speeds when you record a show. Why bother? Well, some people want to stuff a *bunch* of shows onto a single tape. The slower the tape spins, the longer it lasts. Unfortunately, slowly spinning tapes make the picture look pretty awful too.

Most VCRs allow three different speeds:

SP — Standard Play: You can record for two hours with a regular T-120 tape. Use this speed for best quality. If you don't mess with the VCR's speed controls, the VCR chooses this setting automatically.

LP — Long Play: You can record for four hours with a regular T-120 tape. The picture quality suffers, however.

EP — Extended Play (also called SLP, for Super Long Play): You can record for six hours with a regular T-120 tape. Use this speed only if you're cheap and want to pack lots of recorded programs on one tape.

 ✔ Not all VCRs can record at LP speed. Some can only *play back* tapes recorded at LP speed.

 ✔ Tapes come in different lengths. The T-120 length is the most common; the "120" means 120 minutes, or two hours — the length of tape available when you record at SP speed.

 ✔ A less common tape available at some stores is the T-160, which lets you record for 160 minutes (two hours and 40 minutes) at SP speed. Avoid using T-160 tape unless you're desperate. T-160 tape is thinner than T-120 tape and doesn't last as long.

 ✔ To set the tape speed, find the speed button on the VCR's remote control. On most remote controls, the thing is labeled Speed or SP/EP. Press the button to change the speed; an indicator light on the VCR tells you the current recording speed.

 ✔ Good news: Your VCR automatically chooses the right speed to play back a tape. You can even mix recording speeds on a single tape: one show at SP, another at EP, whatever. Your VCR will figure out what's what, and compensate.

The 5th Wave By Rich Tennant

"Excuse me. I don't mean to dominate the group, but I recently learned how to record on one channel while viewing a different channel."

Chapter 7

Programming Your VCR
(Oh, No!)

. .

In This Chapter

▶ Ways to avoid programming a VCR

▶ Why programming sounds harder than it really is

▶ A sample guide to programming a VCR

▶ Canceling a programmed event

▶ Programming a VCR that lacks on-screen programming

▶ Understanding a VCR's manual

. .

*I*f you dream at night about being locked in an iron maiden during the Spanish Inquisition, count yourself among the lucky ones. Some people dream about having to program their VCR so that it will record reruns of *Doogie Howser, M.D.* while they're away at work.

Although programming a VCR can give perfectly normal people anxiety attacks, there's no need to duck for cover whenever the subject comes up. Programming a VCR is only a little more difficult, in fact, than setting a digital wristwatch.

This chapter explains how to program VCRs. All VCRs are programmed in different ways, of course, so you won't find step-by-step instructions. But you'll find enough information to make that VCR record *Doogie Howser, M.D.* whenever you need it.

How to Avoid Programming a VCR

Programming a VCR simply means telling it to record a program while you're away. You tell the VCR which particular channel to tape and at what time — because you can't be there to start and stop the recording yourself.

You can avoid programming your VCR, however, if you meet the following conditions:

✔ You never record programs. There's no need to even bother with the programming feature of your VCR if you use your VCR only to play back tapes. Skip this chapter.

✔ You're at home to start and stop the recording. It's usually easier to just manually control the recording of a VCR if you're at home to do it. Just press Record when the show starts, and the VCR begins recording; press Stop to stop it when the show's over.

✔ You're at home to *start* the recording. Suppose that you're planning to go to the movies and you want to leave right after your favorite show begins. Start recording when the show begins by pressing the Record button. Then just let the VCR run until the tape ends. You may record other shows that come on afterward, but who cares?

✔ You're at home to start the recording, but you want to record for only a certain amount of time. Again, you can start recording when the show begins. Use your VCR's one-touch recording feature, or OTR (also called instant timer recording, or ITR, or a bunch of other things) to specify how long you want to record. On most VCRs, every time you press the OTR button, you add 30 minutes to the recording time.

✔ You have VCR Plus. The VCR Plus controller, described in Chapter 8, substitutes for the programming feature of your VCR. With VCR Plus, you just punch in the string of numbers listed next to the show in your television guide, and the VCR Plus controller handles the rest automatically.

Programming Isn't As Difficult As It Looks — Usually

Programming is a bad word. It conjures up images of blank-eyed nerds hunched around a computer screen, pecking on a keyboard. VCR programming is nothing like that. Programming a VCR is limited to telling the machine three things: which channel to record, when to begin recording, and when to stop recording. That's it; nothing more. No pocket protectors or snack foods.

 Before you can program a VCR, you *must* — emphasis on *must* — set the VCR's clock. If you don't set the clock, the VCR doesn't know the current time, so it doesn't know when to turn recording on and off. See Chapter 5 if you haven't yet set the clock on your VCR.

Programming Your VCR

Most VCRs these days use the remote control for programming. So get to know the remote control and its programming buttons. Figures 7-1 and 7-2 show two typical remote controls, with the important programming and operation controls identified. VCR remote controls can have lots of buttons. Using the control is fairly easy though, once you learn what the buttons do.

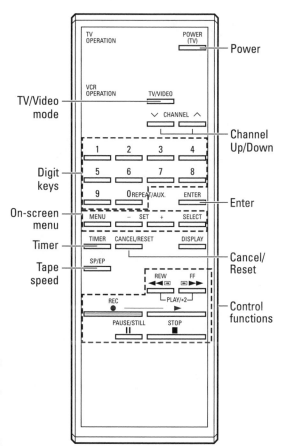

Figure 7-1:
One type of remote control.

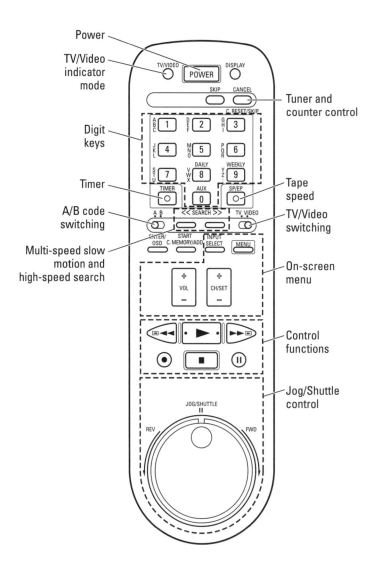

Figure 7-2:
Another type of remote control.

The trend these days is toward less complex-looking remote controls. Your VCR's remote control may be different than the ones in the figures, but most of the buttons should be the same.

The entire process, after you learn how to do it, takes about 30 seconds per show. Here's a more complete rundown of what's involved in programming the average VCR:

1. Find the program menu (usually the hardest part of the whole process).

Most VCRs made these days have on-screen programming, meaning that you see a menu of programming options on your TV screen.

2. Specify the starting date and time.

Most VCRs let you program them a week in advance — sometimes more — so you have to specify the date (or more commonly, the day of the week) in addition to the time of day.

3. Specify the ending date and time.

For some reason, almost all VCR menus require you to tell them a specific date and time for stopping recording; they don't just let you specify "record for 30 minutes" or "record for 60 minutes." If any VCR manufacturers are reading this, hey, add this feature, will ya?

4. Specify the channel to record.

For example, tell it to record Channel 3 (to pick up whatever the cable box is dialed to, for example) or Channel 6 or Channel 15 or whatever channel you're after.

5. Specify the recording speed.

Although most VCRs automatically choose a recording speed, they also let you choose a recording speed for each program. Depending on your model of VCR, your choices are SP, LP (not offered on all VCRs, such as those made by JVC), and EP (otherwise known as SLP). Choose *SP* if you don't want to turn to Chapter 2 to look up what the other options mean.

Most VCRs made since the mid-1980s rely heavily on their remote controls for the programming functions. To save money, VCR makers don't often duplicate the buttons for programming on the VCR; the buttons are only on the remote. So don't lose that remote, or else you can't program your VCR.

Programming a VCR: A Sample Guide

Like we said at the beginning of this chapter, all VCRs work a little differently. There's no single way to program all VCRs. So here's an example of programming a VCR, along with differences you may encounter when you program your machine.

All the steps in this section assume that your VCR has the *on-screen programming* feature — it displays a menu on your TV screen during the programming process, similar to the one shown in Figure 7-3. This chapter also assumes that you've turned your TV set on so that you can see those on-screen cues. Don't have on-screen programming? Then see the section "I Don't Have On-Screen Programming" later in this chapter, for additional help.

Figure 7-3:
To program
a VCR with
on-screen
program-
ming, turn
on the TV
and watch
the screen
as you
press
buttons on
the VCR's
remote
control.

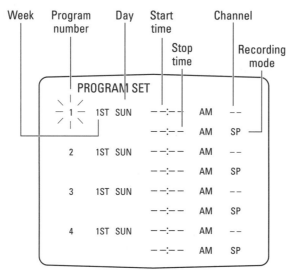

| Week | Program number | Day | Start time | Stop time | Channel | Recording mode |

1. **Switch to programming mode.**

 Here's where most people turn to jelly. Just *how* do you switch to pro-gramming mode? It all depends on your specific VCR, but here are the two most common ways:

 - Push the Program button on your remote control. The button may be labeled Prog or Prg to save space. You're taken right to the spot where you can begin programming the VCR: the main program menu.

 - Push the Menu button on your remote control. Many VCRs take you to a Main Menu, where you have to push other buttons, such as the Channel Up and Channel Down buttons, to choose the Program option. Other VCRs are smart enough to take you right to the spot where you can begin programming: the main program menu.

2. **Specify the program event.**

 Just about all VCRs let you program as many as seven or eight (and sometimes more) programs at a time. Each program you enter into the VCR is called an *event*. If your VCR has a "1-week/8-event timer," it can record as many as eight programs during the span of one week. The VCR starts and stops the recording for each program you have entered in the event list. You just have to remember to make sure that there's enough tape left to record all the shows you want.

 Most people record just one show at a time. So in the main program menu (the spot your VCR took you to when you pressed the Program or Menu

button on the remote control), specify the event number you want to program — in this case, 1. This step takes you to the programming screen, where you enter the time, date, channel, and recording speed.

3. Specify the starting date and time.

First, tell the VCR when to begin recording.

- Use the number buttons on your remote control to insert the starting date and time. You have to enter the date and time separately and press a Select or Enter button in between.

- Or press the +/- buttons (often shared with the Channel Up and Channel Down buttons on most remote controls) to increase or decrease the values shown for the date and time. Again, you have to enter the date and time separately and press a Select or Enter button in between.

Pressing the Select or Enter button moves the cursor in the programming display. The *cursor* tells you which item in the programming display you are going to set. Different VCRs show the cursor in different ways. The cursor may be shown as a flashing bar, a fat box shape, or a different color.

4. Specify the channel.

Press Select or Enter on the remote control to move the cursor to the spot where you indicate the channel to record.

- If you're not on cable, you tell the VCR to record whichever channel you want, such as Channel 2 or Channel 4.

- If you are on cable and your VCR doesn't have a provision for controlling the cable box, tell your VCR you have to record Channel 3. You have to set the channel manually to record on the cable box.

- If you are on cable and your VCR is set up to control the cable box, tell the VCR to record whichever channel you want.

5. Specify the recording speed.

Press Select or Enter on the remote control to move the cursor to the spot where you indicate the recording speed.

- If your VCR has an SP/EP button on it, try pressing it to change the recording speed.

- If your VCR doesn't have an SP/EP button, try pressing the +/- buttons to change the speed (the +/- buttons are often shared with the Channel Up and Channel Down buttons).

Use SP speed for the best recording quality. Remember that the tape is used up fastest at SP speed. A T-120 tape (the standard kind you buy) can record for two hours at SP speed. If you want to record more on the tape, choose LP for four hours or EP (also called SLP) for six hours.

6. Exit from the programming display.

Leave the programming display by pressing Select or Enter. Depending on your model of VCR, you may have to press the Program or Menu buttons until the programming menus disappear.

7. Insert a tape.

Put the tape you want to record on into the VCR. If the tape has to be rewound, be sure to do that now.

Be sure that the record tab on the back of the tape is still in place. If the tab is gone, your VCR can't record with that tape unless you cover up the missing record tab with a piece of masking tape.

8. Press the Timer button on your VCR or remote control.

This last step is *very* important, and it is one that most people forget to do. Even though you've programmed your VCR, it doesn't record shows unless it's in timer mode. You put it in timer mode by pressing the Timer button. (Likewise, you can cancel timer mode by pressing the Timer button again.)

If you want to program another event (record another show), repeat these steps. In step 2, however, specify another event number, such as 2 or 3.

Canceling a Programmed Event

Change your mind? If you don't want to record a program anymore, you can cancel the programming in one of two ways:

✔ Press the Timer button to get the VCR out of timer mode. The VCR doesn't automatically record shows if it's not in timer mode.

✔ Get to the main program menu, as explained in step 1 in the preceding section. Specify the event you want to cancel (such as *1* for the first event) and then press the Cancel button on your remote control.

Use the Cancel-button method just described if you want to cancel one event but still want the VCR to record other shows you may have programmed.

I Don't Have On-Screen Programming

Woe is you. On-screen programming makes programming a VCR much easier. Those VCRs without on-screen programming generally have lots more buttons to press to program the thing. Figure 7-4 shows the front-panel display of a typical VCR that lacks on-screen programming. You press one or more controls — such as Set and Enter — on the VCR to program the machine to record while you're away. These VCRs are the hardest to program. To make matters worse, you have to program each event in a specific order. If you skip setting the channel to record, for example, you often have to repeat all the programming steps again.

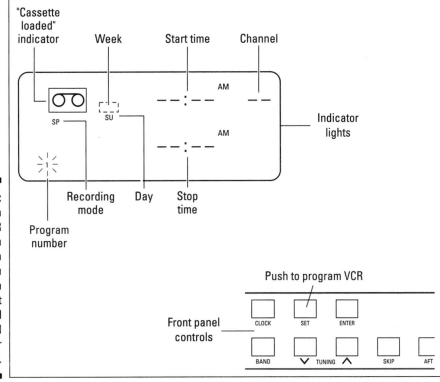

Figure 7-4: To program a VCR without an on-screen display, you must rely on the front panel controls and indicator lights.

Here's the general procedure for programming a VCR without on-screen programming: Don't get frustrated if you can't get the hang of programming your VCR. Few VCRs, especially the older models, were designed to make programming truly easy.

1. **Find the Program button on your VCR and press it. (You may have to hold it down through all the programming steps.)**

2. **Select the programming event, such as 1 for the first event.**

3. **Specify the day of the week to begin recording.**

4. **Specify the start time.**

5. **Specify the stop time.**

6. **Specify the channel.**

7. **Specify the recording speed (on some VCRs).**

The first program is programmed. Repeat the steps to program additional events. When you're finished, insert a tape in the VCR and press the Timer button to turn timer mode on.

Uh, Do I Have to Read the VCR's Manual?

The best place to find specific programming information for your VCR is in the manual that came with your machine. Keep the manual handy as you learn how to program your VCR.

The less you use the programming feature on your VCR, the more likely you are to forget the procedure. To help you remember, write down the steps on the inside front cover of this book or on a piece of paper. Or circle the particular steps you had to follow in this chapter. Or make a copy of the "How to Program" pages from your VCR's manual. Either way, refer to your "cheat sheet" whenever you need help on how to program your VCR.

Don't wait to use the programming feature of your VCR right before you have to dash out the door. Take your time to learn how to program your VCR, and practice programming a show you don't care about. Try recording a few minutes of a program that is about to begin or that is playing right now. You don't have to record the whole thing — just a minute or two, to see whether you've punched all the right buttons.

Chapter 8

Using VCR Plus

In This Chapter

▶ Understanding VCR Plus

▶ Knowing your type of VCR Plus

▶ Setting up VCR Plus

▶ Using VCR Plus

▶ Reviewing your VCR Plus choices

▶ Canceling shows

▶ Avoiding the CLASH message

▶ Finding VCR Plus numbers

*P*rogramming a VCR to automatically record TV shows is a formidable task. So formidable, in fact, that you've probably wondered how some of your co-workers managed to figure it out so easily.

Here's a secret: Chances are that your co-workers never sat down with their manuals and learned how to program. No, they're probably using VCR Plus.

The VCR Plus gadget looks much like a remote control because, in a sense, that's exactly what it is. But rather than let you remotely control your VCR from your living room couch, VCR Plus controls your VCR automatically, while you're away.

To record a show, just punch a number into the VCR Plus and then walk away.

This chapter explains how to set up VCR Plus and make it record your favorite programs while you're away. You also discover a few little-known tricks of VCR Plus — secrets you can casually drop in the lunchroom.

Why Use VCR Plus?

If you don't already have a VCR Plus, there are three good reasons to consider getting one:

VCR Plus is easy to use. That means that you finally can record programs while you're away rather than merely use your VCR to play back tapes.

It takes just seconds to tell VCR Plus which shows to record. Simply punch in a series of numbers listed in your television guide. Because it's so easy, you can tape programs more often while you're away.

VCR Plus is clever enough to know whether you're trying to record two programs at the same time. It also knows whether you have enough tape left in your VCR. That capability reduces accidents and increases your chances of success in capturing your favorite programs.

VCR Plus is used only for recording programs when you can't press the Record button yourself. If you don't ever plan to record with your VCR, or if you're always home to start and stop the recording yourself, VCR Plus won't do you much good. Also, VCR Plus doesn't work with some very old VCRs, especially VCRs connected to their remote control by a cable. (We're talking *old* here.)

Two Flavors of VCR Plus

VCR Plus comes in two flavors: separate or built-in.

The *separate* model looks a great deal like your VCR's remote control (see Figure 8-1). It comes with a little cradle that fastens to the side of your VCR.

The *built-in* type comes built in to the circuitry of your VCR. You already have VCR Plus built in if you see the words *VCR Plus* on your VCR's remote or on one of its menus.

✔ Both kinds of VCR Plus have their advantages and disadvantages. The stand-alone kind is a little more difficult to set up initially because it has to be told what kind of VCR you have. Because the built-in type of VCR Plus already knows what kind of VCR you have, this part of the setup is not necessary.

✔ Things get a little trickier if you have cable TV and you dial channels by using a cable box. The stand-alone type of VCR Plus works OK with your VCR and the cable box. But for the built-in variety of VCR Plus, you have to use this funky-looking remote cable-box controller, which stretches between your VCR and the cable box. More on this cable-box controller in a bit.

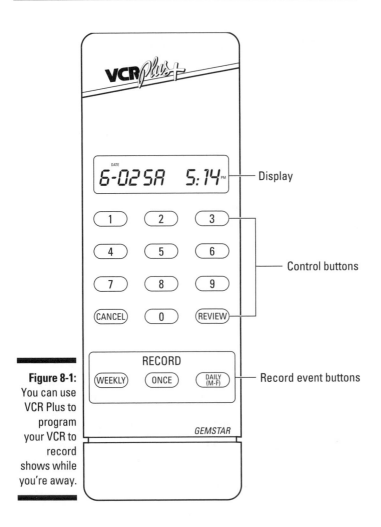

Figure 8-1:
You can use
VCR Plus to
program
your VCR to
record
shows while
you're away.

Setting Up VCR Plus

The hardest part of using VCR Plus is setting it up. Fortunately, you have to do it only once. The manual that comes with your VCR Plus or VCR spells out the exact details, but here's a rundown of what's involved for both the stand-alone and built-in varieties of VCR Plus.

Setting up the stand-alone type

The stand-alone VCR Plus consists of the controller unit — the remote-control thing — plus a little cradle you stick beside your VCR. Have a cable box? Then stick VCR Plus near that, too.

Before you can use VCR Plus, you have to tell it about your VCR, your cable box (if any), and the channels used for TV stations in your area. You set up VCR Plus by lifting up the little cover near the back of the unit. This step exposes a half-dozen or so special buttons. As you program VCR Plus, look at its LCD panel so that you know what to do next:

1. **Tell VCR Plus what kind of VCR you have.**

 The VCR Plus needs to know what language your model of VCR can speak. So look up the VCR's brand in the back of the VCR Plus manual; it's a two-digit number. Then press the VCR button on the VCR Plus, followed by the two-digit number.

2. **Tell VCR Plus the time and date.**

 Without the correct time and date, VCR Plus doesn't know the right times to start and stop recording.

 Be as accurate as possible when you're setting the clock or you'll accidentally chop off the beginning or end of your shows. To set the clock, press the VCR Plus Clock button and follow the on-screen prompts.

3. **Tell VCR Plus what kind of cable box you have, if any.**

 Do you change channels through a cable box? Then VCR Plus needs to know the brand of cable box you're using. Look up your particular brand in the back of the VCR Plus manual; as with your VCR, you'll find a two-digit number for the cable box. Then press the Cable button on the VCR Plus, followed by the two-digit number.

4. **Tell VCR Plus about any odd cable channels.**

 Not on cable? Then ignore this step. If you're on cable, however, here's where things get bogged down a little. Cable companies seem to delight in mixing up channel numbers, making them as difficult as possible to find. Your local TV station might be Channel 12, for example, but the cable company assigns it to Channel 26. And HBO might be anywhere. You have to tell VCR Plus which station lives where.

 How? By following a simple but tedious process of going through each TV channel and specifying which cable channel it corresponds to. This task is the most time-consuming aspect of setting up VCR Plus, and it is also where you are likely to make a mistake, so go slowly. Luckily, you have to mess with this nonsense only once.

✔ VCR Plus uses infrared light signals to control the VCR (and cable box); that means that you have to keep the path between them clear of obstacles. If something comes between them, VCR Plus doesn't work — just as your remote control stops changing channels when the cat gets in the way.

✔ The cradle for the VCR Plus sticks to your VCR or cable box with double-sided tape. This tape is strong and stiff, and, if it's left in place for any length of time, it can be really hard to remove. Avoid attaching the cradle to the cable box, because the cable company will eventually want that back. If possible, stick the cradle to your VCR instead.

Setting up the built-in type

If your VCR comes with VCR Plus built in, you don't have to toil as long to set it up. But like the stand-alone version, you have to set up the built-in version of VCR Plus so that it will work with your cable box — if you have one — and will tune to the correct channels for recording.

Because all VCRs are a bit different, there's no single way that the built-in VCR Plus feature is set up and used. But the following list of steps is a quick overview of what's involved:

1. **Set the VCR's clock.**

 Before setting up the VCR Plus inside your VCR, you first have to set the VCR's clock, as explained in Chapter 5 and the VCR's manual. Be sure to be as accurate as you can when you're setting the clock, and be sure to set the correct date.

2. **Attach the cable-box controller (optional).**

 If you have a cable box, you have to attach the cable-box controller included with the VCR between the VCR and the cable box.

 The cable-box controller plugs into the back of the VCR and attaches — using double-sided tape — near the remote-control sensor on the cable box (the sensor picks up the infrared light signals from the remote control and is usually on the front of the cable box). The cable-box controller allows the VCR Plus in your VCR to control the cable box.

3. **Tell VCR Plus what kind of cable box you have.**

 When you're using a built-in VCR Plus, there's no need to specify the kind of VCR you have. But if you have a cable box, you must determine the brand-number code of your cable box (see the manual that came with your VCR Plus) and enter that number.

4. If you are on cable, set the guide numbers so that VCR Plus knows which channel to tune to in order to record a program.

See step 4 in the preceding section for more information about VCR Plus.

Hurrah! The built-in VCR Plus has now been set up, and you can begin to use it.

If you have a cable box, it must be equipped with an infrared remote sensor or else VCR Plus doesn't work with it. Most modern cable boxes are made this way, but older ones may not have any remote control or may use a wired remote control. In addition, even if your cable box is equipped with an infrared remote sensor, it may not be activated if you don't already use a remote control with it. Better check with your cable company if you're having problems.

Using VCR Plus

The hard part of owning VCR Plus is over. Programming the thing to automatically record programs while you're away is a snap. This section tells you how to do it for the stand-alone VCR Plus. See the manual that came with your VCR for details on how to program its built-in VCR Plus.

1. Put a blank tape in your VCR.

2. Dial the VCR to Channel 3 or 4, if you're on cable.

If you're not on cable, it doesn't matter what you dial the channel to. The VCR Plus takes care of it.

3. Turn your VCR off.

4. Leave your cable box on (if you have one).

5. Find the VCR Plus program number for the show you want to watch.

The number is listed in *TV Guide* or some other TV listings. These are called *PlusCodes*. The PlusCode number is usually listed in bold letters right after the show's description. The number can have anywhere from three to nine digits; most PlusCodes for prime-time programs have four digits.

Be sure to use a *current* television guide. You can't use the one for last week or next week. It has to be for this week. That's the way VCR Plus works — the numbers change constantly, even for the same show.

6. Press Once, Weekly, or Daily M-F on the VCR Plus.

That's how you tell VCR Plus whether you want to record the program just *once, once a week* at the same time, or *once a day* at the same time.

7. **Put the VCR Plus in its cradle near the VCR.**

✔ VCR Plus can store as many as 14 shows at a time but never more shows than will fit on one tape.

✔ If you want to record more shows, just follow Steps 5 and 6. If you are recording more than two hours of shows, set the VCR in EP (or SLP) speed. That way, you get six hours of recording time on a tape rather than the usual two hours.

✔ VCR Plus works like any other remote control. It must be close enough to the VCR for its signal to reach properly. Be sure to keep your VCR Plus unit in its cradle or else it might not be able to turn your VCR on at the right time.

I Want to Review the Shows I Have Programmed

To see the shows you have programmed VCR Plus to record, press the Review button. Each time you press Review, it steps through the list of shows in chronological order.

I've Decided Not to Record a Program

At any time until recording starts, you can tell VCR Plus to hang it up and forget about recording the show you previously entered.

To delete a show from the list, press Review until the show appears in the LCD. Then press Cancel. VCR Plus flashes CANCELED to show you that the show will not be recorded.

I'm Recording a Football Game and I Think That It Will Go to Overtime

When you enter a PlusCode number into VCR Plus, it stores the channel to record, the time to begin recording, and the length of time to record. Sports events seldom last exactly two hours or however long it says in your television guide. If you're sure that the game will go into overtime, follow these steps:

1. **Press the Review button until the programming information for the game appears in the LCD.**

2. Press the Add Time button on the VCR Plus.

This step adds 15 minutes to the length of the show. Press the Add Time button again to add another 15 minutes.

If you happen to be home while the game is being recorded, you can press Add Time to extend the length of the recording. Keep pressing Add Time for every 15 minutes the game runs into overtime.

It Says CLASH When I Enter a Program!

VCR Plus knows that your VCR can't record two programs at the same time. It also knows the length of programs — 30 minutes, one hour, two hours, and so on. Programs you want to record can't overlap each other.

If you accidentally try to record programs that air at the same time, the VCR Plus politely says CLASH. Suppose that you want to record a one-hour show that begins at 8:00. If you also try to program for another show that begins at 8:30, the VCR Plus greets you with a CLASH message: The first show won't be over before the next one begins.

The word CLASH isn't anything tragic; it just means that VCR Plus shrugged its shoulders and pretended that nothing happened. It still records your first program — unless you change your mind and tell it not to.

What Do the Little _ _ _ Bars Mean in the LCD?

VCR Plus displays the amount of videotape it will need to record the next 24 hours of programs. This amount is shown as little bars in the LCD panel. Each bar represents as much as one hour of tape.

If you have programmed VCR Plus to record a two-hour movie and a half-hour sitcom, for example, it shows three bars. (VCR Plus always rounds up to the nearest hour.)

There's nothing worse than running out of tape before all your shows are recorded. Before you leave, be sure to note the number of bars VCR Plus is displaying and that you have enough tape in the VCR to record them all.

The VCR Plus Is Chopping Off My Shows!

VCR Plus automatically adds an extra 30 seconds to the beginning and ending of the shows it records, to make sure that it gets everything. Even so, you may find that it's not getting all of the show. This list shows some reasons:

- ✔ The clock in the VCR Plus (or your VCR's clock if you have a built-in VCR Plus) is not set correctly. Be sure that it is up to the minute.

- ✔ The station you are recording starts its programs a tad earlier (or later) than the hour or half-hour. Write an angry letter to the TV station. It shouldn't be doing that.

- ✔ If the *beginning* of a show is cut off and you know that the clock in the VCR Plus is set correctly, set the clock *forward* a minute or so. VCR Plus will then begin recording a minute earlier.

- ✔ If the *end* of a show is cut off and you know that the clock is set correctly, set the clock *back* a minute or so. VCR Plus then begins recording a minute later.

My TV Listing Doesn't Have PlusCode Numbers!

You need the PlusCode numbers in order to use the VCR Plus. No number, no recording.

TV Guide is the most popular source for the PlusCode numbers. In addition, many Sunday papers include PlusCode numbers with their TV listings.

Not all programs listed in *TV Guide* (or other TV listings) come with a PlusCode number, unfortunately. For example, *TV Guide* may not provide PlusCode numbers for your local newscast, especially if two or more channels have their news at the same time. *TV Guide* just lumps all the news programs together. Not very helpful.

You have several options if you want to record shows that don't have the PlusCode numbers:

- ✔ Call the TV station airing the program you want to record. It may be able to provide the PlusCode number to use.

- ✔ Call the 900 number listed in the VCR Plus manual (or your VCR manual), and give the time, date, and channel of the show you want to record. You'll receive the PlusCode number to use. The cost for the call is about a buck a minute.

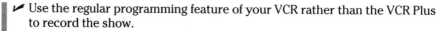

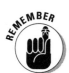

- ✔ Use the regular programming feature of your VCR rather than the VCR Plus to record the show.

- ✔ Break down and stay home to press the Record button when your show starts. *Then* leave the house.

- ✔ PlusCode numbers change daily; the same number doesn't always tell your VCR to record the 5 p.m. news on Channel 10.

Some Do's and Donuts for Using VCR Plus

Keep these do's and don'ts in mind when you're using VCR Plus:

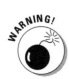

- ✔ *Don't* press your VCR's Timer button when you're recording with the VCR Plus. The Timer button is for the programming feature of your VCR. It will probably override the signals from the VCR Plus, leaving you with no recording at all.

- ✔ *Do* keep the VCR Plus controller near the VCR and cable box. It doesn't work if you leave it in the next room or under a pile of newspapers. The infrared signal from the VCR Plus has to be able to get to your VCR.

- ✔ *Don't* forget to turn off your VCR. If you leave it on, VCR Plus turns it off right before it begins recording, and nothing gets recorded.

- ✔ *Do* remember to leave your cable box turned on. If you turn it off, VCR Plus turns it on right before it begins recording, and the wrong channel (or nothing) gets recorded.

- ✔ *Don't* use an outdated *TV Guide* or other TV listing for the PlusCodes. If the *TV Guide* is less than a month old, VCR Plus warns you with an ERROR message that the PlusCode is out of date. If it's more than about a month old, there's no telling what VCR Plus will record (probably an old rerun of *My Mother the Car,* and you don't want that!).

Other Instant Programming Aids

VCR Plus is currently the most popular programming aid for VCRs. But it's not the only one:

- ✔ The Starsight system lets you view a TV listing on your screen. Using a special remote control, you mark the programs you want to record. Starsight is now standard equipment on new cable boxes made by Zenith, and soon we should see it built in to some high-end VCRs. You have to pay a monthly service charge to use the Starsight system.

✔ TV Guide Onscreen is similar to Starsight. You view an electronic version of *TV Guide* on your TV screen and pick the shows you want to record. And like Starsight, you pay a monthly service charge to use TV Guide Onscreen.

✔ The VCR Voice Commander uses your voice to program the VCR. Rather than press buttons, you just speak: "Record Channel 10 from 8 o'clock to 10 o'clock." Well, it seemed like a good idea at the time. The VCR Voice Commander never took off (at more than $100, it's expensive); with other systems, such as VCR Plus, Starsight, and TV Guide Onscreen, it doesn't look as though it ever will.

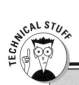

Don't bother reading this if you don't care where the PlusCode numbers come from

The secret behind the VCR Plus system is the *PlusCode* numbers. These numbers contain all the information necessary to tell VCR Plus when to begin recording, when to stop recording, and which channel the show is on.

If you know a little about the ways computers work, you may be tempted to figure out how the PlusCode numbers are derived. Don't waste your time. The PlusCode numbers aren't derived by simply adding up the channel, off time, and on time. Instead, the PlusCode numbering system uses a sophisticated algorithm to translate the numbers into the date, time, and channel.

How Gemstar, the company that makes VCR Plus, comes up with the VCR Plus numbers is a trade secret. And it isn't saying how it all works because a large part of its income comes from charging publications such as *TV Guide* to publish the PlusCodes.

Still, some computer hackers have cracked the code and published the secret on the Internet, CompuServe, and other on-line establishments of the information superhighway. Their techniques work, to a point, but they require a personal computer to use. It's usually easier to look up the number in your television guide rather than calculate the number by using your home PC.

Chapter 9

Keeping Your VCR Healthy

In This Chapter

▶ When to take your VCR to a repair shop

▶ Ways you can make your VCR last longer

▶ Ways you can make your tapes last longer

▶ Dangerous things to keep away from your VCR

*T*his chapter covers general VCR maintenance — little fix-its and chores to keep your VCR running strong. Much of this stuff may not be news to everybody. Most parents know instinctively, for example, that children shouldn't stuff Gummi Bears into their VCR's tape slot.

But these two items may be news, so we mention them up front:

✔ Don't run head-cleaning cassettes for too long. These cassettes can scrub dirt from the innards of your VCR, but they can also cause damage by scrubbing too long. Run a head-cleaning cassette for the length of time stated on its direction sheet, usually 30 seconds or less. But don't run the head cleaner for several hours, thinking that the extra time can clean off stubborn stains even better. Just the opposite — it can damage your VCR.

✔ Don't run your VCR on its side. Some of today's newfangled computers don't mind if you prop them up on one side, but VCRs always want to run flat as a plate. Don't try to save counter space by turning one on its side.

The rest of this chapter lists some other ways to keep your VCR healthy.

Ways to Make Your VCR Last Longer

Sometimes there's simply no getting around taking your VCR to the shop. But you can keep it out of the shop longer by performing a few preventive maintenance chores at home. Here are a few of the easiest ways to keep your VCR healthy and happy.

Clean the outside of your VCR

Like anything else in a house, a VCR eventually becomes covered with an inevitable layer of dust. Dust makes countertops and tables dirty — when it's wiped off, there's no damage done. But a layer of dust on your VCR can make it run warmer than normal, possibly lessening its life span.

To be on the safe side, wipe off your VCR with a damp rag every once in a while, making sure that its case is clean and that its vent holes aren't clogged with any gunk. Any mild household detergent will do; just don't use any rough stuff, like alcohol, benzene, or gasoline.

When you clean your VCR, don't spray cleanser directly on the VCR — spray the cleanser on the *rag,* and rub the damp rag over the VCR to clean any external dust.

All electrical components — including VCRs — last longer if they're kept at cooler temperatures. Be sure to keep your VCR as cool as possible.

Use a dust cover

Because VCRs last longer when they run at cooler temperatures, it's important to keep them clean. A dust cover can keep the dust off your VCR. (It can also keep you from having to clean it as often.)

Always remove the dust cover before running your VCR. Your VCR's vents need air flowing over them to keep its innards cool. Keep the dust cover off whenever the VCR power is turned on. Remember: If the power light is on, the dust cover should be off.

Use a head cleaner

When your head gets dirty, you splash a little water on it, rub in some soap, and go "bluddle uddle uddle uddle um dum" (well, you would if you were one of the Seven Dwarves). The heads in your VCR — used to record and pick up magnetic signals on the tape — can get dirty too. But you don't want to use water or soap for that, and saying silly words from old Disney cartoons doesn't help much, either.

Instead, you use a *dry head cleaner.* A dry head cleaner looks just like a regular videotape cassette. You plop it in the VCR, push Play, and in about 30 seconds the VCR's heads are clean. It is often called a head-cleaning *tape,* although the tape it uses is a special cleaning pad. You can't record anything on a cleaning tape.

You should use a head-cleaning tape if you notice any of these things:

- ✔ You play back a tape and you see snow. The snow can completely fill the screen to make a full blizzard (no picture at all), or it can partially cover over the picture.
- ✔ You record a tape that plays back all snowy on any VCR you use.
- ✔ Your VCR can't seem to lock on to the picture. The picture may roll, and the sound may get slower and then faster.

Many late-model VCRs come with an internal head-cleaning mechanism. If your VCR is so equipped, you probably don't have much use for a head-cleaning tape. Let the internal head cleaner do all the dirty work. Still, sometimes the heads in your VCR may get dirty enough that you have to call in the big guns and use a head-cleaning tape.

There are lots of head-cleaning tapes on the market. The ones sold by 3M are our favorite because they display on the screen a message telling you when cleaning is complete. Head-cleaning tapes are simple, fast, and relatively safe — when used as directed. Run the tape for 30 seconds or less or whatever it says in the instructions. Wait a few seconds, and then try to play a tape that you know is good — one you've viewed before and played fine.

Don't overuse head-cleaning tapes. Use the cleaner only when you notice that your VCR is acting sick, and only for the recommended time (30 seconds or less). If the heads in your VCR get dirty more than every couple of months, you're probably using inferior-quality tapes. Or your videotapes (and VCR) may be dusty, and the dust is getting inside and contaminating the heads.

Sometimes the heads in your VCR can get so dirty that regular head cleaning doesn't fix the problem. If this happens, take your VCR in for a cleaning. The cost is about $25. See Chapter 18 for more on what to do when big problems strike.

Use your VCR once in a while

You know how rubber bands get brittle after they've sat around in the bottom of your kitchen's "junk" drawer? The same thing happens to the big rubber bands living inside your VCR. A VCR's rubber bands are called *belts,* however, so that the manufacturers can jack up the price to at least $20.

By using your VCR regularly — at least every week or two — you keep its internal rubber bands and rollers turning. When the rubber parts aren't resting in the same position for a long stretch of time, they stay more pliable and last longer.

 The very latest VCR models don't use belts or use very few of them. Still, you should crank up your VCR every once in a while to get its living essence flowing again. This technique helps spread the grease and oil to the spots that are supposed to get it and keeps dust from settling into impossible-to-reach places.

Don't set your VCR on a blanket

Chapter 3 separates the safe and scary places to set up your VCR, but here's one in case you missed it: Don't set your VCR on top of a blanket or rug. Unless your VCR sits on a flat surface, air can't reach its underside vents and cool off its internal organs, and it can also cause static problems.

Don't let the curtains block any of the side or back vents either.

Oh, and don't set your VCR on top of a microwave oven — this is no joke. The magnets in the microwave's power supply can mess up your VCR and your tapes. If you want your VCR in the kitchen, put it on its own shelf.

Check the batteries in your remote control

Can't remember the last time you changed the batteries in your remote control? Then it's time to give it a quick checkup (see Figure 9-1).

Figure 9-1:
Periodically check the batteries in the remote control for leakage.

Remote control

Check batteries for leakage

Slide or pop the cover off the battery compartment and look for any gross stuff leaking from the ends of the batteries. All clean? Then you don't have anything to worry about — put the cover back on and return to the couch.

But if there's any leakage, dump the batteries into a nearby trash can and wipe the gross stuff out of the battery compartment with a damp rag. When everything's clean, pop some new batteries in there and try to remember to peek inside there a little more often.

Finally, spray some mild household cleaner on a rag and remove any stray pizza grease you see coating the keys. Those remote controls can get dirty *fast*.

A pencil eraser can often remove stubborn corrosion from the battery contacts inside your VCR's remote control.

Use only alkaline batteries in your remote control. They last longer and tend not to leak as much.

Turn off your VCR when you're not using it

Keeping your VCR turned on all the time keeps it warm 24 hours a day — and warmth shortens the life of electronic gizmos. Turning it off when it's not being used can add to its life span.

By the same token, don't be turning your VCR on and off all the time. The more times you turn your VCR on and off, the more little zaps of electricity you introduce into the busty innards of your VCR (technically, these zaps are called *power spikes,* and they occur whenever you turn on an electrical appliance). If your VCR is going to be off for just an hour or so, you may as well keep it on.

Don't keep a videotape in your VCR

Remove any videotapes from your VCR when you're not using them. Although some VCRs don't seem to mind, leftover tapes can sometimes cause problems by putting pressure on internal rollers and leaving the mechanisms open to dust.

Don't spill liquids in your VCR

Spilled something inside your VCR? Then you'll want to take it to the shop. Even plain ol' water can damage the secret, hidden things inside.

Wipe off any visible liquid from the outside and take it to the repair shop right away. The longer you wait, the longer you're giving your VCR to corrode. The liquid doesn't just evaporate and leave everything OK.

Don't take the cover off your VCR and try to fix things yourself. Not only does it void the warranty on most models, it can expose you to an electric shock.

Get your VCR professionally cleaned

Your VCR eventually has to be professionally cleaned, no matter how careful you are with it. One of the biggest problems comes from rental tapes. You may be immaculate with your *own* videotapes, keeping everything in sanitary condition. But the guy down the street may have spilled Dr. Pepper on his rental tape just before he returned it — and you may be the next person to rent it.

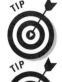

Your VCR will last longer if it's professionally cleaned once a year.

Check the date your VCR's warranty expires — and then have it professionally cleaned the month before your coverage ends. That lets you wring a little more usefulness from the warranty.

Enemies to Keep Away from Your VCR

Like fire and water, VCRs don't mix with the household items described in the rest of this chapter. (VCRs don't mix well with fire and water either.)

Keep smoke and cats away from your VCR

VCR repair folks can immediately deduce two things about a household as soon as they open a VCR's case: whether the owner is a smoker and whether he owns a cat. (A few tech-shop veterans can also tell whether the cat's a smoker and even whether the cat smokes nonfilter cigarettes.)

If you're a smoker, keep a dust cover over your VCR or keep it enclosed in a cabinet when it's not in use. Otherwise, smoke coats your VCR's internal parts.

If you own a cat, don't let it sleep on top of your VCR — especially when the VCR's turned on. The cat blocks your VCR's air vents and coats a VCR's internal organs with hair, making it run warmer. Cat hairs can also float inside the videotape, interfering with recording or playback.

Don't let kids put Gummi Bears in your VCR

As infants, children are taught important skills, like pushing cubical blocks into square holes. So they can't really be blamed when they want to push things into the slot on the VCR. Don't let kids play next to your VCR, and make sure that they realize that it's a "no-no" thing to play with. Then go one step further and keep it in a locked cabinet.

Or at least place your VCR on a shelf high enough to make it difficult for kids to flick stuff into it, like Gummi Bears, pens, frogs, coins, paper clips, sandwiches, and everything else kids play with these days.

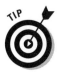

Keep track of your collections of small objects, such as cuff links, earrings, and credit cards. If they are ever missing, look first in the VCR your kids have been using as a safe-deposit box.

Keep your VCR away from sunlight

Don't keep your VCR on a table next to the window where the sun can shine on it during the day. Almost all VCRs are black — the color that heats up the quickest on sunny days.

If possible, keep your VCR in a cabinet. Open the cabinet when you want to use your VCR — that lets it breathe and keeps the heat down. Then close the cabinet when the movie's over.

And try to remember to keep the cabinet door open if your VCR will record shows while you're at work, too.

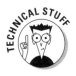

Your VCR doesn't even have to be in direct sunlight for a long time to have problems. Most VCRs use infrared remote controls, which means that the remote controller sends blips of infrared light to the VCR to get it to play, rewind, stop, and so on. The sensor for receiving the infrared light is on the front of the VCR. If sun shines on this sensor for any length of time, it can heat it up and temporarily "blind" it. You'll have trouble using your remote control until the sensor can cool down and it can see again.

Clean the connectors

Your VCR and TV — and other video gear — is connected by cables. Dust and corrosion on the cables can eventually impair the electrical connection between your VCR and TV. Every six months — or at least once a year — take the time to remove each connector, one by one.

Then clean each connector and cable end with a cotton swab dipped in isopropyl alcohol (see Figure 9-2). Let the alcohol evaporate (about 30 seconds), and reattach the cable to the connector. Make this little job part of your household spring cleaning, and it will help you enjoy years of carefree sound and picture.

Figure 9-2:
Use a cotton swab dipped in alcohol to keep the connectors on your VCR and TV bright and clean.

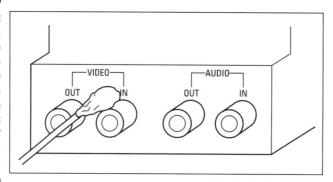

Suntan lotion can dissolve front-panel lettering

Andy Rathbone learned the hard way: Suntan lotion can dissolve the little labels next to the buttons. A little bit of lotion found its way onto the buttons of his camcorder and completely erased them, forcing him to memorize the positions of his White Balance, Shutter Speed, and Exposure buttons.

The ink labeling the buttons on your VCR may be a little more robust, but, still, wash your hands before returning from the beach and hitting the Play button for *Endless Summer.*

Keep loose cables away from traffic

Cables can usually stay tucked into their complicated little world behind your VCR. But if one ever escapes — the one you unplugged so that you could plug in the camcorder, for example — somebody might trip over it. Some of the cables are screwed in to the back of the VCR, so if the cable is pulled suddenly by a wayward foot, the VCR will follow. Not good. Keep cables away from any foot traffic.

Keep tapes off the ground

Tapes on the ground, even on a clean carpet, can pick up dust, fibers, and other junk that can make your VCR dirty inside. The gunk gets inside your VCR when you insert the tape. Pretend that you're Felix Unger. Keep your tapes neat and tidy at all times. Store your videotapes in videotape drawers. They're cheap — about $10 for a drawer that holds 20 tapes. Place the tape — either a tape you rent or a tape you buy — in the little dust jacket that came with it.

If a tape gets dirty, wipe it off before putting it inside your VCR. A clean cloth is enough. If there's gooey stuff on the tape, like remnants of a peanut-butter and jelly sandwich, spray a little household cleaner on the rag and then wipe. Remember: Never spray the cleaner directly onto the tape.

If you use any kind of cleaner on the tape, clean only the outside, and let the whole thing dry before you put it in your VCR. Don't let any of the cleaner drip inside.

Keep tapes cool

By now you've already been warned by the folks at the video-rental store not to leave videotapes in the car. The heat of a closed-up car can literally melt a tape, just like water can melt the Wicked Witch of the West.

But there's another reason to keep your tapes cool: Hot tapes can cause condensation when you play them on your VCR. Condensation is moisture, and that's *very* bad for your VCR. The condensation prevents the tape from playing properly and in some instances can ruin the tape *and* your VCR. (Most VCRs have condensation detectors, which prevents extensive damage, but some damage can happen anyway.) If a tape is hot, let it cool first before putting it in your VCR.

Rent your tapes from a quality rental store

The better movie-rental stores keep periodic tabs on the tapes they rent. At the good rental outfits, if a tape comes back dirty or mangled, they toss it into the dumpster. Not all rental stores are as conscientious. They are liable to rent out the same crudded-up tape over and over again. Mucked-up and damaged tapes can make your VCR dirty and can even wreck it!

If you ever happen to rent a bad tape (bad as in dirty or damaged, not bad as in a dumb movie), be sure to tell the people at the video-rental store. Otherwise, they may unwittingly rerent the tape.

Never open the access door on a videotape

A videotape is made of a hard-plastic outside called the *cassette*. Inside is the reel of actual videotape, the stuff that records Beavis and Butt-head singing with Cher. When you put the tape cassette inside your VCR, the little access door on the front of the cassette opens up, exposing the tape inside. You, too, can open the door manually by putting your finger on the little release latch on the right front side of the cassette.

But *don't!* If you open the access door, it exposes the tape inside. And if you touch the tape, icky grease from your fingers permanently sticks to the tape. If you play the tape, the grease comes off inside the VCR and can make the heads dirty enough that they need a thorough cleaning.

Best treat the tape inside a videotape cassette as though it were plutonium. Pretend that if you open up the little access door, you risk killing everyone on your block.

Chapter 10

Everything You Never Wanted to Know about Videotapes

In This Chapter

▶ Understanding prerecorded tapes

▶ Recording tapes at different speeds

▶ Avoiding wear and tear on your tapes

▶ Buying the right blank tapes

▶ Comparing tape brands and grades

▶ Understanding Super-VHS tapes

▶ Choosing tape lengths

▶ Storing videotapes

▶ Fixing problematic tapes

▶ Dealing with rental tapes

*V*ideotapes are what you feed your VCR. If you don't want your VCR to grow fat and lazy by eating the wrong things, choose the right videotape diet.

This chapter explains everything you never wanted to know about videotapes: tape lengths, how competing brands vary, how to keep your tapes well preserved, and more.

All about Prerecorded Tapes

Prerecorded tapes come with stuff already recorded on them, whether they're purchased at the store or rented from the place down the street. If you watch many prerecorded tapes, you've probably noticed how the quality of the picture and sound varies widely. This section explains how to grab the best quality from prerecorded tapes.

Why isn't the picture any good?

The picture may not be as sharp as it should be, or it may have ugly white lines at the top or bottom. The sound may buzz, or it may not be very loud. Part of the problem stems from the tape's *recording speed* — the speed the tape moved as it absorbed the video information.

🡒 The majority of movies you buy and rent are recorded at the fast *SP* (*Standard Play*) speed. Because Standard Play speed gives the best quality, be sure to choose that speed when you record your own tapes.

🡒 The cheapest prerecorded bargain tapes are recorded at *EP* (*Extended Play*) speed, which is three times slower than SP. EP saves tape, so it can cut costs. Unfortunately, however, the picture and sound quality suffer.

🡒 A few prerecorded tapes are recorded at *LP* (*Long Play*) speed, which is faster than EP but slower than SP. Companies that put out tapes in LP speed claim that it's a compromise between saving tape (so that the price you pay is less) and picture quality. Everybody else says that those companies are greedy, skimping on video quality to put money in their *own* pockets.

🡒 Some VCRs often have trouble playing back tapes recorded by other machines at slow speeds. Your VCR may work fine when it records and plays its own tapes at EP speed, but it may sputter and spit when it plays an EP-speed movie you bought at the discount store.

🡒 Common picture problems when you're playing tapes prerecorded at LP and EP include white lines at the top or bottom of the picture; a picture that rolls like a whiskey barrel goin' downhill; a "bending" of the picture at the top of the screen; or simply an awful picture, such as one with too much color.

🡒 Common sound problems when you're playing tapes prerecorded at LP and EP include pops, buzzes, and clicks; lots of hisses in the soundtrack; and a soundtrack that's too low to hear well.

What speed did you use to record this tape?

How do you know which speed the tape was recorded at? Well, if you already bought the tape, put it in your VCR, push Play, and look at the VCR's tape-speed indicator (the speed may also appear briefly on the screen when you first press the Play button). The indicator will say SP, LP, or EP (some VCRs say SLP rather than EP).

- ✔ If the VCR doesn't indicate any speed, the tape was recorded at LP.

- ✔ Check the box before you buy the tape. Sometimes the fine print reveals the tape's recording speed.

- ✔ If the tape is a movie, compare it with another tape that you know was recorded at SP speed. Look inside the little window at the top of the cassette. A movie recorded at SP contains a *great deal* of tape. If there isn't much tape inside, the movie was probably recorded at EP or LP.

- ✔ Most retail stores don't offer refunds for tapes that don't play well on your VCR. The store manager thinks that you just took the movie home, made a copy of it, and returned it so that you could get your money back. The moral? Buyer beware. If you purchase a prerecorded tape that doesn't play well on your VCR because it was recorded at the LP or EP speeds, you're probably stuck with it.

There's no picture when I pause or fast-scan this tape!

In addition to their lousy picture and sound quality, tapes recorded at the slow, LP speed present yet another problem. Many VCRs can't display a clear picture when you scan through the tape or pause the tape during playback. Or, rather than pause to display a really trashy-looking picture, some VCRs simply blank out the entire screen!

If you try to fast-scan a tape — press Fast Forward or Rewind while the tape is playing — and the picture disappears, the problem probably doesn't lie with your VCR or the tape. No, everything is working normally; the picture simply disappears because the tape was recorded in LP speed.

The same thing may happen when you press the Pause button. Rather than see a still frame of the picture, you see the picture blank out.

Wear and Tear on Tapes Mean Ugly Pictures

Rental tapes may have been viewed dozens and dozens of times before you finally get around to watching them. Each time the tape goes through someone's VCR, it wears out a little. After 50 to 75 viewings, the tape can become so worn that the movie is barely viewable.

A tape may be recorded at SP speed, but the picture and sound quality can still suck eggs. The reason? Too much wear. This section describes the types of wear you may encounter and how they affect the tape playback. None of this stuff can be fixed, unfortunately, but at least you will know that nothing's wrong with your VCR or your TV — or your mind.

Dropouts

Not the high-school kind, but the kind where flecks of magnetic stuff come off the tape, leaving microscopic holes where there is no signal. You can't see the holes in the tape, but to a VCR, they're the size of ditches in the road.

Your VCR tries to compensate for dropouts, but it can't do much for the really bad ones. The result: specks of white that flicker across the screen when you play back the tape. The white flecks appear randomly and are generally worse at the beginning of a tape.

Scratches

Videotape can become scratched as it plays through a dirty VCR or a VCR that's in bad need of repair. Depending on the location of the scratch, the tape can be completely unviewable or merely create an unsightly white line that runs across the screen.

Adjusting the tracking control on your VCR probably won't do any good. In fact, it's a good test. If you adjust the tracking control — turning the little "tracking knob" back and forth — and the white line stays in the same place, the tape has probably been scratched.

Wrinkles

Wrinkles happen when a movie is previously played on a VCR that tries to "eat" the tape. Sometimes the tape gets caught inside the VCR and gets all crunched up and mangled. The tape is wrinkled rather than nice and smooth as it should be. When you play a wrinkled tape, thick, white lines appear on the screen, and you can often hear a nasty-sounding buzz coming from inside the VCR.

A badly wrinkled tape can damage your VCR! If the wrinkle doesn't go away soon, stop the tape. Fast-forward it 30 seconds or so and resume playing it. If it's still wrinkled, eject the tape, return it to the rental place, and tell the employees that their tape is severely damaged.

Stretches

When hungry VCRs eat a tape, they can stretch it out like a spaghetti noodle that's about to snap. You may not be able to see the stretch on the tape, but the stretch can affect your VCR. Stretching can cause the same kind of thick, white lines on the screen as wrinkling does, but the VCR doesn't buzz as it may when a wrinkled part goes through the machine.

Usually, the tape rolls badly and the sound goes out (or most of the way out) as the stretched part goes by.

Rental-Tape Questions and Answers

By far, the most common use of VCRs is to play rental movies. Rather than buy movies to watch, you just rent them for a night or two, at a cost of about a third of a movie-theater ticket. Movie-rental stores are now a dime a dozen, with most cities having at least a half-dozen to choose from.

Most problems with VCRs and videotapes stem from rental movies. This section covers rental tapes and how to combat their special breed of problems.

Is it safe to play rental tapes?

Though it's rare, a seriously damaged tape can hurt your VCR. More common, a tape that's been damaged by another VCR can get the insides of your machine dirty. You have to take your VCR in for a cleaning before it will play tapes as well as it did before.

On the whole, playing rental tapes is safe. But you should always be on the lookout for a badly damaged tape and avoid sticking it in your VCR.

- Avoid renting tapes from sleazy rental outfits. The big rental stores, like Blockbuster and Wherehouse, police their tape inventory pretty well. The smaller joints may not be as careful in weeding out damaged tapes. This doesn't mean that you should avoid the "mom and pop" video-rental stores. Just be careful when you rent from them.

- Examine a rental tape carefully before sticking it inside your VCR. Look for obvious signs of soda-pop spills, bubble gum, and other movie-watcher detritus. If the tape's sticky, take it back to the rental store for a new one.

- The older the movie, the greater the chance the tape has seen better days. Play it with caution.

- When you rent a newly released movie, try to rent it early, before the tapes are played a gazillion times.

- Most damage occurs at the beginning of the tape. When you insert the tape, don't start playing it immediately. Fast-forward it a minute or so, past any potential damage. All you're likely to miss is the FBI warning and a Coming Attractions promo.

Are previously rented tapes OK to buy?

Video stores have to buy gobs of copies of popular movies so that they have enough to rent. For an "A-list" blockbuster movie, the video store may buy two dozen copies so that it has enough to go around. After the demand for the movie dies down, the store has many extra copies on hand. So it keeps some and sells the extras as used. The used copies sell for about $10 and sometimes even less.

Are these used, previously rented movies OK to buy? Usually yes. Many of the better stores test the tape (at least the first five minutes or so) before putting it on the sale racks.

Nevertheless, make sure that the store offers a money-back guarantee in case the movie is damaged and you want to return it.

What happens if I wreck a rental tape?

Uh-oh! You press the Eject button on your VCR and, rather than neatly spit out your rented tape of *The Beast Within,* the tape gets caught in the innards of your VCR. As you pull the cassette away from the VCR, entrails of magnetic tape flow from the cassette to somewhere inside your VCR.

Recriminations aside, you have a problem. The tape has no doubt become damaged to some degree. If the damage is severe, you could be liable for the cost of a replacement movie, which can be anywhere from $5 to $90.

All may not be lost, however. Be calm and take a close look at what has happened; the next three sections offer some quick-fix tips.

The tape is only caught under the little door on the front of the cassette

Whew! The damage is probably minimal, and there is little to worry about. Put the tape back in the cassette by pressing the little button on the right side of the cassette, near the little latch along the front. You can now carefully open the latch.

Next, turn the tape over so that the white reels face you and the access door is on the top. Use your finger (or ask someone for help) to turn the little plastic reel *on the left in the counterclockwise direction* to wind the tape back inside the cassette. You hear a ratcheting sound as you turn the reel. When the tape is all the way back in, test the tape in the VCR to see whether it's OK.

A couple of inches of tape stick out of the cassette

The damage is probably more severe, but the tape may still be watchable. Be careful to not touch the tape and follow the directions in the preceding paragraph to wind the tape back into the cassette. Test the tape in the VCR to make sure that it can still play.

Lots and lots of tape is sticking out of the cassette, and the tape is caught in the VCR!

The damage is probably really bad, and there's good cause for alarm (or least to check the amount of cash you have in your wallet, which you need in order to buy a new tape). Do the best you can to extract the tape from the VCR. Take the tape to the rental store and tell the employees what happened. If you're nice, and a tad lucky, they may not charge you for the tape.

Be a good citizen of the Movie Rental Society and don't return a badly damaged tape without saying anything about it. The store will rent the tape to someone else, and the tape can end up breaking someone else's VCR. You'd hate it if that happened to you.

"Holy hot water, Batman — the tape won't come out of the VCR!" The nightmare of nightmares, the tape you rented becomes trapped inside your VCR. Pressing Eject does nothing; the tape is firmly stuck. When this happens, *don't yank*. You have to take your VCR to a service center to disassemble the thing and get the tape out. Some of the better VCR rental stores can also do this for you.

Can I copy rental tapes?

Theoretically you can, but you're breaking the law if you do. Although the famous Betamax Supreme Court case a few years back gives you the right to tape programs broadcast to you over the air or through cable, it's copyright infringement (a big, naughty no-no) to tape prerecorded tapes.

In addition to the legal ramifications, most prerecorded tapes come with anticopying signals recorded on them. This signal, called *Macrovision,* is meant to disrupt the picture of any copy you try to make. Macrovision isn't foolproof, but it works most of the time.

The Macrovision anticopying signal can also affect the playback of some prerecorded tapes, even when you are *not* trying to record. Read more about the potential problems of Macrovision in Chapter 15.

All about Blank Tapes

When you're ready to record your own shows, start by buying some new, blank tapes that have nothing on them. Blank tapes are available just about every-where, including the corner supermarket. All blank tapes are not created equal, however. Tape quality varies greatly; the better the quality of the tape, the better your home recordings.

The record tab: your best friend; your worst enemy

Look at the label (also called the spine, like the spine of a book) of a video cassette. Look at the left corner. What you see is the record tab, or lack thereof. VCRs use this little tab to know if they can use the tape to record. New blank tapes you buy have the tab in place. With the tab there, your VCR can use that tape for recording.

As shown in Figure 10-1, you can use a fingernail or flat-headed screwdriver to remove this tab — it's just a piece of plastic. With the tab gone, the VCR can't record on the tape. Remove the tab from a tape of Uncle Joe's fifth wedding when he spills coffee on the minister, for example, just so you're sure that you'll never accidentally record over it.

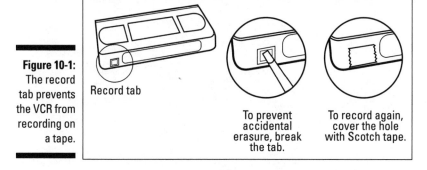

Figure 10-1:
The record tab prevents the VCR from recording on a tape.

Record tab

To prevent accidental erasure, break the tab.

To record again, cover the hole with Scotch tape.

What happens if the record tab has been removed, but you want to use the tape again for recording? The solution is easy. Just apply one or two layers of Scotch tape over the opening where the record tab was (refer to Figure 10-1). Your VCR will think it's a real record tab, and Uncle Joe can use your embarrassing tape to record the latest episode of *Frasier*.

Can I open a video cassette to see what's inside?

When Gordon was a kid, he used to take everything apart to see how it worked. It's a bad thing to do with your videotapes because they have lots of little parts, which can come flying out.

If you're the curious type, resist the temptation to disassemble a tape because you may not be able to get it back together again. Instead, just look at Figure 10-2, which shows the innards of a VHS tape.

Not all tape brands are the same

What's in a name brand? Lots, when it comes to videotape. The best videotape is made by recognizable brands, such as TDK, Memorex, BASF, Sony, Maxell, Fuji, and Polaroid. These companies go to great lengths to make sure that their tapes are made right because they know that little imperfections can cause big, ugly blotches on your screen when a tape is played back.

The name brands cost a little more, but not that much more for the extra quality you get. You can save a little money by buying tapes in bulk packages of three or five (or more) at a time. Shop around; you can often find name brand-quality tapes for less than $3 apiece.

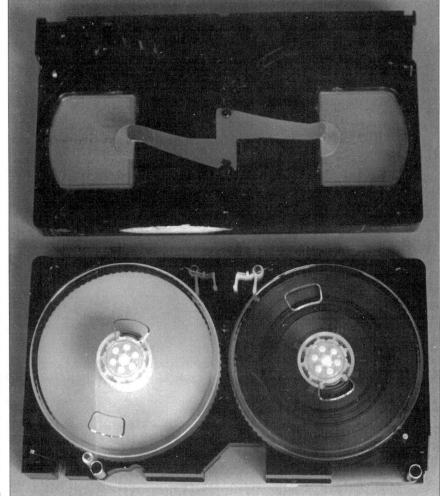

Figure 10-2:
Inside a
VHS
cassette
are
numerous
little parts
that scatter
everywhere
if you try to
take the
tape apart.

Look for the VHS logo on the tape, as shown in Figure 10-3. Although it's not an absolute guarantee of quality, tape makers cannot legally print the VHS logo on the tape box without agreeing to a series of quality-assurance measures from the keepers of the VHS system (mainly JVC, the company that pioneered the format).

Shysters are everywhere, and that includes people who make videotapes. Although it's not common these days, "counterfeit" videotapes still pop up every now and then. The counterfeits use names that are similar, but not identical, to the name brand they are trying to mimic. For example, you may be lulled into buying a tape made by Suny, TKD, or BSAF. (The correct spellings of these brands are Sony, TKD, and BASF — tricky, eh?) Read the label carefully.

Here are some signs of a potentially bad tape:

- A brand you and the sales staff at the store haven't heard of.
- A tape that lacks the VHS logo, as explained in the preceding tip.
- A counterfeit name-brand tape, as explained in the preceding warning.
- Just about any tape made in China. Right now, the worst tapes you can buy are made in China. Avoid them.

Tapes come in different grades

As if minding tape brands isn't enough, tapes from a particular company are available in different *grades*. The nomenclature of the grading is different, but it usually goes something like this:

- **High grade:** Designed for ordinary taping
- **Super high grade:** Designed for stuff you may want to keep awhile
- **Super-duper high grade:** The best stuff, for improved recordings you want to keep for many years

The problem is that one company's "*super* high grade" may be considered "*standard* high grade" by another company. Unlike gasoline, no tape-grade standards exist — there's no way to measure the "octane" of a tape — so quality eventually just comes down to how the grades are marketed.

At one time, TDK (one of the premier blank-tape makers) offered at least five different grades of tape, as though even the most knowledgeable consumer would know the difference between them.

Here are some rules of thumb when it comes to tape grades:

✔ Buy *standard grade* (name brand only, please) for programs you watch once and then erase. For example, you might use your VCR to record *General Hospital* while you're at work. You watch the program when you're making dinner (this is called *time shifting* in video lingo). There's no need for a high-quality tape because you'll use the same tape tomorrow to catch the next heart transplant.

Hey, the tape I bought doesn't have a name brand at all!

Your Uncle Fred found a great deal on blank VHS tapes: a dozen for ten bucks. For that price, you figure that it's worth a shot to give the tapes a try. Fair enough. We would do the same.

But when you get the tapes, they don't have any markings on them. There's no cover, no labels, no brand name printed anywhere. What gives? The tapes you just bought were probably extras from a "tape duplicator."

Tape duplicators are the companies that make copies of tapes for the movie studios. The tape may or may not be a reputable brand name, but that doesn't mean that it isn't any good. Often, surplus tapes from tape duplicators are of decent quality, so that's not the problem.

So what *is* the problem? The tape may not hold a full 120 minutes (at SP speed), like ordinary tapes do. Tapes purchased by tape duplicators are often cut to a specific length, to accommodate the length of the movie being duplicated. The movie may be only 105 minutes, so the tape has just enough in it to record, for example, 108 minutes. You're cheated out of 12 minutes. Imagine how mad you'll be if you try to use that tape to record a two-hour movie from your TV.

Sometimes, but not always, you can see the length of the tape by carefully looking at the back (label) side of the tape. Over on the left side is a *T-* and a number, printed with black or dark blue ink. The number denotes the amount of tape, in minutes, inside the cassette. If you see T-105, for example, you know that the tape records as much as 105 minutes, at SP speed. The T-number stamp is on most blank tapes, so you can use it to verify the length of the tape.

Another possible problem is that many tapes used by tape duplicators lack a record tab. When the record tab is removed, the VCR can't be placed in record mode. There's an easy remedy for this: Just use a small piece of scotch tape to cover the little notch where the record tab goes.

✔ Buy a *better* grade (exactly which one doesn't matter much, as long as it's a name brand) for tapes you want to keep. Use a higher-grade tape for your daughter's graduation, for example, or for a favorite snippet you taped from *The Late Show with David Letterman*.

✔ Because tape grades change from year to year, watch for the videotape reports in such magazines as *Consumer Reports* and *Video*. These articles can help steer you to a high-grade tape worthy of events and shows you want to keep for a long time.

What about tapes for the Super-VHS thing?

If you have a Super-VHS VCR (those super-expensive VCRs), you can use either regular VHS tapes or tapes specially made for Super-VHS. The special S-VHS tapes cost about twice as much as regular VHS tapes do.

How can you tell the difference between S-VHS and VHS tapes? By looking for the S-VHS logo, shown in Figure 10-4.

Figure 10-4:
High-quality
S-VHS tapes
have this
special logo.

You can find more information about VHS and S-VHS in Chapter 1.

✔ Don't try to use an S-VHS tape in a VCR that's not S-VHS. Your VCR can't use the tape adequately.

✔ An S-VHS VCR can record in regular VHS mode by using regular tapes, or it can record in high-quality S-VHS mode by using the special S-VHS tapes.

✔ If you record something on an S-VHS tape, it plays back only on an S-VHS VCR. (Exception: Some standard VHS VCRs can play an S-VHS tape, but they cannot record on one.)

Your S-VHS VCR knows that you're using an S-VHS tape because there's an extra hole in the bottom of the tape cassette. Just drilling a hole in a standard VHS tape doesn't make it an S-VHS one, though. The S-VHS tape has a different *formulation* and is made to hold the extra signal required by the S-VHS system.

Tapes come in different lengths

As you probably know already, blank videotapes come in a standard length. At SP speed, the tape records for 120 minutes. These tapes are known as T-120 tapes because they have as much as 120 minutes of recording time on them.

The tape lasts even longer if you record at the slower LP and EP (also known as SLP) speed, as shown in Table 10-1.

Table 10-1	Record/Playback Times for T-120 Tapes in Different Modes	
SP	*LP*	*EP*
2 hours	4 hours	6 hours

You can also buy tapes in longer and shorter lengths. The most common longer length is the T-160, which means that it holds as much as 160 minutes at SP speed. T-160 tapes are harder to find than the regular T-120 tapes and cost more.

In addition, you can buy tapes of other lengths, but only from specialized outfits and by mail order. Unless you buy a large number of blank tapes at a time, the shorter tapes aren't much cheaper than the ordinary run-of-the-mill T-120 tapes you can buy at the drugstore.

Table 10-2 shows the common lengths for VHS tapes in addition to the amount of information they hold at different recording speeds.

Table 10-2	Common Record/Playback Lengths for VHS Tapes		
Tape	*SP*	*LP*	*EP*
T-30	Half-hour	1 hour	2 hours
T-60	1 hour	2 hours	4 hours
T-90	1 hour 30 minutes	3 hours	4 hours 30 minutes
T-120	2 hours	4 hours	6 hours
T-130	2 hours 10 minutes	4 hours 20 minutes	6 hours 30 minutes

Tape	SP	LP	EP
T-160	2 hours 40 minutes	5 hours 20 minutes	8 hours
T-180	3 hours	6 hours	9 hours
T-200	3 hours 20 minutes	6 hours 40 minutes	10 hours

The T-160 and longer tapes sound like a good idea because they can record a movie that's longer than two hours. Unfortunately, the T-160 and longer tapes are *thinner* than the others because more tape has to be crammed into the regular-size cassette. Because the tape is thinner and more fragile (not to mention more expensive), don't use the extra-long tape formats unless you really have to.

Want to see this information another way? Figure 10-5 is a nifty graph that shows you the recording times for T-120 and T-160 tapes, at SP, LP, and EP (SLP) recording speeds.

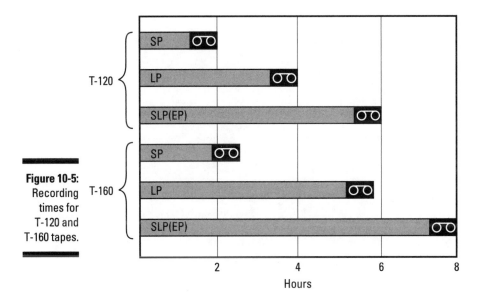

Figure 10-5: Recording times for T-120 and T-160 tapes.

What are these miniature T-20 tapes?

VHS cassettes come in two different sizes: regular size — for home VCRs — and compact, for VHS-C camcorders (the *C* stands for compact). You can play a VHS-C tape on your home VCR, but only if you have a VHS-C adapter, which comes with some VHS-C camcorders.

The standard length for VHS-C tapes is 20 minutes, when you record at SP speed. Some VHS-C tape is available in 30-minute lengths. The tape box says T-20 or T-30 to indicate the length.

I have tapes marked with an *E* rather than a *T*— what gives?

Tapes marked with a *T* are for use in primarily North America and Japan, where televisions use something called the NTSC system to show a video image. Other countries — primarily European ones — use a different system.

These systems, known by names such as PAL and SECAM, are incompatible with the NTSC system. A VCR used in Great Britain with the PAL system runs at a slower speed, for example, than does a VCR used in the United States.

Tapes destined for use in Europe and many other parts of the world often (but not always) use different length markings, most often an *E* (for Europe). In Europe, an E-180 tape is about the same as a T-120 tape used in North America.

Compounding the issue is that in Europe, folks also sell tapes with the *T* but use a different numbering system. For example, an E-180 sold in Europe has about the same amount of tape inside as a T-120 sold in North America (it lasts three hours at SP speed rather than just the two hours). Be careful if you buy tapes in Europe and you're accustomed to the tape-length system used in North America.

The question is, can you record by using a tape marked with an *E*, even though you live in North America and your VCR uses the NTSC standard? Yes. The videotapes themselves are identical. You can record on any blank tape, regardless of whether it was supposed to be used in Europe, the United States, Bora Bora, or elsewhere.

Here's the catch. Although you can record on any blank tape, you cannot play a prerecorded tape designed for a different system. For example, you cannot play a tape made for use in Great Britain if you have a VCR used in the United States. If you absolutely must do this sort of thing, you have to buy a *multistandard* VCR. These types of VCRs, manufactured by Panasonic, Aiwa, and Instant Replay, among others, are expensive.

What's this L-500 tape?

Tapes marked with an *L* are Beta tapes. They can't be used in VHS VCRs because the cassette is too small.

If you have a Beta VCR, of course, you want to buy Beta tapes. They are getting harder to find and can be expensive. Beta tape comes in two standard lengths: L-500 and L-750. You can record for as long as $4^{1}/_{2}$ hours using these tapes, depending on the speed you use, as shown in Table 10-3.

Table 10-3	Record/Playback Times for Beta Tapes	
Tape	*Beta II*	*Beta III*
L-500	2 hours	3 hours
L-750	3 hours	4 hours 30 minutes

What about blank tapes for my 8mm camcorder?

Your 8mm camcorder uses special miniature tape cassettes made just for it. These cassettes are just slightly larger than an audiotape cassette. The same comments apply to 8mm blank tapes as they do to VHS tapes. Name brands are important, and you should buy the best tape grade you can afford.

The standard length for 8mm tapes is 120 minutes at SP speed. Many 8mm camcorders record only at SP speed, but some can switch to the more economical LP speed to double the recording time.

✔ Because of the nature of 8mm tapes, you should record only at SP speed. The reason: 8mm camcorder tape is particularly prone to dropouts — small flecks of magnetic particles coming off the tape. This problem is compounded the more you play and record a tape, and it is visibly much worse at the slower LP speed.

✔ The same comments hold true for the high-quality, Hi8 camcorders. Stay away from the cheap tapes.

✔ You can find more information about tape for camcorders in Chapter 12.

All about Storing Videotapes

Whether you buy movies or record your own, follow these simple steps to properly store your tape collection. Your tapes will last longer and aren't as likely to dirty your VCR.

- Put the tape back in its protective sleeve after you eject it from the VCR.

- Never stack up your tapes like you do old magazines. Tapes are heavy; the tape on the bottom gets squashed by the tapes on the top.

- Store your tapes in videotape drawers. A set of drawers that can hold 20 tapes costs about $10 to $12.

- Whether you buy tape-storage drawers or fashion them yourself, make sure that the tapes are stored spine up. This technique keeps the tape from sagging inside.

- Store tapes so that the long edge points downward. Don't store tapes standing on their short side; the weight of the tape inside can stretch it over time.

- Always keep tapes away from heat. Hot spots to avoid include the top of your VCR, the top of your TV, beside the radiator, and in your car. If someplace is too hot for you, it's too hot for the tape.

- Keep tapes away from magnetic fields at all times. This advice includes speakers, older-style telephones with mechanical ringers inside, micro-wave ovens, and your kid's "You and Magnetism" science-fair project.

- Don't store tapes in a wine cellar or the basement. It's probably too damp. Your tapes like air that is cool and relatively dry. If you can comfortably live in a room, so can your tapes.

Before putting a tape away after watching it, turn it over so that the white reels face you. Position the little access door (where the tape comes out) so that it's on the top. Stick your finger in the *left* reel and turn *counterclockwise,* no more than about a quarter of a turn. You hear a ratcheting sound as you turn the reel; this is normal. Turning the reel a little removes any excess slack in the tape and keeps the tape from becoming deformed. *Be careful not to turn too much!*

Can Tapes Safely Go Through the Airport X-Ray Machine?

Seasoned travelers know that it's a good idea to keep photographic film away from the X-ray machine at the airport. Despite what the security guard says, the X-ray machine can fog your film and ruin the snapshots of your vacation.

Do X-rays harm videotape the same way they do film? No. Videotapes are largely insensitive to the X-ray radiation of the newer airport X-ray machines. Whether the tape has been recorded on or not, putting it through the X-ray machine should pose no problem.

Some of the older X-ray machines, however, use very big magnets to produce X-rays. The machines are all but gone from modern airports, but they may still be used in some of the smaller, older ones. Although it is highly unlikely, the magnet can partially erase the picture or sound on your tape. If you're at an old airport, don't be afraid to have the security people hand-check your videotapes.

Your best bet is to simply pack your videotapes along with your baggage. The airlines usually show a movie on the longer flights anyway.

Chapter 11
Slightly More Strenuous TV/VCR Hookups

- -

In This Chapter

▶ Extra stuff you may have to buy

▶ All about cables, signal splitters, and A/B switches

▶ Hooking up one VCR to two TVs

▶ Hooking up two VCRs to one TV

▶ Hooking up two VCRs to two TVs

▶ Hooking up to both cable and antenna

▶ Hooking up to a stereo system

▶ Hooking up to a satellite dish

- -

Maybe you have more than one TV. Or maybe you have both cable and an antenna for receiving TV stations. The simple VCR/TV hookup scheme in Chapter 3 isn't enough for you. You cry out for more.

The satellite dish coming from the mail-order house just might push your system to the breaking point. But rest easy. This chapter details bunches of ways to hook up your bevy of VCRs to a flock of TVs and other accessories.

Extra Stuff to Buy for Extra VCR Needs

Odds are that you have to purchase extra gadgets and gizmos to hook up your TV and VCR in a special way. Most of the gadgets described here are available at your local Radio Shack and at most electronics stores and home improvement outlets.

Coax cable

Video signals that carry both picture and sound require *coaxial cable*. (Suave VCR enthusiasts simply call it *coax*.) This stuff, usually black, is about $^1/_4$-inch in diameter and has funny-looking F-connectors on the end. The F-connector has a solid wire in the middle and a threaded or slip-on, silver, metal connector lurking on each end.

For most jobs — such as hooking up two VCRs to a TV — you need short 3- to 6-foot lengths of coax cable, available at Radio Shack and many electronics and home-improvement stores. Buy the length you need, but avoid extra long cables because they can degrade the picture and sound quality.

If you want, you can make your own coax cables that are just long enough for the job. You can buy coaxial cable by the foot at Radio Shack and many home-improvement stores. You need a pair of F-connectors for each cable you make: If you're in a hurry, buy the "crimpless" kind; they cost more than the crimp-on type, but they're easier to install. (A picture on the back of the F-connector package shows you how to push them on to the cable.)

Matching transformer

Two kinds of cable are available for hooking up TVs: coax and something called "twin lead." Depending on the terminals on the back of your TV and the kind of cable used for your outdoor antenna, you may have to install matching transformers to get everything connected. These transformers (shown in Chapter 3) are small and cheap and act as adapters to physically match two cable types together.

- *Matching transformers are referred to by an arcane method of electrical resistance.* Coax cable has an electrical resistance of 75 ohms; twin lead has an electrical resistance of 300 ohms. Yawn.

- *Ohm* is pronounced "om," like an Eastern meditational chant.

- Most modern TVs are equipped with just a round F-connector for 75-ohm coax. The older sets have two screw terminals for 300-ohm twin lead.

- Use a 75- to 300-ohm matching transformer to hook up coax cable to a TV that has two screw terminals on it.

- Use a 300-to-75 ohm matching transformer to hook up an outdoor antenna to coax cable.

- If your outdoor antenna uses twin lead now, consider replacing it with coax cable to improve your reception. (Exception: Your reception doesn't improve if your antenna is designed solely to pick up UHF stations; that is, Channel 14 and beyond).

Signal splitters

A *signal splitter* takes a combined audio/video signal from one coax cable and divides it so that it goes down two cables (see Figure 11-1). You need a signal splitter whenever you want to take one signal and make it go two ways. Example: You want to hook up a single VCR to two TVs.

Figure 11-1:
Use a two-way splitter to split one cable two ways.

Two-way splitter

✔ The process of splitting a signal sounds simple enough, but believe it or not, you can't just splice wires. A splitter is absolutely necessary because it uses electrical components inside to balance the signal so that it's equal on both outputs.

✔ The most common signal splitter splits one cable into two (called a two-way splitter).

✔ You can also buy four-way splitters, in which one cable is split into four.

✔ If you want to split the signal into only two cables, don't use a four-way splitter. The picture isn't as good.

✔ Don't use a large number of signal splitters. Every time the signal is split, its strength is halved.

✔ If a signal is weak to begin with (a bad picture coming from the antenna, for example), don't use a signal splitter unless it's one of those expensive, amplified types.

A/B switch

An *A/B switch* is sort of like a signal splitter except that, rather than send a signal down two wires at the same time, the A/B switch sends the signal down one wire or the other, but not both (see Figure 11-2).

The most common use of A/B switches is when you want to choose between either of two signal sources, such as two VCRs or a cable box and an outdoor antenna.

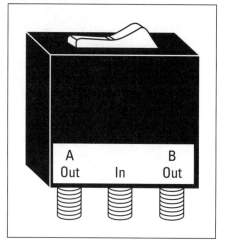

Figure 11-2:
Use an A/B switch to select between two sources, like a cable box or an antenna.

Video input selector

A video selector is a glorified A/B switch. The selector lets you choose between two or more different sources. You push a button on the front of the selector to switch to the source you want. You might push the button, for example, to choose among cable, antenna, or satellite dish. The signal from the selected source is sent to your TV and VCR.

✔ When you're hooking up a VCR, use its Antenna In jack for the cable that comes from the antenna. This connector is the same as VHF In and RF In.

✔ Use a VCR's Antenna Out jack for the cable that goes to the TV. This connector is the same as VHF Out and RF Out.

A nearly useless word about antenna connector names

Different VCRs use different names for the antenna connectors (these connectors are on the back of the machine). Your VCR has at least two antenna connectors. They might be labeled Antenna In and Antenna Out. Or they might be labeled VHF In or VHF Out. Or on some VCRs, they might be labeled RF In and RF Out (the RF stands for radio frequency, the kind of signal carried in the coax cable).

If your VCR has four antenna connectors, they are probably labeled VHF In, VHF Out, UHF In, and UHF Out. The VHF connectors are for Channels 2 through 13, and the UHF connectors are for Channels 14 through 69. Four antenna connectors are generally found only on much older VCRs.

This book refers to the antenna connectors as Antenna In and Antenna Out.

Limitations and Variations

No matter how you hook up your VCR and TV, your setup will always have some limitations. The plans in this chapter are designed to be easy to do, with the fewest number of limitations. We try to warn you of the major limitations for each plan, in a section called "Pros and Cons."

If you're not happy with the limitations, feel free to experiment and try a different route. As long as you're careful, you really can't hurt your VCR and TV by experimenting with different hookup schemes.

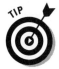

Before doing any wiring, plan your video system on paper first. Draw boxes for your VCR and TV and any other components you have. Draw lines between everything to denote the cables. As you work with your plan, you can see where you need extra cables, signal splitters, A/B switches, and other components.

Hooking Up One VCR to Two TVs

Perhaps the most common alternative VCR hookup scheme involves one VCR and two TVs. The VCR and one TV might be in the living room or den; the second TV might be in a bedroom or family room. We call the TV near your VCR the *primary* TV, and the TV that's placed in the other room the *secondary TV*.

Stuff you need for the job

- ✔ Signal splitter
- ✔ Two short cables (six feet or shorter) to go from your VCR to the primary TV, making a pit stop through the signal splitter
- ✔ A long cable (its length depends on your house) to go from your VCR to the secondary TV

What you have to do

1. **Hook up the short cable between your VCR and the IN connector on the signal splitter.**

 Look at Figure 11-3 as a guide.

 Be sure that the output from the Antenna Out terminal of your VCR is connected to the IN connector of the splitter.

2. **Hook up another cable between one of the OUT connectors of the splitter and the antenna terminals of the primary TV.**

Use a 75- to 300-ohm matching transformer if your TV doesn't have a round F-connector for the antenna input.

3. **Hook up the long cable between the other OUT connector of the splitter and the antenna terminal on the secondary TV.**

How it works

You don't have to do anything special to watch programs from your VCR. Just turn on the TV. The system works the same as though you had only one TV.

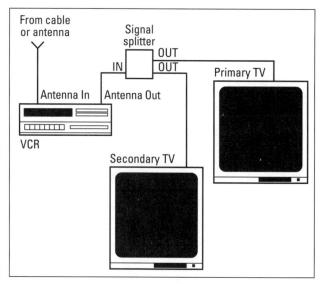

Figure 11-3: Hook up two TVs to the same VCR with a signal splitter.

Pros and cons

✔ **Pro:** You can watch your VCR on the TV in your bedroom.

✔ **Con:** Your VCR is too far away to operate with the remote control.

✔ **Con:** Both TVs get the same signal from your VCR.

Hooking Up Two VCRs to One TV

One VCR isn't enough for you. Oh, no. You have to have two. OK, so having two VCRs may seem a little strange, but a pair of VCRs can come in handy. You can watch a tape on one VCR, for example, while you record on another. And you can make a copy of your family tapes from one VCR to another.

We call one of the VCRs, the one that hooks up directly to the antenna or cable box, the master VCR. To keep parallel metaphors, we call the other VCR the slave VCR.

Stuff you need for the job

> ✔ Two short cables (six feet or shorter) to go between the two VCRs and your TV

What you have to do

1. **Hook up one of the cables from the Antenna Out connector of the master VCR to the Antenna In connector of the slave VCR.**

 Look at Figure 11-4 as a guide.

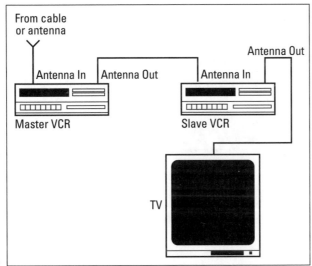

Figure 11-4:
Hook up two VCRs to a single TV using this method.

2. **With the other cable, hook up the cable from the Antenna Out connector on the slave VCR to the TV.**

 Use a 75- to 300-ohm matching transformer if your TV doesn't have a round F-connector for the antenna input.

How it works

- ✔ To watch a program coming from the antenna or cable box, set the TV/Video switch on both VCRs to TV.

- ✔ You can record a program from the antenna or cable box on either VCR.

- ✔ To record a program coming from the antenna or cable box and watch another tape, record with the master VCR. Put the tape you want to watch in the slave VCR.

- ✔ To watch one program and record another (when you're using an antenna), record with the master VCR. Set the TV/Video switch on both VCRs to TV.

- ✔ To make a copy of a tape, put the original tape (the one to copy) in the master VCR and press Play. Put a blank tape in the slave VCR and press Record.

Pros and cons

- ✔ **Pro:** You can make copies of tapes.

- ✔ **Pro:** You can record one program while watching another tape.

- ✔ **Con:** You can record only from master to slave, not from slave to master.

Hooking Up Two VCRs to Two TVs

With a signal splitter and a cable, you can convert the two-VCRs-to-one-TV setup to add another TV. By putting the signal splitter on the cable that comes from the master VCR rather than from the slave VCR, you can pipe different things to the two TVs. One TV might be in the living room and the other in a bedroom or family room.

As we did earlier, we call one of the VCRs — the one that hooks up directly to the antenna or cable box — the master VCR. To keep parallel metaphors, we call the other VCR the slave VCR. And we call the TV nearest the VCRs the primary TV, and the distant TV is the secondary TV.

Stuff you need for the job

- ✔ A signal splitter to split the signal from the master VCR

- ✔ Three short cables (six feet or shorter) to go between the two VCRs and your primary TV

✔ One long cable (its length depends on your house) to go between the master VCR and the secondary TV

What you have to do

1. **Hook up one of the short cables from the Antenna Out connector of the master VCR to the IN connector on the signal splitter.**

 Look at Figure 11-5 as a guide.

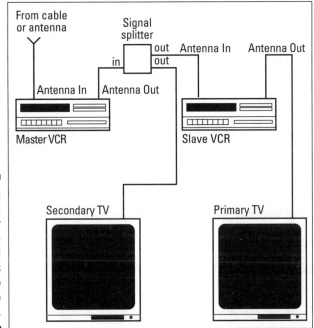

Figure 11-5:
Use a signal splitter between the master and slave VCRs to hook up two VCRs to two TVs.

2. **Hook up another short cable from one of the OUT connectors of the signal splitter to the Antenna In connector of the slave VCR.**

3. **Use the third short cable to hook from the Antenna Out connector on the slave VCR to the primary TV.**

 Use a 75- to 300-ohm matching transformer if your TV doesn't have a round F-connector for the antenna input.

4. **Hook up the long cable from the other OUT connector of the signal splitter to the secondary TV.**

Use a 75- to 300-ohm matching transformer if your TV doesn't have a round F-connector for the antenna input.

How it works

- The system works in pretty much the same manner as described earlier for two VCRs and one TV. Read that section for more information.

- The secondary TV receives its signal only from the master VCR.

- The pros and cons are the same for the two VCRs-one TV hookup. An additional con is that the secondary TV can't show what's on the slave VCR.

Hooking Up Both a Cable and an Antenna

If you have cable and an outdoor antenna, you'll want a way to switch between them so that you can tune to your cable box when you want to watch cable and tune to your antenna when you want to watch a local TV broadcasting station.

Stuff you need for the job

- A/B switch
- One short cable (about six feet) to go between the A/B switch and your VCR

What you have to do

1. **Hook up the cable from the outdoor antenna to the A input (A for Antenna) of the A/B switch.**

Look at Figure 11-6 as a guide.

2. **Hook up the Antenna Out connector of the cable box to the B input of the A/B switch.**

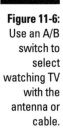

Figure 11-6:
Use an A/B
switch to
select
watching TV
with the
antenna or
cable.

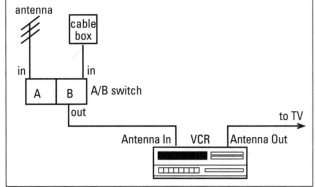

3. **Hook up the short cable from the output of the A/B switch to the An-tenna In connector on your VCR.**

 The TV and the VCR are connected in the normal manner.

How it works

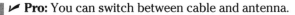

🗸 Push the A switch to watch channels from the antenna.

🗸 Push the B switch to watch channels from the cable.

Pros and cons

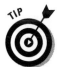

🗸 **Pro:** You can switch between cable and antenna.

🗸 **Con:** You can't watch something from cable and the antenna at the same time.

🗸 **Con:** If you're taping programs while you're away, you have to remember to switch to the channel source (A for antenna or B for cable).

Use the same basic technique as described earlier to hook up a cable box and a satellite box or an antenna and a satellite box. Plug in one channel source to the A input of the A/B switch, and plug in the other channel source to the B input of the A/B switch.

Hooking Up a Stereo System

Want a wire to liven up your TV viewing? Pipe the TV sound through your stereo hi-fi system. No matter how good your TV is, the sound quality through a stereo system is almost always better. Many TV shows and prerecorded tapes are in stereo. If you have a stereo VCR, you can enjoy listening to these shows in stereo.

Stuff you need for the job

✔ A pair of audio cables (the length depends on how far away your stereo receiver is)

✔ Short coax cable (about six feet) to connect between your VCR and TV

What you have to do

1. **Hook up the short coax cable from the Antenna Out connector of your VCR to the antenna terminals on your TV.**

 Use a 75- to 300-ohm matching transformer if your TV doesn't have a round F-connector for the antenna input.

2. **Connect the audio cables.**

 If your TV is not stereo or does not have audio output connectors on it, hook up the pair of audio cables between the Audio Out connectors on your VCR (both the right and left sides), as shown in Figure 11-7. Hook up the other end of the audio cables to the Aux Input of your stereo receiver.

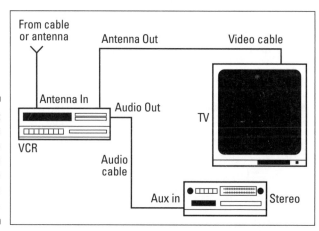

Figure 11-7: Follow this diagram to hook up stereo sound from your VCR.

If your TV is stereo and does have audio output connectors, hook up the pair of audio cables between the Audio Out connectors on your TV (both the right and left sides), as shown in Figure 11-8. Hook up the other end of the audio cables to the Aux Input of your stereo receiver. (If the Aux input is occupied, the CD, DAT, or tape input will work as well.)

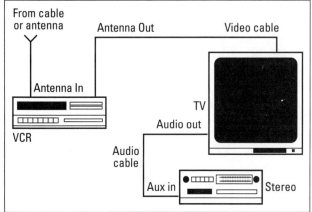

Figure 11-8:
Follow this diagram to hook up stereo sound from your TV.

How it works

- ✔ Use your TV and VCR in the regular way.

- ✔ Turn on your stereo receiver and press the Aux button (or CD, DAT, or tape, if the VCR is connected to one of these inputs instead) to listen to TV sound.

- ✔ For a more full stereo effect, adjust the volume on the TV so that you can hear the sound from the TV as well as from the stereo speakers.

- ✔ For best results, the speakers for the stereo system should be placed to either side of the TV, no more than about eight to ten feet apart.

Pros and cons

- ✔ **Pro:** You can listen to TV sound in stereo.

- ✔ **Con:** You can't easily adjust the sound level by turning down the TV; you have to turn down your stereo also.

- ✔ **Con:** All this cries out for a stereo VCR.

- ✔ **Con:** This hookup requires your stereo system be in close proximity to your TV and VCR.

What's All This "Home Theater" Stuff?

You know what a home is. And you know what a movie theater is. Put 'em together, and you have a home theater. Simple, yes? Well, no, not exactly. Although the concept of a home theater is pretty obvious, what goes into a home theater isn't obvious. The basic home theater is made up of the following:

- A big screen TV. *Big* means that the TV should have a screen over 27 inches (measured diagonally, as always). The bigger the screen, the better because a real movie theater has pretty big screens. Lots of folks like the big rear-screen projection TVs for their home theaters. These TVs sport screen sizes in excess of 45 or 50 inches. Now that's BIG!

- A high-quality VCR with stereo hi-fi capability. A Super-VHS VCR is preferred because it can play back Super-VHS tapes, the tapes that deliver sharper pictures.

- A stereo sound system. The VCR is hooked up through the stereo system, as discussed in the previous section of this chapter. At a minimum, the sound system is comprised of a receiver/amplifier, and two speakers. Better home theaters use a receiver/amplifier equipped with something called Dolby Pro-Logic and extra speakers placed strategically around the room. Specifically, two extra speakers are added to the back of the room (for ambiance) and a fifth speaker is added right beside or on top of the TV. The Pro-Logic circuit in the receiver/amplifier sends the proper sound to the speaker that's supposed to get it. The result: a sound just like the one at the local Bijou!

For your home theater, you can throw in whatever bells and whistles you can afford, such as a satellite dish or a video disc player.

Is home theater worth it? Some TV nuts say it is (and we agree with them). Home theater is mostly about sound, and sound is an often-forgotten part of watching TV. The rich, full sound of home theater gives you part of the excitement you enjoy when watching a movie in a theater.

If you can't afford a home theater, you can still enjoy better sound by hooking up your VCR to your existing stereo. Whether you go the full home theater route, it's a good idea to put the stereo speakers on either side of the TV. Place the speakers about 6 to 8 feet apart, and angle them slightly to the center of the room. Where the sound waves meet is called the *sweet spot,* as shown in Figure 11-9. That's where the sound is the fullest.

Making Your Own Cables

Sooner or later, you'll want to replace those coils of 20-foot black coax cable behind your TV system with cables that are the appropriate length. Using

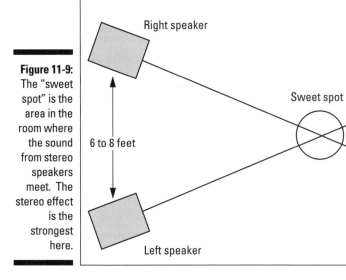

Figure 11-9:
The "sweet spot" is the area in the room where the sound from stereo speakers meet. The stereo effect is the strongest here.

cables that are just long enough helps reduce clutter, and they are not as apt to pick up interference, which you can see and hear on your TV.

It's not hard to make your own coax cables, but you do need the right parts and tools. At a minimum, you need a sharp knife and a package of F-connectors. The knife you can get from your kitchen; the F-connectors you can get at Radio Shack. See Figure 11-10 for details on how to cut the coax cable to make a connector.

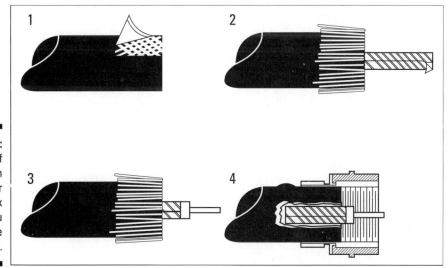

Figure 11-10:
The steps of attaching an F-connector on coax cables you make yourself.

What you have to do

1. **Cut off about an inch-and-a-half of the outer insulation of the cable.**

2. **Pull back the metal braid that's under the outer insulation. Trim off about a half-inch of this metal braid.**

3. **Many coax cables have a thin layer of foil underneath the braid. Cut this away as shown to expose the white foam insulation (this stuff is called the *dielectric*). Carefully cut about 3/4-inch of the dielectric, exposing the thick copper wire. Don't nick this wire with your knife!**

4. **Push an F-connector onto the end of the cable.**

 The sleeve of the connector should fit over the outer insulation of the cable, as shown. The thick copper wire should just protrude past the barrel of the F-connector.

If you don't trust yourself with a knife, buy a coax cable stripper at Radio Shack. The cost is less than ten bucks. The stripper automatically removes the proper amount of insulation and dielectric.

F-connectors come in two types: crimp-on and screw-on. The crimp-on kind are more permanent. You crimp the connector over the cable, preferably using an F-connector crimping tool (Radio Shack has 'em), as shown in Figure 11-11. The screw-on kind actually screws onto the end of the coax cable and is easier to use because you don't have to use a special tool. However, the connector can get yanked off if you try hard enough.

Figure 11-11:
For a professional job, use a special crimping tool to attach crimp-on F-connectors to the coax cables.

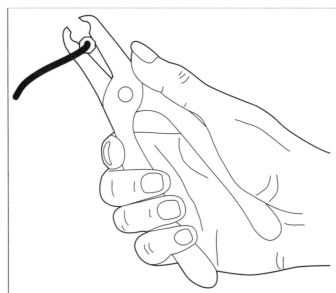

TECHNICAL STUFF

Please don't read this boring stuff on using baseband signals

Coax cable is designed to carry both the picture and sound of a channel at the same time. Technically speaking, the picture and sound are "modulated" to radio frequencies so that they can be sent through the air or down long lengths of wires. You sometimes see coax cable referred to as RF cable; the RF stands for radio frequency.

VCRs, and many TVs, are also designed to take separate audio and video signals. These signals are not combined with one another, and they are not modulated to a radio frequency. Separate audio and video signals are called baseband signals.

Look in the back of your VCR. You see several sets of extra connectors for baseband audio and video cables. If your VCR is monophonic, you see four connectors, or jacks: Video In, Video Out, Audio In, and Audio Out. If your VCR is stereo, you see additional characters for the right and left channels of the Audio In and Audio Out connectors.

Is there an advantage to using the baseband audio and video connectors? You bet. Because the signals aren't carried through radio frequency waves, the picture and sound are better. Not that much better maybe, but better enough for the discerning eye to see.

If you want the best picture and sound possible and your TV has matching audio and video connectors on it, use the baseband audio and video whenever possible. It complicates your video setup somewhat, but the extra improved quality should be worth it.

Bear in mind the following:

- On some VCRs, hooking up cables to the audio/video jacks can override the antenna input. To watch something on a regular channel, you must unplug the cables going to the Audio In and Video In connectors on your VCR.

- On other VCRs (particularly the newer models), you must dial your VCR to Channel Aux (really Channel 1 or Channel 0) to watch the signal coming through the Audio In and Video In connectors on your VCR.

- Be sure to use audio and video cables suited for the job. Cables already made with the appropriate connectors (called phono or RCA) are available at Radio Shack, electronics stores, and most home-improvement stores.

The 5th Wave — By Rich Tennant

"WHOA, HOLD THE PHONE! IT SAYS, 'THE ELECTRICITY COMING OUT OF A SURGE PROTECTOR IS GENERALLY CLEANER AND SAFER THAN THAT GOING INTO ONE, UNLESS -UN-LESSS- YOU ARE STANDING IN A BUCKET OF WATER.'"

Part III
Cradling the Camcorder

In this part...

This part of the book covers the opposite of VCRs: camcorders. Instead of merely playing back movies, camcorders let you play director. You're also playing producer, cameraman, editor, and, unfortunately, financier. Camcorders, tapes, batteries, and other accessories can suck up cash quickly.

Still, camcorders are fun: You can videotape your friends' embarrassing moments at parties (until you're no longer invited). When those UFOs reappear above the hills, you can whip out your camcorder and capture the moment to sell to the major TV networks.

Whether you're looking for the right camcorder videotape, trying to decide what camcorder to buy, or simply trying to figure out the camcorder's White Balance button, this part of the book is for you.

Chapter 12
Camcorders, Tapes, and Formats

. .

In This Chapter

▶ Choosing among camcorder formats

▶ Buying the right videotape

▶ Understanding camcorder features

▶ Caring for a camcorder

. .

Camcorders all do the same thing: They record live action on videotape, which gives every camcorder owner the potential power of a TV news crew. Although every camcorder owner secretly hopes to capture a video clip important enough to be debated on Larry King *and* David Letterman, most videos contain simply birthday candles, wedding cakes, or relatives acting weird.

This chapter explains the differences between the plethora of camcorder formats on the market and to the proper variety of videotape each camcorder format prefers to eat.

You can find explanations of those confusing, one-word "features" boasted about in advertisements from consumer electronics stores. Finally, you get a few tips for keeping that expensive camcorder as healthy as possible.

Which Camcorder Is Which?

As described in Chapter 1, VCRs come in only two basic formats: normal and fancy. Thoroughly confused consumers can simply flip a coin when they're deciding between the two.

Camcorders, however, currently force consumers to choose between *six* different formats. The hardest choice, however, probably boils down to size: big or small.

At first thought, small seems to be the best bet. Why lug around a hefty camcorder when a tiny, palm-size one will do? But the choice isn't that easy. Smaller camcorders use smaller-size tapes — tapes that don't fit into a standard VCR for easy playback.

Big camcorders use the normal, VCR-size tapes. Small camcorders use the newer, smaller-size tapes. And both the big and small camcorder formats are covered in the following two sections.

The big camcorders

Big camcorders have been around for years; you've probably seen people resting them on their shoulders at Disneyland. Most of them weigh at least four pounds.

Big camcorders come in two types, normal VHS and Super-VHS, just like their VCR cousins.

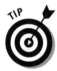

Don't immediately rule out a larger VHS camcorder simply because of its size. Larger camcorders don't wiggle around as much when you're shooting, often leading to smoother shots.

VHS camcorders

Description: These camcorders use the same VHS videotapes that plain ol' VCRs have been using for 20 years. No newfangled tape technology is involved.

Pros: After videotaping an emerging butterfly in the backyard, simply pop the tape out of your camcorder and push it into your VCR: instant *National Geographic* special. These camcorders make recording and viewing quick and convenient.

Cons: These camcorders are *huge;* they *have* to be in order for those large VHS videotapes to fit inside. The size startles even emerging butterflies.

Who buys it: Until a few years ago, most people preferred this format for its convenience. They're also popular with people who don't trust newer tape formats. (Remember 8-track?)

Comments: VHS camcorders accounted for about a quarter of camcorder sales last year.

S-VHS camcorders

Description: This is the higher-quality version of the VHS camcorders just described. They use Super-VHS videotapes, just like the S-VHS VCRs described in Chapter 1 do. Buyers of this format don't mind paying extra for higher quality. In fact, they've probably already paid extra for an S-VHS VCR, and they want their camcorder to match.

The small camcorders

The seven dwarves definitely would have chosen the newer, small-size camcorders for shooting vacation videos with Snow White. You might choose one too, after comparing the size and weight difference to the regular VHS camcorders. By using smaller-size tapes, camcorders have shrunken to less than two pounds.

Small camcorders come in two main formats: 8mm or VHS-C, both described in this section. Both these formats come with a higher-quality, super version, so today's consumer chooses between four types of small camcorders. They're all described in this section.

8mm camcorders

Description: In the early '80s, several Japanese manufacturers contemplated the ideal camcorder format and came up with 8mm format. These tapes are about the size of a fat audiocassette, but they can still record as well as the larger VHS-format camcorders do.

Pros: Because they're smaller and lighter, 8mm tapes can fit in smaller, lighter camcorders but keep the quality on par with the large VHS formats.

Cons: An 8mm tape can't be played back on a normal VHS VCR. To watch your videos, you can either plug the TV straight in to the camcorder and press Play or copy the 8mm tape to a VCR's VHS tape for later viewing. The copying process loses some picture quality, unfortunately.

Who buys it: People looking for small, palm-size camcorders gravitate to 8mm. It's a relatively inexpensive and convenient way to bring home some vacation footage. You won't find professionals using them to film weddings, however; 8mm camcorders are aimed at the consumer market.

Comments: More than half the camcorders sold last year use the 8mm format.

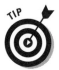

Some vendors *do* sell VCRs that can play back 8mm tapes; those 8mm VCRs are used mostly for editing camcorder tapes. (After all, nobody rents movies on 8mm format.) In fact, some VCRs can hold both an 8mm *and* a VHS tape, making it easy to copy from one format to another.

Hi8 camcorders

Description: The camcorder's equivalent of S-VHS, these camcorders and tapes look just like their 8mm cousins. But Hi8 camcorders can record and play back video with much higher quality.

Pros: Hi8 camcorders can't record *broadcast*-quality video — but they're coming closer than ever. Designed for serious video hobbyists, many Hi8 camcorders come with special editing controls and special effects.

Cons: Hi8 gear is expensive. The Hi8 format adds several hundred dollars to the price of the camcorder, and Hi8 tapes often cost twice as much as ordinary 8mm tapes do.

Who buys it: People who own S-VHS VCRs usually opt for Hi8 camcorders as well. They care more about quality than about price, they have the extra cash, and they've already worked out the expense with their spouses.

Comments: A Hi8 camcorder can play and record video by using either 8mm *or* Hi8 videotapes. It needs the expensive Hi8-format tapes in order to record with the highest quality level, however.

VHS-C camcorders

Description: Standard VHS tapes were too big for truly portable camcorders, so JVC's engineers thought up the Compact VHS (VHS-C) format. These smaller-size tapes lead to smaller camcorders, but the tape can still be played back on a standard VHS VCR by pushing the tape into an adapter as shown in Figure 12-1.

Pros: It's quick and easy: Shoot your movies, pop out the VHS-C tape, push the tape into a little adapter, and start playing back the video on your standard VHS VCR. There aren't any strange new videotape formats to bother with.

Cons: At standard speed, these tapes can't hold much more than a half-hour of video. Carrying around enough tapes to shoot a two-hour boating trip can be awkward.

Who buys it: VHS-C is popular with people who want their camcorders and VCRs to be compatible. These people simply put up with shorter recording times. Also, some people are reluctant to buy new tape formats, such as 8mm or Hi8. (Perhaps they were burned by 8-track or Beta and want to play it safe.)

Comments: Although VHS-C isn't as popular as it once was, it still has its fans.

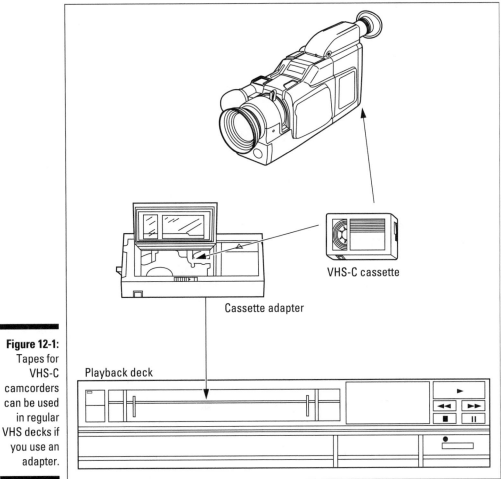

VHS-C cassette

Cassette adapter

Figure 12-1:
Tapes for
VHS-C
camcorders
can be used
in regular
VHS decks if
you use an
adapter.

Playback deck

S-VHS-C camcorders

Description: This Super version of the VHS-C tape adds higher-quality video
and sound (and a higher price tag).

Camcorder Tape Formats

The decisions don't stop after you've chosen a camcorder; you have to buy the
right type of videotape for the camcorder's particular format. This section looks
at some of the decisions camcorder owners must make when they're choosing
videotapes.

VHS camcorder tapes

With these camcorders, the choice is easy: Simply buy the same VHS cassettes you've been buying for your VCR. Avoid the cheapies, though; their cheap components add wear and tear to your camcorder's innards. And stick with the tapes bearing the official VHS logo.

S-VHS camcorder tapes

These camcorders use S-VHS videotapes, just like the ones used in S-VHS VCRs. Brace yourself, though: S-VHS tapes cost at least twice as much as plain old VHS tapes. They're a little more difficult to find, also.

In a pinch, you can use a plain old VHS tape in your S-VHS camcorder. But that brings your masterpiece down to plain old VHS quality.

S-VHS tapes can't be played back in most regular VHS VCRs. They can be played back only in a S-VHS VCR or a newer VHS machine that has a S-VHS playback capability.

8mm camcorder tapes

Because 8mm camcorders are growing in popularity, they're usually carried by the same stores that carry VHS tapes. An 8mm tape is about the size of an audiotape, so it's easy to stuff several of them into a camcorder bag. They come in different lengths; some can record as much as 2 1/2 hours of action.

Long, two-hour tapes also make it more difficult to find your shots later. For example, a single two-hour tape can hold your vacation footage, graduation shots, *and* the barbecue from the company picnic. With all that information clogging a single cassette, you have to do a great deal of fast-forwarding and rewinding to find the shots you're looking for.

An 8mm videotape looks similar to an audiotape, and the two types of tapes are often stocked near each other. Check the package closely to make sure that you're buying a *video*tape, not an *audio*tape.

Hi8 camcorder tapes

Things get a little trickier here. Hi8 tapes come in two varieties, and both are expensive. Hi8 camcorders normally use *metal-particle* tapes, known as MP

tapes. But the camcorders perform best when you use even more expensive tapes called *metal-evaporated* tapes, known as ME tapes. Try both, keep an eye on your wallet, and decide for yourself which works best for you.

Hi8 tapes look similar to 8mm tapes, but they have a Hi8 symbol on the front. If the tape doesn't say Hi8 on the front, you're just getting an 8mm tape.

A Hi8 camcorder can use 8mm tapes in a pinch, but those tapes can't take advantage of the Hi8 quality.

For higher-quality video, avoid tape lengths of two hours or more. Those cassettes often use thinner tape, which lacks the quality of tape lengths of 90 minutes or less.

VHS-C camcorder tapes

Unlike regular VHS and 8mm videotapes, you find these tapes only in electronics stores. At standard speed, they can record only from 20 minutes to a half-hour on a single cassette.

S-VHS-C camcorder tapes

Perhaps the most difficult tapes to locate, S-VHS-C can be found at electronics stores that carry a variety of camcorders. Like their VHS-C counterparts, they come in lengths only as long as a half-hour.

When you're heading out the door with your camcorder, bring more tapes than you think you'll need.

Camcorder Features

Just like their VCR cousins, camcorders are crammed with features. Here are some of the more common features you may encounter. You decide whether they're worth a little extra cash.

Auto Fade

When you're finished shooting that sunset, simply push the Stop button, and the camcorder will stop recording. To get fancy, push the Auto Fade button: The sunset gently fades away to a black screen before the camcorder stops

recording. Faders can work backward too: The screen can start out as black but slowly fade in to the image of the sunset.

On some camcorders, you can fade to white rather than to black. It's handy if you're climbing Mount Everest and you want to accentuate the whiteness of all the snow around you.

Verdict: Auto Fade is a fun feature, but it's not really a necessity. It gets boring quickly, in fact, when you use it at the end of each shot.

Alias: *Mosaic* faders don't fade to black, but they break down the image into progressively larger squares until the picture disappears.

Auto Focus

Tired of turning the little rings on those camcorders until everything's in focus? Well, most camcorders can focus *automatically*. At least, they do when you turn on the Auto Focus feature.

Verdict: Although Auto Focus can be a necessity for on-the-fly shooting, make sure that you can turn it *off* too: Sometimes a camcorder automatically focuses on the *tree,* not on the squirrel in front of it.

CCD pixels

The camcorder's CCD is the little gizmo that translates your view into electrical signals, which can be stored on the videotape as magnetic signals. Yawn.

Verdict: The bigger the number used to describe the CCD, the better the picture. For example, a Hi8 camcorder's CCD can use more than 400,000 pixels; a standard 8mm camcorder uses less than 300,000. But don't let numbers rule you. Let your own eye be your guide, and choose the camcorder that looks best to you.

Character generator

Ever notice how your TV puts the words *Dan Rather* under Dan Rather's face when he starts talking each night? The TV station is using a *character generator* to create those words, known as *subtitles.*

Verdict: Subtitles look cool, no doubt, and some camcorders can add them in. But the letters must be typed in laboriously by repetitively pushing buttons (they don't come with keyboards). The titles don't look nearly as good as Dan Rather's, and they must be created *before* you shoot — you can't add titles to clips you've already shot. You can't change misspellings, either. If you're really into titles, consider a separate gadget ($300 to $800) that can add titles while you're editing the video.

Alias: CG system.

Color viewfinder

For years, a camcorder's viewfinder came in only black-and-white. Surprisingly, that wasn't really a problem unless you were shooting a game of pool and needed a shot of the red ball: The viewfinder couldn't pick out the red ball. Many of today's camcorders offer color viewfinders, so the red ball stands out immediately.

Verdict: Unfortunately, color viewfinders also create a grainier image that's often more difficult to focus. They run down the batteries a little more quickly and add a hundred bucks or two to the price. Some people still prefer black-and-white viewfinders. Compare the two types of viewfinders carefully before making a final decision.

Date/Time stamping

A way of "stamping" videotape with the time and date somewhere on the screen, this feature makes the tape easier to identify and edit down the road.

Verdict: Although a clock ticking at the bottom of the screen can be a distraction, it's also a lifesaver when viewing tapes of old birthday parties and trying to remember how old little Amanda was.

Digital effects

Some camcorders don't just record the action — they let you play with it. They let you fade in and out of shots (see the sections that discuss Auto Fade and Digital Superimpose). They can freeze a picture on the screen or slide one picture in over another. These are all *digital effects*.

Verdict: Although digital effects sound flashy, they're not without problems.

First, they add extra buttons — and extra complications — to a camcorder. Also, they have to be added while you're shooting. If you add an effect that looks dopey right in the middle of the best part of the action, you're stuck with it: It can't be removed. For the best-looking effects, use the camcorder just to collect footage. Then add effects later while you're editing the video (see Chapter 13).

Digital Superimpose

One of several *digital effects* (see preceding section) commonly added to camcorders, this feature lets you freeze a picture in the camcorder's memory — and then recall it later and superimpose it over what you're filming.

Verdict: Like most digital effects, digital superimpose is a feature best left for the editing room.

Image stabilization

Nobody's hands are completely steady. Unless you use a tripod, your camcorder will jiggle and shake slightly as you're taping. You probably won't notice the jitters as you're taping, but you'll notice the movements when you play back the tape later. *Image stabilization* eliminates the minor jiggling and smoothes out the major bumps.

Verdict: Make sure that you get this feature. Try a camcorder with this feature at the store, and turn it on and off to compare results. It's also great for shooting videos from a car window or while you're walking.

When you're shooting from a tripod, turn off the camcorder's image-stabilization feature. The feature drains the battery faster when it's in use.

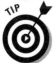

You should also turn off the image-stabilization feature if you're shooting fast action, like a football game, and the camcorder is always in motion. If you don't, the image can become jumpy as the camcorder tries to stabilize the picture. The jumpiness is a bigger problem with camcorders that use electronic tricks to stabilize the image than for those that adjust the lenses in the camcorder to smooth the picture.

Alias: Electronic image stabilization (EIS).

Manual override

Many camcorders come with an automatic mode, in which it automatically adjusts itself for the best picture. *Manual override* lets you bypass the camcorder's "brain" and adjust the controls yourself.

Verdict: You want this feature when the camcorder doesn't understand the shot you're after. If you're shooting the inside of a room that has a bright window, for example, the camcorder's automatic controls often overcompensate and make the room too dark to see. Manual override lets you change the lighting controls yourself.

Remote control

A wireless remote control for the VCR and TV isn't enough. Now you need one for your camcorder too.

Verdict: The remote is handy for putting yourself in the picture, but it's also handy for detailed, close-up work: By pushing the Record button on the remote, you don't have to touch the camcorder and possibly jar it and detract from the shot.

Caring for a Camcorder

Camcorders need the same care as any electronic device does. Because they're most often used outdoors, however, they're subject to even more dangerous conditions. You probably already know not to drop your camcorder; this section describes a few less obvious hazards to watch out for.

Keep your camcorder dry

Water is a deadly enemy to camcorders. In fact, some camcorders won't operate on a humid day: A little light goes on, telling you to let the camcorder dry out for a half-hour or so. Keep your camcorder in its bag when it's not being used, and take pains to keep it warm and dry.

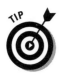

Buy moisture-absorbing packets, also known as *silica gel,* available at most camera stores, and keep them in your camcorder bag along with a rag for quickly wiping off any spills. Then, when moving the camcorder from cold to warm areas, put the packets in a sealed bag with your camcorder, where they can absorb any moisture formed by condensation.

Don't bend anything

Camcorders are a precision bundle of moving parts. If you drop something inside the little gizmo where the tapes slide in — or if something inside there looks a little out of place — don't fiddle around with it yourself. Take it to a service shop for a look-see.

Be careful at the beach

Camcorders don't like sand, hot sun, or water, so the beach is triple trouble. Buy a waterproof bag for your camcorder at the camera shop; slip the camcorder into the waterproof bag, and shoot from inside there.

Or don't bring the camcorder to the beach at all. People will just look at you funny anyway.

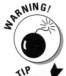

Suntan lotion can permanently dissolve the lettering on your camcorder's buttons. Make sure that your hands are clean and dry before picking up the camcorder and pushing buttons.

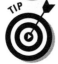

Can't clean your hands of suntan lotion? Then keep the camcorder on a tripod, put its remote control in a zipper-lock plastic bag, and control the camcorder from there.

Store your camcorder carefully

If you won't be using your camcorder for a while — the novelty's worn off and it's going into the closet, for example — remove the batteries and tape before storing it.

Also, load a tape in it every month or so and play it for about three minutes. That helps keep the camcorder's sensitive internal parts alive and well.

Chapter 13

The Camcorder's Arsenal of Knobs and Buttons

In This Chapter

▶ Understanding your camcorder's buttons

▶ Using your camcorder's special features

▶ Connecting your camcorder to your TV or VCR

▶ Editing a camcorder tape

Camcorders do much of the same work that VCRs do. They both record videos, and they both play back the videos. That means that camcorders and VCRs have similar buttons.

The problem? First, the camcorder buttons are tiny; grab your toothpick. Next, camcorders come with an entire set of *extra* buttons, all with sinister names like Exposure and White Balance.

This chapter explains the weird buttons on your camcorder and when you should push them. It also has tips for connecting your camcorder to your TV so that you can watch your latest shots.

Finally, you learn a quick and easy way to edit out the boring (or, more important, the embarrassing) parts of your home movies.

The Camcorder's Strange and Foreign Buttons

Some of your camcorder's buttons don't look or sound like anything on your VCR. Chapter 12 discusses a few of the more common camcorder buttons; this section covers some of the more strange and foreign buttons you're likely to encounter.

Auto/Manual

What it does: Thankfully, most camcorders handle all their settings automatically. A built-in robotic eye tries to figure out what you're pointing at, and then it adjusts everything for the best picture. But if something's goofing up, you want to override the camcorder's faulty thinking and adjust the settings yourself. For that, move the camcorder's Auto switch to the Manual setting.

When to use it: You might want to switch the camcorder to Manual for these reasons:

- The camcorder is not focusing on the right object (adjust the Focus).
- It's messing up the colors (adjust the White Balance).
- It's blurring on fast-moving objects (adjust the Shutter Speed).
- The light doesn't look right (adjust the Exposure).

Alias: Some camcorders call their Auto/Manual button an *Auto Lock* button. Turning off Auto Lock lets you change the settings manually.

Exposure

What it does: This button affects how much light the camcorder accepts. For the most part, leave it set on Auto. But if the sun is behind little Johnny as you videotape him by the swingset, little Johnny will be *underexposed*, and everything around him will be *overexposed:* Angelic Johnny will be a black dot surrounded by a white halo.

When to use it: To fix the problem, adjust the Exposure setting. Keep turning the knob until you can see little Johnny. Everything behind Johnny will still be washed out — you can't fix that, except by shooting from a different location — but at least you can see Johnny's face. Similarly, adjust the exposure if the camcorder isn't letting in enough light.

Focus

What it does: The camcorder's Focus button lets you fine-tune the image until it appears sharp in the viewfinder. Most camcorders focus automatically.

When to use it: For the most part, leave the camcorder's auto-focus feature turned on. If you're shooting something that doesn't move, you can often save batteries — and get better shots — by turning off Auto Focus.

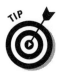

Wait until the camcorder's Auto Focus is finished focusing your view and *then* push the Record button. Otherwise, you'll probably see some blurs at the beginning of all your shots.

Input/Output

What it does: Switches the camcorder's video cables to either accept incoming video (Input) or let loose with its own outgoing video (Output).

When to use it: Switch to Input when you want the camcorder to record something from the TV or VCR. Switch to Output when you want to play back something you've recorded and you want the camcorder to send the video to your TV or VCR.

Record Review

What it does: This button lets you watch through the viewfinder the last few seconds of what you've recorded.

When to use it: Push the Record Review button every so often to make sure that what you think you're filming is the same as what's appearing on the tape. It's a handy way to make sure that you've used the correct settings. (Extremists bring a battery-powered TV set on location so that they can review their videos right away.)

Shutter speed

What it does: Camcorders basically work by taking bunches of snapshots and then playing them back quickly enough that the human eye is fooled into thinking that some *real* motion is going on. A camcorder's *shutter speed* controls how quickly it snaps each snapshot. By snapping the shots more quickly, the speedy shutter can remove any blur from moving objects.While chopping out blur, the higher shutter speeds also chop out light.

When to use it: The faster the shutter speed, the clearer your shots. With a slower shutter speed, moving objects can look blurry, especially when a shot is "frozen" on playback with the Pause button. If you shoot things with lots of movement — moving cars, sporting events, and merry-go-rounds — you want a shutter speed of 1/2000 of a second or faster. Experiment with different shutter speeds until you find one that looks right.

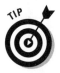

Faster shutter speeds make shots look clearer, but some shots are supposed to look blurry. Those trees moving outside your car window will look weird, in fact, if they *don't* blur when you pass by. Experiment with the shutter speed until you've found the right setting for your particular shot.

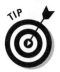

While chopping out blur, higher shutter speeds also chop out light. Unless the sun is shining brightly, a high shutter speed will make your videos look darker unless you (or the camcorder's automatic setting chooser) adjust the *exposure* setting to compensate.

White Balance

What it does: This feature sounds like a laundry commercial: Your camcorder doesn't always make your whites look white. You have to tweak the White Balance button until something that's white *looks* like white in your viewfinder.

When to use it: If your whites don't look white in the viewfinder under the camcorder's normal, automatic setting, choose one of the other settings, usually called Indoors or Outdoors.

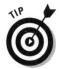

Some camcorders offer an extra white-balance setting for fluorescent lighting, and some get really fancy: You point your camcorder at something that you know is white — a freshly cleaned, white T-shirt, for example — and press a Hold button. The camcorder then uses that white T-shirt as its criteria for judging white.

Zoom

What it does: Zoom turns your camcorder into a telescope: Focus on that faraway sailboat, push the Zoom In button, and watch as the boat gets closer and closer. A *multispeed* Zoom means that the camcorder can zoom in quickly or slowly.

When to use it: To bring distant objects into view, press the Zoom In button (also known as *telephoto*), and the camcorder magnifies your subject. To pack lots of subjects into your shot — a roomful of crowded people, for example, press the Zoom Out button (also called *wide-angle*), and the camcorder crams the people closer together in the viewfinder.

The Camcorder's VCR-Like Buttons

Whew! You don't have to know anything special to use some camcorder buttons. The following buttons do the same thing as the ones on your VCR:

- ✔ **Play:** Plays back your video, both by playing it back through the viewfinder and sending the video through the camcorder's Video Out jacks.
- ✔ **Record:** Records something to videotape.
- ✔ **Stop:** Stops moving the tape and sits still.
- ✔ **Fast Forward:** Moves the tape forward quickly.
- ✔ **Rewind:** Moves the tape backward quickly.
- ✔ **Pause:** Holds the tape briefly in its current position.

Connecting Your Camcorder to TVs and VCRs

Sooner or later you want to connect your camcorder to your TV or another VCR. It's often the quickest way to watch what you've recorded, and it's a handy way to edit out the boring parts when you're getting a video ready to show to some friends. This section shows you how to connect your camcorder to your TV or VCR.

Hooking your camcorder to your TV

If you don't have a VCR, you can hook your camcorder to a TV. The steps in this section show you how to connect your camcorder directly to your TV set (camcorders come with little adapter cables for connecting to TV sets; you have to ferret through all the stuff in your camcorder box until you find yours).

1. **Turn off your TV.**

 Turning off your TV protects the speakers from any sudden blasts of static while you're hooking up the camcorder.

2. **Disconnect the antenna cable from your TV.**

 The antenna cable either unscrews or pulls off the back of your TV.

3. **Connect the camcorder's adapter cable between the TV and the camcorder.**

One end of the adapter should plug into jacks on your camcorder; the other end should push or screw on to the round connector on the back of your TV.

No round connector on your TV? Then your oldster TV probably uses the "two screws and a flat cable" method. You need a 75-to-300-ohm converter, described in Chapter 3. That device converts the two screws into the round connector favored by most camcorders.

Head for Chapter 3, in fact, if you want any other setup information; your camcorder is just a small VCR, after all, that can record from a lens as well as from a TV.

Finally, some TVs have little, round jacks marked Audio In and Video In. If your camcorder's cable fits, plug it in there and ignore the TV's antenna connection; the antenna connection doesn't give you the best picture.

4. Set the channel selector on your camcorder's adapter to Channel 3 or 4.

Choose a channel your TV *doesn't* get very well, either Channel 3 or 4. Your camcorder then takes over that channel without having to deal with outside interference from a competing local TV station.

Make sure that your TV and camcorder (or its adapter) are tuned to the same channel, either 3 or 4.

5. Set your camcorder's Input/Output switch to Output.

The camcorder's toggle switch should slide back and forth; leave it set to Output so that the signal goes out of your camcorder and into your TV.

Finished? When you push the camcorder's Play button, the TV should begin showing your latest footage.

If you often play your camcorder through your TV, leave the adapter connected to your TV; then plug the TV antenna into its special spot on the adapter. That step keeps your TV working normally and lets you leave the adapter hooked up for quick playbacks later on.

Hooking your camcorder to your VCR

If you have a VCR, connect your camcorder to your VCR, not to your TV. The VCR connection is handier, and it lets you edit your recently shot footage to cut out all the boring parts. These steps show you what to do:

1. Find the camcorder's connector cable.

Camcorders come with a specially designed cable or adapter for plugging into TVs and VCRs. Dig yours out of your camcorder's box, along with any special connectors.

2. Plug one end of the camcorder's cable into the VCR.

The special cable can plug into several spots on your VCR. Those spots are listed here in order of preference because some give better video quality than others do. Choose the first method that works with your particular cable.

✓ If your VCR has an S-Video In jack — and you're connecting a Hi8 or Super-VHS camcorder — look for your camcorder's S-Video cable. That cable should plug in between your camcorder's S-Video Out jack and your VCR's S-Video In jack.

✓ Or if your VCR has jacks marked Audio In and Video In, plug your camcorder's cable into those two jacks. If your VCR and camcorder are stereo, you have two audio cables to plug in; otherwise, you have only one. If your VCR is stereo and your camcorder isn't, plug the audio cable into the left Audio In jack on the VCR.

✓ Finally, if your VCR doesn't have a jack marked S-Video In, Audio In, or Video In, you're stuck with the last alternative: Look for the VCR's Antenna In or VHF In jack. That's the jack your cable or TV antenna normally plugs into. Plug in one end of the camcorder cable to that jack.

3. **Plug the cable's other end into the camcorder.**

 The other end of the cable plugs into the camcorder's Audio/Video Out or S-Video Out jacks, whichever your particular camcorder uses.

4. **Set the channel selector on the camcorder's adapter to Channel 3 or Channel 4.**

 Choose a channel your VCR *doesn't* get very well, either Channel 3 or Channel 4. Your camcorder then takes over that channel without having to deal with interference from a competing local TV station.

 Make sure that the VCR and the camcorder (or its adapter) are tuned to the same channel, either 3 or 4.

5. **Set the camcorder's Input/Output switch to Output.**

 It's usually a toggle switch that slides to one side or the other.

6. **Set the TV/VCR (or TV/VIDEO) selector on your TV to VCR.**

 Now when you push the camcorder's Play button, the camcorder's signal should begin running through the cables, into and out of the VCR, and onto your TV screen. Whew.

✓ Using a VCR's Audio/Video Input jacks? Then look for a special button on your VCR. You probably have to switch away from the VCR's normal, TV-tuner setting and onto its Line or External video setting. Look for a switch labeled Video Source or something similar.

- ✔ To record something on the camcorder from your VCR, your VCR needs Audio Output/Video Output jacks. Connect the camcorder cable between those jacks and the camcorder's Audio/Video jacks, and flip the camcorder's Input/Output switch to Input. Push your camcorder's Record button and push the VCR's Play button; your camcorder should begin recording whatever your VCR sends it.

- ✔ Working with a Hi8 or S-VHS camcorder and an S-VHS VCR? Then connect the S-Video cable between the S-Video jack on both the camcorder and the VCR.

- ✔ On some VCRs, plugging anything into the audio and video jacks overrides the antenna input. So as long as you have the camcorder cable plugged in, you can't receive anything on the VCR's channels. (Maybe that's why your VCR doesn't work when the camcorder's plugged in.)

- ✔ If your TV has audio/video connectors, you can hook up your camcorder to it instead. You can watch your camcorder tapes, but you can't make copies of them.

- ✔ VCRs that have front-panel audio and video jacks are made for easy hookup to camcorders. To use these, you have to access the VCR's menu display to switch signal input from the rear audio/video input connectors to the front audio/video input connectors. If your VCR has audio and video jacks in the front only, you don't need to switch anything.

- ✔ When you're hooking up your camcorder to your VCR, you can use your VCR to make copies of your camcorder tapes. This applies to VHS, S-VHS, VHS-C, S-VHS-C, 8mm and Hi8 camcorders.

Editing Camcorder Tapes

Most camcorder owners shoot their movies, watch them at home, and then toss the videotape into a box in the closet. A few months later, the video might earn a second viewing, but that usually ends up in frustration: What happened to that great shot of Margaret and the ducks?

That's why it's important to edit your videotapes: By separating the wheat from the chaff, you not only can find your work more easily, but you also might even convince a friend or two to watch your vacation footage.

Editing doesn't require any elaborate equipment — just knowing The Power of the Pause Button. Follow these steps to whittle down your videos to just the good stuff:

1. Connect the camcorder's output to the VCR's input.

This subject, discussed earlier in this section, involves connecting a camcorder cable between your camcorder's Audio/Video Out (or S-Video Out) jacks and your VCR's Audio In/Video In (or S-Video In) jacks.

2. Put a blank, rewound tape into your VCR.

A one-hour tape will probably do the trick. Keep your edited videos down to 15 minutes, if possible. Editing a video doesn't destroy the original copy; you can always watch the unedited version, if you want. So keep your recording short, and just copy the real gems from the tape.

3. Start recording with the VCR.

Pressing the VCR's Record button usually does the trick; sometimes you have to press two buttons simultaneously. (Chapter 6 discusses recording with a VCR.)

4. Start playing the camcorder.

Push your camcorder's Play button. At this point, your VCR is recording the video being sent by your camcorder. In fact, you might want to stop after a minute, rewind your VCR, and play it back, just to make sure that everything's coming through. Everything OK? Then rewind both tapes, push the VCR's Record button, and push the camcorder's Play button.

5. Push Pause on your VCR when dopey stuff starts.

When your camcorder starts playing back something dumb, push your VCR's Pause button. The camcorder continues to play, but the VCR waits.

Be sure to push the *Pause* button, not the *Stop* button. Unlike the Pause button, the Stop button can leave ugly blotches between scenes when you use it for editing.

6. Push Pause on your VCR when the good stuff starts.

When your camcorder finally begins playing something good again — Margaret finally starts feeding the *black* duck — push the VCR's Pause button again. That step tells the VCR to wake up and start recording. (If the VCR is left in pause mode for more than a few minutes, it will go into stop mode; in that case, make your VCR start recording when Margaret starts feeding the black duck.)

7. Repeat Steps 5 and 6.

By repeatedly pushing Pause on your VCR, you can weed out all the boring stuff and capture only the best 15 minutes of action to tape. All that button-pushing might take a little practice, but it's not so bad after you get used to it.

✔ None of your viewers will know how many hours you've spent putting together 15 minutes of vacation footage. They simply see your finished creation and marvel at your effortless handiwork.

✔ Want to *really* edit your videos? Then plan ahead. Write down the shots you want to keep and the order in which you want them to appear. Keep an eye on your camcorder's tape counter so that you know which scenes are where. Then do some rewinding and fast-forwarding on the camcorder while the VCR is paused, and you'll have more control over your editing.

✔ Camera shops sell mixing boards to help edit soundtracks. Although video seems to be the most important element, a video's soundtrack often makes an even more powerful statement. A mixing board lets you add music, special effects, or narration to your edited video.

✔ The next time you watch a nature video of monkeys eating dinner in the trees, keep in mind that the soundtrack was probably faked. You don't hear a monkey nibbling on leaves — you hear the cameraperson chewing a burrito back at the studio. Similarly, you can be creative with your own soundtracks while you're editing.

✔ Fancy VCRs with flying erase heads work best for editing camcorder videos.

Chapter 14

Pointing and Shooting without Goofing

· ·

In This Chapter

▶ What to bring on a photo shoot

▶ How to compose a shot

▶ Videotaping techniques to avoid

▶ Videotaping techniques to use

▶ Accessories for a camcorder

▶ Conserving battery power

· ·

At first camcorders can seem pretty easy to use: Just point and shoot. But what do you point at? When do you press the Shoot button? And how can you tell if your seemingly eye-catching shot will look as boring as oatmeal when you get back to the house?

This chapter covers the basics of making movies with a camcorder by offering tips for transforming uninteresting events into fascinating artistry. Plus, you'll find some ways to preserve battery power so that your camcorder doesn't run out of energy before you do.

What to Bring on a Photo Shoot

Ready to begin shooting? Then don't forget to bring the stuff on this list:

✔ **The camcorder:** Don't forget this one; it's the hardest one to replace while you're on the road.

✔ **Extra tapes:** Always bring more tapes than you need or else you might have to duck into a local drugstore to pick up some VHS or 8mm tapes. If you're using Hi8, S-VHS, or any of the VHS-C formats, bring twice as many tapes as you think you need. Those types of tapes are almost impossible to find on the road.

✔ **Extra batteries:** Most camcorders use rechargeable batteries, which are described at the end of this chapter. Bring at least *two* batteries. A battery always begins to run out of power when the exciting stuff happens; by bringing a spare, you can still videotape the good stuff.

If you have room in your camcorder case, bring along your battery recharger so that you can recharge one battery while you're using another. Or if you're working close enough to an electrical outlet, you can run the camcorder off the house voltage and save the batteries for outdoor work.

✔ **Lens-cleaning tissues:** They're cheap, they're smaller than a soft cloth, and they're sold at camera shops. And when you remember to wipe off your camcorder's lens, all that hairy stuff doesn't show up on the lens when the sunlight shines on it just right.

✔ **Camcorder case:** Put the camcorder in its case when you're not using it. This trick lessens the chance that something gross will spill on it. Plus, it doesn't look as enticing to thieves.

✔ **Headphones:** Don't forget that your camcorder is recording sound in addition to video. By plugging in a small pair of headphones, you can hear what's going on the tape — and adjust your recording techniques accordingly. (Sony Walkman-type headphones work great.)

✔ **Other stuff:** Any spare room in that camcorder case? Then bring cables for hooking up the camcorder to a TV; that way, you can watch your shots at a friend's house.

Shot Composition 101

Making decent shots with a camcorder takes practice, but beginners can improve their shots dramatically by following the rules spelled out in this section.

✔ Decide what you want to tape *before* you start videotaping it. Look carefully at the scene, and think about what would make an interesting shot. For example, don't just shoot the train station. Wait until a train arrives or departs — that way, you can add some motion to your shot.

✔ Shooting something far away? Zoom in until the object fills the viewfinder (see Figure 14-1). Focus the camcorder on the object and then push the Zoom button the *other* way; the camcorder will zoom back from the object, leaving it far away in the background, once again. That leaves the camcorder perfectly focused.

Best

Good

Figure 14-1:
Whenever
possible,
make the
subject
appear as
large as you
can in the
viewfinder.

✔ Shoot with the sun *behind* you. If the sun (or any bright window) is behind your subject, it washes out the picture.

✔ Give the camcorder's auto-focus feature time to work before pushing the Record button; otherwise, you'll videotape blurs as your camcorder tries to focus itself at the beginning of each shot.

✔ If you're shooting something that doesn't move, turn off the camcorder's auto-focus feature and adjust the focus yourself. This technique not only makes for a better shot but also saves battery power.

✔ For the most part, don't move your camcorder while you're shooting. Keep the camcorder still, and let your subject move around.

This stuff bores viewers

Although some people can never be convinced to watch home movies, some things bore just about *everybody*. If you want people to watch your movies, avoid making the following mistakes when you're videotaping:

Endless zooms: The next time you watch TV or the movies, watch to see how often the cameraperson zoomed in on something. Chances are that you won't see more than a handful of zooms all evening. When you shoot with a camcorder, use the zoom feature to frame your shots — and *then* start video-taping. But try to leave the actual zoom out of the picture.

Unedited, repetitious shots: It's OK to shoot a bunch of footage of the same thing — but only if you edit your videos down to the best shots when you finish shooting. Nobody wants to watch the cute little doggie roll on the floor for five minutes, no matter how cute it looked while you were videotaping.

Boring narration while shooting: There's nothing wrong with playing director, telling people where to go and what to do for the video. But do all that stuff *before* you push the Record button. Videos are most effective when you and the camcorder disappear, leaving the video itself to make the statement.

Inaudible conversations: Just about all camcorders have difficulty picking up conversations. If the words are important, you have to tape from close-up or use a separate microphone, as described later in this chapter, in the section "Fun Camcorder Accessories."

Meandering shots: Always plan your shots *before* videotaping. Viewers don't get excited by boring shots that meander along with no beginning or end. Don't just point the camcorder at the fish market, push the Record button, and tape the counter from one end or the other. Videotape the fish market's sign, and then switch to a close-up of somebody choosing a fish.

Quick shots: Don't move the camcorder too quickly. Your viewers peer at the scene from their little television-size window; what seems big and open to you might be rather claustrophobic to them.

Wiggly camcorders: Keep your camcorder as level as possible. Leave the vertigo to Alfred Hitchcock.

Bad framing. Pay attention to how the subject is framed in the picture. Avoid having too much space on the top or sides, as shown in Figure 14-2.

This stuff turns viewers on

After you fiddle with a camcorder for a while, you watch movies and TV shows a little differently. Camcorder angles that once blended in to the action now bring thoughts of, "Hey, that's kind of neat," or "Jeez, how did they do that?"

Here are some tricks for making your videos interesting enough to attract the most hardened couch potatoes:

Exciting sounds: Look for shots with interesting *sounds* in addition to video. Don't just videotape the train, for example; add a close-up of the steam spraying from the train's whistle as it starts to blow.

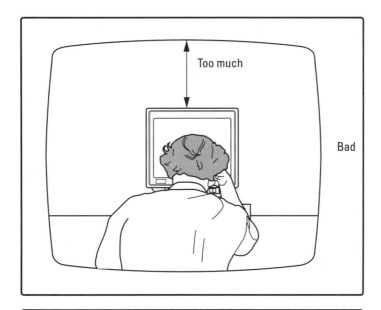

Too much

Bad

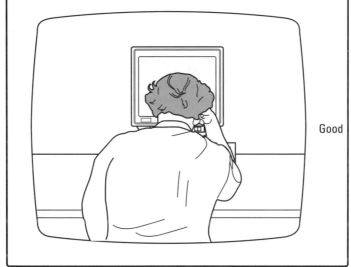

Good

Figure 14-2:
Your tape
looks funny
when there's
too much
space on the
top or sides
of the
subject.

Interesting angles: Don't always stand up while you videotape. Sit down, squat, or try setting the camcorder on the ground or a table. Also, mix in close-ups, faraway shots, and mid-view shots. By mixing different angles in your tape, you automatically add interest.

Finished videotaping a shot? Then shoot the next shot from a different angle. If you've just taped a long shot of the beach stretching away for miles, for example, follow that shot with a close-up of a seashell — not another long shot of the ocean stretching away for miles.

Long shots: Always keep videotaping until you think that you've shot for too long. Quick flips from subject to subject look like hyperactive slide shows.

Smooth shots: Shots taken by a walking cameraperson look like suspenseful horror films. Don't move around while you're videotaping.

People: People naturally enjoy looking at other people. Make sure that you're including lots of people in your shots. Don't just videotape Mickey Mouse at Disneyland. Make sure that you videotape people's reactions to Mickey Mouse at Disneyland.

Fun Camcorder Accessories

A camcorder, videotape, batteries, and carrying case aren't enough. Here are some additional goodies you might want to buy for your camcorder:

- ✔ **Tripod ($50–$200):** Holding a camcorder completely still for longer than 15 seconds can be tiring work; many people lean against walls to keep their shots steady. A tripod keeps the camcorder still for as long as you want. Best yet, most tripods have a movable head: You can still move the camcorder until you have the best shot and avoid that amateur-looking wobble all the while.

 A camera tripod can sometimes double as a camcorder tripod. Unfortunately, the platform atop most camera tripods isn't wide enough to support anything larger than a palm-size camcorder.

 The tripod's head — the part that lets you move the camcorder — comes in three varieties: *friction, fluid-filled,* and *gear.* Friction, the least-expensive alternative, doesn't move around as smoothly as the more-expensive fluid-filled variety. Gear tripods, the most-expensive ones, are designed to support heavy camcorders.

- ✔ **Lenses ($50–$150):** Most camcorders can use two types of screw-on lenses: wide-angle or extra zoom. With a wide-angle lens, you can pack *everybody* into the shot of the picnic table without having to step so far away. An extra-zoom lens gives a camcorder more telescopic power and lets you videotape stuff that's farther away.

- ✔ **Lens filters ($10–$30):** An inexpensive way to create new effects, lens filters screw over your camcorder's existing lens and subtly change the resulting picture. Ever notice, for example, how the jewelry sparkles on TV's shopping channel shows? That's because the shows' cameras uses a "starburst" filter, which turns ordinary reflections into brightly pointed stars.

Buy a protective lens called an ultraviolet (UV) filter and screw it over your camcorder's lens. These inexpensive lenses not only protect your real lens from grime, but they also cut out the extra UV light that can often leave a blue haze on your outdoor shots.

✔ **Automobile AC/DC adapter ($30–$100):** If your battery dies while you're on the road, you'll want one of these devices: a gizmo that plugs into your car's cigarette lighter and either charges your batteries or powers your camcorder.

✔ **Slide/movie converter boxes ($50–$75):** Closet shelves filled with old slides or 8mm movies from the '60s and '70s? These boxes let you display your slides or old movies on one end and videotape them from the other. Watching them on television is more convenient than hauling out the movie screen.

✔ **Microphones ($30–$300):** A camcorder's built-in microphone comes with built-in problems. The microphone is usually too far away from the action to record the sound clearly, and it often picks up the distracting whir of the camcorder's motor. An external microphone offers much more adjustability; it can be plugged into the camcorder's microphone jack and then placed near the action.

For best results, buy a wireless microphone. A small receiving unit plugs into the camcorder, and the tiny microphone can be hidden anywhere near the sound. Because the microphone doesn't use wires, it can be clipped to a shirt lapel, placed on a desktop, or set on a tree branch — wherever the sound can be picked up the best.

A "boom" microphone doesn't necessarily record explosions. It's just a microphone fastened to the end of a long pole so that it can hover over the action being videotaped.

✔ **Lights ($30–$100):** When you shoot indoors, the camcorder sometimes doesn't have enough light to pick up the scene clearly. Lights can be clipped on the camcorder or set on tripods to illuminate the area.

Clip-on lights eat up batteries quickly; be sure to bring some spares if you want to shoot skeletons in the Catacombs.

✔ **Underwater housings ($300–$1,500):** Underwater housings let you videotape underwater. The cheapest ones resemble thick, zipper-lock sandwich bags. The more expensive ones look like small, remote-control submarines. Either way, don't count on being able to see anything deeper than five feet unless the water is exceptionally clear or you have expensive, underwater lights to go with your housing.

✔ **Mixers ($100–$300):** When you edit videos, mixers let you fix soundtracks, add sound effects, and create special effects with the video.

✔ **Yourself:** Remember that you're on vacation. So put down the camcorder and take a look at what the Eiffel Tower *really* looks like.

Keeping Batteries from Dying

Camcorders can eat up batteries quickly. To make matters worse, most camcorders use nickel cadmium batteries (NiCads) with a special quirk: They have a memory of the last time they were charged. When the battery is re-charged before it's fully discharged, it mistakenly "thinks" that this refill point is the full discharge point. So the battery powers the camcorder until it reaches that particular point and then cheerfully stops, thinking that it has completely powered itself down.

The solution? You have to "deep discharge" the battery. Keep charging the battery up and discharging it fully. Eventually, the battery will figure out when it's *really* dead — not when it just thinks that it's dead.

✔ To avoid battery problems, run the batteries down all the way before recharging them. If you recharge them before they're completely run down, they won't last as long the next time you try to use them.

✔ To save battery life, turn off any automatic features you don't need. For example, turn off any "automatic stabilizers" while the camcorder's on a tripod. Or if you're focusing on something that doesn't move, turn off the auto-focus feature and focus manually.

✔ Don't automatically zoom in with the camcorder. That turns on the little motor and chews up battery power. When battery life is at a premium, zoom in with the camcorder's manual control.

✔ If you use lots of accessories — lights and microphones, for example — consider buying a battery belt. Worn around the waist, the belt can supply battery power for many hours more than the little battery that attaches to the camcorder.

✔ Camcorder batteries don't work well in cold temperatures. If possible, keep them in a warm place to ensure maximum life.

✔ While walking around, periodically check for the little red recording light on your camcorder. You would be surprised at how often that camcorder can be accidentally left on, dutifully videotaping the sidewalk as you carry it down the street.

Part IV
Something's Messed Up!

The 5th Wave By Rich Tennant

"Oh, *suure* - it's probably a disturbance on the line. You vendors always use that as an excuse!"

In this part...

Your movie or TV show suddenly starts acting up. Who dunnit? Is it the VCR? The tape? The TV show? The cable box? The cable company? The airwaves? The remote control? A neighbor trying to tap in to your cable system to save himself the monthly charge?

VCR problems bring plenty of suspects and all-too-few clues. This part of the book shows how to determine who's holding the smoking pistol when your VCR is looking injured.

Best yet, it shows how to restore justice and bring things back to normal.

Chapter 15

Pointing Fingers: When the VCR Is Not at Fault

. .

In This Chapter

▶ Making a VCR change channels

▶ Switching to Channel 14 and higher

▶ Working with older VCRs

▶ Understanding scrambled channels

▶ Tuning channels with a cable box

▶ Choosing the right antenna connection

▶ Adjusting a TV's controls

▶ Adjusting a videotape's playback

▶ Understanding Macrovision copy protection

. .

*Y*our VCR giving you fits? Maybe and maybe not. Don't be so fast to blame your VCR for all your picture and sound problems. Some VCR problems stem from other things, like your TV, your antenna, or even your cable company.

This chapter covers problems *not* caused by the VCR. If you're experiencing trouble while watching or recording tapes, start here before grabbing the hammer and whacking the sides. The glitch might be something simple, like a cable that's fallen off the back of the TV or a bad tape or even a TV that hasn't been turned on yet.

My VCR Doesn't Change Channels!

You can play tapes OK, and they appear on your TV with good sound and picture. But you can't seem to tune to any channels, to record them or just to watch them. You see either snow or the faint image of a picture. This section offers some possible fixes.

Try pressing the TV/Video (or TV/VCR) button

One easy way to tell whether the problem lies squarely with the tuning of the VCR is by pressing the *TV/Video* (often called *TV/VCR*) switch. You can use this switch to bypass the tuner inside your VCR and instead let your television start tuning in the channels.

- ✔ With the switch in the Video or VCR position (you see the VIDEO or VCR indicator light on the VCR), the signal goes through the VCR's tuner. That means that you need to change channels with your VCR's remote control — not with the TV's remote control.

- ✔ With the switch in the *TV* position (you see either no indicator or the TV indicator), the signal skips past the VCR's tuner. You dial the channel to watch from your TV's remote control, not from the VCR's remote.

- ✔ Do you have a cable box? If so, you have to dial the VCR and TV to Channel 3 or 4 to receive the signal from the cable box. You then dial the channel to watch from the box.

The show's not on the right channel!

You would be surprised at how easy it is to overlook the relatively simple question "Are you tuned to the right channel?" To be doubly sure, change the channel up and down until you are on the correct one. If you think that you're on Channel 10, for example, press the Channel Up button just to see what it does. Were you really on Channel 10? Make sure that you've also checked your TV/VCR button, as described earlier.

If you have cable, check out the section on loose cables later in this chapter. Cables can create an entirely new set of channel problems.

I can't get Channel 14 and higher!

Most VCRs let you select either of two broadcast band settings. That's a complicated way of saying that most VCRs have a switch for choosing between TV and CATV, sometimes marked CABLE. If the switch is set wrong, you don't get Channel 14 and higher.

First, find the switch. Some VCRs have a little sliding switch; others let you switch between those options through an on-screen menu, usually accessed from the VCR's Initial Setup menu. You might have to check with your VCR's manual if you can't find the switch.

Choose the TV setting if you receive programs over the air from an antenna.

Choose the CATV (or Cable) setting if you receive programs over a cable system and do not have a cable box. (If you *have* a cable box, you can leave the setting at TV.)

✔ Don't know whether you're on cable or an antenna? Then test both settings and choose the one that works best. Nothing gets wrecked if you choose the wrong setting.

✔ If you don't set the TV/CATV setting correctly, you most likely can tune to only Channels 2 through 13; Channel 14 and higher do not come in.

On older VCRs: Setting the HRC and IRC switch

Some older VCRs — made before 1987 or so — have an additional switch that you may have to set in order to receive channels properly. This switch, normally located on the back of the VCR, is labeled something like TV/HRC/IRC. This switch acts as a sort of fine-tuner to ensure that your VCR uses the correct broadcast frequencies for your antenna or cable system.

If you receive channels from an antenna, set the switch to TV. If you receive channels from cable and don't have a cable box, set the switch to HRC; then try to dial all the channels. If they don't come in well, set the switch to IRC.

My Old VCR Doesn't Receive Channels Clearly

The latest, greatest VCRs automatically lock onto the TV channel you choose. Unlike your long-suffering ancestors, you don't have to fine-tune the picture by turning a knob.

Older VCRs — models made before about 1985 or so — use manual fine-tuning, however. Some of these oldsters make you adjust the fine-tuning as you switch from channel to channel; others make you fine-tune each station the first time you set up and use your VCR.

Either way, this fine-tuning stuff is a problem-prone hassle, especially because these old VCRs all use different fine-tuning procedures. Some have knobs, some have rings, and some have funny-shaped, plastic screwdrivers. You have to dig out your VCR's manual for this one.

✔ If your VCR requires manual fine-tuning, consider replacing it with a newer model. Basic VCRs cost about $200 these days, and the price is well worth the technological improvements a new machine offers over that old rust bucket you're using now.

✔ Not all cable systems broadcast their channels on the same frequencies. On newer-model VCRs, this isn't a problem: The VCR is smart enough to automatically adjust to the correct frequency. But if your VCR is older (made before about 1986 or 1987), you may have to set an HRC/IRC switch, described in the preceding section, or manually fine-tune the VCR to bring the picture into sharpness.

Cable Messes Everything Up!

Cable can be a nifty thing: It gives you dozens of channels to watch, and the picture is usually very sharp — much better than most people get with an outdoor antenna.

But cable is also a technology from hell. It complicates your VCR and TV setup by switching around channel numbers. Plus, many cable companies toss a suspicious-looking intruder into your house: a cable box. The next few sections cover problems caused by cable systems.

With cable, the channel numbers are wrong!

Cable companies are fond of mixing the channels around so that Channel 6 is seen on Channel 10, Channel 10 is seen on Channel 12, and Channel 39 jumps around on a weekly basis. They move channels around to make the best use of their system.

That means that if you've grown up watching *Speed Racer* on Channel 6, try to forget your childhood. Cable will probably switch around your old, familiar channels with new ones that are more difficult to remember.

The solution? There isn't one. Just keep your cable channel guide handy to find the channels you want to watch. No guide? Call your cable company; it may provide one free of charge.

Do I tune channels from my VCR or the cable box?

Most cable systems use a special cable box for tuning channels. You place the box on top of your TV or VCR. The box sucks in all the channels through the cable; the box then sends out the channel you want to watch on either Channel 3 or Channel 4.

If you have a cable box, your VCR must be tuned to Channel 3 or 4.

Don't use the tuner in your VCR to watch a different channel. If you try, all you see is snow.

All the good channels are scrambled!

Every once in a while, the cable company comes up with some good stuff. This stuff is so good, in fact, that the cable company believes that you should pay extra money in order to watch it. If you don't pay extra, they *scramble* the picture and hide the action behind wavy lines.

Some cable companies scramble only the "premium" channels (like HBO, Showtime, and similar stuff), and others scramble everything, including the "free" channels. You can unscramble them by paying a monthly fee to the cable company.

✔ A scrambled channel may or may not have sound. The picture is all distorted, sometimes with weird colors and lines.

✔ If some of your channels look scrambled, your VCR and TV are probably working fine. It's just your greedy cable company trying to make you spend even more money.

Channels 3 and 4 Don't Work Right!

When you're watching programs through your VCR — you're playing a tape or you've pressed the TV/Video switch so that the VCR says VIDEO — the VCR sends its signal to the TV on Channel 3 or 4.

If you're getting snow or a messed-up picture on your TV and your VCR is tuned correctly, be sure that the TV is set to either Channel 3 or 4. The picture should come in clearly. Keep the TV on Channel 3 or 4.

✔ A switch on the back of the VCR lets you choose between Channels 3 and 4. The VCR is usually set to Channel 3, but if there's a Channel 3 already in your area, set the switch to Channel 4. Just make sure that the TV is set to receive the channel the VCR is sending, either 3 or 4.

✔ Whenever you're unsure whether it's the VCR or the TV that's not tuned correctly, just play a tape on your VCR. When you can see the picture and hear the sound on the TV, you know that the TV is tuned correctly.

✔ If you're hooked up to an antenna rather than to a cable box, press the TV/Video switch on the VCR so that the VIDEO indicator goes out. You can now dial in other channels on your TV. You don't have to keep your TV on Channel 3 or 4 for this procedure.

My TV Has Two Antenna Inputs

Some TV models have two antenna inputs: Antenna A and Antenna B. A switch on the front of the TV lets you flip between the two antennas.

✔ You might use this kind of setup if you have two antennas installed outside, one pointing north and the other pointing south. By switching between the two, you can receive stations from both directions.

✔ A more common use of the two-antenna input thingie is using Antenna A for an outdoor antenna and Antenna B for your VCR or a cable box. You switch to the one you want to watch.

✔ If your TV has two antenna inputs, push the antenna-switching button to see whether the picture from your VCR comes in clearly.

✔ If your TV has two antenna inputs but you use only one, hook up your VCR to Antenna A. That way, if the power goes out, the TV stays switched to the correct antenna input.

My TV Has Audio/Video Connectors

Chapter 3 covers how to hook up your VCR to your TV. Most folks stretch a cable between their VCR's Antenna Out connector to their TV's Antenna In connector. To see the picture, you dial the TV to Channel 3 or 4.

Other people have a TV with Audio/Video connectors: little pencil-eraser-like stubs protruding from the back of their TV. If your VCR's cables connect to little connectors on your TV marked Audio and Video, forget about this Channel 3 and 4 stuff.

Instead, find the Video switch on the front of your TV (or on the TV's remote control). Press the button to switch between regular TV mode — where you get pictures by switching to other channels — and Video mode. That should let the TV talk to the VCR.

Not all TVs have Audio and Video connectors. But if yours does have them — and you're not using them — read Chapter 11 to see how to hook them up. You get a better picture and stereo sound by using the Audio and Video connectors.

The TV Controls Aren't Adjusted Right

TVs let you control the color, tint, brightness, and contrast of the picture. If these things aren't adjusted right, the picture may be too dark or too light or the colors may be too strong or too washed out.

✔ On older sets, the picture controls (color, tint, brightness, and contrast) are located on the front of the TV, sometimes behind a little door. Find the control for the picture quality you want to tweak and turn the knob to see whether it makes a difference.

✔ Newer sets don't have external picture controls. Everything is done by pressing a Setup or Menu button on the TV or the TV remote control. A menu of choices appears on the screen, and you adjust the color, tint, brightness, and contrast by pushing selector buttons on the TV or remote. TV models differ in how they adjust their pictures; better pull out the TV's manual for some clues.

I Think the Cables and Wires Are Loose

Your VCR and TV are connected with a maze of wires. If just one wire comes loose, the entire system may not work.

After you make sure that the TV and the VCR are tuned to the right channels and all the switches are set to their correct positions, try the following steps with the wires that connect everything:

- ✔ Stay away from the power cord where your TV, VCR, or any other appliance plugs into an electrical outlet; the high voltage can severely injure you. The other cables are safe to touch.

- ✔ Feel for loose connections. With the TV on so that you can see a picture, find each wire that leads to and from your VCR and TV. Wiggle the wire to see whether it's loose, and watch the picture. If the wire is loose — wiggling it makes the picture better — either push it in more or tighten it up to make it snug.

- ✔ Look for broken connections. No loose connections? Then maybe a connector on one of the wires is broken. Carefully remove each wire, one at a time, and inspect it. Does anything look obviously broken? If so, replace that wire. If not, put the wire back and go to the next one.

- ✔ If some of the cable wires look damaged, call the cable company and check its rates. The nicer cable companies send people to your house to hook the cables back up without charge.

Something's Interfering with My Picture!

The picture shows up, and the sound is there, too. But rather than a nice, sharp picture and crystal-clear sound, you see all sorts of ugly lines and hear a constant barrage of pops and crackles.

The verdict: You're suffering from dreaded TVI — Television Interference.

Parents, don't do to your kid what Gordon McComb's parents did to him. When he was young, his folks told him that TVI meant that he would get a third eye in his forehead from watching too much TV. For years, the first thing he did every morning when he got up was check his head for another eye.

Interference can be particularly nettlesome because it can come and go at different times of the day, and it may not affect all channels. Because interference is such a major topic, we've devoted an entire chapter to it — Chapter 16.

TECHNICAL STUFF

Boring stuff about coaxial cable

VCRs and TVs hook everything up with a special kind of wire: *coaxial cable.* You can always tell coaxial cable by its shape (round) and its size (about a quarter-inch thick).

Coaxial cable (dubbed *coax* by the engineering crowd) is pretty durable stuff because of the way it's made: a single copper conductor surrounded by white plastic. This plastic goes by a technical name: *dielectric.* Not that the name should mean anything to you, but now you know that the white plastic covering the center conductor in coax cable has a name.

Around the dielectric is a braided mesh of wire that completely covers the dielectric. The cable needs fittings called F-connectors, one on each end. On coax cables you buy, the F-connectors are solidly crimped on. On coax cables you make yourself, the F-connectors are just screwed on. Radio Shack sells coax cable made up in 100-foot lengths, in case you want to make your own. The store sells both the crimp-on and the screw-on F-connectors.

The figure shows how the ends of a coaxial cable should look.

The metal barrel is the F-connector itself. The little stiff wire you see inside is the wire that runs through the center of the coax. When you inspect the end of a coaxial cable, make sure of the following:

✔ The F-connector is on securely and is not corroded.

✔ The center wire is not broken off.

✔ The center wire has a bright and shiny copper look.

If the end of the coax looks damaged, either replace the entire cable or go to Radio Shack and buy a replacement F-connector. The back of the F-connector package shows how to put it on the end of the coax cable.

The Tape Looks Awful

If your problems occur whenever you play a certain tape, odds are that the VCR and TV are working properly — at least they're tuned to the right channels and everything is hooked up right. The likely culprit is the tape itself.

- ✔ First, look on the VCR for a knob labeled Tracking Control or something similar. Found it? Give the knob a turn back and forth and see if the picture quality improves.

- ✔ If you see only snow when you play the tape, try hitting the Rewind button. You might be trying to play something that's already passed by. As a last resort, rewind to the beginning and try again.

- ✔ If you can see a picture but a great deal of distortion, perhaps the tape — or one you played before it — has made the insides of your VCR dirty. See Chapter 9 for the lowdown on cleaning your VCR.

- ✔ If you try to play a tape but the VCR just stops, the tape may be damaged. Sometimes you can avoid this problem by fast-forwarding the tape for a second or two and then trying to play it.

- ✔ If you play a tape and the picture goes light and dark, you might have problems from Macrovision. On many prerecorded tapes, a special anticopying signal called Macrovision is added to prevent people from making duplicate tapes. The Macrovision signal makes flashes of light on the duplicate tape. Sometimes, though, the light-and-dark flashing can be seen when you're *watching* a movie and not copying it. The next section has more information about Macrovision.

- ✔ If you play a tape and it makes squeaking noises, the tape is rubbing against something in the cassette. Or possibly the tape reels inside the cassette are rubbing against the case. The tape might still be viewable, but the squeaking is annoying. And if the noise gets too bad, stop the tape; it can damage the tape even more or put extra strain on your VCR.

Macrovision Mayhem

The remainder of this chapter is fairly technical and talks about really boring Macrovision technology. Skip it if you never have trouble playing back prerecorded tapes.

Movie studios don't like the idea that someone might make an illegal copy of their tapes and sell them or give them away. So they use a patented technique called *Macrovision* to thwart would-be "pirates" of their movies. Macrovision, an invisible signal studios add to the movie, is designed to wreck any copy you may try to make of a tape.

Ordinarily, the Macrovision anticopy process would be of little importance to the average person who doesn't make copies of tapes. But Macrovision has been known to affect normal tape viewing, so it's something to pay a little bit of attention to.

What Macrovision looks like

Technically, the Macrovision signal is played in a part of the video image called the *vertical blanking interval.* You see this vertical blanking interval if you turn the vertical hold knob on your TV (if your TV has one). It's a dark bar between the "frames" of the video picture.

With Macrovision, the bar has several large white and black patches; these patches randomly switch or fade between light and dark. All this is supposed to confuse a VCR that is trying to record the picture: The VCR sees the patches going from light to dark and tries to adjust the brightness of the picture. What it ends up doing is overcompensating: It makes the entire picture too dark or too light. Pretty sneaky, huh?

My TV goes light and dark

Though it's not supposed to happen, some TVs are susceptible to the strange Macrovision signals on a videotape. When you watch a tape — no copying involved — the pictures goes light and dark.

TVs that are Macrovision-prone tend to be older models, made until about 1975 or so. For some reason, the American TV brands (like Zenith and Curtis-Mathes) seem more susceptible. If you think that a tape is giving you Macrovision fits, you might try it on a different VCR or TV, if one is available. If you get the problem frequently, you may have to think about getting a new TV. Or get a Macrovision-buster box, as detailed next.

What Macrovision does

When Macrovision first came out in 1985, a great deal of misinformation was spread about it, and some of that misinformation exists today. Macrovision does not do the following:

- Destroy the tape after a certain number of plays or a certain period of time
- Alter the sound in any way
- Fill the screen with snow (If you see a snowy picture, odds are that the magnetic heads in your VCR are dirty.)

- Permanently harm your VCR or TV
- Rob you of your precious bodily fluids, no matter what that guy in *Dr. Strangelove* says

Macrovision doesn't affect all VCRs

Although the people who developed Macrovision don't like to admit it, their system doesn't affect some VCRs, particularly older ones — made before 1985 or so. On many of these VCRs, you can make a copy of a tape with Macrovision and nothing happens.

Many of the newer VCRs, but not all, are susceptible to the perils of Macrovision. It all depends on how the innards of the VCR were designed.

Macrovision also does not affect Beta VCRs and 8mm VCRs. These formats use different kinds of circuitry that are immune to Macrovision.

Is there a way to remove Macrovision signals?

Yes, there is. If Macrovision is plaguing you, you might be able to find relief by getting a *Macrovision buster,* an electronic box that strips out the Macrovision signal before it gets to your TV. You put the box between the VCR and the TV. Macrovision busters are available through many mail-order sources; check the current issue of *Video* magazine for a rundown of what's available.

You won't find many Macrovision-buster boxes at local stores or at Radio Shack. The people who developed the Macrovision process also patented almost two dozen ways they could think of to circumvent their system. Anyone who makes a Macrovision-buster box that infringes on one of the patents is likely to be sued.

Things to remember about Macrovision

Hollywood loves Macrovision because they think that it saves them billions of dollars every year. That's fine and dandy, but we're the ones who have to live with it.

- Macrovision works only on prerecorded VHS tapes. You don't find it on blank tapes you use to record on.
- As of this writing, Macrovision is not used for broadcast movies, like the ones from HBO. That could change, and if it does, be sure to write your congressperson and complain.

TIP

✔ Although it doesn't happen often, the Macrovision signal can be applied too strongly on a tape. Just because one copy of a tape is unwatchable on a TV doesn't mean that they all are. Try a replacement tape to see whether the trouble remains.

✔ If you have two VCRs hooked up to one another and you see the flashing on the screen when you play the tape, try playing it in the other VCR.

✔ You can sometimes minimize or eliminate the effects of Macrovision on your TV viewing by making sure that your TV is adjusted properly. In particular, the vertical height of the picture has to be large enough so that none of the nasty vertical blanking interval (described earlier in this chapter) can be seen.

✔ The too-light and too-dark pictures are the most common artifacts of Macrovision spoilage you see on your TV. Others include an annoying bending at the top of the screen; thin, white lines in the picture; and even a strange, ghostly glow in the corner of the picture tube (this happens only with some Sony TVs, believe it or not).

✔ Macrovision has been used since 1985. Tapes made before that do not have the Macrovision signal on them, but they might use an earlier, crude, anticopying system called Copyguard. Copyguard can cause the same kind of annoying bending at the top of the screen as Macrovision does.

✔ The bending at the top of the screen caused by Macrovision and Copyguard can also be caused by an improperly adjusted VCR or a tape that's been stretched out of shape (see Figure 15-1). If the bending occurs on a number of tapes, even ones without Macrovision, you should have your VCR serviced.

Figure 15-1:
If the picture bends at the top of the screen, it could mean that the tape has been recorded with an anti-copying signal that bothers your TV.

Chapter 16

Buzz, Pop, Fizz — Curing TV Interference

In This Chapter

▶ Sparkling interference

▶ Wave-line interference

▶ Horizontal-line interference

▶ Ghost interference

▶ Thick-bar interference

▶ Diagonal-line interference

*I*f the snap, crackle, and pop is in your TV rather than in your breakfast cereal, odds are that you're suffering from *TV interference.*

Interference is a common complaint; many problems with a TV or VCR are really caused by interference. Interference can plague both the sound and the picture. It can come and go. It can appear on only certain channels.

This chapter details the cause of television interference in both cable and antenna systems. You learn how to spot interference and, most important, how to get rid of it.

Before We Begin: Caution

If you have an outdoor TV antenna, take note: Some of the cures for interference involve going outside and moving or inspecting your antenna. Although interference occurs most often during bad weather, don't fiddle with your antenna when the weather's bad.

If there's a storm outside or any hint of lightning, *stay inside.* Forget about getting a better picture and just ride out the interference until the storm ends. The last thing you should do is grab hold of your metal antenna during a storm — you never know when a bolt of lightning will swoop down and bite you in the butt.

I See Sparkles!

What the interference looks like: Your screen flashes with white dots (see Figure 16-1). The dots can appear either randomly or concentrated in the same spot on the picture. Usually, but not always, you hear a crackling sound along with the sparkles on your screen.

Figure 16-1:
Electrical
noise
interference.

What it probably is: The sparkles and crackles are likely caused by electrical noise, most often caused by a nearby car with a faulty ignition system. Is your neighbor working on an old 1950 Dodge? As the engine revs, the car's electrical system can cause the interference you see on the screen. The noise can also travel through the wiring in your house, propelled by a bad vacuum cleaner or blender motor, a sick fluorescent light, or even a bad dimmer switch.

What to do about it: Try to locate the source of the interference. If your spouse is running the vacuum cleaner in the next room and you see the sparkles on your screen, you can be pretty sure that the vacuum cleaner motor is to blame. Yell at the vacuum cleaner.

Other faults are more difficult to locate. It takes the process of elimination:

✔ Check the lights, even the regular incandescent ones. Turn off all the lights in your house, one by one, to see whether the problem goes away.

✔ Check your refrigerator or the air conditioner. Watch to see whether the interference goes away when they stop running.

✔ Check your stereo system. If it is near the VCR or TV, turn your stereo off to see whether the interference goes away.

✔ Check with your neighbors. Are they getting the interference too? If all of them are and you're on cable, the problem may be coming through the cable system. If only some of them are, the problem may be in the electrical wiring to your house.

I See Wavy Lines!

What the interference looks like: You see distinct, wavy lines in the picture like those shown in Figure 16-2. Either the entire picture or just part of it is filled with wavy lines. Although it doesn't always happen, the wavy lines are not constant — they seem to dance around and move and not stay in one place.

Figure 16-2:
Interference from a radio or another TV signal.

What it probably is: Wavy lines in the picture are almost always caused by another broadcast signal somewhere in your area. This signal doesn't even have to be at the same frequency as the channel you are watching, so it's not as though you get two pictures or a second soundtrack. Something called *harmonics* can cause echoes of a signal to appear in different places in the radio frequency band. What you're seeing may be one of these echoes, often coming from CB rigs, radio stations, amateur ("ham") radio stations, or simply other TV stations.

The closer you are to the transmitting antenna of any of these things, the more likely you are to see the wavy-line interference.

What to do about it: Radio Shack, in addition to many TV and VCR shops, sells an assortment of "traps" that help block interfering signals. Knowing exactly which one to get can be the tough part, so it's best to describe the problem to the salesperson. Try one of the traps — such as one for a CB radio; if it doesn't work, bring it back and try something else.

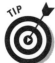

If the interference occurs mostly on Channels 6 or 7, the likely culprit is a nearby FM radio station. Ask the salesperson for an "FM trap."

The best defense against interference is avoiding it in the first place. The interference may be invading your TV system because of sloppy wiring.

The case of the illegal CB

CB — *citizen's band* radio — isn't the big fad it once was, thank goodness. In the mid-1970s, just about everyone had a CB radio at home or in his car. Many of them are still in use, however, and some are used illegally. The illegal ones can cause many interference problems with your TV.

The Federal Communications Commission (FCC) — a department of Uncle Sam — sets limits for the power output of all radio transmitters. For CBs, the legal limit is 5 watts. That doesn't sound like much, but with a good antenna, a 5-watt CB radio can transmit for many miles.

Not content with just a couple of miles, some CB enthusiasts use special, unauthorized amplifiers and antennas to boost their signal. Both are illegal and can make the CB radio belch out 1,000 watts or more. If one of these CB radios is near you, you can be almost guaranteed of lots of interference in your TV.

If you suspect that a neighbor is illegally using a CB radio, contact your local FCC office (check the Yellow Pages for an address and phone number). If your complaint sounds legit, the FCC will look into the matter. If it finds that your neighbor is indeed operating an illegal CB transmitting station, it will confiscate the gear and slap the culprit with a big fine.

✔ If you have an antenna, have it inspected and replaced if it's old and corroded.

✔ Do you use your TV antenna to receive FM stations in addition to TV stations? If so, install a separate FM antenna — try using your TV antenna for just TV channels.

✔ Replace the twin-lead cable from your antenna with coaxial cable.

✔ Have you coiled any excess cable and stuffed the coil behind the TV? The coil may be acting as an antenna. A shorter cable may make the problem to go away.

Cables can go bad, even if they look good on the outside. If the interference is really annoying and you've come up empty-handed when you try the other solutions, replace each cable in your TV/VCR system one at a time. If replacing a cable makes a problem go away, the cable is bad. Chuck it.

I See Dark Horizontal Lines!

What the interference looks like: The picture is filled with dark, thick lines that stretch from one side of the screen to the other (see Figure 16-3). The effect is sort of like a venetian blind. The lines may move slowly up and down, or they may remain stationary. The problem occurs on only one channel.

Figure 16-3:
Interference from receiving two stations at once.

In extreme cases, the lines may form a fast-moving, sweeping pattern, and your TV may look like it has a windshield wiper on it.

What it probably is: The technical name for this interference is called *cochannel interference.* It happens if you live in an area in which you might receive two stations on the same channel. You might live in Hooterville, for example, and receive the Channel 5 in Hooterville in addition to the Channel 5 in Pixley.

Usually cochannel interference comes and goes with the weather. Under certain weather conditions, TV signals travel much farther then they normally do, and you receive a channel you don't normally receive.

What to do about it: Cochannel interference is rare if you are on cable; call your cable company if you suspect a problem. If you have an antenna, point it directly at the station you're trying to receive. If necessary, buy an antenna that is more directional. Directional antennas are better at ignoring TV signals that aren't directly in their path.

If you get cochannel interference while you're watching Channel 3, find the Channel 3/4 switch on the back of your VCR. Switch it to Channel 4, and dial your TV to Channel 3. Likewise, switch the VCR to Channel 3 if you get cochannel interference on Channel 4. By setting them on different channels, the VCR and TV won't interfere with one another.

I See a Ghost of the Picture I'm Watching!

What the interference looks like: The picture you see is really *two* images: You see the picture and a fainter ghost of an image either to the right or left of it (see Figure 16-4).

What it probably is: This form of interference goes by the highly technical name of *ghosting.* Just about everyone has seen it at one time or another. It's caused by your TV getting two signals from the TV station: the main signal directly from the transmitting towers and a reflected signal off a nearby mountain, building, or lake as shown in Figure 16-5.

What to do about it: This list shows you how to exorcise the ghosts in your TV and VCR:

- ✔ If you're on cable, the problem is in your cable system; you have to call and complain.

- ✔ In some cases, you can eliminate the problem by switching the broadcast band your VCR and TV use. It is usually a switch labeled TV/CATV on the back of your VCR or TV. Switch it to CATV.

Figure 16-4:
Signal
ghosts.

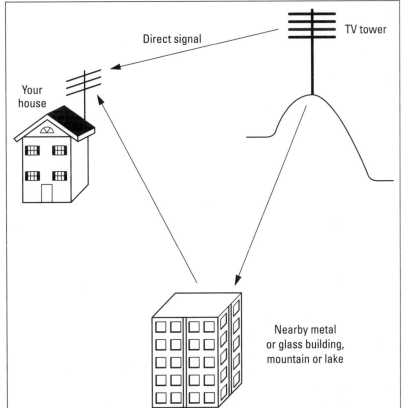

Figure 16-5:
Ghosts
occur when
the signal
bounces off
something,
such as a
building or
lake.

- ✔ If your TV and VCR don't have TV/CATV switches on the backs, you have to use the Menu or Setup buttons on your remote control to set your TV and VCR to CATV mode. Refer to the manual to see how to change the TV/CATV setting.

- ✔ If you use an antenna, try aiming the antenna directly at the TV transmitter tower.

- ✔ Replace your antenna with a better model — one that's more directional.

- ✔ Add a rotor to your antenna so that you can point it directly at the station you want to watch.

- ✔ Buy a *ghost eliminator* and install it where the antenna cable comes in to your house. These things don't always work very well, so be sure that you can return it if you find that it doesn't bust your ghosts as well as you had hoped.

I See the Ghost of Another Picture!

What the interference looks like: You see the picture of the channel you're tuned to, but you also see what appears to be a dim ghost of another, different channel superimposed over the one you're watching (see Figure 16-6).

Figure 16-6:
Interference from receiving two stations at once.

What it probably is: What you're seeing is technically referred to as *cross-modulation interference*. It's caused by receiving two different channels at the same time. The problem occurs on only one or two channels.

What to do about it: Cross-modulation interference usually happens with older TVs; you only have to fine-tune your TV to get the ghost picture to go away. It can also happen under certain weather conditions, such as during some kinds of storms. Wait out the storm, and the picture should improve.

The cross-modulation interference can also happen if your antenna isn't pointed directly at the station you want to receive. If there's a storm, wait it out. If the weather is clear, go outside and adjust your antenna for the best picture.

A good directional antenna can cure most cross-modulation interference. Consider replacing your existing antenna. You may also want to add a rotor to your antenna so that you can move the antenna back and forth, to zero in on the station you want to see from the comfort of your living room.

I See One or Two Thick, Dark Bars That Float up and down My Screen

What the interference looks like: You're innocently watching reruns of *Dragnet*. The picture is clear except for one thing: One or two thick, dark bars move slowly up (or down) the screen (see Figure 16-7). This problem usually occurs on all channels.

Figure 16-7:
Dark bands caused by a ground loop.

What it probably is: This problem is known as a *ground loop*. To fully understand what a ground loop is, you have to know something about the way electricity works and how all electrical circuits have a "ground" and that the ground isn't always zero volts and that when two grounds of different voltages meet, it can create a ground loop. It's completely unimportant, and now you can forget all about it.

What to do about it: The ground loop can be caused by something weird in the electrical circuits, in your house, or by the cable.

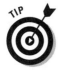

✔ Is your house equipped with the old-style electrical outlets, in which both prongs are the same size? If so, reverse the plug going to your TV or VCR. That is, just pull out the plug, turn it over, and stick it back in.

✔ Are your cable box, TV, and VCR connected to the same outlet? If not, plug them all into the same outlet. Use a power strip (about $10 at a home-improvement store) rather than an extension cord to plug everything in.

✔ Is your TV or VCR plugged in through an extension cord? Try flipping the plug to the extension cord.

✔ Is your VCR hooked up to cable? Try touching the outside, metal piece of the cable as it is connected to your VCR or cable box. Do the dark lines go away or get dimmer? If so, the cable system may not be properly grounded. Best call your cable company.

✔ Is your VCR or TV hooked up to your stereo? Try unhooking it temporarily.

I See Diagonal Lines in the Picture!

What the interference looks like: The screen is filled with diagonal lines, as shown in Figure 16-8. The lines don't move. They just sit there.

What it probably is: Although stationary diagonal lines can be caused by a number of things, perhaps the most common cause is interference from your VCR. Yup, your VCR can interfere with your TV if the VCR is too close to the TV.

What to do about it: Physically move the VCR away from the TV. If the VCR is sitting on top of your TV, remove the VCR (even temporarily) and place it on a nearby table. If the problem goes away, you know that your VCR and TV can't be placed close to one another.

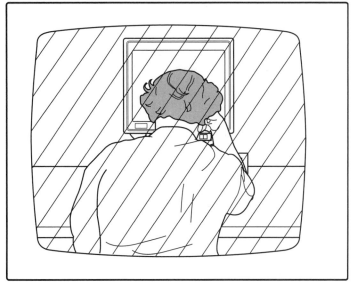

Figure 16-8:
Radio
frequency
interference.

I See Diagonal Lines That "Dance" to the Music

What the interference looks like: You see diagonal lines in the picture, and they move in syncopation to the sound (see Figure 16-9). When the soundtrack really gets going, the lines boogie and dance all over the place.

Figure 16-9:
Another
form of radio
frequency
interference.

What it probably is: Diagonal lines that move to the music can be caused by a maladjusted TV set. It can also be caused by bad cables and by stereo speakers placed too close to your TV or VCR.

What to do about it: This list shows what you can do to eliminate the dancing lines:

- ✔ If your TV set has a fine-tuning adjustment, spin it to see whether the problem goes away.

- ✔ Inspect the cables to your VCR and TV. Are they on tight? Do any look broken? Tighten and replace, as necessary.

- ✔ If a speaker to your hi-fi is located closer than about a foot away from your TV or VCR, move it to see whether the problem goes away.

Do I Have Legal Recourse If I Get Interference?

Most consumers are confused about the laws governing interference of TV signals. Except for the problems of an illegal CB radio, mentioned earlier — and a few other unique situations — no one is breaking the law if they accidentally interfere with your television viewing.

If a local FM station is making your TV viewing miserable, for example, there's probably nothing you can do about it. We say "probably" because the FM station can get into trouble only if it is either breaking the law (pumping out too much power, for example) or intentionally trying to interfere with your television viewing.

All this sounds strange, but it's part of the communication laws that govern TVs and VCRs.

Far from being unsympathetic, members of the engineering staff at most radio and TV stations are very willing to try to help reduce or eliminate any problems of interference their signals cause. Approach them in a reasonable manner, and you'll be surprised by how helpful they can be.

For more information about busting interference

There are many kinds of TV interference and many more causes. We've only touched on the most common causes of interference in this chapter. If you continue to be plagued by interference or you enjoy the subject and just want to know more about it, you can ask for a couple of free and nearly free publications through the mail. Write first to ask for the latest prices. Include a self-addressed, stamped envelope for a reply:

How to Identify and Resolve Radio TV Problems

This general-interest book, published by the U.S. government, tells you how to diagnose and fix interference:

Superintendent of Documents
Government Printing Office
Washington, DC 20402

Consumer Electronics Systems Technician Interference Handbook

This highly technical booklet, designed for engineers and other eggheads, deals with interference issues:

Consumer Electronics Group
Electronics Industries Association
2001 Eve St. NW
Washington, DC 20006

Radio Frequency Interference

This highly technical book, published for amateur-radio enthusiasts, tells how to prevent interference and what to do about interference in ham-radio gear.

Amateur Radio Relay League
225 Main St.
Newington, CT 06111

Chapter 17

In Case of Trouble…
Break Glass

- -

In This Chapter

▶ The clock doesn't work

▶ The tape won't pop out

▶ Something's making weird sounds

▶ The buttons don't work

▶ The picture looks weird

- -

*I*f your VCR isn't working right, stick around. This chapter lists more than two dozen things that can go wrong with your VCR in and tells you how to fix the problems.

When your VCR acts up, follow these steps:

1. **In the Symptom column, find the problem you're having.**

2. **Read more about the problem in the What It Looks Like column.**

3. **Read about possible solutions in the What to Do column. The solutions are listed in order from most common to least common.**

Symptom	What It Looks Like	What to Do
The clock doesn't turn on.	You plug in the VCR, but the clock doesn't appear.	• The power cord isn't plugged in. Plug it in. There's no power at the outlet. Test it by plugging in a lamp or using a different outlet. Maybe it's a "switched" outlet — try flipping wall switches. • The clock isn't set. Some VCRs won't display the clock until it's set. • The extension cord you're using is bad. Try another one. • If you can get to the fuse of the VCR, check and replace it if it's bad.
The VCR doesn't turn on.	The clock works, but the Power light doesn't come on.	• The VCR is in timer mode. Push the Timer button to turn it off. • Try the Power switch on the VCR rather than the one on the remote control. If that works, the remote control is at fault. • The microprocessor brain inside your VCR has temporarily gone insane (don't laugh; it happens). Unplug the VCR for about ten minutes or more, plug it back in, and try again.
The clock blinks "12:00."	Rather than tell the correct time, your VCR's clock blinks "12:00."	• The power went out (or maybe the VCR got unplugged). Reset the clock.
The tape doesn't go into the VCR.	You try to put a tape in the VCR, but it doesn't go in.	• There's already a tape inside; push the Eject button. • You're putting the tape in upside down or backward. Try a different position. • The power is off. Turn the power on. • The little release latch on the tape is bad. (The release latch is the little button on the side, near the front door, that covers the videotape.) Try pushing it with your fingers to free it.

Symptom	What It Looks Like	What to Do
		• Something other than a tape (a peanut butter and jelly sandwich, maybe?) is in the VCR. Remove it and then have the VCR serviced. • Something is busted inside the VCR. Get it fixed.
The tape doesn't eject from the VCR.	You press the Eject button, but the tape doesn't come out.	• The VCR is in timer mode. Push the Timer button to turn it off. • The power is off. Turn the power on. • The VCR isn't stopped. Push the Stop button. • The tape is caught inside the VCR. Take it to a repair shop to have the tape removed.
The tape doesn't play.	You press the Play button, but the tape doesn't play.	• There's no tape inside the VCR. Put your tape in and try again. • The VCR is in timer mode. Push the Timer button to turn it off. • The tape is at the end. Rewind it and then play it. • The tape is bad at the beginning. Fast-forward it a little and then try to play it. • The tape is damaged. Try a different one. • There is condensation (moisture) inside the VCR. Eject the tape and wait up to two hours (keep the VCR on) for the VCR to dry out.
The VCR shuts off after playing for a few seconds.	You press Play and the VCR starts to play the tape. The VCR stops playing after a seconds, however.	• The tape is at the end. Rewind it and then play it. • The tape is damaged. Try a few different one. • There is condensation (moisture) inside the VCR. Eject the tape and wait up to two hours (keep the VCR on).

(continued)

Symptom	What It Looks Like	What to Do
The VCR makes sounds when it plays a tape.	The VCR makes mechanical noises during tape playback (and perhaps also when you rewind it or fast-forward).	• The tape is bad. Try a different one. • The VCR needs servicing. Take it to the service shop.
Tape doesn't rewind or fast-forward.	Nothing happens when you press the Rewind or Fast Forward buttons.	• The tape is already at the end (or beginning). Eject the tape and look. • The tape is damaged. Try a different one.
Tape stops too quickly when you rewind or fast-forward.	When you rewind or fast-forward a tape, the VCR stops before reaching the end (or beginning) of the tape.	• You pressed the Memory button (on VCRs with that feature), and the tape is stopping at the memory location. • The tape is damaged. Try a different one.
The tape doesn't record anything.	You press the Record button, but the VCR doesn't go into record mode.	• There's no tape in the VCR. Put one in there. • Maybe your VCR makes you press the Record and Play buttons at the same time. Try that to see whether the VCR works. • The record tab has been removed from the tape (the record tab is the plastic thingie on the back left side of the tape cassette). You can fool the VCR by covering the notch with Scotch tape. • The VCR is in timer mode. Push the timer button to turn it off.
The VCR acts goofy.	The VCR doesn't respond to its controls, and the clock may display gibberish.	• The VCR is in timer mode. Push the Timer button to turn it off. • The microprocessor brain used in the VCR has gone on the blink. It may be only temporary. Unplug the VCR for 10 or 15 minutes or more, plug it back in, and try again. • Your brother-in-law is sitting on the remote control. Get him off it. (This applies to anyone — or anything — else that might be pressing the buttons on the remote control).

Symptom	What It Looks Like	What to Do
The picture goes black when you press Pause.	You're watching a tape and press the Pause button; rather than displaying a still picture, the TV goes blank.	• You're watching a tape recorded at LP speed. Many VCRs can't display still-frame pictures with these tapes. • Your VCR just isn't capable of still-frame pictures.
The picture is completely snowy when you play a tape.	Rather than a picture, snow fills the screen when you play a tape.	• The TV isn't dialed to the right channel. Dial to Channel 3 or 4. • The TV isn't connected to the VCR correctly. Check the cables. See Chapter 3 for help. • If you hear sound but get snow, the tape or the VCR may be bad. Try a different tape.
The picture is partially snowy when you play a tape.	You can see the picture, but it's filled with lots of snow. The sound is OK.	• The TV isn't dialed to the right channel. Dial to Channel 3 or 4. • The magnetic heads in your VCR are dirty. Clean them with a head-cleaning cassette.
The picture is partially snowy when you fast-scan a tape.	You see some snow — and maybe some heavy white lines — when you fast-scan a tape (press Rewind or Fast Forward while you're playing a tape).	• This is normal. All VCRs do this to some degree. (The snow is worse when you play some tapes.)
The picture is fine when you play tapes but snowy when you try to watch regular TV.	You're not playing a tape, but you're trying to watch TV from your antenna or cable box. You see snow rather than a picture. The sound is gone too.	• Wrong channel. If the TV/Video switch is in the *Video* position, dial a local channel (or Channel 3 or 4 if you are on cable and use a cable box). • Wrong channel. If the TV/Video switch is in *TV* position, switch it to TV and then dial the channel to watch on the TV (dial the TV to Channel 3 or 4 if you are on cable and use a cable box). • The antenna cable to your VCR is loose or broken. Check it for problems.

(continued)

Symptom	*What It Looks Like*	*What to Do*
The picture is full of interference.	You can see a picture, but there's lots of interference on the screen.	• The TV isn't dialed to the right channel. Dial to Channel 3 or 4. • The cables are loose (or bad) between the VCR and TV. Check them and replace them if they're bad. • Something is interfering with your VCR or your TV. See Chapter 16 for help.
Lines appear across the picture.	When you play a tape, you see ugly white lines at the top or bottom of the screen.	• The VCR's tracking is off. Adjust the tracking control. (If your VCR has automatic tracking, you may have to adjust it manually; refer to the VCR's manual to learn how to do this.) • The tape is bad. Try a different one.
The picture is dark at the top and bottom.	The picture has big, dark bands at the top and bottom.	• This process, called *letterboxing,* is normal. It's used to show a movie in the same "wide screen" format it was filmed in originally. (That's why the world is eagerly waiting for wide-screen TVs.)
The picture goes light and dark.	When you play a tape, the picture gets too light and then too dark. It seems to happen randomly.	• The tape (like a prerecorded movie) was recorded with the Macrovision anti-copying signal. See Chapter 15 for help.
The remote control doesn't work.	You press the buttons on the VCR's remote control, and either all or some of the buttons don't seem to do anything.	• The batteries in the remote control are low. Replace them. • The remote has no batteries because your six-year-old stole them for his radio. Replace the batteries; reprimand the child. • The battery terminals in the remote control are dirty. Clean them. • The remote control has an A/B switch and is switched to control the wrong VCR. Check it and switch it back.

Symptom	*What It Looks Like*	*What to Do*
		• The remote control is switched to control the TV or system rather than the VCR. Check it and switch it back. • The sun (or a really bright light) is shining directly into the remote sensor on the VCR. Block the light, wait about five minutes, and then try the remote. • Someone spilled a drink inside the remote control. Let it dry off and try again. If that doesn't work, the remote may need to be repaired or replaced.
The sound is bad.	When you play tapes, the sound rasps, buzzes, and pops.	• The VCR's tracking is off. Adjust the tracking control. (If your VCR has automatic tracking, you may have to adjust it manually; refer to the VCR's manual to learn how to do this.) • The TV isn't dialed to the right channel. Dial to Channel 3 or 4. • The magnetic heads in the VCR are dirty. Clean with a head-cleaning cassette. • If your VCR has hi-fi sound and you hear a random popping sound, the tape may be worn. Switch to Normal sound mode (refer to your VCR's manual to learn how to do this).
The VCR eats tapes.	The tape gets tangled inside the VCR when you play or eject a tape.	• The VCR needs service. Get it repaired immediately.
The tape counter runs slow.	Rather than tick off every second while playing a tape, the counter on your VCR runs slow.	• The VCR's tracking is off. Adjust the tracking control. (If your VCR has automatic tracking, you may have to adjust it manually; refer to the VCR's manual to learn how to do this.) • The magnetic heads in the VCR are dirty. Clean them with a head-cleaning cassette. • The tape is bad. Try a different one.

(continued)

Symptom	What It Looks Like	What to Do
Programs you try to tape while you're away are not recorded.	You use the programming or VCR Plus (stand-alone or built-in) to record a show while you're away, but the show doesn't get recorded.	• The clock in your VCR (or VCR Plus) is not set correctly. Set it properly. • *When you're using the programming feature on your VCR:* You didn't put the VCR in timer mode. Be sure to press the Timer button to automatically record shows. • *When you're using VCR Plus:* Your VCR was left *on* (leave it off), your cable box was left *off* (leave it on), or you punched in the wrong PlusCode number for the show you wanted to record. • The VCR or VCR Plus isn't set up correctly. Check the manual and try setting up the VCR again. (This is especially important if you move to a different town.) • *If you're on cable:* Your cable system switched the channels around. You have to reset your VCR (or VCR Plus) for the changes. • You didn't have enough tape to record the show. Next time, check the amount of tape remaining, and use a different one if there's not enough.
VCR's clock displays strange numbers rather than the time.		• Rather than display the current time, the clock on your VCR displays some strange numbers, such as 0:00:00 or CH03. The display mode of the VCR is set to show the tape counter or channel number other than the time. Press the Display button on the VCR or remote control to change the display mode of the clock.

In addition to the troubleshooting charts in this chapter, check the manual that came with your VCR for additional help. Yes, it's a drag, but most manuals provide troubleshooting tips for features that are unique to your particular VCR.

Chapter 18

When Trouble Persists: Fixing the Big Problems

. .

In This Chapter

▶ Don't forget the simple, obvious things!

▶ Get a VCR that "eats" tapes fixed immediately

▶ Find out whether the VCR is still under warranty

▶ Find a good repair shop

▶ Call first before taking your VCR in

▶ Don't pay for an estimate of repairs

▶ Don't repair your VCR if it's not worth it

▶ Avoid getting ripped off

▶ Think about extended service

▶ Know when to fix some of the big problems yourself

. .

*Y*ou've tried everything. You've tightened cables. You've fiddled with the tracking control. You've vacuumed the dust off all sides of your VCR. You even lit some incense and sang a chant to Transistoron, the Goddess of Electronics. All to no avail — the problem still persists.

What now? If you've truly exhausted all the things you can do to fix the problems with your VCR, it's time to call in the big guns: Take your VCR to the service shop.

This doesn't mean that you should just cart your VCR off to the first repair geek you find in the phone book. If you're not careful, you can wind up spending hundreds of dollars to repair a sick VCR and still not get the problem fixed.

This chapter covers the ins and outs of getting professional VCR help. It shows how to spot problems that are too big for you to fix and where to take your VCR to get it repaired. And it evades the question everybody else evades: Are extended service contracts *really* worth it?

Check Everything Else First

Odds are that the problem is a simple one. Don't forget to check the obvious things before assuming that something loathsome is eating away at your VCR's craw.

✔ Most VCR problems — loose cables, dirty magnetic heads, and so on — can be fixed by the VCR's owner. You can save time and money if you check everything yourself before calling in the expensive guns.

✔ The troubleshooting charts in the preceding chapter can help you find and cure the problem. The most common reasons for a problem are listed first in the charts. The process of elimination might help you find the cause of the problem.

✔ Don't forget to look at your TV, your antenna, the cable box, the cables, your tapes — everything. Your VCR may be working perfectly, but you may get a lousy picture (or no picture) if any of these other things isn't working right.

Your VCR Eating Tapes? Get It Fixed Immediately!

One of the most common serious complaints is that the VCR "eats" tapes. As your VCR gets older, it gets dirty inside and the parts become worn. When this happens, the tape doesn't always slide through the VCR as smoothly as it should. When you play or eject the tape, excess bits can get caught in the innards of the VCR, and the tape becomes all mangled inside: The VCR begins dining on the tape.

If your VCR does this even once, have it serviced immediately. Like man-eating tigers, after your VCR gets a taste of videotape, it develops an appetite for the stuff and eats more and more of them!

OK, that's a little dramatic, but it's true. A VCR that exhibits the tendency to eat tapes, even occasionally, is trying to tell you something, and it will continue to do so until you fix it. The problem rarely goes away by itself.

Is It Still under Warranty?

If your VCR is still under warranty, you don't have much of a choice about where to take the blasted thing for repair. You have to return the VCR to an authorized factory-service center. Depending on where you live, the nearest center may not even be in the same state.

Here are your choices:

- Return your VCR to the store you bought it from. They may be able to offer local warranty service.

- Ship your VCR off to the nearest factory-service center, as printed in the back of the manual that came with the VCR. Most VCR makers insist that you get a return authorization number first, for use when you ship the VCR back to them.

When you ship your VCR, always insure it for the amount of replacement. The insurance costs only a few dollars. You'll be glad that you spent the extra money if the VCR gets lost, stolen, or damaged in transit. The shipper just buys you a new one (a new one that *works*).

Another thing to remember when you ship your VCR is to use its original box and packing materials. This strategy affords the most protection. If you don't have the original box, buy a suitable cardboard box at your local U-Haul store. Pack the VCR carefully with foam, those annoying little plastic "peanuts," or wadded-up newspaper.

In all warranty service, your VCR's purchase date is very important. Be sure to keep receipts. Provide a *copy* of the receipt (always keep the original) as proof of when you purchased it.

Many VCRs come with a limited warranties. If your VCR breaks within the first 90 days, the manufacturer pays for both parts and labor. After 90 days, and for a period of as long as (usually) one year, you pay any labor charges (they pay for the parts). After one year, you pay for parts and labor. When you shop for a VCR, it never hurts to look for one with an extra-long parts *and* labor warranty.

Finding a Good Repair Shop

These days, VCR repair shops are a dime a dozen. Most towns of any size have a couple of them, many of which offer to fix other appliances, too, such as TVs and radios. With so many outfits to choose from, how do you know that you're taking your VCR to a reputable shop? The next few sections offer some tips.

Word of mouth is best

The absolute best way to find a good VCR repair shop is to ask around. Collar your friends at work. Ask them whether they've ever had a problem with their VCR and, if so, where they took it for repair. Odds are that you'll find at least one person who has experience in dealing with a VCR repair shop.

Do the same at church, the next PTA meeting, around the sauna at the "Y" — wherever you're with people who won't flee if you ask them for recommendations for a good VCR shop.

VCR repair shops are sometimes brand-specific — they fix VCRs made by JVC and Sony, for example, but no others. Be sure to ask which brand of VCR the repair shop will fix so you know whether they will repair your brand.

Referrals from the people at the video-rental store

You can also ask for a referral from the people who rent you movies. They often have experience with at least a couple of local repair technicians, and they know their work. If possible, get a list of two or three names.

Some movie-rental stores may offer to handle the repair for you. Avoid taking them up on it, at least initially. Many don't do the work themselves but instead just farm it out. They tack on an additional fee for their service, and it unnecessarily adds to your expense.

Recommendations from places that sell VCRs

If you bought your VCR from an electronics store, it probably has a service center that can repair your VCR. Odds are that the price will be competitive, so it's a good place to begin your search.

The store doesn't have to be the one where you bought your VCR. Most electronics stores don't care whether you bring in for repair a VCR you purchased from them or from the joint down the street. Radio Shack has an extensive network of service centers, for example, and it repairs its own brands of VCRs in addition to brands from many other makers.

Most department stores that sell VCRs, such as Wal-Mart and K-Mart, don't offer their own service, but they may be able to suggest a good local repair shop. Be sure to ask the manager or sales clerks in the electronics department for ideas about where to take your sick VCR.

Letting your fingers do the walking

When all else fails, there's always the Yellow Pages. Look for VCR repair under Video Equipment — Service and Repair. If you can't find anything there, look under Television — Service and Repair. (Many TV repair shops also do VCRs these days.)

Always Call First

No matter how you find a prospective VCR repair shop, be sure to call first. Never just take the thing in and plop it on the service counter. Calling first lets you weed out the deadbeats and saves wear and tear on your car and feet. It's a sad fact: VCR repair shops come and go, and you may drive all the way into town just to see a For Lease sign in the window of the shop that used to be Acme VCR Repair.

 ✔ If you're looking to give your VCR an overall cleaning and servicing, ask over the phone whether the shop offers any sales or discounts.

 ✔ Ask whether someone can look at your VCR now or whether there's a backlog. VCR repair shops are the busiest right before the holidays (especially Christmas) and before summer vacation.

 ✔ Don't bother asking for prices. You can't get an accurate assessment of what it will cost to repair your VCR until someone has a chance to look at it.

Should I Pay for an Estimate?

Video repair shops are about evenly split in offering free estimates. Some do; some don't. Our advice: Always try first the shop that offers a free estimate. At the very least, you can use the estimate to compare prices. There's nothing illegal or immoral about that. It's called comparison shopping, and it's always a good idea.

The free estimate is also helpful if your VCR is terminally ill. It's not unusual for VCR repair to cost more than a new VCR! There's no sense in paying for an estimate just to find out that your VCR is beyond hope.

 ✔ Not all free estimates are truly free. Some shops don't charge for an estimate if they do the repair work. Otherwise, you pay from $10 to $50 for the estimate.

✔ Not all estimate fees are the same. Some shops have a flat-rate, applies-to-everything estimate. Others charge an estimate on a sliding scale, depending on what they think the problem is.

✔ Don't pay more than about $50 for an estimate, no matter what the problem is. Fifty dollars should pay for a good half-hour of the VCR tech's time, and that should be enough for him (or her) to discover the problem and determine how much it will cost you to fix it.

✔ In a deplorable new trend, some VCR service centers — particularly the authorized factory-service ones — don't even offer estimates. You pay a flat rate for the repair, no matter what's wrong with your VCR. If the problem is major, you win. Most often, though, the problem is not major, and you end up paying more money than you need to.

When to Throw In the Towel

Your beloved VCR is on its deathbed. It wheezes whenever you insert a video-tape. Its picture is all fuzzy. Things are looking mighty bad, Doc.

Depending on what's really wrong with your VCR, it may cost you more in parts and labor to have it repaired than it would cost to just buy a new VCR. Don't think about how much your VCR cost when it was new; prices almost always drop, and you can get a VCR with the same or more features for less than what you paid for your old machine.

Although you have to be the final judge of when to replace your VCR as opposed to when to repair it, Table 18-1 gives you some numbers to help you make the decision. In the table, the break-even point is the amount at which you have to begin thinking about getting a new VCR as opposed to repairing your old one.

The break-even point figures are based on the repair being about 60 percent of the cost of a new, similarly equipped VCR purchased at a discount electronics store.

✔ If the repair costs *less* than the break-even point, you're probably saving money by having it serviced.

✔ If the repair costs *more* than the break-even point, you're probably wasting money by having it serviced.

Table 18-1	Repair Costs That Might Warrant Buying a New VCR or Camcorder
Type of VCR	**Break-Even Point**
Basic two-head	$100
Basic four-head	$130
Four-head with HQ	$175
Four-head with HQ, hi-fi	$200
Super-VHS	$275
Camcorders	$350 to $500 (varies widely according to features)

You can come up with your own break-even point by looking at how much new models cost. This is especially important if you're having your camcorder serviced — camcorders are generally more expensive than VCRs. Find one that has similar features as yours. If the repair is more than about half the cost of the new model, you should think twice about having your VCR or camcorder repaired.

How to Avoid Getting Ripped Off

Although no one in the biz likes to admit it, consumers get ripped off more than they should when it comes to VCR repair.

- ✔ In most states, such as California, people don't need a license to repair VCRs. *Anyone* can open up shop as a "VeeCeeAre Repear Tecknishun." Other states (such as Oregon) require certification, which can provide extra protection against fly-by-nighters.

- ✔ Some repair technicians who fix VCRs have little experience with them. They're trained to repair TVs, microwave ovens, garage doors, and orange juicers.

- ✔ VCRs look mighty complicated, so it's easy for most repair shops to get away with charging a large amount of money for repairs that probably weren't necessary to begin with.

- ✔ Odds are that you won't have any trouble getting your VCR repaired. But realize that bandit repair-techs are ready to pick your pocket, so you have to be on the lookout for them.

Look for established outfits

The best way to avoid the shysters is to find established VCR repair shops. Although it's no guarantee of good service, a shop that's been around for at least two years is a pretty good indicator that they're honest.

Get everything in writing

No matter where you take your VCR, be sure to get the estimate and any repair bill in writing. Never leave your VCR with anybody without getting a receipt for it. Don't trust an oral agreement. If the repair estimate or work order doesn't say it, it doesn't exist.

Ask for all the parts that were replaced

Ask ahead of time for the technician to give you any old parts that were replaced. This isn't always possible, depending on the part. In some cases, the repair technician swaps out the bad part for a good one and sends the defective component back to the factory so that it can be refurbished.

Expensive repairs: Get a second opinion

If the repairs are expensive, get the opinion of another repair shop. This is particularly true of camcorders, which can be costly to repair (and costly to replace). If the bill is more than about $200, ask to have your VCR back, and take it to another shop.

What to Do If You Do Get Ripped Off

Despite watching for danger signs, finding a repair shop that's been around for the last decade, and getting everything in writing, you find that you've been ripped off. Maybe your VCR came back in worse shape than when you took it in. Or maybe your VCR is gone — stolen by someone at the repair shop! What do you do now?

✔ Go back to the repair shop with copies of receipts, canceled checks, the bill from your credit card — anything and everything having to do with your VCR repair. Remember: Don't leave originals with anybody.

✔ Ask to see the manager or owner of the repair shop.

- ✔ If you can't see the manager or owner or if things don't work out to your satisfaction, write letters to the Better Business Bureau, the Chamber of Commerce, and the manufacturer of your VCR.

- ✔ If your state licenses VCR repair technicians and shops, write a letter to the appropriate state licensing board.

- ✔ If you paid by check, you may still have time to stop payment.

- ✔ If you paid by credit card, write to the credit-card company and tell them your story.

- ✔ Think about taking the VCR repair shop to small claims court.

All about Extended Service

All new VCRs come with a warranty of some type. VCR warranties differ mostly in the length of time they will fix problems at no charge. The warranty usually covers replacement parts and labor for a stipulated amount of time (such as 90 days) and covers only parts for a longer length of time (about one year). As you might have guessed, the labor costs the most.

Extended service, provided by your dealer when you buy the VCR, is supposed to prolong the warranty period. It might be another year or two, or even four or five years. Different stores have different extended service plans.

Extended service is like insurance: You probably don't need it, but if you do need it, it saves you a bunch o' money. Typical extended service plans for VCRs run about $50 to $75, and they cover parts and labor for two or three years beyond the warranty that comes with your VCR.

Is an extended service plan a good bet? Only you can decide. But consider these bits of advice:

- ✔ Your credit card may offer its own extended service if you buy the VCR with the card. Call 'em and check.

- ✔ Avoid buying an extended service plan unless it's backed by either the VCR manufacturer or a large retail chain.

- ✔ With some extended service plans, if your dealer goes out of business, your extended service contract is void. Stay away from these folks.

- ✔ Never spend more on extended service than the cost of the average service bill. For VCRs, that's about $75 to $100.

- ✔ Finally, realize that extended service contracts are simply a gamble. If a $50 contract saves you the cost of a $125 repair, you'll be a smiling winner. But if your $50 contract never saves you any money, you'll be a frowning loser. But at least your VCR will be healthy.

Should I Change the Belt Myself?

If you're mechanically inclined and your VCR is not completely kaput, you may be able to fix some of the more serious problems yourself. Maybe your VCR is just extra dirty inside. You might be able to take it apart and give it a good cleaning or perhaps change an old belt or two.

The subject of getting to the guts of a VCR is beyond the scope of this book, but a number of guides are available that provide these types of details, if you're interested and rarin' to roll up your shirtsleeves. It just so happens that this type of book was written by the coauthor of this book, Gordon McComb. It's called *Troubleshooting and Repairing VCRs,* Third Edition (published by Tab/ McGraw-Hill).

The 5th Wave **By Rich Tennant**

VCR OPERATING MANUALS PUBL.

"WAIT A MINUTE! THE MONSTER SEEMS CONFUSED, DISORIENTED. I THINK HE'S GONNA PASS OUT! GET THE NETS READY!!"

Part V
The Part of Tens

The 5th Wave **By Rich Tennant**

"MY GOSH, BARBARA. IF YOU DON'T THINK IT'S WORTH GOING A COUPLE OF WEEKS WITHOUT DINNER SO WE CAN AFFORD A SUPER-VHS VCR WITH FLYING ERASE HEADS, JUST SAY SO."

In this part...

What do I need to edit sound onto my home videos? How should I store my tapes? What else can I do besides tape home movies — now that I'm comfortable with my camcorder and VCR? Is it legal to tape movies off of premium-cable channels? If you're asking yourself these questions, then this part is for you.

This easy-to-digest part contains information such as how to make money with your VCR or camcorder, the ten most common mistakes and how to avoid them, and ten ways to drive the information superhighway, among other topics. If you've just mastered setting the clock or programming your VCR, sit back and take a breather with these chapters. But note the part title - Parts of Tens. Sometimes we give more and sometimes less, but never exactly ten. That would be too symmetrical.

Chapter 19

Ten Tips for Making Better Tapes

In This Chapter

▶ Start with good connections

▶ Buy good-quality, brand-name videotape

▶ Record only at SP speed

▶ Don't record anything for the first 30 seconds

▶ Prepare tapes before using them

▶ Use audio/video connections rather than antenna connections

*L*ooking for ways to improve the picture and sound on the tapes you make on your VCR and camcorder? Surprise! Several simple tips and tricks can greatly enhance the quality of your tapes. Most of the following suggestions don't cost a dime, which makes them doubly good. And, no, there aren't ten tips. There are only six, but that's why this part of the book is called "The Part of Tens."

Start with Good Connections

Before you tape any important stuff, be sure that all the cables and connections going to your VCR are the best they can be. All the cables should be just long enough to connect to all the goodies in your TV den; longer cables — especially if they are looped in an effort to make them tidy — can pick up interference from other sources of radio signals. Be sure that all the cables have good connectors. Replace any cable if the connector is broken or loose.

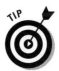

✔ If you have an outdoor antenna, make sure that it's pointed directly at the TV station. If the antenna is old or broken, consider replacing it.

✔ If you're on cable and the picture isn't so hot, call your cable company. You're paying for quality pictures, and the company should send somebody out to see what's wrong.

Buy Only Good-Quality, Brand-Name Videotapes

Not all videotapes are made the same. Some of them are downright trash, even stuff you may buy at a reputable store. To be on the safe side, buy only recognized brand-name videotapes. They may cost a little more, but you'll be amazed at how much better the picture and sound will be.

There's another benefit, too: Higher-quality tapes keep the innards of your VCR cleaner. Low-quality tapes can shed little particles of the magnetic coating. In time, this stuff can gum up the works of your VCR, cause premature head wear, and could eventually require a costly service call.

To save money on videotapes, buy them in quantity. Even the three-packs of videotape represent a savings compared to buying tapes individually. If you can, try to buy a case of 10 or 12 tapes at a time. Be sure to ask for a quantity discount.

Record Only at SP Speed

VCRs can record at two (and sometimes three) different speeds. Assuming that you're using the standard two-hour tape

- At SP speed, you can record for as long as two hours on one tape.
- At LP speed, you can record for as long as four hours on one tape. (LP is not offered as a recording option on some VCRs.)
- At EP (or SLP) speed, you can record for as long as six hours on one tape.

The slower the speed, the lower the picture and sound quality. You get the best quality when you record at the fast SP speed. Use this speed on tapes you want to keep. You can use the slower LP and EP speeds for taping programs you watch once and then erase.

Record Junk Stuff for the First 30 Seconds

All videotape (especially 8mm) suffers from something called dropout. A *dropout* occurs when a piece of the magnetic coating on the tape falls off. The pieces are incredibly small, usually too small for you to see. But on a narrow videotape, even a small piece of magnetic coating can cause a tiny, white fleck to appear on the screen when you play back the tape.

Dropouts occur most heavily at the beginning of a tape, especially during the first 30 to 60 seconds. You can reduce the annoyance of dropouts by recording just *anything* for the first half a minute or minute (you can record a commercial, for example, or simply record the screen that appears when you're tuned to a channel that doesn't have a station on it).

Then begin recording your important stuff.

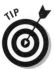

Don't just fast-forward a new tape to skip past the first minute. Nothing is recorded on this part of the tape, and your VCR may have trouble trying to find a signal on the tape when you first play it.

Before Using a Tape, Fast-Forward It to the End and Then Rewind

Brand-new tapes are often wound unevenly inside the cassette. You get slightly better results if you first fast-forward a new tape and then rewind it before you record on it. You have to do this only when the tape is brand new.

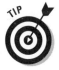

A great deal of fast-forwarding and rewinding can put extra wear and tear on your VCR. You may want to fast-forward the tape in the VCR but rewind it in a videotape rewinder, which you can buy for about $10 or $15.

Use Audio/Video Connections Rather Than Antenna Connections

You get better picture and sound if your VCR is hooked up to your TV by way of the separate audio/video connections rather than by the antenna connections. Your TV must have audio and video jacks before this technique will work, however.

Using the separate audio and video connections also greatly improves picture and sound quality if you're making a copy of a tape on another VCR. Hook up the two VCRs by using the Audio and Video In/Out jacks rather than the antenna connectors. Cables for use with the audio/video jacks are available at Radio Shack, as well as most electronics and home-improvement stores.

Chapter 20

Ten Neat Things to Buy for Your VCR

. .

In This Chapter

▶ Gold-plated cables

▶ Automatic tape rewinder

▶ Surge protector

▶ Head-cleaning cassette

▶ Fancy electronic labeler (such as the Brother p-Touch)

▶ Cassette drawers

▶ Complete home theater system for your VCR

▶ Bulk tape eraser

. .

*H*int: after reading this paragraph, use some Wite-Out to cover it up; then hit the copy machine and pass around copies of this chapter to all your friends just before Christmastime.

The somewhat-less-than-ten items described in this chapter (hint, hint) would make exceptional Christmas presents (hint, hint) for caring friends and relatives to give to VCR owners.

Gold-Plated Cables and Connectors

Behind a VCR lives a thick mass of cables. The more complicated the setup, the thicker the bundles of cables: cables for stereo sound, camcorder hookups, second VCRs, additional TVs, and extension cords leading to cable outlets down the hall.

The longer and more involved your cable setup, the more chances your picture has to deteriorate before the signal finally reaches your TV set. Cables with gold-plated connectors help keep your picture from oozing away at every juncture.

If your picture doesn't look very good, try switching to gold-plated cables and connectors; they can't hurt anything but your pocketbook.

Automatic Tape Rewinder

VCRs spend most of their lives playing back tapes. It's a big enough job by itself. Now you want it to rewind the tape at high speed so that you can put it away and watch another. Well, how about this: Many VCRs have rubber rollers, belts, and other things that can wear down, and lots of rewinding just makes them wear down that much faster.

To save your VCR from the inevitable wear and tear of rewinding tapes, buy an *automatic tape rewinder.* It's a cheap device that only rewinds tapes. Push the tape inside, and the rewinder kicks out a rewound tape a few minutes later.

Andy Rathbone found an automatic tape rewinder for only $4.99 at a discount store. Shaped like a '63 Corvette, it rewinds the tape when you stick it inside the Corvette's hood. When you're protecting a VCR that costs $300 to $500, $5 isn't much to spend.

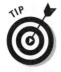

For a few dollars more, you can get a deluxe rewinder that fast-forwards too! Some really cool models even have a gizmo on them that erases the tape as it rewinds.

Surge Protector

Ever notice how the lights in a room flicker in unison, as though somebody thought about turning off the power to the entire neighborhood but then changed his mind? That's one example of a power surge, and electrical devices don't like them.

No, electronic parts expect to be spoon-fed electricity at a steady rate, and a *power surge* — in which the voltage changes rapidly — is like hot sauce.

To protect your VCR's sensitive internal parts, buy a surge protector, available just about anywhere that sells VCRs. The surge protector absorbs the electrical jolts, keeping your VCR safe.

Head-Cleaning Cassette

Your VCR, like just about every other creature, has at least one head. The videotape flows over the head, and the VCR reads the information from the tape. Even the cleanest, G-rated videotape can cover the head with dirt over time, so engineers created a special *head-cleaning* cassette.

Pop the cassette inside the VCR and follow its instructions, usually by pushing the Fast Forward or Play buttons. Use the tape for the designated amount of time and then remove it from your VCR.

Hopefully, the cassette will remove the dirt, resulting in a better picture. If it doesn't work, however, it may be time to take the VCR in to the shop for a professional cleaning.

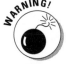

The cheapest videotapes coat your VCR's heads with dirt. Don't buy or use any videotapes that don't have the official VHS logo (shown in Chapter 1).

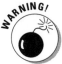

Overused head-cleaning cassettes can damage your VCR. Be especially careful with the ones that require you to soak the cleaning tape with a cleaning solution; some VCRs and camcorders warn against these wet head cleaners.

Fancy Electronic Labeler (such as the Brother p-Touch)

If your handwriting looks like it's just this side of Sanskrit, you may want to invest in an electronic labeler, such as the popular Brother p-Touch (available at many electronics and department stores).

Electronic labelers are like miniature typewriters: You type some text and press the Print button. Out comes this neat label you can peel off and stick just about anywhere — such as on a videotape. The labels don't rub off, and they look a heck of a lot better than scribbles on a piece of masking tape.

The p-Touch, like most electronic labelers, uses label cartridges. You can get all sorts of colors, but for labeling videotapes, good ol' black on a white background works best. Gordon McComb has discovered that he can label about 30 tapes with a single cartridge.

Cassette Drawers

Like goldfish, videotape collections grow to fill the amount of room given to them. When your collection no longer stands in a single pile or fits on the shelves under your TV, consider a cassette drawer.

Designed specifically for videotapes, the drawers not only provide a way to organize your videos but also keep dust from falling into the tape's cracks.

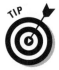

The best videotape drawers let you see the tape's labels *without* having to pick up the whole tape.

Complete Home Theater System for Your VCR

At a cost of several thousand dollars, this item may be beyond Santa's budget. Nevertheless, those gargantuan TV sets and sound systems sure make those low-budget home videos look impressive.

Bulk Tape Eraser

Sick of those 20 *Bewitched* reruns you recorded back when that new VCR made *everything* seem exciting? You don't have to keep them around. In fact, you can erase all those videotapes in seconds with a bulk tape eraser.

Simply turn on the *bulk tape eraser* and slide the tape over it a few times to completely erase anything that may have been on the tape, no matter how embarrassing.

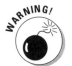

With bulk tape erasers, there's no return. If you've accidentally erased the wrong video, it's lost forever. Make sure that you've chosen the right video before running it past the bulk tape eraser.

Can't seem to bulk-erase those 8mm tapes? You're not alone. The special metal formula of 8mm tapes makes them almost impervious to all but the strongest bulk erasers. You may have to try erasing the tape three or four times before it does any good.

Chapter 21

Ten Ways to Make Big Bucks with Your VCR or Camcorder

In This Chapter

▶ Send your tape to *America's Funniest Home Videos*

▶ Videotape weddings (and other events)

▶ "String" for the local news

▶ Make instructional videos of something you know about

▶ Write a book about VCRs and camcorders

▶ Make a video album autobiography for your family

*N*ow that you spent all that money on a VCR or camcorder, you have to justify the expense to your spouse. No problem. This chapter covers bunches (but not ten) of ways to rake in some cash with your new equipment.

For each money-making scheme, we provide a "pro tip," designed to help make your tapes stand out from the crowd.

Send Your Tape to America's Funniest Home Videos

Slipped on a banana peel lately? Had your pants fall down in public? Thrown up on the prime minister of Japan? If so, you might make a ton of cash by recording your most outlandish antics and sending them to the producers of *America's Funniest Home Videos*. You can win a sizable cash prize of several thousand dollars if they judge yours to be the funniest. The runner-up prizes aren't too bad either.

Pro tip: Be crafty enough to make the event look spontaneous. If your pants really *do* fall off, pretend to be very surprised. And be original. Lots of people have had their pants fall off, so think of something different. Maybe have them fall off in front of the Queen of England. That probably hasn't been done yet.

Videotape Weddings (and Other Events) for Profit

Hot dogs and baseball. Mom and apple pie. Camcorders and weddings. Some things were just made for one another. Set yourself up to tape the blessed event for couples-to-be (you can advertise in the paper or comb the paper for engagement announcements). Have a buddy come with another camcorder, and you can edit the two tapes together for a more professional look.

Pro tip: Lots of people videotape weddings, so think about how you can make your services unique. Maybe go in halfsies with the pilot of a hot-air balloon. Offer a complete wedding package of a hot-air balloon ride, champagne, a minister, and a videotape of the whole thing.

"String" for the Local News

People have a voracious appetite for news, especially news that includes a picture. The crews of local news shows can be in only one place at a time, and they can't possibly get all the worthy news that goes on in your town. If you have a police-and-fire radio scanner, you can listen in on calls. If something exciting happens near you, dash out with your camcorder and be the first to get it on tape. If it's good and the news is important, sell the tape to your local news station. This process, called "stringing for the news," is becoming quite common.

Police-and-fire radio scanners are legal in most parts of the country. However, most places don't allow you to have a scanner in your car. You have to listen for the police and fire reports in your home and then drive to the trouble spot.

Pro tip: If you want to get serious about stringing for various TV news stations, talk with the news editor at the station and ask about procedures and policies — videotape formats, for example.

Make Instructional Videos of Something You Know About

All of us have specialized knowledge about something. It might be about computers or woodworking or quilting or milking aphids. If you have an interesting hobby or job — and you like to be in front of the camera — turn it into a money-making opportunity.

First, write a script showing how to accomplish some task, such as pouring cement for a sidewalk. Then have someone videotape you while you go through the steps. You can narrate as you go or add the narration later if your VCR or camcorder has an audio dub capability. Then advertise the tape in your local paper or even in a national magazine.

Pro tip: You can make a reasonable amount of money in instructional videos *if* you have something unique to talk about and you strive for the best picture and sound quality you can.

Write a Book About VCRs and Camcorders

See? We practice what we preach.

Pro tip: There's room for only one mass-market book about VCRs and camcorders. Find something else to write about.

No Money in It But It's Fun Department: Make a Video Album Autobiography for Your Family

Here's an idea that won't make you much money but will probably make you a hero in the family: Use your camcorder to create a video family album. What you put in this video family album is up to you, but it might include some of the following elements:

- Close-ups of old photographs and documents (such as birth certificates)
- Old 16mm and 8mm movies transferred to tape

✔ Interviews with family members

✔ Visits to cemeteries or old family homesteads

When you finish the video family album, make copies for every member of your family. Finally, make extra copies in case something happens to your original tape, and store the tapes in a safe place to make sure that they last a long time.

Pro tip: Use variety to make your video family album interesting. If you have 30 minutes' worth of Grandpa and Grandma on 16mm film, use just a minute or two in your album. Insert shots of other things, such as photos, documents, headstones, and live interviews with surviving members of your family. Think in terms of making your video family album an interesting documentary you would want to see on PBS.

Chapter 22

Ten Most Common Mistakes (and How to Fix Them)

• •

In This Chapter

▶ Keeping the dust cover on when the VCR is on

▶ Placing tapes beside speakers and your child's collection of fridge magnets

▶ Inserting a dirty or wet tape in a VCR or camcorder

▶ Storing tapes the wrong way

▶ Taking apart your VCR or camcorder without knowing what you're doing

▶ Leaving tapes and your camcorder in a hot car

▶ Forgetting to recharge your camcorder battery

▶ Forgetting to label your tapes (erasing over the ones you want to keep)

• •

*Y*ou've found the most important part of the entire book: the almost ten most common mistakes people make with their VCRs and camcorders. And even more important, we've included the easiest ways to fix each one of those mistakes.

Keeping the Dust Cover on When Your VCR Is on

A dust cover is a good thing — it keeps dust from falling into your VCR's air vents and coating its sensitive internal parts. But there's one catch:

Don't ever run your VCR while it's wearing its dust cover. A VCR is supposed to heat up as it runs; its air vents let it cool down naturally. But the heat can't escape through the VCR's dust cover, and the resulting high temperatures can do much more damage than dust ever would.

Always remove the dust cover before turning on your VCR.

Placing Tapes Near Speakers or Your Child's Collection of Fridge Magnets

For some reason that is fully understood only by scientists, VCRs record movies by magnetizing the videotape in certain ways. Yeah, it's kind of a weird technology.

And it means that a 99-cent magnet can destroy the hard work of a $300 VCR and wipe out a videotape's movie. So keep your videotapes away from magnets and anything that contains a magnet: speakers, telephones, paper-clip holders, and other items containing disguised magnets.

Inserting a Dirty or Wet Tape in a VCR or Camcorder

If it's not clean and dry, don't stick it inside your VCR or camcorder. 'Nuf said.

Storing Tapes the Wrong Way Without Protective Cover

Have you ever gotten down on your carpet and looked closely, and we mean *closely,* at what was down there? It's enough to make you grab your vacuum cleaner (or at least think about grabbing your vacuum cleaner). But a common mistake lots of people make is to put their tapes on the carpet. Sure enough, the tape picks up little pieces of dirt and carpet fuzz, which go right into your VCR when you put the tape inside. It's sort of like dropping your avocado-and-tomato sandwich on the ground and then picking it up and eating it.

All this brings us to two cardinal rules of keeping tapes:

Cardinal Rule #1: When you're finished with a videotape, put it back in its little sleeve. That way, it doesn't pick up as much of the crud that can get inside the VCR.

Cardinal Rule #2: To keep even more dust off 'em, put the tapes into a little tape drawer. You can buy tape drawers — big enough to fit 20 to 24 tapes — at almost any department store. They're cheap and will help you organize your tape collection.

Tape drawers also store tapes the proper way — vertically on the long side. Video purists consider it a no-no to store tapes flat, like books stacked on a desk, or vertically, on the short side. Both methods can eventually deform the tape inside.

Taking Apart Your VCR or Camcorder without Knowing What You're Doing

Sometimes a VCR or camcorder adjustment looks so easy: Just remove those three little screws, pull out that black thing, and bend that metal strip over to the left a *fraction* of an inch.

But after you remove those three little screws, pull out the black thing, and bend the piece of metal to the left by a fraction of an inch, you probably will find that the VCR or camcorder doesn't work at *all*. Even worse, you've probably voided the warranty.

Leave the internal repairs to the pros. The only things you should be sticking in your VCR or camcorder are tapes and an occasional head cleaner.

Leaving Tapes and Your Camcorder in a Hot Car

Hopefully, you know not to leave your dog or cat in the car in the supermarket's parking lot. During a hot day, the temperature can easily reach higher than 100 degrees.

Those high temperatures can easily harm camcorders and melt videotapes too. Don't keep your tapes and camcorder in the car, especially on the dashboard.

In fact, don't keep your camcorder exposed and alone in a car. Even if it doesn't melt, it might get stolen.

Forgetting to Recharge Your Camcorder Battery

This mistake happens over and over again: You grab the camcorder and head out the door. But when it's time to shoot, the little red light doesn't come on: The battery has died since the last time you used the camcorder. And unfortunately, you didn't charge it the night before you wanted to shoot.

If you want to be able to videotape things at a moment's notice, make sure to keep a camcorder battery charged up and ready to go.

You'll find more camcorder battery tips at the tail-end of Chapter 14.

Forgetting to Label Your Tapes (Erasing over the Ones You Want to Keep)

Labeling videotapes is about as much fun as scrawling return addresses on a stack of bills. So most tapes don't get labels: "Aw, I can remember that *that* videotape has the latest episode of *Deep Space Nine*," you murmur to yourself, "and that *that* tape has Jerry playing fiddle at the last school talent show."

But after you accidentally erase little Jerry's performance for yet another copy of *Deep Space Nine,* it sinks in: The human memory is no match for a videotape label.

So label your tapes. And then take the time to write down the tape's *contents* on its label.

If possible, peel off old labels before putting on new ones. Otherwise, the heavily labeled tapes can get too thick to slide easily in and out of the VCR or camcorder.

Chapter 23

Ten (or more) Answers to the Most Common Questions

In This Chapter

▶ Why is my VCR flashing 12:00?

▶ How do I record one show while watching another?

▶ How can I quickly see what's on an unmarked tape?

▶ Why doesn't my VCR record when I press the Record button?

▶ Why do I see ugly white lines on my screen when I play a tape?

▶ Why are some PlusCode numbers longer than others?

▶ What is this "Dolby Surround" thing I see on the back of the videotape box?

▶ Why are the top and bottom of the picture black?

▶ What stuff is legal to copy?

▶ How do I make video copies of my slides and movies?

▶ Will my tape work in Uncle Miklos' VCR in Greece?

*T*here's no such thing as a dumb question unless you're the one asking it. At least that's how some wise guys make you feel when you ask a question that they think has a simple answer.

This chapter saves you the embarrassment of having to ask a common question and risk a "Boy, aren't you dumb" response.

Why Is My VCR Flashing 12:00?

You haven't set the VCR's clock. The VCR flashes 12:00 to tell you that the time is wrong and that you need to set the correct time. The clock flashes the first time you plug in the VCR. It also flashes if you lose power, even momentarily (although many of the latest VCRs keep the current time for as long as 10 or 15 minutes in the event of a power outage).

The clock is used to help tell you the time. It's also used to record programs automatically when you're away. If you don't need another clock in the living room and you never program your VCR to record shows while you're away, you don't really need to set the clock.

See Chapter 5 for more info about setting the clock on your VCR.

How Do I Record One Show While Watching Another?

Being able to record one show while watching another is one of the main selling points of a VCR. Trouble is, if you're on cable and use a cable box, you probably *can't* watch one show and tape another. Because the cable box tunes in the channel, you're stuck with watching and recording the same thing. They don't often tell you that when you're buying your VCR.

If you have an antenna or a cable system that doesn't use a box, you can watch one show while recording another by first tuning to the channel you want to record with the VCR. Begin recording. Press the TV/Video button on the VCR, and then tune in the channel you want to watch on the TV.

See Chapter 6 for more information about recording with your VCR while watching other programs.

How Can I Quickly See What's on an Unmarked Tape?

"Quickly" is in the wristwatch of the beholder. You should avoid creating a stack of unmarked tapes because it's a pain to have to go through them just to find the one you want. Besides, you might accidentally use one to tape a new program and erase something you meant to keep. Label your tapes as you record them.

Lecture over. For the quickest way to preview what's on an unmarked tape, pop the tape into the VCR and press Fast Forward for a few seconds. (This advice assumes that the tape was rewound.) Press Play to view the tape. After you figure out what's on the tape, press Stop and then press Rewind. Eject the tape, and use a label to mark the contents of the tape.

Why Doesn't My VCR Record When I Press the Record Button?

There are three reasons a VCR might not record when you press the Record button:

- ✔ On many VCRs, particularly the older models, you must press the Record button and the Play button at the same time before the VCR will record. This fail-safe measure keeps you from accidentally pressing Record and erasing something you meant to keep.

- ✔ The record tab has been removed from the tape. The record tab is located on the left side of the tape spine (the part where you put the label). If the record tab has been broken off, you see a little square indentation in the tape — that little hole means that you can't record with that videotape. If you *really* want to record something on the tape, cover the little notch — that indentation — with masking tape.

- ✔ Uh, is there a tape in the VCR? All VCRs need a tape before they can record.

See Chapter 4 and Chapter 6 for more information about recording with your VCR.

Why Do I See Ugly White Lines on My Screen When I Play a Tape?

Those ugly white lines are caused by incorrect *tracking*. When a videotape is recorded, it makes tiny, tiny tracks for the picture and sound information. When the tape is played back, the VCR must retrace these tracks exactly or else the ugly white lines appear at the top or bottom of your screen.

If your VCR has an automatic tracking feature, it should adjust itself to eliminate or at least reduce the ugly white lines. Even with automatic tracking, the white lines may remain. You may have to help your VCR along by manually adjusting the tracking. The buttons for manually overriding the automatic tracking differ from VCR to VCR; consult the manual that came with your VCR to learn how to adjust the tracking manually.

Other VCRs lack automatic tracking, and any adjustments in the tracking have to be made by you. Turn the tracking knob (or push the tracking buttons) to minimize or eliminate the white lines.

See Chapter 4 and Chapter 16 for more information about using the tracking control on your VCR.

Why Are Some PlusCode Numbers Longer Than Others?

PlusCode numbers are the numbers you see beside the program listing in *TV Guide* and other TV-listing publications. The number is for exclusive use with the VCR Plus VCR programming controller.

The PlusCode numbers used in your television listings uniquely identify a particular program for a particular week, so when you enter the numbers in the VCR Plus, it knows when to turn the VCR on and off and which channel to tune to.

The VCR Plus number is derived from a complex (and top secret) computer algorithm. This algorithm — which is just a fancy way of saying a "set of rules" — tends to favor programs in prime time and on the most popular channels; these programs are often given short PlusCode numbers of just four digits. That makes them easier for you to enter. Programs shown on other, less popular channels and at oddball times of the day might have PlusCode numbers of eight or nine digits.

Read more about VCR Plus in Chapter 8.

What Is This "Dolby Surround" Thing I See on the Back of the Videotape Box?

Dolby Surround is used in movies to put sound in the back of the theatre in addition to the front. It's an improvement on the old "quad" sound system popular in the early 1970s.

The sound of a Dolby Surround soundtrack is left untouched when the film is put on videotape. That means with the right equipment, you can hear the movie in about the same way it was originally shown in the movies. To listen to Dolby Surround, you need a stereo hi-fi VCR. You also need a stereo amplifier with the Dolby Surround feature. The ProLogic Dolby Surround offers better results.

To complete the Dolby Surround setup, you need five speakers: the regular left and right stereo speakers, a center speaker near the TV, and two smaller speakers in the rear of the room. The two rear speakers add ambiance to help you feel enveloped in the sound of the movie.

A few TV programs — most notably *The Simpsons* — are broadcast in Dolby Surround, and you can use the same sound system to listen to these shows.

Why Are the Top and Bottom of the Picture Black?

You're watching a movie on TV or tape, and the movie appears squeezed into a rectangle in the middle of the screen. On the top and bottom of the screen are wide, black bars. Though it may appear otherwise, this rectangle is intentional. This effect, called *letterboxing,* shows the movie in the same wide-screen format used to project the film in the theatre. Without letterboxing, you can see only part of a wide-screen movie at a time. You might miss important action that way. In some movies, you may not even be able to see all the actors who are supposed to be on the screen!

Letterboxing makes the action part of the movie smaller. To do it justice, you really need a large-screen TV — anything over about 21 inches will do, although 25 inches and larger is better. If you have a small 9- or 13-inch TV, you'll probably want to either sit very close to the set or stay away from letterboxed movies.

What Stuff Can I Copy?

The U.S. Supreme Court has ruled that it is perfectly legal to copy programs you receive over the air and through cable. Although the programs are copyrighted, the Court considers this kind of copying "fair use" — but only if you don't try to profit from the copies. You can also give these copies away and share (or trade) them with others. To be on the safe side, no money should trade hands, even if it's only to pay for the cost of the blank tape.

It is not legal to copy a movie you rented on tape or video disc. This is copyright infringement, even if you make the copy only for yourself.

How Do I Make Video Copies of My Slides and Movies?

Before camcorders, there was Super 8 film. If you shot much Super 8, you'll probably want to copy it to videotape so that you can watch it without lugging out the projector. You can copy (also known as *transfer*) movies to videotape yourself, or you can pay a service to do it.

- To transfer movies yourself, set up the projector and screen so that the image is about two feet across. Put your camcorder on a tripod next to the projector and aim it at the picture. Start the projector and the camcorder and then begin recording. The video picture will probably have some flicker in it, especially if the movies are projected at 24 frames per second. There's really little you can do about this.

- For better results, take your movies to a local photo store that offers film-to-tape transfers. The price is often reasonable — most places charge from a quarter to 50 cents per minute and sometimes less. Shop around for the best price, especially if you have lots of film to transfer.

You can also transfer your slides to videotape and add narration as you go. Set up the projector and screen so that the projected image of the slide is about two feet across. Put your camcorder on a tripod and aim it at the screen. For a more professional job, pause the camcorder between slides so that you don't tape the slide change.

Will My Tape Work in Uncle Miklos' VCR in Greece?

Tapes made in one country don't always play back on VCRs used in a different country. The reason is that broadcasters use several TV transmission standards throughout the world. The standard used in the United States, Canada, and Japan (and in a few other places) is called NTSC. It is incompatible with the TV standard used in South America, Europe, and most other countries. That means that if you make a tape in the U.S., it probably won't play when it's used on a VCR in a different country.

You can watch tapes made with an incompatible television system if you have a *multistandard* VCR. These VCRs play tapes in two or more television systems, such as NTSC (North America and Japan) and PAL-M (most of western Europe, except France). Multistandard VCRs are about two to three times as expensive as regular VCRs, and they are usually available only by special order.

Chapter 24
Ten Camcorder Tricks and Tips

· ·

In This Chapter

▶ Cleaning the lens

▶ Preparing camcorder tapes

▶ Recording new movies on a camcorder

▶ Recording old movies and slides on a camcorder

▶ Recording classes in school

▶ Making records for insurance claims

▶ Recording sounds in addition to video

▶ Remembering the rule of thirds

▶ Keeping a second battery handy

▶ Avoiding checking your camcorder as luggage

▶ Filtering out wind sounds when you're videotaping

▶ Using a shotgun microphone

▶ Checking the battery on camcorder accessories

· ·

Don't have time to read the whole book? Want to grab that new camcorder and head out the door? Then just check out this one chapter before pushing the Record button.

Clean the Lens

It's simple, it's obvious, and it's ignored by most camcorder owners. Whenever you take your camcorder out of the bag, stop and clean the lens with a soft cloth or lens tissue, available at most camera stores.

Don't clean the lens with paper, such as facial tissues or toilet paper. Doing so can scratch the lens.

If the lens is just a little dusty, use a bulb brush designed for cleaning camera gear to get rid of the dust. A bulb brush is available at any photo store. If there are oily smudges on the lens or the dirt is caked on, buy a liquid lens cleaner and cloth. (Be sure that it's the kind for camera lenses, not for eyeglasses!) Carefully clean the lens and make sure that you don't scratch it.

Fast-Forward and Rewind New Hi8 Tapes

Hi8 "metal-particle" and "metal-evaporated" tape is coated with little metal particles that can fall off the tape when it's stored for a long time. By fast-forwarding and immediately rewinding new tapes, you can shake the loose particles off the tape. That keeps the bits from falling off the tape after you've recorded something on it. The falling bits take little bits of your picture along with them.

Record Real Movies on Your Camcorder

Heading on a business trip? Then feel free to use your camcorder as a VCR. Record a favorite movie or two on tapes by using your camcorder and then play the movies back on the TV in your hotel room. That way, you don't have to pay those outlandish movie rental fees that hotels manage to slap onto the tab.

Record Old Family Films on Your Camcorder

Many camcorder owners are moving up from the old world of 8mm movies or slides. And chances are that those old movies and slides are sitting in a box somewhere. Movie and slide projectors are just too much of a bother to set up and maintain — not to mention replacing their light bulbs.

So convert your movies and slides to videotape. You have three options:

- ✔ Take the movies and slides to a professional. This option is the simplest, but it can be costly — especially if you have lots of movies and slides.
- ✔ Put your camcorder on a tripod and film the movie screen while the movies or slides are playing back. Hook up a TV to the camcorder and experiment with different angles until you find one that makes the slides and movies look good on the TV; then begin videotaping.

✔ Use slide/movie converter boxes. These boxes work like miniprojectors for either slides or movies. Fasten the camcorder to one end and pop the slides or movie in the other end; the camcorder captures the action.

Some nostalgia buffs intersperse photographs with their slides and movies. Simply place the photograph underneath glass so that it lies flat and then shoot it up close.

Record Classes in School

It used to be cool to bring a tape recorder to class; you could relax while taking notes, knowing that you weren't missing anything. And if you were majoring in business, you could sell the tape to other students who had missed the class.

Now people set up tripods in the back of the room and videotape the lectures. These tapes bring top dollar because they include the blackboard. The *really* successful business majors can even sell the tapes to the professors, who often want to see how their lectures look on TV.

Caveats: First make sure that the prof doesn't mind. Then make sure that you have a long enough tape and battery life to capture the class. Finally, if your camera doesn't have Auto Focus, focus it manually on the blackboard and hope that the prof doesn't move around much.

Make Tapes for Insurance

One of the problems with insurance policies comes when you try to prove what something looked like *before* it was damaged. Insurance claims adjusters tend to raise their eyebrows when they're asked to replace the 16th century Persian rug you lost in the flood.

So make a videotape of everything you've insured: your car, your house, and any other covered possessions. Keep your receipts around, if you have them. In fact, videotape the receipt sitting next to the item.

While you're filming, talk out loud and explain what you're looking at and how much it cost. Get in close to record any serial numbers or identifying characteristics. Finally, stick the tape in your safe-deposit box at the bank, just in case your house burns down.

Use Fake Sounds in Your Videos

If you'll be editing your tape later, bring a tape recorder along to record extra sounds. That way, you can capture extra bird squawks to slip into your nature video. Or if you're recording a wedding, put the tape recorder and microphone up near the action. Then you can edit the "I do" sounds into your final tape — even if your camcorder was too far away to record the sounds.

Don't have a tape recorder? Then fake your sounds. Pour sand slowly down a paper-towel tube to create a rain sound; blow gently across the top of a glass bottle to make a foghorn. Crunch newspapers together to make the sounds of footsteps in gravel or snow.

The Weird Rule of Thirds

This gets weird, but hold on a second. Some ancient Greek came up with the rule of thirds, and it goes like this: When things are chopped into thirds, they look better than when they're chopped into halves. So when you're looking through the viewfinder, imagine a grid hovering over your image, as shown in Figure 24-1.

Figure 24-1: Things look more aesthetically pleasing when they're placed near lines.

If you see any natural lines in what you're shooting — a horizon, skyscrapers, windows, standing people — try to line up the natural lines with the "third" lines shown in Figure 24-1.

The items you're trying to emphasize should appear near the *intersections* of the lines. Sure, this sounds superstitious. But play with the concept awhile. Eventually, you'll shrug your shoulders and say, "Hey, whatever works."

Keep a Second Camcorder Battery Handy

You can be assured of always having enough battery power by packing an extra, fully charged battery for your camcorder. If the first battery dies while you're shooting, you can pop it off and replace it with the fresh one. The second battery is particularly handy on outings such as Disneyland, where you can't easily stop and recharge your camcorder's battery.

If you get a spare battery for your camcorder, be sure to use it every once in a while. Camcorder batteries last longer if you use them before recharging them.

Never Check Your Camcorder As Luggage

Airline luggage handlers can be downright abusive to suitcases. The ramps and carousels for luggage at most airports also tend to jostle suitcases. Camcorders are extremely fragile, and it always pays to carry them aboard the plane yourself; never check them as luggage. This advice also helps prevent the camcorder from being stolen.

The more carefully you pack your camcorder, the less likely it will receive a jolt that might break it. Gordon McComb's camcorder was mishandled once, and the microphone broke. Although the microphone still works to a point, more often than not it just fills the soundtrack with a crackling sound. Gordon had to buy an expensive external microphone as a replacement (the repair shop wanted too much money to fix the camcorder's own microphone).

Wear Your Wind Sock

Shooting outdoors? Then put a sock in it. Or rather, over it. *It* is the camcorder's microphone, of course.

A wind sock is a piece of fabric that lets sounds pass through, but not big puffs of wind. This strategy helps prevent the pops and cracks that normally happen when wind suddenly hits your camcorder's microphone.

Some camcorder microphones have wind socks built into them; others make you slip the wind sock over the tip of the microphone as though it were a bootie. On other camcorders, the wind sock is electronic: Flip a switch, and magical circuits in the camcorder knock out the pops from the wind. They don't always work, however, so don't trust everything just because it's electronic.

If your wind sock suddenly blows away, make a makeshift wind sock from a piece of women's hosiery. Snip out a piece about five inches square, wrap it around the microphone a few times, and secure it with a rubber band. (Ask the woman for permission before snipping, especially if she's a stranger.)

Use a Shotgun Microphone to Get Faraway Sounds

The microphone built into most camcorders is great for sounds that are five or ten feet away, but it's terrible for sounds that are farther away. When you're using the camcorder's built-in microphone while videotaping the high school football game, you just hear the crowd getting cranky over the cold hot dogs.

The solution is to invest in a *shotgun microphone*. It's called a shotgun because it sort of looks like one — it has a long barrel. But rather than shoot bullets, the long barrel can concentrate on the sounds in *front* of the microphone, not from the sides. The sensitive circuits inside the microphone amplify faraway sounds: You can hear the players grunt and the coaches swear.

To use an external shotgun microphone, your camcorder must be equipped with an *accessory shoe* (that's where the microphone attaches) and a microphone jack.

Check the Battery If You're Using an External Microphone

Gordon McComb is still living in the doghouse over this one. He completely botched taping his son's preschool graduation because he forgot to check the battery that's built into the external microphone he was using with his camcorder. The result? A picture with no sound.

Most external microphones, such as the shotgun mikes that pick up long-distance sounds, come with their own batteries. Remember to replace them before shooting any important events. (Gordon certainly will.)

Chapter 25

Ten Ways to Drive the Video Superhighway

In This Chapter

▶ Try a crystal-clear laser-disc player

▶ Get on the direct-broadcast satellite bandwagon

▶ See lots of stuff on a satellite dish

▶ What is this wireless cable thing?

▶ Talk back with interactive cable

▶ Get the scoop on high-definition TV

▶ See TV on a CD?

▶ Digitize Rover with Digital Videocassette

▶ What else might come down the information superhighway?

*E*verybody loves catchwords. One of the all-time favorites among the ten o'clock news writers is "the information superhighway." It's a good phrase because it means absolutely nothing. That way, people can make up any meaning they want for it.

The phrase was coined to represent all the ways in which information and entertainment can find its way to your home. Along this road might travel the information of an encyclopedia, music videos "on demand," and maybe even the latest movies. Though the "information superhighway" is a rather nebulous thoroughfare and much of it is yet unpaved, it's fun to see what the road planners are doing now and what they have in mind for tomorrow.

Because not all technologies involved in the information superhighway have been fully developed, we include one of the following comments about their "road condition":

✔ **Fully paved:** You can drive on this part of the information superhighway today.

> ✔ **Narrow but drivable:** Sure, it's a highway, but it's a narrow, two-lane job.
>
> ✔ **Men (and women) working:** Part of the road exists today, but it's not complete. Drive with caution.
>
> ✔ **Just a dirt road:** A great idea in the works, but the road is closed to through traffic.

Try a Crystal-Clear Laser-Disc Player

Road condition: Fully paved

Laser-disc players are so old that their road is now full of potholes. But despite their age, laser discs still represent the best way to watch movies at home with the highest-quality picture and sound possible. After you watch a movie on laser disc, you'll never again be satisfied with the quality of VHS.

A laser-disc player is about the size of a stereo receiver, and it uses shiny, silvery discs that are the same diameter as an old LP record. Laser-disc players use laser light to pick up the sound and picture recorded on the disc; you can play a disc hundreds of times and it doesn't wear out. Videotape begins to wear out little by little every time you play it on a VCR. Many of the latest laser-disc players combine the capability to play laser discs with music CDs. You get two disc players for the price of one.

Movies on laser disc aren't as easy to buy and rent as are movies on VHS tape, which is one of the main reasons laser-disc players aren't more popular. (They've been around almost as long as home VCRs.) You can buy laser discs at specialty video stores and some of the larger music stores. Some of these stores rent laser discs, too, for about the same money as renting a VHS tape.

Get on the Direct-Broadcast Satellite Bandwagon

Road condition: Fully paved

Imagine pointing your TV antenna toward the sky rather than across town. That's the idea behind something called direct-broadcast satellite, or DBS. The notion of DBS has been around for more than a decade, but in the United States, real DBS service didn't start until a few years ago. DBS is sort of like cable but without the wires, and you can sign up for the service — which consists of the same sorts of things you can see on cable — from most anywhere in the country.

Right now, there are two main DBS services: DSS, the brainchild of electronics giant RCA/Thompson, and Primestar, operated by a coalition of cable TV operators. The technology of the two systems is similar, but the cost of getting on board differs. With DSS (which stands for Digital Satellite System), you buy the satellite dish and receiver (about $500 to $800, depending on the model). Then you are required to install the system yourself or have it professionally installed. With Primestar, you pay an installation fee (you aren't generally allowed to install it yourself) and then rent the equipment by the month. With both systems, you then pay a monthly fee to receive the programming, such as HBO, Showtime, CNN, and MTV.

Expect to see DBS services expand in the coming years as they launch new satellites and competition gets fierce. More and more people may elect to get their cable TV from a satellite, not a cable.

See Lots of Stuff on a Big Satellite Dish

Road condition: Fully paved

The direct-broadcast satellite (DBS) system just described uses an antenna — or dish — that points to one or two satellites simultaneously in the sky. Yet dozens of satellites are hovering over the United States right now. Many carry programming you can watch — if you have a full-scale satellite system. Unlike DBS, a full-scale satellite system uses a motorized dish, so it can sweep from one edge of the sky to the other, looking for different satellites. The dishes for full-scale satellites measure six or more feet in diameter; a popular size — because it offers the best pictures — is ten feet in diameter.

A full-scale satellite dish costs more money than a DBS setup, but the programming costs less per month and offers more variety. Unless you really know what you're doing, however, you need a professional to install the dish.

Although you can tune in to some of the shows on satellite for free, most cost something. You pay a subscription charge to see services such as HBO, Cinemax, the Disney Channel, and dozens of others. Specialty TV listings just for full-scale satellites, such as *Orbit* and *Satellite TV Week,* often carry ads from companies that will sell you subscriptions to individual services or complete program packages.

What Is This Wireless Cable Thing?

Road condition: Narrow but drivable

Few people like the cable companies. But cable companies have a virtual monopoly on their business because they're the ones who laid the cable that carries the TV signals. *Wireless cable* is a way to provide cable service without the wire. Rather than beam TV channels through a cable, with wireless cable the signals go through the air.

Wireless cable is an old idea (one ancient name for it was multipoint distribution system, or MDS), but it's finally catching on in some parts of the country. The first wireless cable system carried just one or two channels; these days, some wireless cable systems carry a dozen or more channels — the same ones you get on ordinary cable. Wireless cable is a great alternative if your house isn't yet on cable or you're disgusted with your current cable company and want to try something else.

Wireless cable requires an outdoor antenna. The antenna is dish-shaped but small and unobtrusive. The major disadvantage of wireless cable is that it works best in towns that are flat. The signal doesn't go through mountains and tall buildings, and the receiving antenna must be pointed directly at the transmitting tower.

Is wireless cable here to stay — amid regular cable systems and satellite TV? Could be. Just recently, the U.S. government passed a law allowing the phone companies to get into the cable TV business. Instead of hooking up subscribers by wire, many of the regional phone companies, such as Pacific Telesis out on the West Coast, plan to first offer television via wireless cable technology. In the years to come, say the phone companies, they plan to slowly wire homes with fiber optic cables so customers can receive television and telephone signals all on one wire.

Talk Back with Interactive Cable

Road Condition: Just a dirt road

When it comes to cable TV, the information superhighway is one-way. You can get signals from cable companies, but they can't get any from you, at least not without using some other means (such as the telephone, when you want to order a pay-per-view movie). Cable companies want to provide information in addition to entertainment, so many are working on ways to make their systems interactive, or two-way.

With interactive cable, you might tune into the Encyclopedia Channel. You type a command on a keyboard — suppose that you want to see more information about ancient Rome — and it gets sent to the cable company. Within seconds, you see on your TV screen an encyclopedia entry for *Caesar, Brutus* and the rest of those Roman guys.

Although interactive cable has been around for more than ten years, it has existed only in test form. Interactive cable is not likely to be a reality for many years. Cable companies have to dig up all their old cable and put down new stuff, and the cost to put in two-way cable could be a billion dollars, even for a medium-size town.

Get the Scoop on High-Definition TV

Road Condition: Just a dirt road

The TV pictures you see today are based on technology more than 50 years old. Back then, picture TV quality was about as good as one could hope for, what with all the tubes and other archaic stuff used in television sets. The quality of TV pictures hasn't improved in all these years because making a change would mean having to buy all new TVs.

But it looks like that's what we'll have to do by the end of this decade, when the makers of high-definition television (HDTV) plan to make a big entrance. HDTV has been in the works since the 1970s, but no one could agree on a new standard. The Federal Communications Commission (a branch of the United States government), in its infinite wisdom, asked several competing companies to propose ways to deliver better-quality pictures by using the same TV channels now in use. What we've ended up with is several of the companies banding together to form what's known as the Grand Alliance, which together are working out the technical snags to make HDTV work.

How much better will the picture be? The HDTV system the Grand Alliance has planned just about doubles the resolution (sharpness) of the system we have today. It also allows for wider screens. Rather than watch movies crammed in a square picture tube, movies with HDTV appear more like they were originally shown in the movie theaters — in a wide rectangle.

See TV on a CD?

Road condition: Men (and women) working

You've already read about laser-disc players. They play discs that are about 12 inches in diameter, which is pretty big for a video disc, though small for a pizza. Now they're coming out with videos on CDs, those little silver platters you've been using to listen to music and to play neat games on your home computer. Several video CD formats have been proposed, and a few you can buy right now. All require a special video CD player. You can't play a video CD on a regular 12-inch video disc player or on the audio CD player in your living room.

One of the first video CD formats was VideoCD, which fits an entire movie (up to about 75 minutes) on one side of a CD. The trick to cramming an entire movie onto such a small disc: The picture and sound are converted to digital pulses and compressed to make more room. When you play them back, the digital bits are decompressed, so you see the movie in regular form.

VideoCD uses an older digital compression technique, so the picture isn't all that great. Besides, few movies are under 75 minutes long, so two (or more) VideoCD discs are needed to hold an entire flick.

VideoCD was a nice first try. Now the electronics industry is taking a second stab at the idea of little movie discs, using a format it calls digital video disc, or DVD. As of this writing, the technology behind DVD is still being worked out. Players for DVD movies are supposed to be available sometime in 1996 or maybe as late as 1997. Each DVD disc will hold about 135 minutes of super-quality video. What makes DVD an interesting idea is that it has the backing of both the consumer electronics industry — always interested in coming out with new hardware you can buy — and the Hollywood studios — preferring video CDs because they are cheaper, in the long run, to make than are VHS tapes.

Digitize Rover with Digital Videocassette

Road condition: Men (and women) working

Digital this, digital that. All these digits are taking over our lives, including tapes we make with our camcorders. Forget 8mm, VHS, or C-VHS. The camcorder format of tomorrow is teeny-tiny 6mm tape, enclosed in a cassette the size of a finger sandwich. Instead of recording a regular video signal on the tape like your current camcorder does, a 6mm camcorder like the one shown in Figure 25-1, a U.S. model marketed by Matsushita Consumer Electronics Company (a

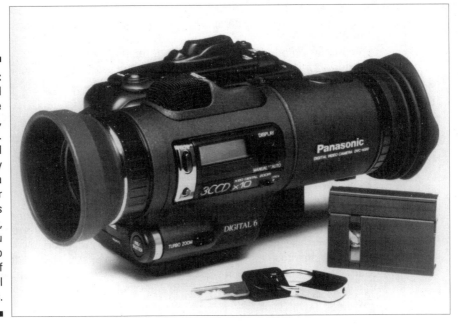

Figure 25-1:
New digital videocassette camcorders, like this U.S. model marketed by Matsushita Consumer Electronics Company, let you record up to an hour of digital pictures.

division of Matsushita Electric Corporation of America) records a digital signal on the tape. When played back, the picture is supposed to be sharper. And because your videos of your latest fishing trip are in digital format, you can copy them to other digital tapes and never lose picture quality.

The 6mm digital format (sometimes also called digital videocassette, or DVC) isn't just for camcorders. Expect to see it used for regular desktop VCRs, too. Don't throw your VHS deck away just yet, though. It'll take several years for manufacturers to come out with a really affordable 6mm VCR.

What Else Might Come down the Information Superhighway?

Much more is planned for the information superhighway. Microsoft, the maker of Windows and a bunch of programs for the IBM PC and Apple Macintosh computers, has all sorts of grand plans for offering electronic information through a worldwide network of wires and radio signals. Eventually, says Microsoft head honcho Bill Gates, you can get just about any kind of information you want through the superhighway and into your living room, such as the latest sports data, historical tidbits, recipes, and movie reviews.

The phone company wants in on the information superhighway, and the only thing stopping it is the federal government. Currently, the phone company cannot use its vast network of wires and fiber-optic links to provide entertainment and information on tap, but many industry watchers believe that it's only a matter of time before these laws are lifted and phone companies can compete with local cable companies, direct broadcast satellite, and other technologies.

Some companies have this idea of offering *movies on demand*. You pick any of several thousand movies from a master menu and, within 15 minutes, watch one on your TV. No more running down to the local video rental store (and paying extra when you forget to return it the next day). The movies-on-demand concept sort of sounds good, but so far it's just a pipe dream. Lots of technological hurdles have to be overcome first.

If you have a personal computer, you can jump on the information superhighway now, although with current technology you risk a head-on crash if you don't know the road. With a computer and a telephone modem, you can call up any of several information service providers, such as America Online, CompuServe, and Prodigy. Reams and reams of useful information are available on computer info services, but right now it can be difficult to get to unless you know exactly where to look.

But don't get anxious. When the information superhighway is truly built, you certainly will hear about it from phone solicitors, doorknob hangers, TV commercials, and print ads.

Part VI
Appendixes

In this part...

1 f you're interested in checking out videos by mail, look no futher than Appendix A. We've included lots of businesses to contact, and they represent a wide variety of movie tastes.

Not sure how to read the TV listings in your *TV Guide* or local program directory? Then head to Appendix B to have all your questions answered.

And if you're still not clear about what a *coax cable* is or if other technoid words make little sense, Appendix C provides you with a glossary of terms. After reading it, you'll be able to discuss comb filters and double azimuth with the best of them.

Appendix A

Sources for Videos You Can Order by Mail

• •

*T*ired of movies, movies, movies all the time? Looking for some interesting video tapes that are a little (or a lot) out of the ordinary? You can find a wide assortment of videotapes through the mail. This appendix provides a selected listing of mail-order video outlets. Most offer a regular catalog.

Appalshop, Inc.
306 Madison Street
Whitesburg, KY 41858
606-633-0108

What it offers: Programs on Appalachian culture.

Barnes & Noble Bookstores, Inc.
126 Fifth Avenue
New York, NY 10011
800-242-6657

What it offers: General interest movies.

Barr Media Group
12801 Schabarum Ave.
P.O. Box 7878
Irwindale, CA 91706-7878
800-331-1387
818-338-7878

What it offers: General interest and old classics.

Butterfly Video
Box 184
Antrim, NH 03440
603-588-2105

What it offers: Dance lessons (ballet, country-western, ballroom, and so on) on tape.

Cambridge Educational
P.O. Box 2153
Charleston, WV 25328-2153
800-468-4227
304-744-9323
800-FAX-ONUS (Fax)

What it offers: Educational videos.

Canyon Cinema, Inc.
2325 3rd Street, #338
San Francisco, CA 94107
415-626-2255

What it offers: Experimental and avant garde films (most of the films are on 16mm, but some are on videotape).

Careertrak Inc.
3085 Center Green Drive
P.O. Box 18778
Boulder, CO 80308-1778
800-334-1018
303-440-7440

What it offers: Tapes on self-development, business management, and improving your career.

Champions of Filmsport Videos
School-Tech, Inc.
P.O. Box 1941
745 State Circle
Ann Arbor, MI 48106
800-521-2832
313-761-5072

What it offers: Specialty video catalogs for sports.

Classic Performances on Video Cassette
Famous Artists and Artworks on Video
Frederic H. Weiner, Inc.
1325 2nd Avenue
New Hyde Park, NY 11040
516-437-9873
800-622-2675 (outside NY)

What it offers: Specialty catalogs for musical performances, artists, and artwork. Also rents tapes.

Collage Video
5390 Main Street NE
Minneapolis, MN 55421
800-433-6769
612-571-5840

What it offers: Exercise tapes.

Critic's Choice Video Catalog
P.O. Box 749
Itasca, IL 60143-0749
800-367-7765

What it offers: Current and classic movies and TV shows.

Fine Woodworking **Book and Video Catalog**
The Taunton Press
63 S. Main Street
P.O. Box 5506
Newtown, CT 06470-5506
800-888-8286 (Orders)
800-283-7252 (Customer Service)

What it offers: How-to tapes about woodworking (from the publishers of *Fine Woodworking* magazine).

Friendly Videos
Stewart Instruments, Inc.
P.O. Box 11926
Prescott, AZ 86304
602-778-6988

What it offers: How-to videos about using computers and computer software.

Fusion Video
17311 Fusion Way
Country Club Hills, IL 60478
800-959-0061

What it offers: General interest video, classics, old TV shows, instructional tapes, and more.

Green Mountain Post Film/Video
P.O. Box 229
Turners Falls, MA 01376
413-863-4754
413-863-8248 (fax)

What it offers: Documentaries on the environment and other subjects.

The Learning Skills Company
P.O. Box 9777
Norfolk, VA 23505
804-423-4903

What it offers: Instructional videos.

Movies Unlimited Video Catalog
Movies Unlimited
6736 Castor Avenue
Philadelphia, PA 19149
215-722-8298
800-523-0823

What it offers: Very large library of general interest movies and classics.

Photography Books and Visual Resources
Light Impressions Corporation
439 Monroe Avenue
P.O. Box 940
Rochester, NY 14607-0940
716-271-8960
800-828-6216

What it offers: Videos about photography.

Special Interest Video Collection
Alan Communications Group
586 Nashua Street
Suite 215
Milford, NH 03055
603-673-3279

What it offers: Instructional and how-to tapes.

Time Warner Viewer's Edge
PO Box 3925
Milford, CT 06460
800-224-9944

What it offers: General interest videos, classics, and sports.

V.I.E.W. Video, Inc.
Catalog Sales
34 E. 23rd Street
New York, NY 10010
212-674-5550
800-843-9843

What it offers: Videos on the performing arts, jazz, special interest, and classical music.

The Video Catalog
P.O. Box 64267
St. Paul, MN 55164-0267
800-733-2232

What it offers: General interest videos.

Appendix B
How to Read a TV Listing

*J*ust about everybody has gone "channel surfing" — gliding from channel to channel with the TV's remote control and catching bits of shows as they pass. By comparison, the organized show listings in *TV Guide* seem almost scholastic.

In fact, just what is all that junk in the *TV Guide* and other TV listings supposed to mean? This part of the book is your cheat sheet for figuring out weird VCR Plus numbers, funny abbreviations such as CC or SL, and other modern television oddities.

What Does All the Junk in the TV Listings Mean?

Figure B-1 shows a typical TV listing for a movie in *TV Guide,* which is the most popular TV listing in the U.S. You can find other TV listings in the TV or entertainment supplement that comes with your Sunday paper, among other places.

Channel number Length

Type of program Plus Code

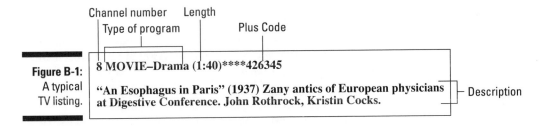

Figure B-1:
A typical
TV listing.

8 MOVIE–Drama (1:40)****426345

"An Esophagus in Paris" (1937) Zany antics of European physicians at Digestive Conference. John Rothrock, Kristin Cocks.

— Description

This listing shows the following:

- The program's channel number or service name (8, for example).

 If you see letters — such as HBO or LIF — rather than a channel number, they stand for a special service on your cable system. Check out your cable system's channel guide to see which channel number corresponds to which special service. Don't have a channel guide? Call your cable company and ask it to mail you one. (The phone number's listed on your latest monthly bill.)

 Channel numbers listed in black mean that the station is local — in your "market," as they say in TV lingo. If you're on cable, you should be able to get this channel.

 Channel numbers listed in white mean that the station is distant, possibly located in the next major city closest to you. If you are on cable, you probably don't get this channel — federal regulations might require it to be "blacked out" and left off your service. The station might be too far away for a rooftop antenna to pull in, too.

- The type of the program (Movie, Game, or New, for example).
- The length of the program (1:40 equals "1 hour and 40 minutes," for example).

 If the show is longer than 30 minutes, the TV listing tells you how long the program lasts. That information is useful when you're programming your VCR to record the show while you're away: Just tell your VCR to turn on when the show begins and to stop after it has recorded for one hour and 40 minutes.

 Other VCRs make you plug in the start and stop times manually. If the movie begins at 8:30, for example, and it's 1 hour 40 minutes long, you have to figure out that the VCR should shut off at 10:10. Pencil and paper often help when you're making calculations.

- The PlusCode number (426345, for example).

 If your VCR has the VCR Plus feature, entering this number tells your VCR to automatically record that particular program. Not all TV listings include the PlusCode number, but *TV Guide* does.

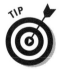

 If you see two PlusCode numbers, such as 1234/9876, the first number is for the first channel shown for the listing, and the second number is for the second channel. Ninety-nine percent of the time, you want to use only the first number.

- The description of the show and its major stars.

Other Symbols You May See in a TV Listing

TV listings use abbreviations to squeeze lots of information into a small amount of space. This section lists some of the more confusing abbreviations you've probably encountered.

BW: Black-and-white. The movie (or other program) is shown in glorious black-and-white. It's usually an oldie, although some directors, such as Woody Allen, use black-and-white to be arty.

CC: Closed captioned. Along the bottom of the screen, the program displays the words of the people currently talking or singing; that lets people with hearing disabilities follow the action more closely. The catch? Your TV set must have the closed-captioning feature built in or an attached closed-captioning box.

CZ: Colorized. The movie was originally filmed in black-and-white but has been *colorized* — color has been added by using a special computer process. (Gordon McComb detests colorized movies and turns down his TV's color control when he's watching them.)

Dubbed: The actors and actresses spoke a different language when they made this movie, so their original dialogue was erased and new dialogue was inserted to match your own language.

LBX: Letterboxed. The film is presented in its original wide-screen format: The picture appears as a long rectangle in the middle of the screen, with black strips along the picture's top and bottom.

OC: Open captioned. Like closed captioned, but the words appear on the screen for everybody to see on their plain old TV sets. Not often used.

SL: Sign language. For the benefit of those with hearing disabilities, the program is translated in sign language. A person doing the signing is shown in a little inset picture in the corner of the screen. Most often used for religious programs.

St: Stereo. Although the program was recorded in stereo, you might not be able to hear it in stereo, depending on the technical capabilities of your TV set and your local TV broadcaster or cable company.

Subtitled: On foreign-language films, the dialogue is translated to your language, and the translated words appear along the bottom of your screen.

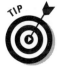

- If the program doesn't have BW or CZ, it was made in color and is shown in color.

- The star symbols you see beside the name of a movie in the TV listing is a subjective rating of the film's quality. Most TV listings use a series of one to four stars; one star means that the film is probably a dog, and four stars mean that the movie is an all-time classic. Most movies fall somewhere in between.

All about Film Ratings and TV Listings

VCRs are often used for watching movies — either movies you've rented or movies you've taped from the late-late show. Since 1968, the industry has been rating movies so that people know the intended audience. The rating system was invented to get Uncle Sam out of the film-censorship business — a role it played since the 1930s.

Movies are rated by a special group of people hired by the Motion Picture Association of America (MPAA), a trade group for movie studios, producers, and theaters. Filmmakers voluntarily submit to the MPAA rating process. Why? Because unrated films have a hard time getting shown in theaters or advertised in newspapers.

Here's what the ratings mean (the same ratings apply to movie channels such as HBO and Showtime):

G (general audiences): Everyone gets in, but because there's no sex or violence, few people bother. Very few movies made these days are rated G, even from Disney.

PG (general audiences; parental guidance advised): Some material may not be suitable for children. Everyone still gets in, but parents are supposed to say OK first. Yeah, right. PG movies usually contain some cuss words, a scary scene or two, and maybe a *quick* shot of a naked body. But nothin' much more.

PG-13 (parental guidance required; no one under 13 admitted without a parent or guardian): Supposedly, no kids under 13 are allowed in to a PG-13 flick without an adult. Not all theaters are strict about this rule, though. PG-13 films can contain violence and mondo cuss words, and they may be too extreme for the little tots, who might see lots of blowing up things or ugly monsters eating people. (Interesting history tidbit: The PG-13 rating was created especially for the movie *Indiana Jones and the Temple of Doom.*)

R (restricted): No one under 17 admitted without parent or guardian. The film probably has lots of gratuitous sex and violence and maybe some naked bodies.

NC-17 (no one under 17 admitted, with or without a parent or guardian): This new rating is intended for films that are too extreme for an R rating. Movies of a highly sexual nature generally are given the NC-17 rating; lots of blood and gore still get the R rating.

X (no one under 18 admitted): The X is an unofficial rating created by the MPAA. In the early days of movie ratings, only a few legitimate films got an

X rating (the most notable was *Midnight Cowboy,* which won an Oscar for Best Picture; the film was later rerated as an R). Today only hard-core pornography films carry the X rating, although they seem to prefer to write XXX on their movie marquees.

✔ TV listings include the original rating of the film only if the movie is shown on a movie channel, such as HBO, Cinemax, or Showtime. When a movie is listed in the TV listing with its rating, you can assume that the film is being shown in its uncut version.

✔ For movies shown on commercial TV — network and local channels — the rating is not often used: The film is edited to remove any juicy parts.

✔ Even after editing for TV, some movies still contain material not suitable for kids (the subject matter is for a mature audience), so the TV listing often says "parental discretion advised."

✔ Most TV listings nowadays use the following code words to help you better know ahead of time what a rated movie contains in the way of sex and violence:

AC: Adult content

AH: Adult humor

AL: Adult language

AS: Adult situations

BF: Brief nudity

GL: Graphic language

GV: Graphic violence

MV: Mild violence

N: Nudity

R: Rape

SC: Strong sexual content

V: Violence

Appendix C
Glossary

- -

8mm
A popular camcorder format. (An 8mm camcorder uses a videotape that is about 8mm wide.)

A/B switch
A switch for choosing between two TV signals, such as from an antenna or a cable box.

AC (alternating current)
The kind of electricity that flows through the power outlets in your house. *See also* DC.

AFT (automatic fine-tuning)
A circuit that locks onto a TV signal so that you don't have to turn a fine-tuning knob yourself. Also known as AFC on some old VCRs. *See also* quartz tuning.

antenna
Anything that picks up a signal from the air. An antenna can be something as simple as a piece of wire, to some "rabbit ears," to a big satellite dish in your backyard.

audio dubbing
Recording just the sound portion onto a tape and leaving the video portion.

auto rewind
A feature that makes the VCR automatically rewind when the tape reaches the end.

auto tracking
A feature that lets the VCR automatically adjust the picture tracking to remove white lines that appear at the top or bottom of the screen. *See also* digital tracking.

baseband

Audio and video signals that aren't combined and carried on radio waves.

Beta (Betamax)

A once-popular VCR format now made almost obsolete by the VHS format.

cable box

A control box used to tune in to various cable channels. The cable box often includes a circuit for "descrambling" the picture — if you pay extra to receive that particular channel.

cable ready

A VCR or TV that can tune in to cable channels. Cable-ready TVs and VCRs cannot unscramble a scrambled cable picture, however.

cassette

The black box that contains the videotape. The cassette protects the tape inside.

CATV

Stands for *cable TV.*

CCD (charge coupled device)

The technoid term for the thing in a camcorder that picks up an image through the lens and turns it into electrical pulses that can be recorded on tape.

Channel 3/4 switch

A switch on the back of a VCR to change the output channel to Channel 3 or 4. You dial the TV to this channel to watch a tape on the VCR.

closed caption

A system that places text on the screen. It's used primarily to add subtitles so that people who are hearing-impaired can watch their favorite shows.

coax (coaxial) cable

Cable used to connect your cable system, antenna, VCR, and TV. Coax cable is capable of carrying lots of channels at a time.

comb filter

A special kind of electronic filter used in VCRs and TVs to separate the colors used to reproduce color and picture brightness.

control box

An attachment used with some VCRs to allow them to control a cable TV box. You plug the control box into the VCR and place the control box over or near the cable box.

Control-L

A standardized signal format used for editing videotapes. Only specialized VCRs offer a Control-L feature.

Copyguard

A now-defunct method for keeping people from copying prerecorded video-tapes. Nowadays, prerecorded movies use a system called Macrovision.

DC (direct current)

The kind of electricity that comes from batteries. *See also* AC.

desktop video

Editing videotapes on a computer rather than on a VCR.

digital

A kind of signal in which information is stored as computer data; binary 1s and 0s.

digital tracking

See auto tracking.

Dolby NR

A noise-reduction (that's what the *NR* stands for) technique developed by Dolby Laboratories and used on some videotapes.

Dolby Surround

A method of adding additional channels of stereo sound to the two normal ones (left and right stereo).

The Surround system was developed by Dolby Laboratories.

double azimuth

A rather useless technoid term for the way video heads in some VCRs are made. The technology clears up slow motion and still shots.

dropout

In video, dropout occurs when a tiny bit of the magnetic coating on a videotape comes off. The effect on the screen is a white dot that flashes by. In teenagers, a dropout is a kid who stops going to school.

EP (Extended Play)

One of the three recording speeds on a VHS VCR and the same as SLP (Super Long Play). EP is the slowest recording speed. *See also* LP, SP.

exposure

The amount of light that's allowed when you're videotaping with a camcorder.

F-connector

The special connector used on coax cables. No one knows what the *F* stands for.

fade

A picture that gently turns to black — *fading* away.

flying erase head

A special spinning video head in a VCR or camcorder that erases the picture track just before a new recording is made. The flying erase head makes for better-looking video edits.

four heads

The number of spinning video heads in the typical mid- and high-end VCR. A four-head VCR generally delivers better picture quality at the SP and EP speeds than a two-head VCR does. *See also* two heads.

frame advance

Watching a tape in slow motion, one frame at a time.

freeze-frame

Watching a single frame of the picture on a videotape.

HDTV

Stands for high-definition television, an as-yet unavailable system for improved picture quality.

heads

Little magnetic doodads in a VCR for recording and playing audio and video signals. VCRs have several heads, each with a distinct purpose.

herringbone pattern
A form of interference that produces a crisscross pattern on the screen, sort of like a herringbone suit.

hertz
The modern nomenclature for "cycle per second." Audio and video signals are recorded at thousands of hertz (cycles per second) and millions of hertz. *See also* kilohertz, megahertz.

Hi8
An improved version of the 8mm format that offers cleaner, crisper pictures.

hi-fi stereo
A feature of VCRs in which stereo sound is recorded in high fidelity by using special spinning, magnetic heads.

high-speed shutter
A feature in which a camcorder videotapes fast-paced images without any blur.

HQ (High Quality)
A feature on some VHS VCRs for improving the clarity of the picture, both during recording and playback.

ITR (instant timer recording)
One of several names used for a common VCR feature that lets you record for a set period of time, usually in 30-minute increments.

indexing
A feature of some VHS VCRs that lets you record a special "mark" signal at a certain spot on the tape so that you can later go back to that same spot.

infrared remote
The most common kind of remote control used with VCRs, camcorders, and TVs.

input
A place where signals enter a VCR or TV. *See also* output.

IR
Stands for infrared, as in infrared remote controls.

jack

A connector (such as on a VCR or TV) for hooking up a cable.

kilohertz

A thousand cycles per second. *See also* hertz, megahertz.

laser disc

A medium for prerecorded movies and other programs. Laser discs require a special laser-disc player. The information on the disc is played back by using a laser, in a system similar to that of audio CDs.

LP

One of the three recording speeds on a VHS VCR. (Not all VCRs offer an LP recording speed, however.) LP is the middle recording and playback speed. *See also* EP, SP.

Macrovision

A system used to prevent people from copying prerecorded videotapes.

megahertz

A million cycles per second. *See also* hertz, kilohertz.

monitor

A special kind of TV that lacks a tuner. A monitor has no antenna connector on it — only connectors for baseband audio and video signals.

mosaic

A camcorder special effect that lets the end of a shot break into progressively larger squares.

MTS

A dumb acronym for *mul*t*ichannel s*ound, the system used to transmit and receive stereo TV sound.

noise

Any sort of interference that makes the TV picture look or sound bad. *See also* herringbone pattern.

NTSC (National Television Standard Committee)

The video standard used primarily in the United States, Canada, and Japan.

on-screen programming

A VCR that puts a menu on the TV screen and lets you choose options, such as an ATM machine at a bank.

OTR (one-touch recording)

A quick way of making the VCR start recording a show; each press of the OTR button usually makes the VCR record for another 30-minute interval.

output

A place where signals exit from a VCR or TV. *See also* input.

pan

A slow, side-to-side movement of the camcorder that records everything between two points.

pause

A way to make the VCR or camcorder temporarily stop its current task.

phono plug/RCA phone plug

The type of plugs that fit into a VCR's audio/video jacks.

PIP (picture-in-picture)

A small picture that fits in to the corner of a TV, usually for watching two channels at the same time.

quartz tuning

A precise way of receiving channels without having to tune them in manually.

rabbit ears

An antenna that fits on the top of a TV, sending out two prongs that look like *My Favorite Martian.* (Other people say that they look like "rabbit ears.")

real-time counter

A way for expensive VCRs to track which part of a videotape they're displaying.

record tab

A special tab on a videocassette's spine that, if removed, prevents the VCR from recording on that particular cassette.

resolution

The quality of a picture. The higher the resolution, the better the quality.

RF (radio frequencies)

The method by which television channels are broadcast over radio frequencies.

RF-connectors

Ways for antennas to connect to gizmos such as TVs and VCRs. *See also* RF.

S-VHS (Super-VHS)

A higher-quality way to record tapes than with regular VHS.

S-video

The connectors and cables used by S-VHS VCRs and Hi8 camcorders.

SAP (separate audio program)

A second soundtrack broadcast with a program, usually in a different language to accompany foreign shows.

shielding

Protective covering to keep stray signals from interfering with sound or video.

simulcast switch

A way to turn off a TV program's sound and instead record a different audio signal from somewhere else.

splitter

A gizmo that lets a single cable connect to two devices.

SLP (Super Long Play)

Also called Extended Play; a recording speed that lets a VCR pack six hours of action on a 120-minute tape, but with less picture quality.

SP (Standard Play)

The normal recording speed; lets a VCR record two hours of action on a 120-minute tape. *See also* EP, LP.

still frame

A single picture from a movie that has been frozen on the TV for a closer look.

Super-VHS

See S-VHS.

time-shifting

Recording something and then watching it hours or days later.

tracking control

A method of adjusting a VCR's playback performance for a finer picture.

two heads

The number of spinning video heads in the typical low-to-mid-end VCR. A two-head VCR generally delivers less picture quality than a four-head VCR does. *See also* four heads.

UHF

The radio frequencies used in broadcasting Channels 14 and higher.

VCR (videocassette recorder)

The thing that displays a movie on the TV when you insert a tape and push its Play button.

VHF

The radio frequencies used for broadcasting Channels 2 through 13.

VHS (Video Home System)

The standard used by most VCRs for playing and recording tapes.

VHS-C

A small tape format used by some camcorders; the small tape fits into a larger shell for playback on regular-size VCRs.

VTR (videotape recorder)

Another name for a VCR.

video dubbing

Recording just the video portion onto a tape and leaving the audio portion.

Index

• *Symbols* •

- (minus) button, 64, 77, 79, 103
+ (plus) button, 64, 77, 79, 103
6mm digital format, 264–265
8mm camcorder tapes, 174
 blank, 145
 VCRs and, 172
 See also camcorder tapes
8mm camcorders, 171–172
 defined, 301
 pros/cons, 171
 See also camcorders

• *A* •

A/B button (VCR remote), 69
 defined, 151
 illustrated, 152
A/B switch, 151–152
 defined, 301
 using, 169
AC (Adult content), 299
AC/DC adapter, 197
adaptive picture control (APC), 32
advanced features, 20–33
 audio/video jacks, 20–21
 auto head cleaning, 21
 auto power on/off, 22, 93
 auto rewind, 22
 auto-manual tracking, 22
 cable ready, 23
 center/midmount chassis, 23
 closed caption, 23
 commercial skipper, 24
 crystal clear freeze frame, 24
 digital effects, 24
 EP (Extended Play), 24–25, 95, 103, 304
 flying erase heads, 25, 304
 heads, 25
 hi-fi, 25–26
 HQ, 26
 index search, 26–27, 305
 LP (Long Play), 24–25, 103, 306
 message center, 27
 PIP (picture-in-picture), 24, 307
 power backup, 27
 programming, 27–28
 quartz tuning, 28, 307
 Quasi S-VHS playback, 28–29
 quick start, 29
 real-time counter, 29
 SAP (secondary audio program), 29–30, 308
 shuttle ring, 30
 SP (Standard Play), 24–25, 103, 308
 StarSight, 30–31, 116
 stereo, 32
 VCR Plus (VCR+), 32, 107–117
 video-noise reduction, 32
 voice-activated programming, 33
 See also VCRs
AFT (automatic fine tuning), 301
AH (Adult humor), 299
AL (Adult language), 299
America's Funniest Home Videos, 259–260
Ampex, 15
antennas
 Antenna In connector, 47, 50, 152, 155, 159
 Antenna Out connector, 47, 50, 152, 155, 159, 160
 connecting cable and, 158–159
 connecting to VCR, 48
 connections, 253
 connectors, 152
 cross-modulation interference and, 223
 defined, 301

antennas *(continued)*
 direction of, 151
 disconnecting from TV, 48
 dual outputs, 206–207
 rabbit-ears, 49, 307
 radio/TV signal interference and, 219
 signal ghosts and, 222
 TV connection, 44
 TV interference and, 215–216
 VCR connection with, 47–49
Appalshop, Inc., 289
AS (Adult situations), 299
audio
 in camcorder videos, 276
 connecting, 160–161
 Dolby NR, 303
 Dolby Surround, 270–271, 303
 exiting (camcorder), 194
 home theater, 162
 sweet spot, 162, 163
 troubleshooting, 235
 See also video
audio cables, 53–54
 connecting, 54, 160
 illustrated, 53
 RCA phono jacks, 53
 stereo jacks and, 54
 using, 160–161
 See also cables; video cables
audio/video jacks (VCR), 20–21
 illustrated, 21
 picture quality and, 21
auto fade, 175–175
Auto Fade button (camcorder), 182
Auto Focus feature, 176
Auto/Manual button (camcorder), 182
automatic head cleaner, 21
automatic picture control (APC), 32
automatic power on/off, 22, 92
automatic rewind, 22, 301
automatic tape rewinders, 256
 cost of, 253
 defined, 256

auto-tracking, 22, 67, 269, 301
Aux (auxiliary) audio connectors, 51, 52–53

• *B* •

backup circuit, 74
bar codes, 28
Barnes & Noble Bookstores, Inc., 289
Barr Media Group, 289
baseband, 302
batteries, 40, 42, 122–123
 alkaline, 42, 123
 camcorder, 192
 external microphone and, 278
 extra, 277
 forgetting to recharge, 266
 NiCad, 198
 tips, 198
 checking, 122–123
 corrosion, 123
 installing, 42
belts, 121
Beta format, 14–15
 defined, 14, 302
 pros/cons of, 14–15
 See also video formats
BF (Brief nudity), 299
blank tapes, 136–145
 8mm camcorder, 145
 before using, 253
 brands, 137–139, 257
 E number, 144
 grades of, 139–141
 L-500, 145
 lengths of, 142–143
 name brand, 137
 no name brand, 140
 purchasing, 252
 record/playback times, 142–143
 standard grade, 140
 S-VHS and, 141
 T-20, 144

T-120, 142–143
T-160, 142–143
T number, 140, 142–143
thinner, 143
VHS logo and, 138–139
VHS-C, 144
warning signs, 139
See also tape; videotapes
Brother p-Touch, 257
bulk tape erasers, 12, 258
 defined, 258
 using, 258
Butterfly Video, 290
buttons (camcorder), 181–185
 Auto Fade, 175
 Auto/Manual, 182
 Exposure, 182
 Fast Forward, 185
 Focus, 182–183
 Input/Output, 183, 186
 Pause, 185, 188, 189
 Play, 185, 189
 Record, 179, 185
 Record Review, 183
 Rewind, 185
 shutter speed, 183–184
 Stop, 175, 185
 White Balance, 184
 Zoom In/Out, 184
 See also camcorders
buttons (VCR), 62–64
 + (plus), 64, 77, 79, 103
 - (minus), 64, 77, 79, 103
 A/B, 69
 Cancel, 64, 104
 channel control, 55
 Channel Up/Down, 58, 63, 67, 103
 Clock, 69, 72, 75, 76–77
 Clock Set, 80
 Counter Memory, 64
 Counter Reset, 64
 Display, 72

Eject, 55, 63, 87
Enter, 77
Family Message, 64
Fast Forward, 30, 62, 87, 88
 hidden, 87–88
Index Search, 26, 27
Menu, 58, 64, 70, 78–79, 102, 222
Pause/Still, 10, 63, 87, 89, 131
Play, 19, 55, 56, 62, 87, 88
Power, 55, 62
Program, 69, 102, 106
Record, 7, 18, 19, 55, 56, 63, 92, 93–94
remote control, 69–70
 See also remote control, buttons
Rewind, 55, 87, 88
Select, 58, 64, 78, 79
Skip, 24, 69
Speed, 95
Stop, 18, 55, 63, 87, 90
symbols for, 87
Timer, 64, 94, 104
tracking, 66
TV/VCR, 20, 63, 69, 76, 92, 202, 268
Up/Down-arrow, 78, 79
See also VCRs
BW (black-and-white), 297

• C •

cable box
 defined, 302
 recording and, 92
cable decoder, 45
cable ready VCRs, 19, 23, 302
cable TV
 antenna connection with, 158–159
 interactive, 282–283
 messes everything up, 204–206
 poor picture quality and, 251
 wireless, 282
 wrong channel numbers and, 205
 See also TVs
cable wall outlets, 49

cables, 40
 audio, 53–54, 160–161
 coax, 150, 162–165, 209
 defined, 44
 gold-plated, 255–256
 hookup process, 45–47
 to TV, 46
 to VCR, 47
 loose, 126, 208
 making, 162–164
 TV interference and, 219
 video, 44–47
 F-connector, 44, 150, 163, 209, 304
 slip-on connector, 45
 Y adapter, 54
Cambridge Educational, 290
camcorder tapes, 173–175, 192
 8mm, 174
 editing, 188–190
 flying erase heads and, 190
 planning ahead and, 190
 procedure, 188–189
 soundtracks, 190
 fast-forwarding/rewinding, 274
 Hi8, 174–175
 metal-evaporated, 175, 274
 metal-particle, 174–175, 274
 recording
 family films and, 274–275
 for insurance, 275
 movies and, 274
 rule of thirds and, 276–277
 school classes, 275
 sounds, 276
 S-VHS, 174
 S-VHS-C, 175
 VHS, 174
 VHS-C, 175
camcorders
 8mm, 171–172, 301
 accessories, 196–197
 adapter, 186
 Audio Out jack, 189

automobile AD/DC adapter, 197
batteries, 192
 external microphone and, 278
 extra, 277
 forgetting to recharge, 266
 NiCad, 198
 tips, 198
big, 169, 170–171
buttons, 181–185
 See also buttons (camcorder)
care for, 179–180
 beach and, 180
 careful storage and, 180
 keeping dry and, 179
 not bending and, 180
cases, 192
connecting, 185–188
 to TV, 185–186
 to VCR, 186–188
connector cable, 186–187
disassembing, 265
features, 175–179
 auto fade, 175–176
 Auto Focus, 176
 CCD pixels, 176
 character generator, 176–177
 color viewfinder, 177
 date/time stamping, 177
 digital effects, 177–178
 digital superimpose, 178
 image stabilization, 178
 manual override, 179
 remote control, 179
formats for, 169
headphones, 192
Hi8, 172, 305
lens filters, 196–197
lenses, 196
 cleaning, 273
lights, 197
microphones, 197
 external, 278
 shotgun, 278

wind socks, 277–278
mixers, 197
photo shoot equipment, 191–192
shot composition, 192–196
slide/movie converter boxes, 197
small, 169, 171–173
storing, 180
S-VHS, 171
S-VHS-C, 173
S-Video Out jack, 187, 189
tips and tricks, 273–278
traveling with, 277
tripod, 196
underwater housings, 197
using, 191–198
VHS, 170
VHS-C, 172–173
Video Out jack, 189
Cancel button, 64, 104
Canyon Cinema, Inc., 290
Careertrak, Inc., 290
cassette drawers, 258, 265
CATV (cable TV), 302
CB (citizen's band) radio, 218
CC (closed captioned), 297
CCD pixels, 176, 302
CG system, 176–177
Champions of Filmsport Videos, 290
Channel Up/Down buttons, 58, 63, 67, 103
channels
 band of, 68
 channel 3/4 setting, 9, 50–51, 55
 choosing, 51
 switch, 50–51, 69, 302
 channels 3/4
 cochannel interference and, 220
 won't work, 206
 control buttons, 55
 guide, 57
 memory, 20
 number display, 68
 "presets," 68

record
 on-screen programming, 103
 setting, 101
 scrambled, 205–206
 setting for VCR use, 9, 50–51, 57
 switching, 8
 troubleshooting
 can't get beyond channel 13, 203
 unclear, 204
 VCR won't change, 202–203
character generator, 176–177
chassis mounts, 23
Cheat Sheet, Faux O'Clock, 81–82
CLASH, 114
Classic Performances on Video
 Cassette, 291
cleaning
 connectors, 125–126
 heads, 21, 119, 120–121
 outside VCR, 120
 professional, 124
 See also health (VCR); repair
clock
 accuracy, 74
 backup circuit and, 74
 daylight savings and, 74
 functions, 72, 268
 not setting, 72–73
 available functions, 73
 excuses, 73
 non-available functions, 73
 setting, 71–82
 automatic, 82
 before, 76–77
 manual help and, 75
 methods, 76–80
 programming and, 99
 with remote Clock button, 77–78
 with remote Menu button, 78–79
 on VCR front panel, 80
 writing down how to, 81
 troubleshooting, 230, 236

clock *(continued)*
 blinking "12:00," 230, 267
 displays strange numbers rather than
 time, 236
 won't turn on, 230
 VCR plugged in and, 73
 when to set, 73–74
 See also time
Clock button, 69, 72, 75, 76–77
Clock Set button, 80
closed caption, 23
 abbreviation, 297
 defined, 302
coax cable, 150
 audio/video cables vs., 165
 braided mesh, 209
 copper wire, 164, 209
 defined, 302
 dielectric, 164, 209
 function of, 165
 illustrated, 209
 making, 162–164
 crimping tool and, 164
 F-connectors and, 163
 procedure for, 164
 See also cables; F-connectors
cochannel interference, 219–220
 appearance of, 219
 cause of, 220
 fixing, 219
 See also TV interference
Collage Video, 291
color viewfinder, 177
comb filter, 302
commercial skipper, 24
connecting, 44–50
 with antenna, 47–49
 cable and antenna, 158–159
 with cable hookup, 45–47
 cables
 audio, 54
 to TV, 46
 to VCR, 47

camcorder to TV, 185–186
camcorder to VCR, 186–188
limitations of, 153
matching transformer, 48
one VCR to two TVs, 153–154
stereo system, 51–54, 160–161
transformer, 46
two VCRs to one TV, 154–156
two VCRs to two TVs, 156–158
with video games, 50
See also setting up
connections
 antenna, 253
 audio/video, 253
 good, 251
 See also connecting
connectors
 Antenna In, 152
 Antenna Out, 152
 Audio Out, 54
 Aux, 51, 52–53, 54
 cleaning, 125–126
 F, 44, 150, 163, 209, 304
 gold-plated, 255–256
 Phono, 53, 307
 TV Audio/Video, 207
 UHF, 152
 VHF, 152
control box, 303
Control-L feature, 303
converters. *See* matching transformers;
 slide/movie converter boxes
Copyguard, 213
copying
 legality of, 271
 slides/movies, 272
Counter Memory button, 64
Counter Reset button, 64
counters
 memory set, 67
 real-time, 29, 307
crimping tool, 164
Critic's Choice Video Catalog, 291

cross-modulation interference, 222–223
 antennas and, 223
 appearance, 222
 cause of, 223
 fixing, 223
 illustrated, 222
 See also TV interference
crystal-clear freeze frame, 24
CZ (colorized), 297

• *D* •

damage, unpacking and, 41
date
 setting, 56
 ending, 101
 with on-screen programming, 103
 starting, 101
 stamping, 177
 VCR Plus, 110
 See also time
decoder, cable, 45
desktop video, 303
dielectric, 164, 209
digital effects
 camcorder, 177–178
 VCR, 24
Digital Satellite System (DSS), 281
digital superimpose, 178
digital video disc (DVD), 284
digital videocassette (DVC), 284–285
direct-broadcast satellite (DBS), 280–281
 defined, 280
 services, 281
Display button, 72
Dolby NR, 303
Dolby Surround, 270–271
 defined, 270, 303
 ProLogic, 270
 setup, 271
double azimuth, 303
dropouts, tape, 132, 252–253
 avoiding, 253
 defined, 252, 304

dubbing, 107, 309
dust cover, 120, 263
 keeping off during VCR use, 263

• *E* •

editing, 10
 camcorder tapes, 188–190
 quick-start feature and, 29
Eject button, 55, 63, 87
electrical noise interference, 216–217
electromagnets. *See* heads
electronic image stabilization (EIS), 178
electronic labelers, 257
Enter button, 77
EP (Extended Play), 24–25, 95, 103
 defined, 95, 304
 four-head VCRs and, 34
 light, 67
 See also recording, speeds
estimates, 243–244
 fees, 144
 free, 143
exposed, over, 182
 under, 182
Exposure button (camcorder), 182
extended warranties, 37, 247

• *F* •

fade, 304
Family Message button, 64
Fast Forward button (camcorder), 185
Fast Forward button (VCR), 30, 62
 function, 87
 for scanning, 88
 symbol, 87
Faux O'Clock, 81–82
F-connectors, 44, 150
 attaching, 163, 209
 defined, 209, 304
 illustrated, 44

F-connectors *(continued)*
 screw-on connector, 45
 See also coax cable
features (camcorder), 175–179
 auto fade, 175–176
 Auto Focus, 176
 CCD pixels, 176
 character generator, 176–177
 color viewfinder, 177
 date/time stamping, 177
 digital effects, 177–178
 digital superimpose, 178
 image stabilization, 178
 manual override, 179
 remote control, 179
 See also camcorders
features (VCR). *See* advanced features
Federal Communications Commission
 (FCC), 218
film ratings, 298–299
Fine Woodworking Book and Video
 Catalog, 291
flat wires, 48
flying erase heads, 25, 304
Focus button (camcorder), 182
four-head VCRs, 10, 25, 34
 defined, 304
 playback with, 34
frame
 advance, 304
 still, 308
free estimates, 243–244
Freeze Frame, 10
frequency synthesized tuner (PLL tuner), 28
Friendly Videos, 291
front-panel controls, 61–62
 illustrated, 61, 62
 programming with, 105–106
 testing, 56
 See also buttons (VCR)
Fusion Video, 292

• G •

G (general audiences), 298
ghost eliminator, 222
 See also signal ghosts
GL (Graphic language), 299
glossary, manual, 59–60
Green Mountain Post Film/Video, 292
ground loop, 223–224
 appearance, 223
 cause of, 224
 fixing, 224
 illustrated, 223
 See also TV interference
GV (Graphic violence), 299

• H •

harmonics, (high-definition TV), 218
HDTV, 283, 304
head cleaning
 auto, 21
 cassettes, 21, 120, 257
 defined, 120, 257
 running time, 119, 121
 types of, 121
 using, 121
 defined, 304
 dry, 120
 internal, 121
 professional, 121, 124
 solution, 21
 See also health (VCR)
headphones, camcorder, 192
heads
 defined, 12, 25
 flying erase, 25, 304
 four, 10, 25, 34, 304
 purchase decision and, 34
 two, 10, 25, 34
 See also head cleaning

health (camcorder), 179–180
 beach and, 180
 careful storage and, 180
 cleaning lens and, 273
 keeping dry and, 179
 no bending and, 180
health (VCR)
 blankets and, 122
 cats and, 124
 clean connectors and, 125–126
 cleaning outside and, 120
 dust cover and, 120, 263
 head cleaners and, 120–121
 kids and, 125
 liquids in VCR and, 123–124
 loose cables and, 126
 professional cleaning and, 124
 remote batteries and, 122–123
 smoke and, 124
 sunlight and, 125
 suntan lotion and, 126
 turn off VCR and, 123
 using VCR and, 121–122
 videotapes in VCR and, 123
herringbone pattern, 305
hertz, 305
Hi8 camcorder, 172
 defined, 305
 pros/cons, 172
 tapes, 174–175
 fast-forwarding/rewinding, 274
 metal-evaporated, 175, 274
 metal-particle, 174–175, 274
 VCR connection, 187
 See also camcorders
hi-fi VCRs, 25–26
 purchase decision and, 34
 See also stereo VCRs
high-definition television (HDTV), 283, 304
high-speed shutter, 305
home theater, 162, 258
hookup. *See* connecting

HQ (High Quality), 26
 defined, 26, 305
HRC/IRC switch, 69, 203, 204

• *I* •

icons, this book, 4
image stabilization, 178
Index Search button, 26, 27
Index Search feature, 26–27, 305
information superhighway, 279–280
 future, 285–286
 phone company and, 286
 technologies, 280–285
infrared remote sensor, 112
Initial Set screen, 55
Input/Output button (camcorder), 182, 186
instructional videos, 261
insurance, taping for, 275
intelligent picture, 32
interactive cable, 282–283
interference, 215–217
 See also TV interference
IR (infrared remote), 305
ITR (instant timer recording), 305

• *J* •

jacks. *See* connectors
jog control, 30, 64–65
 defined, 65
 knob, 66
 using, 65
 See also shuttle control

• *K* •

kilohertz, 306
knobs, 65–66
 jog/shuttle control, 66
 phone level, 65
 picture sharpness, 65
 tracking, 65, 270
 See also buttons (VCR)

• *L* •

laser-disc players, 162, 280, 306
LBX (letterboxed), 297
LCD display, 114
Learning Skills Company, 292
legality of
 copying tapes, 136, 271
 recording tapes, 93
 repair ripoffs, 246–247
 TV interference, 226
lens filters, 196–197
lenses, 196
letterboxing, 234, 271
 abbreviation, 297
 appearance, 234
 defined, 234, 271
lights, 67–68
 camcorder, 197
 EP, 67
 LP, 67
 M, 67
 Play, 67
 Power, 67
 Record, 67
 SAP, 67
 SP, 67
 Stereo, 67
 TIMER, 67
 VIDEO, 67
LP (Long Play), 24–25, 103
 defined, 95, 306
 light, 67
 See also recording, speeds

• *M* •

M light, 67
Macrovision, 210–213
 buster, 212
 defined, 210, 306
 effect of, 212–213
 light/dark picture and, 211, 213
 look of, 211
 removing, 212
 vertical blanking interval, 82, 211
magnets, 11
mail order video outlets, 289–293
 Appalshop, Inc., 289
 Barnes & Noble Bookstores, Inc., 289
 Barr Media Group, 289
 Butterfly Video, 290
 Cambridge Educational, 290
 Canyon Cinema, Inc., 290
 Careertrak, Inc., 290
 Champions of Filmsport Videos, 290
 Classic Performances on Video
 Cassette, 291
 Collage Video, 291
 Critic's Choice Video Catalog, 291
 Fine Woodworking Book and Video
 Catalog, 291
 Friendly Videos, 291
 Fusion Video, 292
 Green Mountain Post Film/Video, 292
 Learning Skills Company, 292
 Movies Unlimited Video Catalog, 292
 Photography Books and Visual
 Resources, 292
 Special Interest Video Collection, 293
 Time Warner Viewer's Edge, 293
 V.I.E.W. Video, Inc., 293
 Video Catalog, 293
maintenance. *See* health (camcorder);
 health (VCR)
manual(s), 40
 clock setting and, 75
 glossary, 59–60
 programming and, 106
 reading, 58–60
 setup information, 58
 special-feature section, 59
 storing, 60
 troubleshooting section, 59
 VCR Plus, 109
 VCR specifications, 59

manual override, 179
matching transformers, 40, 150, 155, 158
 connecting, 46
 defined, 48
 function of, 150
 illustrated, 48, 49
Menu button, 58, 64, 70, 78–79, 102, 222
message system, 27
metal-evaporated tapes, 175
metal-particle tapes, 174–175
microphones, 197
 external, 278
 shotgun, 278
 wind socks for, 277–278
 See also camcorders
mixers, 197
money opportunities, 259–261
 America's Funniest Home Videos, 259–260
 book writing, 261
 instructional videos, 261
 "string" for local news, 260
 videotape weddings, 260
monitors, 306
mono VCRs, 34
mosaic faders, 176, 306
movies
 copying, 272
 on demand, 286
 editing, 10
 frame-by-frame viewing, 10
 playing, 9
 recording, 9
Movies Unlimited Video Catalog, 292
MTS (multichannel sound), 306
multistandard VCR, 144
MV (Mild violence), 299

• N •

N (Nudity), 299
NC-17 (no one under 17 with/without
 parent/guardian), 298
noise bars, 89, 306
NTSC standard, 144, 272, 306

• O •

OC (open captioned), 297
Ohm, 150
one-touch recording (OTR), 18, 63
 timer feature, 93, 94
 using, 93–94
 See also recording
on-screen programming, 28, 76
 channel, setting, 103
 defined, 101, 307
 exiting, 104
 Main Menu, 102
 program event specification, 102–103
 programming mode, 102
 recording speed, setting, 103
 screen, 102
 setting clock
 remote has Clock button, 77–78
 remote has Menu button, 78–79
 starting date/time, 103
 using, 101–104
 you don't have, 105–106
 See also programming
output, 307
overexposed, 182

• P •

packing list, 41
PAL standard, 144, 272
 PAL-M, 272
panning, 307
Pause button (camcorder), 185, 188, 189
Pause/Still button (VCR), 10, 63, 89
 function, 87
 no picture and, 131
 symbol, 87
pausing, 89–90
 blank screen and, 90
 defined, 307
 noise bars, 89

PG-13 (parental guidance required; no one under 13 without parent/guardian), 298

PG (general audiences; parental guidance advised), 298

phone company, 286

phone level knob, 65

Phono connectors, 53, 307

photo shoot equipment, 191–192

Photography Books and Visual Resources, 292

picture sharpness knob, 65

picture, troubleshooting
 dark at top/bottom, 234, 271
 goes black when Paused, 233
 goes light and dark, 234
 interference, 215–217
 lines across, 234
 snowy when fast-scanning tape, 233
 snowy when regular TV is on, 233
 snowy when tape is played, 233

PIP (picture-in-picture), 24, 307

Play button (camcorder), 185, 189

Play button (VCR), 19, 55, 56, 62, 88
 symbol, 87

Play light, 67

playback, 9, 18–19
 automatic, 19
 four-head VCR, 34
 options, 19
 Quasi S-VHS, 28–29
 quick, 29
 test tape, 55
 videotape, 86–87

PLL tuner (Quartz tuner), 28

plugging in
 power strip and, 224
 VCR, 50

plugs
 polarized, 50
 same size prongs and, 224
 switched outlets and, 54, 73

PlusCode numbers, 32, 112, 296

defined, 117

derivation of, 117, 270

length of, 270

not listed, 115–116

See also VCR Plus (VCR+)

polarization, 52

Power
 button, 55, 62
 light, 67

power backup, 27

power strip, 224

power surge, 256

prices
 repair-shop, 35
 VCR, 35

Primestar, 281

problems. *See* troubleshooting

Program button, 69, 102, 106

programming, 27, 97–106
 canceling event, 104
 channel, 101, 106
 defined, 98
 ending date/time, 101, 106
 with front panel controls, 105–106
 on-screen, 28, 76, 101, 101–104, 307
 procedure, 99–101
 record speed, 101, 106
 sample guide to, 101–104
 setting clock and, 99
 starting date/time, 101, 106
 time taken for, 100
 timers, 28
 troubleshooting, 236
 VCR manual and, 106
 voice-activated, 33
 ways to avoid, 98
 without on-screen programming, 105–106
 See also VCR Plus (VCR+)

programs
 channel number/service name, 296
 description of, 296
 length of, 296
 recording

while you're not around, 9, 94
 as you watch different programs, 9, 92
 as you watch same program, 9, 91
searching for, 26–27
type of, 296
See also PlusCode
purchasing (VCRs), 33–37
 decisions, 33–34
 extended service warranties and, 37, 247
 locations, 35
 old VCRs and, 36
 remote control and, 36
 stereo/mono and, 34
 two/four heads and, 34
 VHS/S-VHS and, 33

• *Q* •

quartz-tuning, 28, 307
Quasi S-VHS playback, 28–29
quick-start feature, 29

• *R* •

R (Rape), 299
R (restricted), 298
rabbit ears, 307
radio frequency interference, 224–226
 appearance, 224, 225
 cause of, 224, 226
 fixing, 224, 226
 illustrated, 225
 information on, 227
 See also TV interference
radio/TV signal interference, 217–219
 antenna and, 219
 appearance, 217
 cable and, 219
 cause of, 218
 CBs and, 218
 fixing, 218
 information on, 227
 See also TV interference

ratings
 film, 298–299
 TV, 299
RCA phono jacks, 53, 307
real-time counter, 29, 307
Record button (camcorder), 182, 185
Record button (VCR), 7, 18, 19, 55, 56, 63, 91
 OTR, 93–94
 won't record, 269
Record light (VCR), 67
Record Review button (camcorder), 183
record tab, 91, 136–137
 defined, 136, 307
 illustrated, 137
 location of, 269
 recording after removed, 137, 269
 removing, 135
 See also videotapes
recording, 90–93
 automatic shutoff and, 93–94
 beginning, 18
 cable box and, 92
 on camcorder
 family films, 274–275
 for insurance, 275
 movies, 274
 rule of thirds and, 276–277
 school classes, 275
 sounds, 276
 ending, 18
 legality, 93, 136
 one-touch (OTR), 18, 63, 93–94
 programs, 9, 18
 while you're not around, 9, 94
 as you watch different program, 9, 92, 268
 as you watch same program, 9, 91
 speeds, 24–25, 34, 95
 EP, 24–25, 34, 95, 103, 304
 LP, 24–25, 95, 103, 306
 on-screen programming and, 103
 setting, 101
 SP, 24–25, 34, 95, 103, 252, 308

recording *(continued)*
 test tape, 55
 troubleshooting, 236, 269
 with two VCRs, 156
 See also VCR Plus (VCR+)
remote control (camcorder), 179
remote control (VCR), 11
 batteries, 40, 42, 122–123
 alkaline, 42, 123
 checking, 122–123
 corrosion, 123
 installing, 42
 buttons, 69–70
 A/B, 69
 Cancel, 104
 channel, 70
 Clock, 69, 72, 76, 77–78
 Enter, 77
 Menu, 79, 102, 222
 Play, 88
 Program, 69, 102
 Select, 78. 79
 Skip, 69
 Speed, 95
 Timer, 104
 TV control, 70
 TV/VCR, 69
 Up/Down, 78
 See also buttons (VCR)
 checking, 122–123
 choosing, 36
 damaged/lost, 75
 illustrated, 99, 100
 infrared, 305
 multifunction, 70
 shuttle ring, 30, 63
 testing, 56
 troubleshooting, 234–235
 universal, 75
 unpacking, 40, 42
 using, 56, 57, 88
rental tapes. *See* videotapes
repair

break-even point, 244–245
 costs, 245
 disassembly and, 265
 extended service and, 247
 ripoffs, 245–247
 avoiding, 245–246
 recourse, 246–247
 self, 248
repair shops, 239–248
 ask for old parts and, 246
 calling first and, 243
 checking everything first and, 240
 established, 246
 estimate costs and, 243–244
 finding, 241–243
 get it in writing and, 246
 rates, 35
 referrals and, 242
 ripoff recourses, 246–247
 second opinions and, 246
 word of mouth and, 242
 Yellow Pages and, 243
resolution, 307
Rewind button (camcorder), 185
Rewind button (VCR), 55, 63
 function, 87
 for scanning, 88
 symbol, 87
rewinding
 automatic, 19, 22, 301
 with automatic tape rewinder, 253, 256
RF (radio frequency), 308
RF cable. *See* coax cable
rule of thirds, 276–277

SAP (secondary audio program), 29–30
 defined, 308
 light, 67
satellite
 Digital Satellite System (DSS), 281
 direct broadcast (DBS), 280–281

dish, 162, 281
 Primestar, 281
 See also TVs
SC (Strong sexual content), 299
scanning, 88
 no picture and, 131
school classes, taping for, 275
scratches (tape), 132
screw-on connector, 45
Select button, 58, 63, 78, 79
serial number, 58
setting up, 56–57
 channels, 57
 date and time, 56
 reception band, 57
 VCR Plus guide channels, 57
 See also connecting; testing setup
Setup screen, 55, 58
shielding, 308
shot composition, 192–196
 exciting sounds and, 194
 interesting angles and, 195
 long/smooth shots and, 196
 meandering/wiggling and, 194
 moving camcorder and, 193
 narration and, 194
 people and, 196
 repetitious shots and, 194
 sun and, 193
 zooming and, 192, 193
 See also camcorders
shows. *See* programs
shutter speed, 183–184
shuttle control, 30, 63, 64–65
 defined, 65, 87
 ring, 30, 65
 using, 65, 87
 See also jog control
signal ghosts, 220–223
 appearance, 220
 cause of, 220, 221
 eliminator, 222
 fixing, 220–222

illustrated, 221, 222
 of other pictures, 222–223
 See also TV interference
signal splitters, 151
 IN connector, 153, 157
 OUT connectors, 153, 154, 157, 158
 using, 154, 157
silica gel, 179
simulcast switch, 308
Skip button, 24, 69
SL (sign language), 297
slide/movie converter boxes, 197
slides, copying, 272
slip-on connector, 45
SLP. *See* EP (Extended Play)
sound. *See* audio
SP (Standard Play), 24–25, 103
 defined, 308
 four-head VCRs and, 34
 light, 67
 recording at, 252
 See also recording, speeds
Special Interest Video Collection, 293
specifications, VCR, 59
splitters. *See* signal splitters
St (stereo), 297
stamping, date/time, 177
standards
 NTSC, 144, 272, 306
 PAL (PAL-M), 144, 272
StarSight, 30–31, 116
 defined, 30, 116
 screen, 31
Stereo light, 67
stereo system
 Aux (auxiliary) audio connectors, 51,
 52–53, 54
 connecting VCR to, 51–54, 160–161
 Phone connectors, 53
 TV interference and, 217
stereo VCRs, 32
 purchase decision and, 34
 See also hi-fi VCRs

still frame, 308
Stop button (camcorder), 175, 185
Stop button (VCR), 18, 55, 63
 function, 87
 symbol, 87
 when to press, 90
storage
 camcorder, 180
 VCR Plus limits, 113
 videotape, 127, 146
stretching, tape, 133
"stringing for news," 260
subtitles, 297
Super 8, 272
Super-VHS (S-VHS) format, 13–14
 blank tapes and, 141
 defined, 308
 logo, 14, 141
 pros/cons of, 13
 purchase decisions and, 33
 See also video formats
surge protector, 256
S-VHS camcorder, 171
 pros/cons, 171
 tapes, 174
 VCR connection, 187
 See also camcorders
sweet spot
 defined, 162
 illustrated, 163
switched outlets, 54, 73

● *T* ●

tape, 12
 damage, repairing, 135
 dropouts, 132, 252–253, 304
 duplicators, 140
 magnetic fields and, 11
 problems. *See* troubleshooting
 scratches, 132
 stretches, 133

wrinkles, 133
 See also blank tapes; camcorder tapes;
 videotapes
taping. *See* recording
television tuner, 19
testing setup, 54–56
 dialing channels and, 55
 front panel controls and, 56
 playing prerecorded tape and, 55
 recording test tape and, 55
 remote control, 56
 turning on VCR and, 54–55
time
 display, 68
 setting, 56
 ending, 101
 with on-screen programming, 103
 starting, 101
 shifting, 309
 stamping, 177
 VCR Plus, 110
 See also clock; date
Time Warner Viewer's Edge, 293
Timer button, 64, 94, 104
TIMER light, 67
timers, programming, 28
top-loading VCRs, 86
tracking
 automatic, 22, 67, 269, 301
 buttons, 66
 defined, 309
 digital, 303
 incorrect, 169–170
 knob, 65, 66, 270
 manual, 22, 67, 269–270
 white lines on screen and, 269–270
transferring. *See* copying
tripod, 196
troubleshooting
 cable messing up, 204–206
 cables/wires loose, 208
 can't get channel 14 and higher, 203
 channels 3 and 4 don't work right, 206

clock blinks "12:00," 230, 267
clock displays strange numbers, 236
clock doesn't turn on, 230
interference. *See* TV interference
lines across picture, 234
loading tape cassettes, 86
Macrovision mayhem, 210–213
picture goes black when paused, 233
picture goes light and dark, 234
picture interference, 208
picture is dark at top/bottom, 234, 271
picture is snowy, 233
picture is snowy during fast-scan, 233
remote won't work, 234–235
sound is bad, 235
tape counter runs slow, 235
tape looks awful, 210
tape won't eject, 231
tape won't go in, 230–231
tape won't play, 231
tape won't record anything, 232
tape won't rewind or fast forward, 232
timed programs not recorded, 236
TV Audio/Video connectors, 207
TV controls not adjusted right, 207
TV dual antenna inputs, 206–207
TV picture is snowy, 233
VCR acts goofy, 232
VCR doesn't turn on, 230
VCR eats tapes, 235, 240
VCR makes sounds when playing, 232
VCR manual, 59
VCR shuts off after few seconds, 231
VCR won't change channels, 202–203
VCR won't receive channels clearly, 204
VCR won't record, 269
white lines on screen, 269–270
Troubleshooting and Repairing VCRs, 248
TV Guide. See TV Guide On-Screen;
 TV listings
TV Guide On-Screen, 31, 117
TV interference, 215–227
 antennas and, 215–216

cochannel, 219–220
cross-modulation, 222–223
dark horizontal lines, 219–220
dark thick bars, 223–224
defined, 215
diagonal lines in picture, 224–225
diagonal lines moving with sound,
 225–226
electrical noise, 216–217
ground loop, 223–224
herringbone pattern, 305
information on resolving, 227
legal recourse and, 226
radio frequency, 224–226
radio/TV signal, 217–219
signal ghosts, 220–223
sparkles, 216–217
storms and, 216
wavy lines, 217–219
See also troubleshooting
TV listings, 295–299
 abbreviations, 297
 film ratings and, 298–299
 illustrated, 295
 PlusCode number, 296
 program channel number/service
 name, 296
 program description, 296
 program length, 296
 program type, 296
 ratings, 299
 VCR Plus numbers and, 32
TV/CATV switch, 57, 69, 187, 203
TV/IRC/HRC switch, 69, 203, 204
TVs
 access to back of, 43
 antenna connection, 44, 49
 Audio/Video connectors, 207
 big screen, 162
 channels. *See* channels
 closed caption, 23
 control of, 8–9
 controls aren't right, 207

TVs *(continued)*
 dual antenna inputs, 206–207
 high-definition (HDTV), 283, 304
 Menu button, 207
 Setup button, 207
 stereo, 32
 VCR cable connection to, 45–46
 VCR space next to, 42–44
 Video switch, 207
 See also cable TV; connecting; TV listings
TV/VCR button, 20, 63, 69, 76, 92, 202, 268
TV-VCR combinations, 14
 defined, 14
 pros/cons of, 14
two-head VCRs, 10, 25, 34
two-way splitter, 151

• U •

UHF, 152, 309
ultraviolet filter, 197
underexposed, 182
underwater housings, 197
universal remote controls, 75
unpacking (VCR), 39–42
 batteries, 40, 41
 damage and, 41
 hookup wire (cable) and, 40
 manual and, 40
 opening box and, 40–41
 packing list, 41
 remote control, 40, 42
 saving materials and, 41
 space for, 40
 transformer and, 40
 See also setting up
Up/Down buttons, 78, 79
used VCRs, 35
UV filter, 197

• V •

V (Violence), 299
V.I.E.W. Video, Inc., 293
VCR back
 Antenna In, 47, 50, 152, 155, 159
 Antenna Out, 47, 49, 50, 152, 155, 159, 160
 Audio Out, 54, 160–161, 188
 audio/video jacks, 20–21, 187
 Channel 3/4 switch, 51, 69
 illustrated, 47, 52
 S-Video In, 187
 TV/CATV switch, 57, 69
 TV/IRC/HRC switch, 69
 VHF In, 50
 VHF Out, 47, 49, 50
 VHF/UHF Out, 47, 49
 Video Output, 188
 See also connecting; VCRs
VCR front. *See* front-panel controls
VCR Plus (VCR+), 11, 18, 27, 98, 107–117
 900 number for listings, 115
 _ _ _ bars, 114
 Add Time button, 114
 built-in, 27, 32, 108
 cable box and, 108
 setting up, 111–112
 VCR clock setup and, 111
 cable box and, 110, 111, 112
 cable channels and, 110
 cable-box controller, 108, 111
 Cancel button, 113
 CLASH message, 114
 defined, 18, 32, 107
 do's/don'ts for using, 116
 ERROR message, 116
 guide channel, 57, 112
 infrared remote sensor, 112
 manual, 109
 old VCRs and, 108
 Once/Weekly/Daily M-F buttons, 112
 PlusCode numbers, 32, 112, 296
 defined, 117

derivation of, 117, 270
length of, 270
not listed, 115–116
program
 canceling, 113
 chopping off, 115
 clashing, 114
 modifying, 113–114
 review, 113
reasons for using, 108
Review button, 113
setting up, 109–112
stand-alone model, 108
 cradle, 111
 illustrated, 108
 infrared light signals, 111
 initial setup, 108
 placement, 113
 setting up, 110–111
 VCR type and, 110
storage limits, 113
tape needed for recording and, 114
time/date setup, 110
types of, 108
using, 112–113
See also programming
VCR Voice Commander, 117
VCRs
 beginners guide to, 7–15
 belts, 121
 buttons, 62–64
 See also buttons (VCR)
 cable ready, 19, 23, 302
 chassis mount, 23
 cleaning, 120, 124
 clock. *See* clock
 comparing, 35
 connecting, 44–50
 camcorder, 186–188
 one VCR to two TVs, 153–154
 stereo system, 51–54, 160–161
 two VCRs to one TV, 154–156
 two VCRs to two TVs, 156–158

control and, 18
defined, 309
difficulty in using, 10–11
disassembing, 265
functions of, 8–10
health of, 119–128
hi-fi, 25–26
history of, 15
hooking up, 39–60
illustrated, 8
maintenance. *See* health (VCR)
master, 155, 157
mono, 34
placement of, 42–43
 not on blanket, 122
plugging in, 50
popularity of, 7–8
prices, 36
problems. *See* troubleshooting
purchasing, 33–37
regular use of, 121–122
setup testing of, 54–56
slave, 155, 157
space for, 42–44
specifications, 59
speed of, 24–25
stereo, 32
television tuner, 19
turning on, 54–55
TV channel setting, 9, 19–20, 50–51, 57
TV/VCR combinations, 14
unpacking, 39–42
used, 35
 See also front-panel controls; VCR back
vertical blanking interval (VBI), 82, 211
VHF, 152, 309
VHS (video home system), 309
VHS camcorder, 170
 pros/cons, 170
 tapes, 174
 See also camcorders
VHS format, 12–13

VHS format *(continued)*
 blank tapes and, 138–140
 defined, 309
 logo, 13, 21, 138–139, 257
 pros/cons of, 12
 purchase decisions and, 33
VHS-C camcorder, 172–173
 defined, 309
 tapes, 144, 175
 See also camcorders
video
 disc player, 162, 280, 306
 dubbing, 107, 309
 family album, 261–262
 games, 50
 mail order, 289–293
 See also audio
video cables, 44–47
 F-connector, 44
 attaching, 163, 209
 illustrated, 44
 screw-on connector, 45
 illustrated, 44
 slip-on connector, 45
 See also audio cables; cables
Video Catalog, 293
video CD formats, 284
video formats, 11–15
 Beta, 14–15
 S-VHS, 13–14, 33, 141, 308
 VHS, 12–13, 33, 138–139
 See also videotapes
video heads. *See* heads
Video Home System. *See* VHS format
VIDEO light, 67
video selector, 152
videocassette players (VCPs), 18
videocassette recorders. *See* VCRs
videocassettes. *See* videotapes
VideoCD, 284
video-noise reduction, 32
videotape recorders (VTRs), 15, 309

videotape rewinders. *See* automatic
 tape rewinders
videotapes
 access door, 128
 blank, 136–145
 8mm camcorder, 145
 before using, 253
 brands, 137–139, 257
 E number, 144
 grades of, 139–141
 L-500, 145
 length of, 142–143
 name brand, 137
 no name brand, 140
 purchasing, 252
 record/playback times, 142–143
 standard grade, 140
 S-VHS and, 141
 T-20, 144
 T-120, 142–143
 T-160, 142–143
 T number, 140, 142–143
 thinner, 143
 VHS logo and, 138–139
 VHS-C, 144
 warning signs, 139
 cheap, 21
 contents, viewing, 268
 copying slides/movies to, 272
 dropouts, 132, 252–253, 304
 functioning of, 12
 head cleaning, 21, 120–121
 health of, 127, 146
 HQ-recorded, 26, 305
 inside illustration, 138
 instructional, 261
 label, 136
 lengths, 95, 142–143
 loading, 86, 91, 104
 magnetic fields, 11
 mistakes
 forgetting to label, 266

inserting dirty/wet tape, 264
leaving in hot car, 265
leaving in VCR, 264
placing in sun, 127
placing near speakers/magnets, 264
placing on ground, 127, 264
name brands of, 137
opening, 137
pausing, 89–90
playing, 86–87
prerecorded, 130–131
 cheap, 130
 no picture on pause/fast/scan, 131
 poor picture and, 130
 renting, 127
 sound problems and, 130
 speed of, 131
record tab, 91, 136–137, 269, 307
rental questions/answers, 133–136
 can I copy, 136
 is it OK to purchase, 134
 is it safe to play, 133–134
 what if I wreck, 134–135
scanning, 88
scratches, 132
speed, 24–25
 setting, 95
storing, 146
 cassette drawers and, 258, 265
 hot car and, 265
 keeping cool and, 127
 keeping off ground and, 127, 264
 rules for, 146
 speakers/magnets and, 264
stretches, 133
tips for making, 251–253
troubleshooting
 tape counter runs slow, 235
 tape looks awful, 210
 tape stops too quickly, 232
 tape won't eject, 231
 tape won't go into VCR, 230, 231

 tape won't play, 231
 tape won't record anything, 232
 tape won't rewind/fast forward, 232
 VCR eats tapes, 235, 240
wear and tear on, 132–133
wrinkles, 133
X-ray machines and, 147
See also tape; video formats
VISS (VHS Index Search System), 26
voice-activated programming, 33

• *W* •

warranties, 241
 extended, 37, 247
 manufacturer, 247
 using, 241
watching. *See* playback
wear/tear on tapes, 132
White Balance button (camcorder), 182
wide angle, 184
wind socks, 277–278
 built-in, 278
 defined, 277
 makeshift, 278
 See also microphones
wireless cable, 282
wrinkles, tape, 133

• *X* •

X (no one under 18 admitted), 298–299
X-rays, videotapes and, 147

• *Y* •

Y adapter cable, 54

• *Z* •

Zoom In/Out button (camcorder), 184
zooms, 192
 endless, 193
 multispeed, 184

Notes

The Fun & Easy Way™ to learn about computers and more!

Windows® 3.11 For Dummies,® 3rd Edition
by Andy Rathbone

ISBN: 1-56884-370-4
$16.95 USA/
$22.95 Canada

Mutual Funds For Dummies™
by Eric Tyson

ISBN: 1-56884-226-0
$16.99 USA/
$22.99 Canada

DOS For Dummies,® 2nd Edition
by Dan Gookin

ISBN: 1-878058-75-4
$16.95 USA/
$22.95 Canada

The Internet For Dummies,® 2nd Edition
by John Levine & Carol Baroudi

ISBN: 1-56884-222-8
$19.99 USA/
$26.99 Canada

Personal Finance For Dummies™
by Eric Tyson

ISBN: 1-56884-150-7
$16.95 USA/
$22.95 Canada

PCs For Dummies,® 3rd Edition
by Dan Gookin & Andy Rathbone

ISBN: 1-56884-904-4
$16.99 USA/
$22.99 Canada

Macs® For Dummies,® 3rd Edition
by David Pogue

ISBN: 1-56884-239-2
$19.99 USA/
$26.99 Canada

The SAT® I For Dummies™
by Suzee Vlk

ISBN: 1-56884-213-9
$14.99 USA/
$20.99 Canada

Here's a complete listing of IDG Books' ...For Dummies® titles

Title	Author	ISBN	Price
DATABASE			
Access 2 For Dummies®	by Scott Palmer	ISBN: 1-56884-090-X	$19.95 USA/$26.95 Canada
Access Programming For Dummies®	by Rob Krumm	ISBN: 1-56884-091-8	$19.95 USA/$26.95 Canada
Approach 3 For Windows® For Dummies®	by Doug Lowe	ISBN: 1-56884-233-3	$19.99 USA/$26.99 Canada
dBASE For DOS For Dummies®	by Scott Palmer & Michael Stabler	ISBN: 1-56884-188-4	$19.95 USA/$26.95 Canada
dBASE For Windows® For Dummies®	by Scott Palmer	ISBN: 1-56884-179-5	$19.95 USA/$26.95 Canada
dBASE 5 For Windows® Programming For Dummies®	by Ted Coombs & Jason Coombs	ISBN: 1-56884-215-5	$19.99 USA/$26.99 Canada
FoxPro 2.6 For Windows® For Dummies®	by John Kaufeld	ISBN: 1-56884-187-6	$19.95 USA/$26.95 Canada
Paradox 5 For Windows® For Dummies®	by John Kaufeld	ISBN: 1-56884-185-X	$19.95 USA/$26.95 Canada
DESKTOP PUBLISHING/ILLUSTRATION/GRAPHICS			
CorelDRAW! 5 For Dummies®	by Deke McClelland	ISBN: 1-56884-157-4	$19.95 USA/$26.95 Canada
CorelDRAW! For Dummies®	by Deke McClelland	ISBN: 1-56884-042-X	$19.95 USA/$26.95 Canada
Desktop Publishing & Design For Dummies®	by Roger C. Parker	ISBN: 1-56884-234-1	$19.99 USA/$26.99 Canada
Harvard Graphics 2 For Windows® For Dummies®	by Roger C. Parker	ISBN: 1-56884-092-6	$19.95 USA/$26.95 Canada
PageMaker 5 For Macs® For Dummies®	by Galen Gruman & Deke McClelland	ISBN: 1-56884-178-7	$19.95 USA/$26.95 Canada
PageMaker 5 For Windows® For Dummies®	by Deke McClelland & Galen Gruman	ISBN: 1-56884-160-4	$19.95 USA/$26.95 Canada
Photoshop 3 For Macs® For Dummies®	by Deke McClelland	ISBN: 1-56884-208-2	$19.99 USA/$26.99 Canada
QuarkXPress 3.3 For Dummies®	by Galen Gruman & Barbara Assadi	ISBN: 1-56884-217-1	$19.99 USA/$26.99 Canada
FINANCE/PERSONAL FINANCE/TEST TAKING REFERENCE			
Everyday Math For Dummies™	by Charles Seiter	ISBN: 1-56884-248-1	$14.99 USA/$22.99 Canada
Personal Finance For Dummies™ For Canadians	by Eric Tyson & Tony Martin	ISBN: 1-56884-378-X	$18.99 USA/$24.99 Canada
QuickBooks 3 For Dummies®	by Stephen L. Nelson	ISBN: 1-56884-227-9	$19.99 USA/$26.99 Canada
Quicken 8 For DOS For Dummies,® 2nd Edition	by Stephen L. Nelson	ISBN: 1-56884-210-4	$19.95 USA/$26.95 Canada
Quicken 5 For Macs® For Dummies®	by Stephen L. Nelson	ISBN: 1-56884-211-2	$19.95 USA/$26.95 Canada
Quicken 4 For Windows® For Dummies,® 2nd Edition	by Stephen L. Nelson	ISBN: 1-56884-209-0	$19.95 USA/$26.95 Canada
Taxes For Dummies,™ 1995 Edition	by Eric Tyson & David J. Silverman	ISBN: 1-56884-220-1	$14.99 USA/$20.99 Canada
The GMAT® For Dummies™	by Suzee Vlk, Series Editor	ISBN: 1-56884-376-3	$14.99 USA/$20.99 Canada
The GRE® For Dummies™	by Suzee Vlk, Series Editor	ISBN: 1-56884-375-5	$14.99 USA/$20.99 Canada
Time Management For Dummies™	by Jeffrey J. Mayer	ISBN: 1-56884-360-7	$16.99 USA/$22.99 Canada
TurboTax For Windows® For Dummies®	by Gail A. Helsel, CPA	ISBN: 1-56884-228-7	$19.99 USA/$26.99 Canada
GROUPWARE/INTEGRATED			
ClarisWorks For Macs® For Dummies®	by Frank Higgins	ISBN: 1-56884-363-1	$19.99 USA/$26.99 Canada
Lotus Notes For Dummies®	by Pat Freeland & Stephen Londergan	ISBN: 1-56884-212-0	$19.95 USA/$26.95 Canada
Microsoft® Office 4 For Windows® For Dummies®	by Roger C. Parker	ISBN: 1-56884-183-3	$19.95 USA/$26.95 Canada
Microsoft® Works 3 For Windows® For Dummies®	by David C. Kay	ISBN: 1-56884-214-7	$19.95 USA/$26.95 Canada
SmartSuite 3 For Dummies®	by Jan Weingarten & John Weingarten	ISBN: 1-56884-367-4	$19.99 USA/$26.99 Canada
INTERNET/COMMUNICATIONS/NETWORKING			
America Online For Dummies,® 2nd Edition	by John Kaufeld	ISBN: 1-56884-933-8	$19.99 USA/$26.99 Canada
CompuServe For Dummies,® 2nd Edition	by Wallace Wang	ISBN: 1-56884-937-0	$19.99 USA/$26.99 Canada
Modems For Dummies,® 2nd Edition	by Tina Rathbone	ISBN: 1-56884-223-6	$19.99 USA/$26.99 Canada
MORE Internet For Dummies®	by John R. Levine & Margaret Levine Young	ISBN: 1-56884-164-7	$19.95 USA/$26.95 Canada
MORE Modems & On-line Services For Dummies®	by Tina Rathbone	ISBN: 1-56884-365-8	$19.99 USA/$26.99 Canada
Mosaic For Dummies,® Windows Edition	by David Angell & Brent Heslop	ISBN: 1-56884-242-2	$19.99 USA/$26.99 Canada
NetWare For Dummies,® 2nd Edition	by Ed Tittel, Deni Connor & Earl Follis	ISBN: 1-56884-369-0	$19.99 USA/$26.99 Canada
Networking For Dummies®	by Doug Lowe	ISBN: 1-56884-079-9	$19.95 USA/$26.95 Canada
PROCOMM PLUS 2 For Windows® For Dummies®	by Wallace Wang	ISBN: 1-56884-219-8	$19.99 USA/$26.99 Canada
TCP/IP For Dummies®	by Marshall Wilensky & Candace Leiden	ISBN: 1-56884-241-4	$19.99 USA/$26.99 Canada

For scholastic requests & educational orders please call Educational Sales at 1. 800. 434. 2086

FOR MORE INFO OR TO ORDER, PLEASE CALL ▶ **800. 762. 2974**

For volume discounts & special orders please call Tony Real, Special Sales, at 415. 655. 3048

Title	Author	ISBN	Price
The Internet For Macs® For Dummies® 2nd Edition	by Charles Seiter	ISBN: 1-56884-371-2	$19.99 USA/$26.99 Canada
The Internet For Macs® For Dummies® Starter Kit	by Charles Seiter	ISBN: 1-56884-244-9	$29.99 USA/$39.99 Canada
The Internet For Macs® For Dummies® Starter Kit Bestseller Edition	by Charles Seiter	ISBN: 1-56884-245-7	$39.99 USA/$54.99 Canada
The Internet For Windows® For Dummies® Starter Kit	by John R. Levine & Margaret Levine Young	ISBN: 1-56884-237-6	$34.99 USA/$44.99 Canada
The Internet For Windows® For Dummies® Starter Kit, Bestseller Edition	by John R. Levine & Margaret Levine Young	ISBN: 1-56884-246-5	$39.99 USA/$54.99 Canada

MACINTOSH

Title	Author	ISBN	Price
Mac® Programming For Dummies®	by Dan Parks Sydow	ISBN: 1-56884-173-6	$19.95 USA/$26.95 Canada
Macintosh® System 7.5 For Dummies®	by Bob LeVitus	ISBN: 1-56884-197-3	$19.95 USA/$26.95 Canada
MORE Macs® For Dummies®	by David Pogue	ISBN: 1-56884-087-X	$19.95 USA/$26.95 Canada
PageMaker 5 For Macs® For Dummies®	by Galen Gruman & Deke McClelland	ISBN: 1-56884-178-7	$19.95 USA/$26.95 Canada
QuarkXPress 3.3 For Dummies®	by Galen Gruman & Barbara Assadi	ISBN: 1-56884-217-1	$19.99 USA/$26.99 Canada
Upgrading and Fixing Macs® For Dummies®	by Kearney Rietmann & Frank Higgins	ISBN: 1-56884-189-2	$19.95 USA/$26.95 Canada

MULTIMEDIA

Title	Author	ISBN	Price
Multimedia & CD-ROMs For Dummies® 2nd Edition	by Andy Rathbone	ISBN: 1-56884-907-9	$19.99 USA/$26.99 Canada
Multimedia & CD-ROMs For Dummies® Interactive Multimedia Value Pack, 2nd Edition	by Andy Rathbone	ISBN: 1-56884-909-5	$29.99 USA/$39.99 Canada

OPERATING SYSTEMS:

DOS

Title	Author	ISBN	Price
MORE DOS For Dummies®	by Dan Gookin	ISBN: 1-56884-046-2	$19.95 USA/$26.95 Canada
OS/2® Warp For Dummies® 2nd Edition	by Andy Rathbone	ISBN: 1-56884-205-8	$19.99 USA/$26.99 Canada

UNIX

Title	Author	ISBN	Price
MORE UNIX® For Dummies®	by John R. Levine & Margaret Levine Young	ISBN: 1-56884-361-5	$19.99 USA/$26.99 Canada
UNIX® For Dummies®	by John R. Levine & Margaret Levine Young	ISBN: 1-878058-58-4	$19.95 USA/$26.95 Canada

WINDOWS

Title	Author	ISBN	Price
MORE Windows® For Dummies® 2nd Edition	by Andy Rathbone	ISBN: 1-56884-048-9	$19.95 USA/$26.95 Canada
Windows® 95 For Dummies®	by Andy Rathbone	ISBN: 1-56884-240-6	$19.99 USA/$26.99 Canada

PCS/HARDWARE

Title	Author	ISBN	Price
Illustrated Computer Dictionary For Dummies® 2nd Edition	by Dan Gookin & Wallace Wang	ISBN: 1-56884-218-X	$12.95 USA/$16.95 Canada
Upgrading and Fixing PCs For Dummies® 2nd Edition	by Andy Rathbone	ISBN: 1-56884-903-6	$19.99 USA/$26.99 Canada

PRESENTATION/AUTOCAD

Title	Author	ISBN	Price
AutoCAD For Dummies®	by Bud Smith	ISBN: 1-56884-191-4	$19.95 USA/$26.95 Canada
PowerPoint 4 For Windows® For Dummies®	by Doug Lowe	ISBN: 1-56884-161-2	$16.99 USA/$22.99 Canada

PROGRAMMING

Title	Author	ISBN	Price
Borland C++ For Dummies®	by Michael Hyman	ISBN: 1-56884-162-0	$19.95 USA/$26.95 Canada
C For Dummies® Volume 1	by Dan Gookin	ISBN: 1-878058-78-9	$19.95 USA/$26.95 Canada
C++ For Dummies®	by Stephen R. Davis	ISBN: 1-56884-163-9	$19.95 USA/$26.95 Canada
Delphi Programming For Dummies®	by Neil Rubenking	ISBN: 1-56884-200-7	$19.99 USA/$26.99 Canada
Mac® Programming For Dummies®	by Dan Parks Sydow	ISBN: 1-56884-173-6	$19.95 USA/$26.95 Canada
PowerBuilder 4 Programming For Dummies®	by Ted Coombs & Jason Coombs	ISBN: 1-56884-325-9	$19.99 USA/$26.99 Canada
QBasic Programming For Dummies®	by Douglas Hergert	ISBN: 1-56884-093-4	$19.95 USA/$26.95 Canada
Visual Basic 3 For Dummies®	by Wallace Wang	ISBN: 1-56884-076-4	$19.95 USA/$26.95 Canada
Visual Basic "X" For Dummies®	by Wallace Wang	ISBN: 1-56884-230-9	$19.99 USA/$26.99 Canada
Visual C++ 2 For Dummies®	by Michael Hyman & Bob Arnson	ISBN: 1-56884-328-3	$19.99 USA/$26.99 Canada
Windows® 95 Programming For Dummies®	by S. Randy Davis	ISBN: 1-56884-327-5	$19.99 USA/$26.99 Canada

SPREADSHEET

Title	Author	ISBN	Price
1-2-3 For Dummies®	by Greg Harvey	ISBN: 1-878058-60-6	$16.95 USA/$22.95 Canada
1-2-3 For Windows® 5 For Dummies® 2nd Edition	by John Walkenbach	ISBN: 1-56884-216-3	$16.95 USA/$22.95 Canada
Excel 5 For Macs® For Dummies®	by Greg Harvey	ISBN: 1-56884-186-8	$19.95 USA/$26.95 Canada
Excel For Dummies® 2nd Edition	by Greg Harvey	ISBN: 1-56884-050-0	$16.95 USA/$22.95 Canada
MORE 1-2-3 For DOS For Dummies®	by John Weingarten	ISBN: 1-56884-224-4	$19.99 USA/$26.99 Canada
MORE Excel 5 For Windows® For Dummies®	by Greg Harvey	ISBN: 1-56884-207-4	$19.95 USA/$26.95 Canada
Quattro Pro 6 For Windows® For Dummies®	by John Walkenbach	ISBN: 1-56884-174-4	$19.95 USA/$26.95 Canada
Quattro Pro For DOS For Dummies®	by John Walkenbach	ISBN: 1-56884-023-3	$16.95 USA/$22.95 Canada

UTILITIES

Title	Author	ISBN	Price
Norton Utilities 8 For Dummies®	by Beth Slick	ISBN: 1-56884-166-3	$19.95 USA/$26.95 Canada

VCRS/CAMCORDERS

Title	Author	ISBN	Price
VCRs & Camcorders For Dummies™	by Gordon McComb & Andy Rathbone	ISBN: 1-56884-229-5	$14.99 USA/$20.99 Canada

WORD PROCESSING

Title	Author	ISBN	Price
Ami Pro For Dummies®	by Jim Meade	ISBN: 1-56884-049-7	$19.95 USA/$26.95 Canada
MORE Word For Windows® 6 For Dummies®	by Doug Lowe	ISBN: 1-56884-165-5	$19.95 USA/$26.95 Canada
MORE WordPerfect® 6 For Windows® For Dummies®	by Margaret Levine Young & David C. Kay	ISBN: 1-56884-206-6	$19.95 USA/$26.95 Canada
MORE WordPerfect® 6 For DOS For Dummies®	by Wallace Wang, edited by Dan Gookin	ISBN: 1-56884-047-0	$19.95 USA/$26.95 Canada
Word 6 For Macs® For Dummies®	by Dan Gookin	ISBN: 1-56884-190-6	$19.95 USA/$26.95 Canada
Word For Windows® 6 For Dummies®	by Dan Gookin	ISBN: 1-56884-075-6	$16.95 USA/$22.95 Canada
Word For Windows® For Dummies®	by Dan Gookin & Ray Werner	ISBN: 1-878058-86-X	$16.95 USA/$22.95 Canada
WordPerfect® 6 For DOS For Dummies®	by Dan Gookin	ISBN: 1-878058-77-0	$16.95 USA/$22.95 Canada
WordPerfect® 6.1 For Windows® For Dummies® 2nd Edition	by Margaret Levine Young & David Kay	ISBN: 1-56884-243-0	$16.95 USA/$22.95 Canada
WordPerfect® For Dummies®	by Dan Gookin	ISBN: 1-878058-52-5	$16.95 USA/$22.95 Canada

For scholastic requests & educational orders please call Educational Sales at 1. 800. 434. 2086

FOR MORE INFO OR TO ORDER, PLEASE CALL ▶ 800. 762. 2974

For volume discounts & special orders please call Tony Real, Special Sales, at 415. 655. 3048

Fun, Fast, & Cheap!™

The Internet For Macs® For Dummies® Quick Reference
by Charles Seiter

ISBN: 1-56884-967-2
$9.99 USA/$12.99 Canada

Windows® 95 For Dummies® Quick Reference
by Greg Harvey

ISBN: 1-56884-964-8
$9.99 USA/$12.99 Canada

Photoshop 3 For Macs® For Dummies® Quick Reference
by Deke McClelland

ISBN: 1-56884-968-0
$9.99 USA/$12.99 Canada

WordPerfect® For DOS For Dummies® Quick Reference
by Greg Harvey

ISBN: 1-56884-009-8
$8.95 USA/$12.95 Canada

Title	Author	ISBN	Price
DATABASE			
Access 2 For Dummies® Quick Reference	by Stuart J. Stuple	ISBN: 1-56884-167-1	$8.95 USA/$11.95 Canada
dBASE 5 For DOS For Dummies® Quick Reference	by Barrie Sosinsky	ISBN: 1-56884-954-0	$9.99 USA/$12.99 Canada
dBASE 5 For Windows® For Dummies® Quick Reference	by Stuart J. Stuple	ISBN: 1-56884-953-2	$9.99 USA/$12.99 Canada
Paradox 5 For Windows® For Dummies® Quick Reference	by Scott Palmer	ISBN: 1-56884-960-5	$9.99 USA/$12.99 Canada
DESKTOP PUBLISHING/ILLUSTRATION/GRAPHICS			
CorelDRAW! 5 For Dummies® Quick Reference	by Raymond E. Werner	ISBN: 1-56884-952-4	$9.99 USA/$12.99 Canada
Harvard Graphics For Windows® For Dummies® Quick Reference	by Raymond E. Werner	ISBN: 1-56884-962-1	$9.99 USA/$12.99 Canada
Photoshop 3 For Macs® For Dummies® Quick Reference	by Deke McClelland	ISBN: 1-56884-968-0	$9.99 USA/$12.99 Canada
FINANCE/PERSONAL FINANCE			
Quicken 4 For Windows® For Dummies® Quick Reference	by Stephen L. Nelson	ISBN: 1-56884-950-8	$9.95 USA/$12.95 Canada
GROUPWARE/INTEGRATED			
Microsoft® Office 4 For Windows® For Dummies® Quick Reference	by Doug Lowe	ISBN: 1-56884-958-3	$9.99 USA/$12.99 Canada
Microsoft® Works 3 For Windows® For Dummies® Quick Reference	by Michael Partington	ISBN: 1-56884-959-1	$9.99 USA/$12.99 Canada
INTERNET/COMMUNICATIONS/NETWORKING			
The Internet For Dummies® Quick Reference	by John R. Levine & Margaret Levine Young	ISBN: 1-56884-168-X	$8.95 USA/$11.95 Canada
MACINTOSH			
Macintosh® System 7.5 For Dummies® Quick Reference	by Stuart J. Stuple	ISBN: 1-56884-956-7	$9.99 USA/$12.99 Canada
OPERATING SYSTEMS:			
DOS			
DOS For Dummies® Quick Reference	by Greg Harvey	ISBN: 1-56884-007-1	$8.95 USA/$11.95 Canada
UNIX			
UNIX® For Dummies® Quick Reference	By John R. Levine & Margaret Levine Young	ISBN: 1-56884-094-2	$8.95 USA/$11.95 Canada
WINDOWS			
Windows® 3.1 For Dummies® Quick Reference, 2nd Edition	by Greg Harvey	ISBN: 1-56884-951-6	$8.95 USA/$11.95 Canada
PCs/HARDWARE			
Memory Management For Dummies® Quick Reference	Doug Lowe	ISBN: 1-56884-362-3	$9.99 USA/$12.99 Canada
PRESENTATION/AUTOCAD			
AutoCAD For Dummies® Quick Reference	by Ellen Finkelstein	ISBN: 1-56884-198-1	$9.95 USA/$12.95 Canada
SPREADSHEET			
1-2-3 For Dummies® Quick Reference	by John Walkenbach	ISBN: 1-56884-027-6	$8.95 USA/$11.95 Canada
1-2-3 For Windows® 5 For Dummies® Quick Reference	by John Walkenbach	ISBN: 1-56884-957-5	$9.95 USA/$12.95 Canada
Excel For Windows® For Dummies® Quick Reference, 2nd Edition	by John Walkenbach	ISBN: 1-56884-096-9	$8.95 USA/$11.95 Canada
Quattro Pro 6 For Windows® For Dummies® Quick Reference	by Stuart J. Stuple	ISBN: 1-56884-172-8	$9.95 USA/$12.95 Canada
WORD PROCESSING			
Word For Windows® 6 For Dummies® Quick Reference	by George Lynch	ISBN: 1-56884-095-0	$8.95 USA/$11.95 Canada
Word For Windows® For Dummies® Quick Reference	by George Lynch	ISBN: 1-56884-029-2	$8.95 USA/$11.95 Canada
WordPerfect® 6.1 For Windows® For Dummies® Quick Reference, 2nd Edition	by Greg Harvey	ISBN: 1-56884-966-4	$9.99 USA/$12.99/Canada

9/19/95

Windows® 3.1 SECRETS™
by Brian Livingston

ISBN: 1-878058-43-6
$39.95 USA/$52.95 Canada
Includes software.

MORE Windows® 3.1 SECRETS™
by Brian Livingston

ISBN: 1-56884-019-5
$39.95 USA/$52.95 Canada
Includes software.

Windows® GIZMOS™
*by Brian Livingston
& Margie Livingston*

ISBN: 1-878058-66-5
$39.95 USA/$52.95 Canada
Includes software.

Windows® 3.1 Connectivity SECRETS™
*by Runnoe Connally,
David Rorabaugh,
& Sheldon Hall*

ISBN: 1-56884-030-6
$49.95 USA/$64.95 Canada
Includes software.

Windows® 3.1 Configuration SECRETS™
*by Valda Hilley
& James Blakely*

ISBN: 1-56884-026-8
$49.95 USA/$64.95 Canada
Includes software.

Internet SECRETS™
*by John Levine
& Carol Baroudi*

ISBN: 1-56884-452-2
$39.99 USA/$54.99 Canada
Includes software.

Internet GIZMOS™ For Windows®
*by Joel Diamond,
Howard Sobel,
& Valda Hilley*

ISBN: 1-56884-451-4
$39.99 USA/$54.99 Canada
Includes software.

Network Security SECRETS™
*by David Stang
& Sylvia Moon*

ISBN: 1-56884-021-7
Int'l. ISBN: 1-56884-151-5
$49.95 USA/$64.95 Canada
Includes software.

PC SECRETS™
by Caroline M. Halliday

ISBN: 1-878058-49-5
$39.95 USA/$52.95 Canada
Includes software.

WordPerfect® 6 SECRETS™
*by Roger C. Parker
& David A. Holzgang*

ISBN: 1-56884-040-3
$39.95 USA/$52.95 Canada
Includes software.

DOS 6 SECRETS™
by Robert D. Ainsbury

ISBN: 1-878058-70-3
$39.95 USA/$52.95 Canada
Includes software.

Paradox 4 Power Programming SECRETS™ 2nd Edition
*by Gregory B. Salcedo
& Martin W. Rudy*

ISBN: 1-878058-54-1
$44.95 USA/$59.95 Canada
Includes software.

Paradox 5 For Windows® Power Programming SECRETS™
*by Gregory B. Salcedo
& Martin W. Rudy*

ISBN: 1-56884-085-3
$44.95 USA/$59.95 Canada
Includes software.

Hard Disk SECRETS™
*by John M. Goodman,
Ph.D.*

ISBN: 1-878058-64-9
$39.95 USA/$52.95 Canada
Includes software.

WordPerfect® 6 For Windows® Tips & Techniques Revealed
*by David A. Holzgang
& Roger C. Parker*

ISBN: 1-56884-202-3
$39.95 USA/$52.95 Canada
Includes software.

Excel 5 For Windows® Power Programming Techniques
by John Walkenbach

ISBN: 1-56884-303-8
$39.95 USA/$52.95 Canada
Includes software.

...SECRETS®

INFO WORLD TECHNICAL BOOKS

Windows is a registered trademark of Microsoft Corporation. WordPerfect is a registered trademark of Novell. ----SECRETS, ----GIZMOS, and the IDG Books Worldwide logos are trademarks, and ...SECRETS is a registered trademark under exclusive license to IDG Books Worldwide, Inc., from International Data Group, Inc.

For scholastic requests & educational orders please call Educational Sales, at 1. 800. 434. 2086

FOR MORE INFO OR TO ORDER, PLEASE CALL ▶ 800. 762. 2974

For volume discounts & special orders please call Tony Real, Special Sales, at 415. 655. 3048

Macworld® Mac® & Power Mac SECRETS,™ 2nd Edition

by David Pogue & Joseph Schorr

HOT!

This is the definitive Mac reference for those who want to become power users! Includes three disks with 9MB of software!

ISBN: 1-56884-175-2
$39.95 USA/$54.95 Canada

Includes 3 disks chock full of software.

NEWBRIDGE
BOOK CLUB
SELECTION

Macworld® Mac® FAQs™

by David Pogue

HOT!

Written by the hottest Macintosh author around, David Pogue, *Macworld Mac FAQs* gives users the ultimate Mac reference. Hundreds of Mac questions and answers side-by-side, right at your fingertips, and organized into six easy-to-reference sections with lots of sidebars and diagrams.

ISBN: 1-56884-480-8
$19.99 USA/$26.99 Canada

Macworld® System 7.5 Bible, 3rd Edition

by Lon Poole

ISBN: 1-56884-098-5
$29.95 USA/$39.95 Canada

NATIONAL BESTSELLER!

Macworld® ClarisWorks 3.0 Companion, 3rd Edition

by Steven A. Schwartz

ISBN: 1-56884-481-6
$24.99 USA/$34.99 Canada

NATIONAL BESTSELLER!

Macworld® Complete Mac® Handbook Plus Interactive CD, 3rd Edition

by Jim Heid

BMUG SPRING 1995 CHOICE PRODUCT

ISBN: 1-56884-192-2
$39.95 USA/$54.95 Canada

Includes an interactive CD-ROM.

NEWBRIDGE
BOOK CLUB
SELECTION

Macworld® Ultimate Mac® CD-ROM

by Jim Heid

ISBN: 1-56884-477-8
$19.99 USA/$26.99 Canada

CD-ROM includes version 2.0 of QuickTime, and over 65 MB of the best shareware, freeware, fonts, sounds, and more!

Macworld® Networking Bible, 2nd Edition

by Dave Kosiur & Joel M. Snyder

ISBN: 1-56884-194-9
$29.95 USA/$39.95 Canada

Macworld® Photoshop 3 Bible, 2nd Edition

by Deke McClelland

ISBN: 1-56884-158-2
$39.95 USA/$54.95 Canada

Includes stunning CD-ROM with add-ons, digitized photos and more.

WINNERS 1994-95
TECHNICAL
PUBLICATIONS
AND ART
COMPETITIONS
OF THE SOCIETY
FOR TECHNICAL
COMMUNICATION

NEW!

Macworld® Photoshop 2.5 Bible

by Deke McClelland

ISBN: 1-56884-022-5
$29.95 USA/$39.95 Canada

NATIONAL BESTSELLER!

Macworld® FreeHand 4 Bible

by Deke McClelland

ISBN: 1-56884-170-1
$29.95 USA/$39.95 Canada

Macworld® Illustrator 5.0/5.5 Bible

by Ted Alspach

ISBN: 1-56884-097-7
$39.95 USA/$54.95 Canada

Includes CD-ROM with QuickTime tutorials.

COMPUTER
BOOK SERIES
FROM IDG

For Dummies who want to program...

Delphi Programming For Dummies®
by Neil Rubenking

ISBN: 1-56884-200-7
$19.99 USA/$26.99 Canada

Access Programming For Dummies®
by Rob Krumm

ISBN: 1-56884-091-8
$19.95 USA/$26.95 Canada

TCP/IP For Dummies®
by Marshall Wilensky & Candace Leiden

ISBN: 1-56884-241-4
$19.99 USA/$26.99 Canada

HTML For Dummies®
by Ed Tittel & Carl de Cordova

ISBN: 1-56884-330-5
$29.99 USA/$39.99 Canada

Windows® 95 Programming For Dummies®
by S. Randy Davis

ISBN: 1-56884-327-5
$19.99 USA/$26.99 Canada

Mac® Programming For Dummies®
by Dan Parks Sydow

ISBN: 1-56884-173-6
$19.95 USA/$26.95 Canada

PowerBuilder 4 Programming For Dummies®
by Ted Coombs & Jason Coombs

ISBN: 1-56884-325-9
$19.99 USA/$26.99 Canada

Visual Basic 3 For Dummies®
by Wallace Wang

ISBN: 1-56884-076-4
$19.95 USA/$26.95 Canada

Covers version 3.

ISDN For Dummies®
by David Angell

ISBN: 1-56884-331-3
$19.95 USA/$26.99 Canada

Visual C++ "2" For Dummies®
by Michael Hyman & Bob Arnson

ISBN: 1-56884-328-3
$19.99 USA/$26.99 Canada

Borland C++ For Dummies®
by Michael Hyman

ISBN: 1-56884-162-0
$19.95 USA/$26.95 Canada

C For Dummies® Volume I
by Dan Gookin

ISBN: 1-878058-78-9
$19.95 USA/$26.95 Canada

C++ For Dummies®
by Stephen R. Davis

ISBN: 1-56884-163-9
$19.95 USA/$26.95 Canada

QBasic Programming For Dummies®
by Douglas Hergert

ISBN: 1-56884-093-4
$19.95 USA/$26.95 Canada

dBase 5 For Windows® Programming For Dummies®
by Ted Coombs & Jason Coombs

ISBN: 1-56884-215-5
$19.99 USA/$26.99 Canada

Order Center: **(800) 762-2974** *(8 a.m.–6 p.m., EST, weekdays)*

Quantity	ISBN	Title	Price	Total

Shipping & Handling Charges

	Description	First book	Each additional book	Total
Domestic	Normal	$4.50	$1.50	$
	Two Day Air	$8.50	$2.50	$
	Overnight	$18.00	$3.00	$
International	Surface	$8.00	$8.00	$
	Airmail	$16.00	$16.00	$
	DHL Air	$17.00	$17.00	$

*For large quantities call for shipping & handling charges.
**Prices are subject to change without notice.

Ship to:

Name _____

Company _____

Address _____

City/State/Zip _____

Daytime Phone _____

Payment: □ Check to IDG Books Worldwide (US Funds Only)

 □ VISA □ MasterCard □ American Express

Card # _____ Expires _____

Signature _____

Subtotal _____

CA residents add
applicable sales tax _____

IN, MA, and MD
residents add
5% sales tax _____

IL residents add
6.25% sales tax _____

RI residents add
7% sales tax _____

TX residents add
8.25% sales tax _____

Shipping _____

Total _____

Please send this order form to:
IDG Books Worldwide, Inc.
7260 Shadeland Station, Suite 100
Indianapolis, IN 46256

*Allow up to 3 weeks for delivery.
Thank you!*

IDG BOOKS WORLDWIDE REGISTRATION CARD

RETURN THIS REGISTRATION CARD FOR FREE CATALOG

Title of this book: VCRs & Camcorders For Dummies, 2E

My overall rating of this book: ❏ Very good [1] ❏ Good [2] ❏ Satisfactory [3] ❏ Fair [4] ❏ Poor [5]

How I first heard about this book:

❏ Found in bookstore; name: [6]

❏ Advertisement: [8]

❏ Word of mouth; heard about book from friend, co-worker, etc.: [10]

❏ Book review: [7]

❏ Catalog: [9]

❏ Other: [11]

What I liked most about this book:

What I would change, add, delete, etc., in future editions of this book:

Other comments:

Number of computer books I purchase in a year: ❏ 1 [12] ❏ 2-5 [13] ❏ 6-10 [14] ❏ More than 10 [15]

I would characterize my computer skills as: ❏ Beginner [16] ❏ Intermediate [17] ❏ Advanced [18] ❏ Professional [19]

I use ❏ DOS [20] ❏ Windows [21] ❏ OS/2 [22] ❏ Unix [23] ❏ Macintosh [24] ❏ Other: [25]_____
(please specify)

I would be interested in new books on the following subjects:
(please check all that apply, and use the spaces provided to identify specific software)

❏ Word processing: [26]

❏ Data bases: [28]

❏ File Utilities: [30]

❏ Networking: [32]

❏ Other: [34]

❏ Spreadsheets: [27]

❏ Desktop publishing: [29]

❏ Money management: [31]

❏ Programming languages: [33]

I use a PC at (please check all that apply): ❏ home [35] ❏ work [36] ❏ school [37] ❏ other: [38] _____

The disks I prefer to use are ❏ 5.25 [39] ❏ 3.5 [40] ❏ other: [41]_____

I have a CD ROM: ❏ yes [42] ❏ no [43]

I plan to buy or upgrade computer hardware this year: ❏ yes [44] ❏ no [45]

I plan to buy or upgrade computer software this year: ❏ yes [46] ❏ no [47]

Name: _____ Business title: [48] _____ Type of Business: [49] _____

Address (❏ home [50] ❏ work [51]/Company name: _____)

Street/Suite# _____

City [52]/State [53]/Zipcode [54]: _____ Country [55] _____

❏ **I liked this book!** You may quote me by name in future
 IDG Books Worldwide promotional materials.

My daytime phone number is _____

IDG BOOKS
THE WORLD OF COMPUTER KNOWLEDGE

❑ **YES!**

Please keep me informed about IDG's World of Computer Knowledge.
Send me the latest IDG Books catalog.

COMPUTER
BOOK SERIES
FROM IDG